D1423190

The View Painters of Europe

The View Painters of Europe

Giuliano Briganti

Phaidon

TRANSLATED FROM THE ITALIAN

BY PAMELA WALEY

All rights reserved by Phaidon Press Limited
5 Cromwell Place, London SW7
First published 1970

Phaidon Publishers Inc., New York
Distributors in the United States: Praeger Publishers, Inc.
111 Fourth Avenue, New York, N.Y. 10003
Library of Congress Catalog Card Number: 75-112770

© 1969 by Electa Editrice, Milan
English translation © 1970 by Phaidon Press Limited

ISBN 0 7148 1407 5
Printed in Italy

CONTENTS

VIEW PAINTING AND ITS CRITICAL HISTORY

Although the words *veduta* and *vedutismo* are not to be found in the Italian *Enciclopedia dell'Arte* and the few short references under other headings in the general index are inadequate, the interest aroused by this aspect of eighteenth-century European art, not only in recent years, is amply demonstrated by the number of books that have been written about it and by several exhibitions, such as the memorable Bellotto exhibition seen in Warsaw, Dresden and Vienna, and the more controversial one of Venetian view painters in Venice. This interest is chiefly concentrated on the great Venetian *vedutisti*, but there has been no lack of studies on more general questions related to eighteenth-century view painting as a genre, its origins, its significance in the context of the artistic and cultural tendencies of the century, the methods and techniques employed by individual artists, its connections with the theories and the practical application of perspective and with the science of optics, and with other specialized forms of painting such as illusionism (*quadraturismo*) and scenography.

I have myself made an extensive study of Gaspar Van Wittel, chronologically the first of the topographical view painters in the eighteenth-century sense of the word, in which I endeavoured to define the term and to attempt a brief summary of the history of this form of visual art from the beginning of the seventeenth century, and indeed before that.[1] This outline of *vedutismo*, since it was related to the career of Van Wittel, ended in the early decades of the eighteenth century, which was, among many other things, the age of the view painter. It is always difficult and even more tedious to repeat in slightly different words what one has already written, especially if it was written only a short time previously. Faced with the unwelcome task of quoting myself with tiresome frequency, I have preferred to give here a brief summary of my ideas, referring the reader who requires a more detailed investigation of the antecedents and genesis of eighteenth-century *vedutismo* to my book on Van Wittel;[1] and instead of a straightforward essay on the subject, which would of necessity have been repetitive, to offer what is in effect an anthology of passages taken from other writings which I consider relevant and significant. I do this not so much to declare openly my indebtedness to all those who were of assistance to me in my previous research, as in the hope that this will enable me to make as objective as possible a survey of the changes in critical appreciation to which the genre of view painting has been subject. It might be considered as a survey obtained by means of a kind of *camera ottica*, a method dear to the *vedutisti* themselves who, typical of their time, the age of enlightenment, were certain that reality could be reproduced exactly. This anthology, in which the passages are linked by the thread of a personal view, follows a clear plan, being divided into sections which deal with the definition of the term, the origin of the genre, the discussion of problems relevant to the theme, and the evaluation of the work of individual artists.

It is well known that in the famous letter of Marchese Vincenzo Giustiniani to Theodor Ameyden, written between 1620 and 1630, in which he discusses the differences between various categories of paintings, architectural view painting is listed as the sixth of twelve classes.

> 'Sixthly, to know how to paint well perspectives and buildings; for which it is necessary to have some practical knowledge of architecture and to have read books which treat of it, and also books dealing with perspective, in order to understand regular and visual angles and to ensure that all is in concord and painted without disproportion'.[2]

The Marchese, by natural inclination and by specialized knowledge, was well qualified to perceive the influences at work in the world of art and the current tendencies of every 'class' of painting at the time; and when he insists on the necessity for some knowledge of perspective he certainly has in mind the architectural landscapes which, whether inspired by reality or the imagination, were clearly distinguishable from the fantastic and panoramic 'bird's-eye' views, predominantly descriptive in intention, characterized by Giulio Mancini in his life of Paul Bril: 'the horizon is not high, as with the Flemish, whose landscapes present as a result the majestic quality of scenery rather than the actual appearance of a countryside'.

In order to give a concrete example of the clearly contrasting principles and approach implied in the two passages which I have just quoted, I drew attention in my essay on Van Wittel to the fact that at the time Giustiniani and Mancini were writing, Viviano Codazzi was beginning his work in Rome. His point of departure was the methods of the illusionist painters or *quadraturisti*, who were primarily concerned with perspective, and he was preparing the way for those artists whom Lanzi calls *prospettivi*, among whom he included the seventeenth-century *vedutisti*. The perspective painters took as their principal and characteristic concern the strict application of architectural perspective, deriving in this from the vogue for the various applications of practical geometrical perspective (*grammica*, as Gemino and Lomazzo called it), their main objective being 'the better to deceive him who looks'. In other words, they were concerned with optical illusion, and with the problems, pleasures and tricks of perspective. In certain conditions of artistic culture and expressive tension this approach was to coincide with the most progressive principles of pictorial realism and so to contribute to the origins of topographical view painting, particularly in the work of Codazzi. At the same time, under the influence of other stimuli, it had effects in other directions and notably on the theatrical scenography of the seventeenth and eighteenth centuries.

It is also significant that the term *veduta* itself, as it is most widely understood today – a topographical view depicting a site, a building, a picturesque corner of a city, a panoramic townscape – is closely connected with the terminology of perspective. It derives from the same word meaning 'the point to which the sight is directed' and thence 'the appearance of a place', the 'prospect' of a place whether countryside, city or architectural subject, the picture or plane which is framed by the diverging lines of the visual pyramid. In the work to which I have already referred I have described at length the fundamental relationship of the word *veduta* to the science of optics, or what was called *prospettiva naturale*. During the seventeenth-century the term *prospettiva naturale* lost the identification with optical science, that is, with direct vision and the laws which govern it, which it had had in prece-

ding centuries and especially in the fifteenth, and from the middle of the seventeenth century, *prospettiva*, deriving from *prospettiva naturale*, meaning a natural perspective, became synonymous with *veduta* in the sense of a view, a prospect, a perspective, of topographical reality. The following passage, taken from the *Paradossi per praticare la prospettiva senza saperla* of 1683, by Giulio Troilo, is significant in this respect: 'Thus such views (*vedute*) as villages, mountains, the sea, islands, castles, cities, valleys, towns, houses and so on are natural perspectives (*prospettive naturali*)'.

A century later Lanzi called *prospettive* not only the works of Codazzi and other illusionist painters but also the view paintings of Carlevarijs, Canaletto, and Bellotto; and in course of time the word gradually tended to disappear and to be replaced by *veduta*. Emerging from this complicated evolution of terminology and especially owing to the drastic simplification which common usage imposes upon a language, the concept of the *veduta* has become part of the normal and almost unambiguous vocabulary of art criticism.

'The *veduta* is not merely a painting of landscape which may emanate from the painter's imagination and only incidentally be suggested by a definite place: a *veduta* is a landscape portrayed precisely and recognizably, which gives in an image a faithful account of a definite place and ambience — a historically objective landscape. This is consistently the approach of the real view painters: absolute fidelity to the visual perception of reality, to the appearance of reality, whether in normal or exceptional conditions (a square with a market in progress, buildings, famous palaces, townscapes, picturesque corners, fires, eruptions, etc.). The painter goes outside the four walls of his studio and descends into the street, if not with his easel, then certainly with a sketchbook which he will soon cover with notes drawn from life. This material constitutes his visual stockpile, a repertory of images which from time to time he uses in his paintings, in his views. When these notes are transmuted from drawing into painting, if the artist then checks his remembered and recorded experience by comparing it with the reality, the picture will be true both as to line and as to light; but this checking and verifying happens only rarely, and the view painter is more likely to let himself be guided by ability, habit and his supposed knowledge of the place, which frequent commissions may have compelled him to reproduce often and almost without variation. Again, he often plans his view with a stylized spatial lay-out, making repeated use of the same tricks of composition — emphasis on one side of the picture, on a branch or on a rock or on a part of a building. This leads to a kind of mechanical reproduction, which constitutes a limitation that may confine minor artists to the illustration of costume or to topography, on the fringes of the history of art' (A. Martini, 1965).[3]

VIEW PAINTING AND PERSPECTIVE PAINTING

There is obviously a very strong connection between view painting, illusionism and scenography (including stage design and scene painting), both in the origins of the genre and in the early stages of the careers of individual artists. Like the *veduta*, illusionism and scenography are concerned with the problems of the representation of space, and make use of the guidance offered by the practice of perspective. They developed simultaneously and influenced each other continuously. They are

linked by common principles which draw inspiration from actual architecture, take their departure from the most elementary application of perspective and become involved in its more subtle and complex problems. The links between illusionism, scenography and view painting are an essential part of the investigation of one of the historical origins of the *veduta*.

'...The origin of this specialized form of art could well be found in Mannerism and thus date from an age which delighted in classifying and subdividing the various fields of representational art; but its ancestry was as old as the sporadic manifestations of illusionism which had for centuries been used to bridge the gap between figurative mural painting and the actual architecture to which it was attached, so as to emphasize by artifice the real existence of the latter. The science of perspective had furnished illusionist painters with mathematical principles from Melozzo and Bramante onwards, and during the sixteenth century had developed in various directions which would repay study as rather vague antecedents of the 'optical view' of the seventeenth century. It is not by chance that such painters, and in the first place Codazzi, should have been called *prospettivi*, perspective painters, until the time of Lanzi. Other profitable lines of study would be the evolution of the important Brescian school of the sixteenth century from the Rosa to Sandrini and Viviani; the Lombard and Emilian stream which includes Castelli, Tibaldi and Cambiaso before producing the great perspective scenic artists of Bologna and Modena who, with such painters as Dentone, Colonna, Mitelli, Vigarani, Joli and so on, dominate the whole of Europe; and the Central Italian stream, which, after the experiments of the *raffaelleschi* (including Tuscan artists such as Salviati), includes the Alberti, who significantly came from San Sepolcro, Laureti, Zaccolini, Tarquinio da Viterbo, and so on, down to 'Padre' Pozzo. It should also be remembered that the treatise on the subject written by Niceron in 1643 is called *Thaumaturgus opticus*' (R. Longhi, 1955).[4]

As a result of this significant observation of Longhi's, made almost casually in an aside, in a study not immediately concerned with research of a general nature, recent criticism has investigated in greater detail the relationship of illusionist architectural painting with the historical origin of view painting.

'...It is symptomatic that not only the art of Canaletto but eighteenth-century view painting in general should have been founded on illusionism, on the use of perspective to achieve *trompe-l'oeil* effects. In other words, these *vedute*, which have been taken to constitute a separate genre in painting — in the sense that there are genres in literature — have their origin more in intellectual activity and less in the appearance of nature than do Mannerist landscapes. It is evident that here a perspective frame is gradually filled with representational figures. The fact that in most cases this framework remains no more than that, and only in a few cases succeeds in conveying the initial personal experience which becomes an image, does not alter the common birth of two kinds of paintings, of which the first achieves no more than illusionism and the other achieves pure reality. But in this sense there is no doubt that in the early Canaletto can be traced the hidden ancestry that derives from the scenography and illusionism of the Bibiena, rather than the strictly optical and receptive painting of Van Wittel' (C. Brandi, 1960).[5]

Besides, given the illusionist and decorative nature of perspective scenography, which presupposes a rational handling of space, view painting was inevitably liable to a mechanical and repetitive sta-

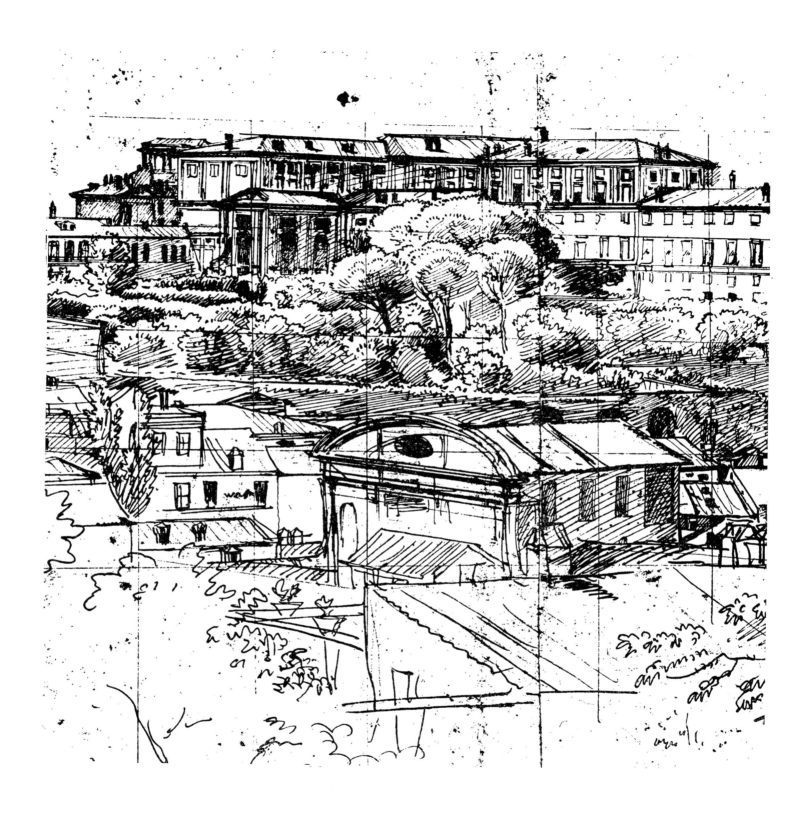

Gaspar Van Wittel: *View of the Quirinal* (detail). Rome, Biblioteca Nazionale.

gnation, even if in fact the best artists were capable of overcoming this limitation.

'...Perspective scene painters were no less active in the eighteenth century than were the landscape painters, and although they did not dominate elsewhere as they did in the Emilia, they were nonetheless untiring. The many theatres open in Venice required an ever-increasing and ever-renewed activity on the part of theatre designers and scene painters, and although theirs was an ephemeral art, confined to paper and pasteboard, it served as a stimulus to decorative perspective painting. Throughout the century teams of scenic artists succeeded one another, and influenced in their turn by the major art form of painting, they freed scenography from the narrow perspective principles followed by the Bibiena which had restricted it at the begininng of the century, giving it new life and a broader basis, striving for more mobile and adaptable pictorial effects.

'Marco Ricci himself had been a scene painter during his period in England, as his drawings in Windsor Castle show. His imagination, rather than being trammeled by the exigencies of perspective painting, took its departure from the free principles of painting from nature; and Crosato, as we have seen, in his turn gave new life to scene painting in Piedmont. The engraved and painted *vedute* of Marieschi are clearly theatrical in spirit. G.B. Piranesi was able to achieve fantastic effects with his starting-point in perspective scenography, interpreting the antiquities of Rome from a point of view that was not at all classicizing, but with a creative energy that was entirely pre-romantic.

'But those artists who were by profession perspective painters and, for the most part, theorists and teachers, and thus at the outset the dominating force in the Venetian Academy, restricted the decorative impulse of architectural and landscape scenography into arid geometrical formulae. Underlying the work of such perspective painters there was clearly an incorrigible error; and whereas Canaletto, although his point of departure was a scenographic training, which he himself declared he had forsworn, was able to create real space, that is, a poetic reality of light and atmosphere, the perspective painters reduced space to the result of illusionist techniques, merely decorative and rationally calculated. The stream of Venetian perspective painting was thus easily made to conform to neoclassical taste, and indeed became a strong support of it' (R. Pallucchini, 1960).[6]

THE ORIGINS OF VIEW PAINTING

The figurative and cultural elements in which are to be found the origins of eighteenth–century topographical view painting are as varied as they are different; and clearly all these diverse contributions go back to the beginning of the seventeenth, and in some cases to the preceding, century. On to the perspective element of illusionism was grafted the optical and realistic veracity which reflected, in this specific context, the new seventeenth-century discovery of reality; while other tendencies, some of which they had in common and others which were confined to one or the other, are seen to derive from the knowledge of nature which was characteristic of that century and concern more or less directly the rise of view painting. Thus one can go back not only to Codazzi and

Tassi, but also to the followers of Elsheimer of around 1620, and trace its descent through the succeeding generations of Italianized Dutch painters who worked in Rome during the seventeenth–century and at the beginning of the eighteenth, glancing at the protoromantic delight in ruins; or follow the thread which leads from the sixteenth-century North European painters who portrayed the most atmospheric and decaying aspects of Rome.

Here again the insight and perception of Longhi provide guidance to the relevance of the genre, in the context of the naturalistic tendencies which played so great a part in the art and culture of Rome at the beginning of the century, and to those characteristics which were analogous to but not identical with those of the perspective and the illusionist painters.

'...According to the new conception of truth, a street may be painted as it is — a fragment of what appears. As early as 1627, a Genovese painter, Sinibaldo Scorza, set up his easel in Piazza Pasquino while the shadows moved across the buildings and people took off their hats to one another, and the knife-grinder and paper-seller attended to their business. This has nothing to do with a survey map of properties, what we see here is a view painting. And twenty years later Codazzi of Bergamo, who was already something of a specialist in these views, paints Palazzo Gravina from Monte Oliveto, with a great shadow falling across it, and the Duke's carriage in the depths of the shadow, while two black-clad Jesuits walk along beside the sunlit wall towards the corner where a dealer in second-hand wares has his stall. This is the road which leads to Canaletto' (R. Longhi, 1950).[7]

'...The presence of Codazzi in Rome and Naples and Rome again between 1625 and 1672 could well demonstrate the opposite view to that which Denys Sutton has correctly identified as the protoromanticism of ruins: the converse view, that is, which looks beyond the apparent category of 'archaeological' scene–painting to derive view painting *secundum veritatem*, based on optical and realistic veracity which leads without interruption to Canaletto and Bellotto.
Codazzi certainly also liked painting ruins; he knew them by heart, and would even assemble scattered fragments into a kind of anthology, as required by his patrons, a practice also widely used by Panini. But these were not romantic ruins — they were fragments of reality mingled with everyday events and observed with a detachment so sceptical and objective that when they are invested in light and shadow they have a certain flavour of drama about them, but not one of elegy and nostalgia.
'...Whether or not he may be accounted a 'thaumaturge', Codazzi has always been considered an innovator in this field, and it may be his frequent use of archaeological motives that led Lanzi to call him "the Vitruvius, as it were, of this type of painting" ...The extraordinary career which led him from scenography on the strictest perspective lines combined with Caravaggesque contrast, to view painting from nature should ensure that Codazzi will not be forgotten among the artists of seventeenth-century Rome and Naples' (R. Longhi, 1955).[8]

These were all suggestions that led to new lines of critical investigation into the more or less remote origins of the pictorial experience offered by the view painters. Estella Brunetti follows one of them:

'Because of their exquisite transformation of reality into image, the architectural pieces of Codazzi (the imaginary views) may be considered as examples of view painting, and offer the same subtle pleasure of the immediately and profoundly real.

'...Codazzi's paintings were always intended as views, and the form he used makes this evident. But the opposite is also true; for if a painter who reproduces accurately determined arrangements of buildings must inevitably face a task which involves both reality and illusion, Codazzi is very well aware of this antithesis; with him, far from being an obvious motive and an exterior attempt to organize space, it is resolved in real pictorial terms and, transcending the limitations of a simple adjustment of perspective, attains values which, rather than ideal, are abstract. I can think of no other way of describing the intangible purity which emanates from his architectural views, even from those which might be called real, as opposed to imaginary, which confers on them the subtle charm of a *pulchritudo* which is both *vaga* and *adhaerens*.

'...There is certainly no reason to suppose that Codazzi was ignorant of the discoveries of optical science when he conveys surfaces flat or curved by delicate transitions of colour instead of deploying light and counterlight. He tended constantly to transform the observation of reality from a scientifically rigorous exactitude into a truth which is essentially pictorial. This tendency also led him to correct the falsifications of perspective in a manner which could not be bettered, just as a century later Canaletto was to correct the distortions produced by the *camera ottica*' (E. Brunetti, 1956).[9]

These are substantially the historical antecedents which provided guidance for my attempt to analyse the historical and formal premises of the phenomenon, which obviously go back far beyond the compass of the paintings of Van Wittel, the starting-point of my investigation.

But as I have attempted to show in my earlier work, at the beginning of the history of view painting, and more particularly of the topographical view painting as it developed and spread especially in the eighteenth century, we do not find only the naturalistic component, typical of Codazzi, the view from nature, based on contrasting light and shade in the Caravaggesque tradition and closely linked to the perspective of illusionism and optical illusion. The true nature of the genre will not be grasped, or will be only partially understood, if we do not take into account an entirely different tendency, the prevalence of descriptive intention, almost of programmatic intention, over formal intention — in other words, the importance of content. If indeed by *veduta* is meant 'what is seen' (and hence the naturalistic connection), it should not be forgotten that one sees only and always what one wishes or is conditioned to see. And here there is an element of affinity, if not a close one, with a period, that of Mannerism, which more than any other was prepared to subdivide and classify the whole field of representational art; a way of looking at visual reality which seeks stimulation not so much from the illusory effects of perspective as from the more subtle suggestiveness of an interior perspective, and an intellectual attitude, which is turned towards the past and may be thought of as a kind of historical perspective.

It is a kind of vision born of the consciousness of the existence of an insoluble fusion of natural scenery and reminiscence, which is aroused by a sentiment that is ready to accept the message, or the warning, conveyed by the crumbling evidence of an irrecoverable past; a consciousness and a sentiment which are inevitably stirred by the relationship between present and past, nature and history, and so between the indifference of nature, present and eternal, and the fragile transience of past greatness. I have already remarked that such an attitude is discernible, in an undertone, as it were, particularly in the drawings and sketchbooks of those artists from Northern Europe who were

8

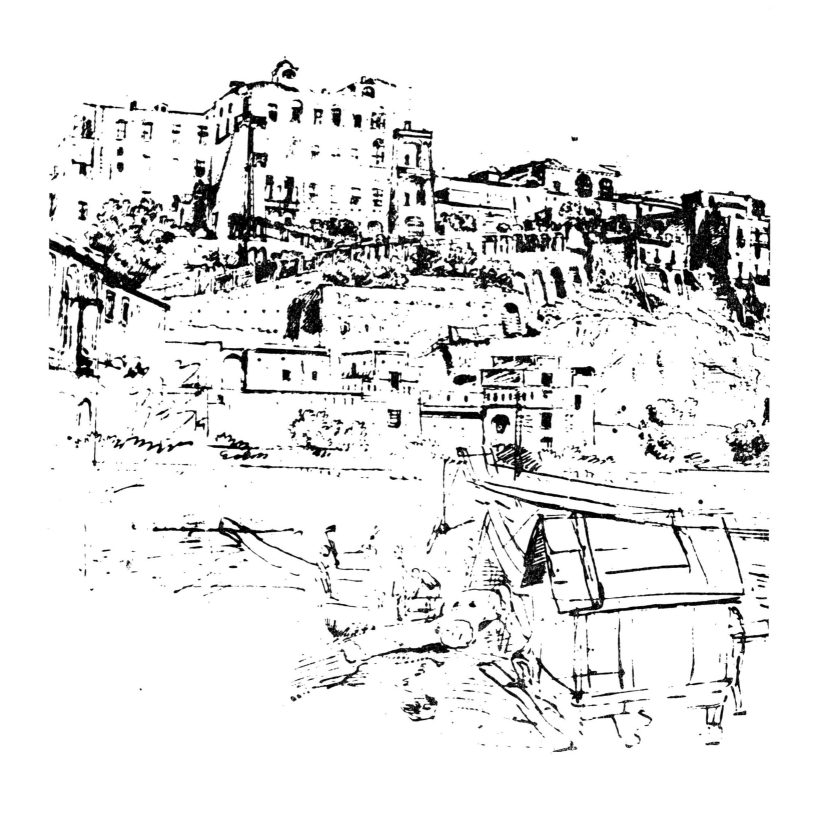

Gaspar Van Wittel: *View of Naples* (detail of Monte Echia). Naples, Museo di San Martino.

drawn to Rome by the renown, the prestige and the archaeological wealth of the city, which provoked a response typical of a time of crisis, in which nostalgia for a past so different from the present joined with admiration for a declined greatness which was in a sense unknown and mysterious. All this was, however, accompanied by a realistic and descriptive impulse appropriate to the portrayal of the actual state of the venerable ruins and a wish to make this known, a didactic and almost inventorizing attitude, which affected the choice of subject and the aim of the vision, and which is more directly concerned with the origins of view painting. *Quanta Roma fuit ipsa ruina docet*: a vision which can be considered as a protoromanticism of ruins, as Denys Sutton has acutely perceived:

'Any examination of the origins of the consciousness of nature at this period makes it clear that various trends, some connected, others independent, were operative. Hence the extreme fascination of this particular aspect of the age. Perhaps the most intriguing movement that emerged was the cult of ruins, either in Rome itself or the Campagna. That they should fascinate artists such as the Dutch and Flemish, who came from lands where the physical presence of antiquity was almost non-existent, is understandable. A danger is that in looking back now at such pictures — and Rose Macaulay's brilliant survey *The Pleasure of Ruins* has made us more than ever aware of the pitfalls of the subject — we may see them in a more romantic, more symbolical guise even than we should; they may, in fact, often be no more than views, expressly designed to give a taste of foreign parts to those unable to make the pilgrimage themselves. Yet Bril's endeavour to compose as he did, to place particular buildings in relation one to the other, was an expression of the romantic spirit. Earlier painters — such as Heemskerck — had been concerned to record the appearance of individual items of an antiquarian nature. Now, the painter was anxious to provide a summary of what could be seen, so that a vision was revealed of the ideal, rather than the actual, Rome.

'To understand the inner meaning of such pictures (that is to say, if one accepts that any arrangement of forms masks a particular comprehension of facts), one would have, so it seems, to delve into the layers of consciousness at the time. Such pictures may be considered simply for their topographical value; but the *ruine herbose* (as Marino termed them) may also be read as symbols of the strength of natural forces as compared to the transitoriness of human endeavour. Are these ruins, echoes of antiquity, posed amidst trees and grass, there to emphasize that natural life, untroubled by external problems, continues, and to stress the continuity of such factors in the very spot where noble buildings once stood?

'If the fact is accepted that the artist, consciously or unconsciously, reflects states of mind, may we say that there is some connexion between the straightforward ruin pictures of Bril and the more subtle suggestions as to decay apparent in certain works of Annibale Carracci? That in this period of paradox Annibale was prepared to take an actual building, the Palazzo Farnese in Rome, and present it under a particular guise, with vegetation encrusting a detail and suggesting a mood of abandonment, and that Breensbergh chose to imitate the Dome of St Peter's in the same state may well be significant. Are we to conclude from these examples that meanings existed within meanings, and that there prevailed, at the turn of the century — in the vital years between 1590 and 1620 — some sense of impermanence which demanded artistic expression? It is for these reasons that such isolated pictures, recalling the curious ruin mythology of certain

Surrealists, suggest the value of examining the past, and the exhibition may shed further light not only on the situation as it then was but on the perplexing and intriguing question of the various *familles d'esprit* that may be discerned in the arts' (Denys Sutton, 1955).[10]

Returning to my argument, it is obvious that such an attitude, which enabled the artist to 'see' the circumstances, the context, of a place, whether natural or historical, in its reality as an actual scene, isolating and emphasizing its most suggestive aspects and its most picturesque contrasts, was the prerogative of the North European artists who worked in Rome, drawn thither by the attraction of an atmosphere so different from that of the countries from which they came, where the the physical presence of antiquity was almost non-existent. Artists such as Poelemburgh and Breensbergh, for example, and the rest of the Italianized Netherlanders who succeeded one another in brief visits to Italy throughout the second half of the seventeenth century and the first decades of the eighteenth, cannot be omitted from any consideration of the origins of the topographical view painting. Even if they were mainly landscape painters (but many of their drawings and sketches are in fact of the subjects treated by the *vedutisti*), it should not be forgotten that they were attempting to project a vision of the reality around them which, even if it was imaginary, was at least probable and always based on sketches made from life and constituted what was substantially a *veduta*. The intention, whether latent or explicit, of expressing a visual idea in terms of a *veduta* has a clearly distinguishable effect on the result. As an autonomous genre, however, as distinct from an occasional achievement, the topographical view painting in the late seventeenth- and eighteenth-century sense of the word, the *veduta*, reached full development fairly late compared with the other genres, although its characteristics were features in the art of the early seventeenth century, on the one hand in the North European tendency to landscape painting that was inspired by particular scenes and an endeavour to convey them, and on the other hand in the methods of the perspective painters, and especially of Codazzi, whose strict architectural compositions served as a frame for the portrayal of the atmosphere and actuality of daily life.

THE METHODS OF THE VIEW PAINTERS

The close connection between view painting and the problems of optics and of perspective, and above all the intention of the eighteenth-century view painters to reproduce reality — topographical reality — objectively, as a mirror, and their belief that this was possible in an absolute fashion, are factors which induced the artists to make use of special methods and techniques, and occasionally to make use of the aid offered by the *camera ottica*.

These processes, once they have been identified, can help to explain the working methods of the individual artists and the genesis of their works, or to reveal to us their convictions and, in the profoundest sense, their relationship, conscious or unconscious, with the fundamental tendencies of the century in which they lived. But they cannot tell us much more than this, because that particular accuracy of perception and of portrayal of reality was of an interior, intellectual nature — at least with Canaletto and Bellotto. Even if the *camera ottica* could help to immobilize and concentrate the image of the view in a limited space, flat and two-dimensional, without depriving it of stereoscopic

effect, what really mattered was the spirit which led them to draw inspiration from that small, concrete microcosm, which led them to discover the process, or at least its practical application, rather than the modest aid towards effects which the *camera ottica* could offer towards the realization of the images.

In this connection it is instructive to read the description of the use and features of this optical device given by one of the outstanding men of letters of the period, Francesco Algarotti:

'...There is no doubt that if it were given to man to see a picture made by the hand of Nature herself, and to study it at his ease, it would be of more profit than anyone could ever imagine. Nature paints such pictures continually within our eyes. The rays of light which emanate from objects, entering the pupil, pass through the crystalline humour, which is the size and the shape of a single lentil. Refracted by this, the rays are again united on the retina, which is at the back of the eye, and there they fix the image of the objects towards which the pupil is directed; and thus the mind, however this happens, apprehends and sees them. This mastery of nature, which has been revealed to our time, might only have provided food for the curiosity of philosophers and been of no avail to painters, had not art succeeded in counterfeiting it, making it familiar and evident to the eyes of all. By means of a lens of glass and a mirror a device may be constructed which conveys the image or picture of anything, in a very convenient size, on to a fine sheet of paper where anyone may see it at his ease, and study it; and this device is called the *Camera Ottica*. Since no other light enters there save the rays proceeding from the object which is to be portrayed, its image appears with unbelievable clarity and strength. Nothing is more pleasant to see nor of greater utility than such a picture. And leaving aside the exactness of the outline, the truth of perspective and chiaroscuro, which could not be excelled or imagined, the colour is both so vivid and so mellow that it could not be surpassed. The lights on the figures are well-defined and bright in the parts which are most prominent and exposed to the source of light, and diminish gradually and insensibly as they recede. The shadows are strong but not hard, and the outlines are precise but not sharp. In the reflecting parts of the object can be perceived an infinite array of tints which it would be difficult to distinguish in any other way. And in every sort of colour, because of the reverberation of light between one and another, there is such harmony that very few can be called truly hostile one to another.

'Nor is it to be wondered at that by means of this device we succeed in discerning what we cannot do by any other means. When we turn our eyes to an object to consider it, there are so many other things surrounding it which also send their rays to our eyes at the same time that they do not permit us to distinguish clearly all the modulations of colour and light which the single object possesses, or at the most they show them muted, lost, between seen and unseen; whereas in the *Camera Ottica* our visual energy is concentrated upon the single object it has before it, and all other light is silent.

'Wonderful also in such a picture is the impression it gives of what is before, what behind. Besides the decrease of size in objects which is conveyed according to their distance from the eye, one sees also the decrease in intensity of colour, of light and of the parts. The further away from the eye, the more colour it loses and the vaguer are its outlines; and the shadows are far duller in less light or at a greater distance. On the other hand, the objects which are closer to

Canaletto: *Palazzo Vendramin-Calergi*. From the *Quaderno dei Disegni*. Venice, Accademia.

the eye and larger in size have also more precise outlines, stronger shadow, more definite colour. This constitutes the perspective which is called aerial perspective, as though the air between the eye and the objects, as it obscures them just a little, were wearing them away, consuming them. Upon this kind of perspective a great deal of the pictorial art depends, in matters of recession, foreshortening and background; and with its aid, together with that of linear perspective, are born 'things sweet to see, and sweet deceptions'.

'Nothing can show this better than the *Camera Ottica*, in which Nature paints the objects closest to the eye with firm and pointed brushes and more distant ones with brushes increasingly broad, and softer.

'The most celebrated painters of views today make great use of the *Camera Ottica*, and without it they could not have portrayed so vividly. It was probably also used by figure-painters beyond the Alps, who depicted what lay before them so well and in such minute detail; and it is known that Crespi, *lo Spagnolo*, of Bologna availed himself of it, and there are paintings of his that are wonderfully effective. I happened to be present when a good painter was shown the device for the first time: he was filled with indescribable delight, he could not tear himself away from the sight nor see enough of it; he tried it a thousand ways, turning the glass now to one thing now another; and he openly confessed that nothing could compare with pictures by so sovereign and excellent a master. There is a certain gentleman who is wont to say that in order to revive painting in the present time he would like to found an Academy which should contain only the book of da Vinci, a catalogue of the merits of the greatest painters, plaster casts of the most excellent Greek statues and, above all, the pictures produced by the *Camera Ottica*. A young student should begin to study them early in order that one day he may approach as close to them as a man can.

'The same use that astronomers make of the telescope, the physicists of the microscope, should be made by painters of the *Camera Ottica*. All these devices lead equally to a better knowledge and description of Nature' (F. Algarotti, 1756).[11]

But with rather less confidence in the new techniques, a contemporary theoretician gave warning of the dangers inherent in an over-mechanical exploitation of mechanical means:

'Canale taught by his example the true use of the *camera ottica* and how to recognize the defects which it may cause in a painting when the artist trusts entirely to the perspective he sees in the *camera*, especially in the colours of the air, and when he does not obviate by his skill what might offend the sense. The Professor will understand...' (A.M. Zanetti, 1792).[12]

And indeed it appears that professors (or in this case, the critics) did take heed of the arch warning of the eighteenth-century scholar. In his introduction to the Canaletto drawings in the Venetian Galleries, Pignatti gives a full and illuminating account of the working methods of this artist and the limited use which he made of the aid afforded by the *camera ottica*:

'...It is curious that until the discovery of the *Quaderno* (of Canaletto's drawings) the problem of the identification of these drawings made 'on the spot' was always rather a confused one and was indeed made more difficult by the uncertainty regarding the use of the *camera ottica*, that is, of the portable *camera oscura* which the perspective painters and engravers of the preceding generation had certainly used for their views of Venice. It is well known that Zanetti, a contemporary

of Canaletto, asserted that Canaletto not only used the instrument but also perfected its application. What is odd is that many scholars have maintained that drawings such as those in the *Quaderno* (and frequent reference is made to the exact copy of a drawing in Berlin) could have been made with the *camera ottica*. Since the publication of the *Quaderno* this opinion no longer seems tenable; it would reduce a collection of very impressive drawings from life to mechanical transpositions. This is clearly refuted by their quality, from the page in Berlin to the *Quaderno* in Venice and the drawings in the Fogg Art Museum in Cambridge, Mass.

'Patient experiments have been made using an authentic eighteenth-century portable *camera ottica* preserved in the Museo Correr. The wide-angled image of the view appears upon ground glass, on which it is an easy matter to place a transparent sheet of paper in order to draw the principal lines. But it is difficult to obtain more than the outline, and even this presents difficulties such that the results are uncertain, mechanical, rigid. I have several times used the *camera ottica* for the same views and from the same viewpoints as drawings which are included in the *Quaderno*, and I have obtained perspective diagrams which are very similar, on paper of the same size; but the nature of the line, even allowing for the effects of inexperience, has been consistently different. Canaletto's drawings was in comparison always infinitely more lively, more animated in every part, even if at times not lacking in what might be called signs of mechanical drawing (such as those which make use of drawing pens and squaring up, which are essential in architectural subjects.)

'I think that Canaletto certainly made use of a *camera ottica*, as the sources tell us, but not to make drawings such as those in the *Quaderno*. Very probably he used it only in the initial stages, for a brief general sketch of the view, to give an indication of levels and vanishing points. And there is a kind of documentary proof of this: an inscription on one of the Viggiano drawings provides unexpected confirmation of this thesis. It reads: "Buildings shown in the view of the entrance to the Salute Canal opposite the said church, with more that comes after this paper, as can be seen from the scribble (*scaraboto*) of the said locality". The *scaraboto* is no doubt one of those general preliminary sketches mentioned above, and very probably made with the help of the *camera ottica*, providing a panoramic schema which would then be subdivided into different sections of the drawing: some on pages before and some on those 'after', as the inscription says and as the *Quaderno delle Gallerie* shows' (T. Pignatti, 1958).[13]

PATRONS AND THE GRAND TOUR

The success and diffusion of the *veduta*, which implies the increased activity and the growth in numbers of view painters, were naturally affected by external factors which are to be included among the origins of the genre in so far as they correspond with the reasons for its taking a definitively topographical character. The tendency towards accuracy and exactness of the *veduta* was accentuated as demand for this type of painting increased, as it did especially in Rome and Venice from commissions for foreign patrons. This was a type of commission which, as I have explained elsewhere,[14] also existed on a small scale, a kind of wholesale trade, which did not assume that the purchaser

possessed a humanistic education or a literary or sentimental awareness of past greatness. Rather than idealized and symbolic representations, what was required were accurate portrayals of the most famous, most picturesque or most memorable places. Small view paintings like those of Baur, which were obviously painted to comply with such requirements, owe to this circumstance their apparent role of precursors of the trend towards *vedutismo* which was to assert itself rather later, towards the end of the century, and to expand in the following one: the age of the Grand Tour was approaching. But already in the seventeenth century the commercial factor, if only on a minor scale, had a certain significance as a feature of the growing fashion for view paintings. The relationship between traveller and view painter became more specific as the eighteenth century proceeded, and it came subsequently to determine the activity of the artist.

'...English collectors, it is well known, constituted the principal clientele for the painter of views. This singular fact cannot, I think, be explained simply in terms of the sentimental tourist, however strong the nostalgia provoked by the places admired during the Grand Tour and the desire to prolong the pleasure they afforded by possessing faithful representation of those places; or at least, not only by this. I think that English purchasers delighted in these 'views' because of their objectivity, the workmanlike realism which was congenial to their character and their way of considering works of art. There was also, of course, the matter of the social prestige conferred by the possession of Italian *vedute*, a sign of culture and refined taste. I should say that the great success of view painting in eighteenth-century Europe, especially of Italian view painting, was connected with the fashion prevailing in the country seats and manor houses of England at that time' (A. Martini, 1965).[15]

This question of view painters and the tourists who patronized them is of particular importance when it concerns the great Venetian painters and rich English patrons. To know something of these transactions, on however banal a level, means in many cases to have concrete evidence of the conditions of birth of a masterpiece.

'...Relations between England and Venice have always been peculiarly friendly. As great maritime and trading powers, they faced similar political and economic problems, and it was to Venice that England first sent a resident ambassador; while admiration for the efficiency and stability of Venetian government was widespread in England. Indeed, for a long time Venice came in English eyes to typify the whole of Italy; and to provide for English writers an unfailing source of themes and settings.

'With the decline in Venetian seapower and commerce, the strength of political and economic ties weakened; but that of cultural links remained, and probably attained its highest point during the eighteenth century. This was the age of the Grand Tour, of the travelling Englishman, and of an unparalleled growth in English wealth. Never before had so many English people visited Venice or come to reside there; and with them came not only money, but an ardent desire to patronize the arts. So the products of the Venetian eighteenth-century Renaissance found an immediate market among the English. Not only did Venetian works of art go to England, but also Venetian artists, either by invitation or to seek their fortune in the then richest country in the world.

'...Connoisseurs and collectors regarded a visit to Rome as obligatory. But most of them had

an incorrigible taste for the elegant and ornamental art of Venice — to use the jargon of the day — which made them liberal patrons of that art. In certain directions this followed conventional lines: the employment of Venetians to decorate the walls of churches or of great houses; the commissioning of portraits, either in Venice or England; the purchase from the easel of idealizing and picturesque landscapes. But in one direction it took a novel form — the acquiring of topographical views, in somewhat the same spirit as we today collect photographs or even picture postcards; and to this demand, the topographical painters of Venice made immediate and extraordinary response.

'A crucial event in the development of this patronage was connected with the appointment in 1707 of the fourth Earl of Manchester as Ambassador Extraordinary to Venice. There he had painted by Luca Carlevarijs a representation of his arrival at the Ducal Palace to present his credentials; an event which marks the beginning of a considerable connection between Carlevarijs and English collectors. Equally important, however, was that on his return to England in 1708 the Earl of Manchester took with him Giovanni Antonio Pellegrini and Marco Ricci, forerunners of a long succession of Venetian visitors.

'Such direct dealing between artists and patrons were, however, unusual. More often there would be a professional go-between, generally an Englishman resident in Venice. Typical of these was Owen MacSwinny, a playwright and theatre manager in London, who on becoming bankrupt, went to Italy in 1711 and remained there for over twenty years. He acted as agent chiefly for the Earl of March, who in 1723 became second Duke of Richmond. Through MacSwinny the Duke of Richmond acquired Venetian paintings, notably two small works by Canaletto, painted on copper, which are still at Goodwood. These are early works; and MacSwinny, writing to the Duke in 1727, says of the painter: "The fellow is whimsical and varies his price every day; and he that has a mind to have any of his work must not seem to be too fond of it, for he'll be the worse treated for it both in the price and the painting too". This is not the only evidence that Canaletto quickly developed all the characteristics of a prima donna.

'But the activities of MacSwinny pale before those of Joseph Smith, who after spending some years in Venice became British Consul in 1744. But he was active and prosperous long before then. In 1729, for example, he despatched to Samuel Hill in London, works by Piazzetta, Rosalba, Titan or Polidoro, and Marco Ricci; and in 1731 two paintings by Canaletto, still owned by one of Hill's relatives, after a correspondence containing a good many disparaging remarks about the artist's reliability. Smith's activities extended far beyond acting as agent for collectors. He was busy as merchant and banker; and as early as 1730 was able to rent a still-existing villa at Mogliano, represented in a series of drawings of the subject made for Smith by Visentini. More important was that Smith's prosperity enabled him to acquire a fine library and a great collection of paintings, mainly by contemporary Venetian artists. Both were sold to George III of England, the library in 1762, the collection some time between 1763 and 1770. The books of the library provided the foundation for what is known as the King's Library in the British Museum. Included therein were a number of albums containing drawings mainly by Venetian contemporary artists, among them no less than 143 drawings by Canaletto. These are now at Windsor Castle, where is also the bulk of the painting collection. Included in this were 54 works

by Canaletto, 41 by Marco Ricci, 38 by Rosalba, and 36 by Zuccarelli. So it is that the Royal Collections in England are the *locus classicus* for the study of eighteenth-century Venetian painting. 'Smith's library and collection were housed in a small palace on the Grand Canal, now the Palazzo Mangilli-Valmarana, which Smith bought in 1740, and had completely remodelled by Visentini, the work being completed in 1751. Contemporary estimates of Smith vary from that of an unscrupulous exploiter of artists to that of a generous patron. Horace Walpole described him as having "purchased the fee simple of Canaletto for the purpose of selling to English travellers". Yet Smith kept for himself most of the paintings he bought; and Canaletto could certainly take care of himself. In any case, Smith will always be remembered as one of the chief channels through which English patronage of Venetian artists was exercised.

'George III was not the only English collector to buy on a large scale in Venice. Still in England, or only recently dispersed, are notable groups of Venetian paintings acquired in the eighteenth century, such as the twenty–four views by Canaletto which belong to the Duke of Bedford, and the group of twenty-eight Venetian views formerly belonging to the Earl of Carlisle.

'Canaletto was perhaps the most sought-after of Venetian *vedute* painters; but Guardi also had his admirers. As early as 1764, Pietro Gradenigo speaks of two paintings ordered from him by an Englishman; and works by him are often mentioned in lists of paintings sent to England. An interesting case is that of Ingram, an Englishman resident in Venice in the later eighteenth century, who not only bought from Guardi, but whose daughter was a pupil of Guardi. Later, when Ingram settled in England, Miss Ingram is reported to have made most skilful copies of her father's pictures; and these are now in circulation as works by that painter.' (W.G. Constable, 1955).[16]

Opportunities for the view painter could also be less dependent upon chance. Unlike the Venetian painters, for example, Vernet worked on official commissions: the famous series of seascapes which he painted for the King of France at the orders of the Marquis de Marigny is well known; and the condition under which they were painted was perhaps responsible for a certain courtly quality in the rendering of the view which, however, by no means invalidates the principle of truth upon which they were based.

'...Your views must have two qualities: that of pictorial beauty and that of resemblance. In the plan which you have proposed to me the one is undoubtedly understood, but I fear that this may be at the expense of the other, and I doubt whether the port of Sète painted from the sea would be recognized by those who have seen it from the land. The storm you propose to portray would make your picture even less like reality since it is rare to see a sea roughened by storm inside a harbour. The foreground of your painting would have to be the open sea with the port itself in the background, which would prevent you from portraying it in enough detail to characterize it. It appears to me that the plan for this picture as it stands in the Itinerary that I have commissioned from you is the subject that you must treat. On one side a large area of the lake of Thau, on the other the entrance to the Languedoc canal, would give your picture an individuality which it would not have if you follow your earlier plan. Think it over before you decide, and above all do not lose sight of the King's wish, which is to see the ports of his realm depicted according to nature in your paintings. I realize that your imagination will be

View of Madrid from the Manzanares. From an eighteenth-century print. Milan, Bertarelli Collection.

obstructed by this; but you with your ability will succeed in reconciling veracity with invention, as you have already shown you can' (Letter from the Marquis de Marigny to Vernet, 9 October 1756) (L. Lagrange, 1864).[17]

THE VIEW PAINTERS

Naturally the discussion of view painting becomes more illuminating and effective when it centres upon individual artists, whose work may be reduced to common denominators only in its external aspects, their authentic personal motivation remaining, as it must, personal and unique.

Gaspar Van Wittel is the first painter to feature in this anthological review if only for reasons of chronology and legitimate precedence, for in the penultimate decade of the seventeenth century he chose topographic view painting as his speciality, and he raised it to a level of expressiveness and of artistic quality which had been unknown in that field before. His was the merit of having been the first to portray the living Rome, to convey its special character and immediacy not only by a minutely accurate recording of places, always chosen with extraordinary discernment, but also by an intelligent awareness of its contrasts, never dramatic or harsh, which were one of the most singular features of the city. It was not only the more obvious contrast between ancient and modern that he knew how to make less dramatic by introducing the reality of the everyday life of the city which penetrated into every corner, but also the contrast between the blackest poverty, or the infiltration of pastoral life and rural atmosphere, and the proud display of wealth and pomp. Only rarely did he paint famous sights or single buildings, he had no romantic feeling for ruins and was not particularly concerned with archaelogical interests; but he sought out new angles, viewpoints and scenes that had not previously been thought of. Views of Rome are the most numerous among the many works which still survive by Van Wittel, because from the time he first arrived in 1674, before he was twenty years old, this was the city he chose for his permanent residence. But he also explored its surroundings, and in a long journey undertaken in the last decade of the century he went as far as Lombardy and the Veneto, passing through Emilia and Tuscany and making many drawings in several cities, especially in Venice, that were to serve him in future years as the basis for many paintings.

The influence of Van Wittel had more direct and important consequences in Rome than elsewhere. It was particularly effective in the early career of Panini, who often shows that he had learnt much from the experience of the Dutch artist, in his real views and especially in his early works. His example was decisive also in the case of Hendrik Van Lint, who may be considered his direct heir, and he also influenced the artistic development of Paolo Anesi, Alesio De Marchis and Joli.

The topographical view painting became increasingly popular as the century progressed, and the English, who in every field of art were now the most active and open-handed purchasers in Europe, were among the most faithful and numerous customers. I have pointed out elsewhere that the increasing success of the genre, especially with the English noblemen who undertook the Grand Tour, depended not only on the fact that the view paintings of Van Wittel and his followers, both direct and indirect, constituted a tangible reminder of sites and buidings visited and wondered at during

the journey, but also on a more profound reason: that the mirrorlike objectivity, the essential realism and the direct simplicity of style with which the views were conceived and executed were particularly congenial to the English outlook.

It is not surprising that the Venetian masters have received fuller treatment from critics and historians. As far as they are concerned, a brief synthesis will suffice, beginning with the vivid observations made by Longhi in the immediate post-war period:

'The great Antonio Canal starts from the bald Roman views of the type painted by VanWittel and then, in order to achieve greater veracity, he makes use of the *camera ottica* and miraculously, by doing this, he produces poetry. When it is remembered that sixty years earlier in Venice the most highly esteemed in this line was Monsù Cussin, while in Holland Vermeer was painting his view of Delft, it will be obvious to what European level Canaletto succeeded in raising Venetian painting. His enlightened certainty as to the absoluteness of truth, directed on to the golden light of empty afternoons, barred by shadows, in a Venice which was crumbling and cracking, like the lines of his wonderful etchings, has the stereoscopic melancholy of the views of the Cosmorama.

'And his hardly less well-known nephew, Bernardo Bellotto, transposed that poetry to the bridges of Turin, the city-walls and towers of Dresden and Pirna, with a magical substantiality which foreshadows that of the great Russian writers of the nineteenth century.

'And Francesco Guardi? He derives from a more bizarre cultural background, which was inspired by the verve of Callot, sharpened in Magnasco and always lurking in the corner of every seventeenth-century studio disguised as Arlecchino or Coviello, Pulcinella or Zanni. Some traces of it remained with him for a long time, in the over-elaborate sketch, in the over-meticulous manner of the *Festa per i Conti del Nord*. One can see too soon, too easily, where the gondola will pass and the tired sail will fall in his lagoon scenes, where the groups of three and four will pause in his piazze, with their terraced tricornes, and even where the little dog will stop for his own trifling business. The fact is that Guardi, who had grown up in a workshop of painters of religious subjects for provincial commissions, was never fully aware of his own powers and was sometimes prepared to consider his activity as a view painter, as did the public, always traditionally and academically-minded, as painting for foreigners, amusing illustrated tickets from Venice, made by hand. He was capable of recovering his senses, and did not hesitate to paint in the chancel of a church, as Tiepolo would never have dared to do, his biblical 'caprices', his unfinished stories, which Fragonard would have admired. And on the ceilings of some minor palaces he painted his vaguely allegorical fantasies or lyrics, without the bravura of Tiepolo, without Tiepolo's scenic effects and mounting perspective; a few empty remnants of decorative forms swayed by the windless air. The same can be said of his *capricci*, juxtapositions of landscape and ruined buildings, which appear as ingenious versions in literal terms of the figurative poetry of the Far East, which he might have absorbed from coffeecups; the same applies to his views of Venice, vibrating, sandy with rust and silver, not indeed lacking in optical subtlety but on the whole as poetically removed from truth as those of Canaletto are poetically faithful to it. He thus seems sometimes to represent a shifting link between the ideal of capricious transience of Rosalba and

that of melancholy truth of Canaletto; but the first so clearly prevails that it is certainly impossible to accept the current rather ingenuous interpretation which makes of him a precursor of Impressionism' (R. Longhi, 1946).[18]

'...Certainly his contacts with Van Wittel prior to 1690, renewed when Gaspar visited Venice in 1697 (and again in 1706), were of great importance to the first essays of Luca Carlevarijs as a view painter. But it is also helpful to underline the sense of *construction* which was typical of his paintings of buildings and which is not to be found, on the other hand, in the work of the painstaking Dutchman: it is a quality which is clearly Italian, and whose origins are to be sought in the perspective painting which so many lovers of art had discovered in seventeenth-century Italy' (E. Brunetti, 1956).[19]

'...The view painters were in some ways yet more humble than the landscapists. Whereas Venetian interiors of the period may well show a Zuccarelli on the wall, they never show a view of the city itself. And the view painters had every cause to be grateful to the tourists, especially the English tourists, who filled Venice. It was tourist demand which called into existence the supply of picture-souvenirs which could be carried back to the North, shown to admiring untravelled friends, and which brought Southern light and warmth into that cold world...

'The eighteenth-century had perfected the idea of the 'Grand Tour'. It was particularly an English idea and equally specific was its devotion to Italy. "A man who has not been in Italy", said Johnson (who had not) "is always conscious of an inferiority". And the visitors in Venice, eager to be portrayed by Rosalba, were probably eager to bring back further proof of their superiority with a painted view of Venice. Venetians did not want, or need, view pictures. And so the view painters received few commissions from their fellow-citizens; their fellow-painters despised them, and most of them even now remain in oblivion — only the famous names of Canaletto and Guardi being generally known. They had little place in the discussion of art in their own period and none in the period which followed. Canaletto was lucky to get a mention at all in the mid-nineteenth century — even an unfavourable one by Ruskin. Guardi was barely known and seldom mentioned.

'But they are among the most important, as they are among the most typical, aspects of art in eighteenth-century Venice. Canaletto and Guardi between them have created a concept of Venice which influences those who have not seen it — and those who have. There has never been a city so extensively the subject of such sustained representation, but perhaps that can quickly be explained by adding that no other city has deserved to be. The view painters, besides, are a marvellous tribute to the eighteenth century's rational use of art; their pictures have a definite purpose, a purpose the English did not find in the contemporary history painters whom they therefore ignored. Nothing had yet been said about 'same delineation of a given spot', and the record of 'a given spot' had all the impartial value of an eyewitness record. Enthusiasm was required less than accuracy.

'Nor did Venice need any enhancing of the picturesque. It presented, as it still presents, the traveller with an eternal surprise. This was the lure of Italy, in general, and though the sober qualities of the eighteenth-century mind are so often emphasized the age actually loved a good surprise, appreciated fantasy and enjoyed incongruity; it was civilized enough to be the first century

which could truly savour and indulge these emotions. "One finds something more particular in the face of the country (Italy), and more astonishing in the works of nature," Addison remarked, "than can be met with in any other part of Europe".

'That ability to astonish was crystallized by Venice, beginning with the enchanting infraction of nature's law whereby it rises from the water; it was a city of the imagination to console those who without it would have had no illusions; it was a *pays lontain* which fortunately turned out to be not too far away. Not only tourists felt its permanent attraction. A native like Goldoni, by no means uncritical of his city and its citizens, looked back to it, the city he would never see again, as an old man in Paris: "Venise est une ville si extraordinaire qu'il n'est pas possible de s'en former une juste idée sans l'avoir vue... Chaque fois que je l'ai revue, après de longues absences c'était une nouvelle surprise pour moi".

'As well as a surprise, Venice offered entertainment with its theatres, cafés, gambling houses, brothels. Its prostitutes were famous and the general air of licence and amorality excited even the sluggish hearts of the English. It was the civilized world's concept of a city, although it had not the glamour of antiquity which took travellers on to Rome. What it lacked in classical ruins it made up in carnival, the delightful air of being for ever *en fête* deceiving many visitors into thinking it an ideal city.

'The view painters catered for the eyes alone; they represented, and they did not need to comment. What Goya, for example, would have made of the corrupt but fascinating spectacle is an intriguing question; but the Venetian republic would have dealt with Goya long before his satire grew savage. From the fact of the city's declining power the view painters turned tactfully away; more, they concealed that decline under the splendour their pictures derived from the great pageants so often represented. The pictures became then both view and pageant scenes recalling those of Carpaccio. The annual feasts which the Doge attended at various churches became popular subjects, and each of these was part of Venetian history, a traditional spectacle which age had consecrated and time made meaningless. Like a simulacrum, the Doge revolved through the pre-ordained circle of pompous empty activity. Painted by Canaletto, such moments as the *Wedding of the Sea*, most splendid of all Venetian festivals, must have made his countrymen proud again; the crowd agog on the Piazzetta that he shows us, a seething mass through which the ducal procession had to push its way to reach the golden many-oared barge of the *bucintoro*, forgot politics and poverty in the excitement of the day. And in the *bucintoro* the Doge was enshrined as the gilded symbol of the Most Serene Republic — like the Host in a monstrance was Goethe's apt comparison. With Canaletto and still more with Guardi, the ordinary man sinks his significance until he becomes a mere blob on the horizon, an articulated puppet to enliven the scene...

'Certainly these figures seem part of the gaiety of the view pictures; and part of the attraction for the English was to gaze at these variegated Venetian throngs: "in S.Mark's Place, such a mixed multitude of Jews, Turks and Christians; lawyers, knaves, and pickpockets; mountebanks, old women, and physicians..." However arbitrarily Canaletto grew to treat this assortment, he did not ever omit them, and in his early paintings he hit off the Jews and the Turks, the raffishness of the loungers and beggars, the pride of a passing senator; and, as the eighteenth century enjoyed

its life as mirrored on the stage in topical comedy, it enjoyed these reminders of man amid the topography of Venice.

'The view picture was a microcosm. It was basically a product of observation, almost a scientific one since it was often observed through the *camera ottica*, a sort of camera obscura in which mirrors reflected the scene outside. In his dark box, as he peered towards it, the view painter saw his scene composed — rather too steeply in perspective, admittedly, but this could easily be corrected. Canaletto occasionally, and Guardi more often did not bother to correct the distortion and it can be seen in some telescoped line of buildings, or in a sprawling distant feature which was beyond the *camera ottica's* range of true focus. But in the *camera ottica* the world was mirrored while the viewer watched, himself withdrawn. Life became a peepshow, and the painter himself was no more part of what he saw than somebody looking through a keyhole is part of what he sees' (M. Levey, 1959).[20]

'...Canaletto owes his radically new vision, which is new because it is the result of a fresh approach to artistic creation, neither to Van Wittel nor to the dull Carlevarijs, although he does not hesitate to borrow details, compositions, perspectives from Carlevarijs — those aspects of scenographic painting, that is, adapted by the mathematician-painter Carlevarijs to the charming scenes of Venice. This approach to visual reality has no precedent in the Veneto, nor in France or Italy, either at that time or earlier.

'...For Canaletto, the wonderful work of the sixteenth-century Venetian painters represented an unforgettable and precious part of his visual heritage, and although it afforded him ready examples of the handling of colour and of space, he did not find there a firm outline of image. It should be noted, moreover, that the rendering of atmosphere is not among the natural affects to be found in Canaletto's painting... The jewel-like clarity of his pictures almost precludes the intrusion of a breath of air; of the natural phenomena of which Canaletto makes use in order to give his images concrete form, atmosphere has a negative function; in a lens, it is the thickness of pure crystal that matters.

'...Thus from the outset he uses light to make a point stand out in space: a point which approaches the onlooker, which comes to meet him, offers itself to him, so to speak. Light settles like a thick, tangible deposit, a deposit which will spread, drop, mingle with shadow; the perfect equilibrium between light and shadow is ensured precisely because of this uniting and disintegrating function of the rhythm of light and shadow with regard to the conformation of the object. And this is why Canaletto needed to concentrate his object within the *camera ottica*.

'The resulting stereoscopic value which Canaletto strives to confer upon the painted image is what was destroyed by the old illusionist mechanism of perspective, and results from a basically new manner of seeing his subject. Canaletto's perspective does not construct a receding image, but one that is approaching. The vanishing point on the horizon does not draw towards it the images of buildings and scenery, absorbing them into the indistinctness of distance, but rather it projects them forward, from indistinctness towards the spectator. The ideal horizon of these paintings is not on the pictorial horizon but in the eye of the beholder. It is, then, in this emergence, this coming forward from the back towards the front of the stage, that the stereoscopic quality of Canaletto's handling of space is most evident. This, fundamentally and radically, is his vision,

View of Vienna and the Danube. From an engraving of 1760. Milan, Bertarelli Collection.

his manner of seeing.' (C. Brandi, 1960).[21]

'...Bellotto was not an unknown painter. His belief, characteristic of the age in which he lived, in the absolute nature of truth, and the poetry of his magical, enchanted vision have already been stressed, especially by Roberto Longhi and Rodolfo Pallucchini. But in general he has been inadequately appreciated, considered on a secondary and subordinate level, due principally to the fact that he had always to share his glory with an older and more famous uncle... This naturally had the effect of making him thought of rather as a 'stand-in' for the older Canaletto, with the result, especially an earlier period, that there was considerable confusion between them and, more recently, that his real stature and originality undoubtedly suffered some diminution. It must be said at once that he was not only a great artist but a very great one, in no way inferior to Canaletto himself, and indeed from several points of view he appears a more modern, more committed, artist.

'...It is true that from the very beginning of his career he adopted the manner of looking at reality that Canaletto had been developing and, in his forties, had succeeded in bringing to full perfection. He had absorbed it almost with the air he breathed, and so radically and profoundly that between 1740 (as a contemporary, Guarienti, noted in 1753) it was difficult to distinguish between the works of the two artists. But it must be added that the training he received, and this is the point, was based on the firm conviction that a visual reality corresponded to something absolute, objective, existing in and for itself, and therefore recognizable through experience; that was not only certain and indisputable but also unique, not to be confused with anything else. It was the certainty that this reality could be achieved by one road alone, and with the help of a specific method, which caused this training to concentrate above all on the means considered most suitable to carry out the operation of recording a reality. These were means such as the *camera ottica* and the strict application of practical perspective which, given the eighteenth-century belief in scientific objectivity, were considered indispensable instruments for the reproduction of this reality, the visible appearance considered as certain and objective. This was something more radical, therefore, and in a way more likely to lead to results closely resembling each other than a simple handing on from master to pupil of the subjective methods of achieving a certain pictorial style. The fact that Canaletto was then able to transmute into poetry this confidence in an absolute truth is quite another matter: and the same is true for Bellotto, who, starting from identical principles, touched with a fresh spirit different keys of feeling. This enabled him, without abandoning anything that he had been taught, to find a way which led to results quite distinguishable from those of Canaletto.

'...It was certainly a lucky chance that enabled him to leave the Italian scene for the novel and different one of Dresden in Saxony. Everything that was seductive, antique, decayed, in the cities of Italy, the way in which the immediacy of modern life inserted itself into the welcoming folds of a past which lay everywhere, the feeling of inevitable crumbling into slow ruin of the evidences of ancient greatness, could not help but induce a tendency to delight in the picturesque. This was an insinuating invitation to make elegant arrangements with which the eighteenth-century taste for the *capriccio* nudged the original objective attitude towards actuality in the direction of the realms of fantasy and imagination. The views of Dresden and Pirna which Bel-

lotto painted during his residence in Saxony from 1747 to 1758 perhaps mark the highest point in his striving for that absolute objectivity which was one of the two opposing poles of the figurative arts in the eighteenth-century. The impression of veracity which they convey has something magical about it, their power of evocation seems inexhaustible. In their contemplation the spectator lives through peaceful afternoons on the banks of the Elbe, in an enchantment of veiled melancholy, on the gentle eastern fringe of eighteenth-century Germany, still polite and civilized, while around the horizon the perspective diorama follows the ordered elegance of the new constructions with which Frederick Augustus II was rebuilding his city. With a natural objectivity that does not conceal his secret but rather seems to confirm that a methodical way of seeing is the only one capable of recording truth, Bellotto brings before our eyes the life of this modern city, its buildings still with sharp corners projecting among the scaffolding, and blocks of stone being chiselled into shape in the shadow of the old wooden buildings which are in course of demolition. The tranquil life of the new market-place dominated by the cupola and pinnacles of the Frauenkirche, the wide prospect of the Zwingerhof with the symmetrical, somewhat military, ranks of its buildings, the seething crowd in the old market, the Oriental pavilions and gardens on the banks of the Elbe, with great green flowerbeds writhing in slow convolutions; or the rustic prettiness of the little village of Pirna, and the fortress of Sonnenstein at the edge of the meadows which slope down towards the river, the vineyards on the hillsides, the unused cannon beside which soldiers are dozing in the strong light of a lazy afternoon.

'His residence in the more ostentatious scene of the Vienna of Maria Teresa... brings a supra-real accentuation of the magical solidity of his vision, with almost pre-romantic effects, as in the wide views of the Schlosshof or the ruins of Theben. Bellotto gives his greatest demonstrations of this verism, transposed into a still colder and brighter atmosphere, in Warsaw. Here his objectivity is transported into natural surroundings which suit it well, and the existence of a simple and reliable affinity with the reality is evident in his views of the Polish city... and shows how open towards future possibilities was the vision of an artist whose beginnings were nevertheless so deeply rooted in the culture of his own age' (G. Briganti, 1965).[22]

If it is true that the view paintings of the Venetian artists represent both in quantity and in quality the most important aspect of the genre, the fact remains that other parts of Italy, and elsewhere in Europe, produce, and not only occasionally, original paintings. The London views of Canaletto would not be conceivable in the climate of Venice, and still more, the northern views of Bellotto owe their modernity at least in part to the fact that the painter had moved away from the classic centre of *vedutismo*. From this point of view Naples too is a special case, offering an example of individual characteristics.

'In Naples, the recent sensational archaeological discoveries had drawn general interest to the present reality of that part of the country, and its distant heritage, Roman and Greek, lived again in a glamorous present similar to that of Rome but still further enriched by the beauty of the views which readily lent themselves to full elaboration by the imminent wave of romanticism. During these years the city became one of the obligatory goals, and the most attractive one, for the stream of foreigners who travelled from the north in search of those sunny lands "where the lemon trees flower". Already by the middle of the eighteenth century there was a

growing eagerness to become the possessor of a landscape painting which would both convey the new poetic feeling of the *veduta* and retain the subtle aura of a historical curiosity, in such a way that the suggestion of antiquity of the land of Virgil, surviving the enormous cataclysms of Vesuvius, merged with the bright myth of a southern land still primitive and happy. This new factor cut short the last possibilities of survival of the local tradition, now deprived of authority and worn into increasingly conventional cyphers, and it restricted also the possibility of modernization, a tendency emanating from Rome as a result of the work of Panini and Locatelli and making an appearance in Naples in the undoubtedly important works of Bonavia... And even if it is not yet firmly proved that the spread of the English landscape tradition and its importance on a European scale had made the desire for innovation felt even on the furthest fringe of the Campania, nevertheless it seems to be confirmed by the number of works by the greatest painters of that school which were inspired by the Neapolitan countryside.

'...There had been, at the very beginning of the eighteenth century, the great figure of Van Wittel in Naples to demonstrate the potentialities of the painting of landscape in terms of the Dutch school, accurate yet not devoid of the elements of the poetry of light and episode. This was indeed a notable precedent, but it was to have its effect in a totally indirect manner, in so far as all that was new and fertile which Van Wittel had brought to the artistic life of Venice, from Canale to Marieschi, Carlevarijs and Bellotto, passed into a tradition which, becoming European, was only then received in Naples. His presence in the city was unlikely to have had any direct influence at a time and in a milieu that was dominated by the successes of Roman scenographic painting, originating with Rosa; but the weight of his achievement made itself felt there half a century later, when the Modenese artist, Antonio Joli, who had received his training in Venice in contact with the greatest manifestations of that school, moved to Naples as scenographer of the Teatro San Carlo, and remained there, with few absences, from 1762 to 1777, the year of his death. Art historians have paid little attention to Joli, and his life and work still await a full study. He has been treated mainly as an architectural and perspective painter, but far greater is his achievement as a view painter in the style of Canaletto, enlivened with a decorative flourish which was the result of his contact with the Roman school. His *Views of Naples*, always convincing with subtly observed treatment of light and obvious documentary value, are preserved in the collection of Lord Montagu, in the Museo di S. Martino, Naples and in the Royal Palace at Caserta, and they not infrequently appear on the market. These works are significant enough to restore to Joli a position of prime importance among the view painters of his time, and also to establish that his residence in Naples must have had some influence on the development of landscape painting in that city, almost achieving an abrupt change of direction, a call to the treatment of natural reality in the face of the Arcadian scenes and the theatricality of current taste.

'The fact that the lesson had to come from an artist who was officially a professional scenographic painter is a fact not without significance, and a warning against an over-simplified classification of schools, genres and tendencies. But in comparison with the elegant, courtly, terse renderings of the ruin-fantasies of a Coccorante, the true-to-life ruins of Joli offered different values — immediacy and rational observation; and his work is distinguished by conventions, an unexceptionable decisiveness and severity, which are peculiar to him, if they are considered without reference

View of Warsaw, from a print of 1705.

Milan, Bertarelli Collection.

to the new climate of opinion which was developing. Painters of lesser distinction who are nevertheless worthy of note, such as Gabriele Ricciardelli and Pio Fabris, took their inspiration from Joli, although its mark is visible in only a few known works. In his paintings there are signs which anticipate by a few years the other great personality in the renewal of Neapolitan landscape painting in the second half of the eighteenth century, the German Philipp Hackert. Joli's work was sufficiently developed for Hackert not to need to break new ground, so that his influence flowed along channels that were already established, but to Hackert fell the task of making a substantial change in the character of Neapolitan painting, propagating with a nordic serenity which has too often been held against him in accusations of purely calligraphic painting and empty decoration, the new principle of documentary fidelity in the reproduction of landscape, without recourse to the conventional formulae and romantic vagueness of the old school.

'1770 was the significant year in which Sir William Hamilton summoned Hackert to Naples to draw views of Vesuvius; and an important role should be attributed to the English diplomat in the development of art in Naples, particularly when the *Campi Phlaegraei* and his patronage of other painters in the same field are borne in mind. Kniep, also a member of the Hamilton circle before his friendship with Goethe, is too superficial a painter to be treated beside these more important figures, but the case of Pio Fabris is rather different, and to him belongs the credit for having been among the first to draw attention to the picturesque and colourful life of the lower classes in Naples, initiating a taste for paintings of small scenes of folkloric interest, the life of the people, which was later to form one of the basic themes of Neapolitan painting. 'Hamilton and Goethe are only extreme cases, because it is clear that it is the ever-increasing number of foreign patrons and buyers in the city that fertilised the artistic life of Naples, awakening energies that had lain dormant and injecting a new fund of sensibilities and ideas which would have consequences not only in the history of painting but also in political history, contributing to turn Neapolitan society towards heroic and unfortunate adventures from which it was to emerge impoverished and, in its best aspects, cruelly so' (R. Causa, 1956).[23]

Naples, an obligatory stop on the Grand Tour, is naturally, after Venice, one of the subjects most frequently portrayed in the geography of *vedutismo*. The contribution of Van Wittel, who visited Naples several times from the beginning of the eighteenth century onwards and painted a variety of views of the city, was certainly fundamental, but its effect was a delayed one and not fully felt until his works had been reinforced by the authority of the great Venetian view painters and the establishment of an European tradition. It was only in the second half of the century that painters such as Antonio Joli, Pio Fabris, Carlo Bonavia, Gabriele Ricciardelli and Pietro Antoniani created what can be called a Neapolitan school of view painting, which was given an international character by its association with largescale undertakings such as the illustrations for Sir William Hamilton's *Campi Phlaegraei*, begun in 1777, or the *Voyage Pittoresque de Naples et de Sicilie* of the Abbé de Saint-Non, published in 1781, with many views contributed by Hubert Robert, Chatelet, Renard, Paris and Desprez.

'...Antoniani appears as a good view painter closely concerned in the cultural scene in Naples in the second half of the eighteenth century. He can be compared to some extent with the "Canaletto of Naples", the Modenese Antonio Joli, even if his touch is somewhat external, calligra-

phic, mechanical, and his perspective diagrams freer and sometimes distorted. There is, in short, a noticeable difference of generation between Joli and Antoniani, and a difference of interests, passing from the optical objectivity of the first, still warmly enthusiastic for the new discoveries of Canaletto, to the cursive illustration of the second, tending to the externally spectacular and in any case concerned with the unusual' (A. Martini, 1965).[24]

French view painting, which alone can worthily stand beside the great Venetian school, has been examined and discussed by acute and accurate critics who have defined its particular characteristics, its relationship with contemporary developments and its practical aims.

'...It is strange that the Italians felt no urge to paint or draw the ancient monuments among which they lived: they admired them, true, but this only led them to reproduce them in another fashion, by building new ones which were to be the equal of the old, and they were ready to do this fearlessly, even destroying them, using as stone quarries the Septizonium of the Palatine or the Colosseum, of which little would remain today had not Benedict XIV saved it from ruin by consecrating it to the memory of the Christian martyrs who died there. In this destruction of Rome for Rome's sake can be glimpsed the neoplatonic koncept which was always implicit in Italy, that the true essence of a thing is its idea rather than its nature; whereas North Europeans remain faithful to reality...

'In Rome, when the French began to study there regularly, the chief painters of ruins were Andrea Locatelli, a close follower of the Flemish Jan Frans van Bloemen, known as l'Orizzonte, who had made the pastoral genre of Claude into an academic form, and Giovanni Paolo Panini, the Baroque representative among ruin painters. The preceding generation of view painters had had as its champion an artist of Dutch origin, Gaspar Van Wittel, known as Vanvitelli, who, as Briganti has shown, derives directly from the seventeenth-century Dutch tradition of view painting.

'Pierre de Nolhac in his *Peintres français en Italie* appears to attribute to Hubert Robert and Fragonard the merit of having first encouraged the painting of landscape from nature, in Rome and the country villas around it, among the French artists who were studying at the French Academy there. He adds "it is amusing to see them leading the director, Natoire, astray, and persuading him in his old age to turn to landscape painting". The correspondence between the Director of the French Academy in Rome and the Directeur des Bâtiments in Paris provides ample proof that this form of exercise was in fact part of the normal routine of the *pensionnaires*. Natoire himself recommended it, seeing it as a useful corrective to an excess of the alternative exercise of copying from the Renaissance masters. "Most of them," writes Natoire to Marigny, the Directeur des Bâtiments, "are afraid of lowering themselves by practising this kind of painting (landscape) and prefer to do what they can in the other (copying) rather than to seek to distinguish themselves in the first".

'...As early as 1724 Wleughels, on his arrival in Rome, and even before he had officially taken up the post of Director of the Academy, had begun to take his students out into the country, to Frascati and Tivoli, with the purpose of reviving the declining genre of historical landscape... Wleughels had also close connections with Panini, who had married his sister and was under the protection of Cardinal Polignac. The strength of Panini's influence in French circles may be

judged from the fact that on the death of Wleughels on 11 December 1737 he was for a time considered a possible successor as Director. This demonstrates also the importance that must be given to the revival of historical landscape as a genre. The example of the great Roman view painter clearly contributed to the orientation of the Academy in the direction of painting 'on the spot', which took its place beside the wearisome exercise of copying from ancient and Renaissance masters.

'...Wleughels' interest in landscape is also shown in his encouragement of Joseph Verne t.Sent to Rome in 1734, he was welcomed by the Director all the more warmly because he carried letters of recommendation from the Directeur Général and an introduction from the Bishop of Cavaillon, who was a friend of Wleughels. Since he was above all interested in marine painting, was it necessary for him to copy from the antique? The sensible Wleughels wrote: "He is a marine painter, and must study in sea-ports", and elsewhere "I have advised [Vernet] to follow his bent, especially now that he has shown me two of his sea pieces". The Duc d'Antin approved: "You are very right to advise him to follow his own inclination, for otherwise he would be wasting his time without achieving anything".

'Joseph Vernet, who was to remain in Italy for eighteen years (1734-52) soon lost interest in painting reality in favour of imaginary landscapes in the wake of Claude Lorrain, Salvator Rosa, Adrien Manglard; and in his paintings of seascapes, by day and by night, he substituted for the mythical figures of Claude the soldiers, washerwomen, fishermen and shipwrecked sailors of Salvator Rosa. This was a type of painting which was very successful and paying, which pleased tourists and attracted imitators, such as Carlo Labruzzi (1748-1817) whose works often pass under Vernet's name.

'Meanwhile, in the years towards 1760, drawing 'on the spot' scenes of Rome and its surroundings became increasingly important, largely on account of the meeting together of two artists and a connoisseur, who were to take it up with enthusiasm: Fragonard, Hubert Robert and the Abbé de Saint-Non' (G. Bazin, 1961).[25]

'The journey of the Abbé de Saint-Non, which followed that of Vandières by a few years but was in a relatively minor key, had nevertheless consequences that were no less important: it definitely created and gave direction to the modern school of French landscape painting, intimated by Desportes. The attraction exercised by archaeological excavation in Italy had provoked a new discovery, apart from that of ancient objects: the discovery of landscape, of nature's architecture. This interest revealed the beauty of everyday scenes, reviving after two centuries the forgotten achievement of the Flemish Paul Bril. The present was discovered together with the past, and eyes which were sharpened by the darkness of the excavations were opened also to the incomparable luminosity of the Italian countryside. While many painters flocked to the studio of Raphael Mengs and aspired to learn a way of reviving painting through the study of sculpture, three Frenchmen rediscovered for mankind the appearance and the spirit of the Mediterranean landscape, its horizon, trees, gardens, ancient ruins, its daily life and its crumbling monuments, the posthumous evidence of the permanence of man. These three Frenchmen, who thus deliberately turned their back on archaeology in favour of life, were Hubert Robert, Fragonard and their brilliant guide Jean Claude Richard de Saint-Non, abbé *in commendam* of Poultières

in the diocese of Langres, deacon and formerly conseilleur de Parlement, too often absent from Paris. Their choice determined, within the limits of European art, the particular originality of French art, which alone did not lose itself in the labyrinth of antiquity.

'...Hubert Robert admired Piranesi and was an enthusiastic pupil of the great Panini, but when he painted ancient ruins he was careful not to use them as a pretext for grandiose architectural drawing nor for pre-romantic meditation: he wished neither to be moved by a dead past not to reconstruct a departed vision. He considered antiquity as a kind of luminous décor into which he was to insert familiar everyday life. Antiquity was for him the root of the human plant; he painted not ruins but the flowers of the Italian soil.

'The wish to see antiquities drew Robert to Rome, where he arrived in the retinue of the future Duc de Choiseul who had been appointed French Ambassador to the Papal See. He was not, therefore, a pupil of the Academy at Palazzo Mancini, although he was freely welcomed there; and this position, on the fringes of the Rome school, allowed him to profit from the advantages it offered without having to submit to the paralysing discipline, and to enjoy a freedom which he used to plunge himself into the glorious life of the Mediterranean region.

'He would certainly not have been able to achieve this equilibrium without the presence of the Abbé de Saint-Non, who had also been drawn by Herculaneum and Pompeii. Robert needed a sort of manager and spiritual director, and the intelligent and well-informed abbé willingly filled this role for him, especially as he was ready to welcome all requests from artists.

...But these architectural illustrations, these pencil-drawn anecdotes, these travellers' tales in the form of engravings, even the verse letters and poems which celebrated them can only be considered stories, collector's pieces or material for scientific study. This raw material was, however, by the fortunate conjunction of Hubert Robert, Fragonard and Saint-Non transformed into living matter. From the almost providential association of these three artists was to be born a first school of French landscapists and painters of everyday life, containing *in fieri* the whole of the eighteenth century and, in the case of Fragonard, even of Romanticism.

'...If chronological considerations call for the treatment of the landscape of Joseph Vernet before the Roman period of Hubert Robert and Fragonard, his development was too much on the margin of the evolution of French art, his aesthetic appeals too much bound to that of the preceding century, for it to have been studied earlier. The originality of Vernet can only be seen when the new phase has already begun, and understanding of his work must be retrospective.

'...Vernet in Italy, Vernet the painter of the ports of France, seems to herald nothing, his art seems empty. Only in the light of a young school can he be explained and brought into focus. Then he appears to complete and conclude an art of the past, without the strength to regenerate it and lacking the energy to secure for it a new beginning.

'The method of Vernet consists entirely in an accurate physical record, in the memory of the seeing eye, of the clear and precise form of objects, the nuances of light, the reflections of the water, the appearance of a place or of a building that can be recognized...

'His *Ports of France* are like solutions of a puzzle; the elements which make up his shipwrecks, his stormy mornings, his nocturnal fires, are interchangeable, and the different combinations of rock, wreck, mountain and cascade are infinite. Dully wedded to a nature which he is inca-

pable of dominating, he imitates without personalizing it, he cannot transform it either into the ancient world of Poussin nor the lyrical world of Watteau nor a personal world of his own, a creation of his own mind and soul. He is a literal portraitist — one might almost say a photographer — of landscape in which truth surpasses beauty; and even in his more fantastic combinations of buildings or mountains each element can be identified, as in a collection of documents each paper can be recognized. (In the twentieth century Vernet would have been an excellent producer of travel documentaries). In Claude, on the other hand, the buildings, which are also accurately painted, acquire a flavour of unreality and eternity and form an ideal universe. Vernet's subjects belong to this side of his work, those of Hubert Robert do not say what they should, but they do not say less than that. Hubert Robert, when he returned to France, frequently made use of Vernet's method when obsessed by his memories or obliged by commissions; he detaches himself from everyday reality, but the classicism of Hubert Robert's last manner is lacking in all ambition to greatness, he offers a complete and pleasing compendium of all the recognized formulae of the great periods of art. Three or four times, however, Vernet overcomes his limitations with a stroke of genius, and then he shows himself as a link between the seventeenth and the nineteenth centuries, and the flame appears to pass from Claude to Corot by his hand' (M. Florisoone, 1948).[26]

NOTES TO THE INTRODUCTION

1. Giuliano Briganti, *Gaspar Van Wittel e l'origine della veduta settecentesca*. Rome, Ugo Bozzi editore, 1966.

2. Letter of the Marchese Vincenzo Giustiniani to Theodor Ameyden, about 1625.

3. Alberto Martini, 'Notizia su Pietro Antoniani milanese a Napoli', *Paragone*, March 1965, pp. 81-2.

4. Roberto Longhi, 'Viviano Codazzi e l'invenzione della veduta realistica', *Paragone*, November 1955, pp. 41-2.

5. Cesare Brandi, *Canaletto*, Milan, 1960, p. 23.

6. Rodolfo Pallucchini, *La Pittura Veneziana del Settecento*, Venice-Rome, 1960, pp. 205-06.

7. Roberto Longhi, 'Velazquez 1630: La « rissa all'Ambasciata di Spagna »', *Paragone*, January 1950, pp. 30-40.

8. Roberto Longhi, *op. cit.*, p. 71.

9. Estella Brunetti, 'Situazione di Viviano Codazzi', *Paragone*, July 1956, pp. 52, 54.

10. Denys Sutton, Introduction to: *Artists in 17th Century Rome*. Catalogue of loan exhibition, Wildenstein and Co. Ltd., London, June-July 1955.

11. Francesco Algarotti, *Raccolte di lettere sopra la Pittura e l'Architettura*, Leghorn, 1765, vol. II, pp. 151-5.

12. Anton Maria Zanetti, *Della pittura veneziana e delle opere pubbliche dei veneziani maestri*, 1792, vol. II, p. 597.

13. Terisio Pignatti, *Il Quaderno del Canaletto alle Gallerie di Venezia*, Milan, 1958, pp. 20-21.

14. Giuliano Briganti, *op. cit.*

15. Alberto Martini, *op. cit.*, pp. 82-3.

16. William G. Constable, 'Venice and England in the XVIIIth century', *Venezia e l'Europa, Atti del Congresso Internazionale di Storia dell'Arte*, 1955, pp. 95-103.

17. Léon Lagrange, *Joseph Vernet*, Paris, 1864, pp. 85-6.

18. Roberto Longhi, *Viatico per cinque secoli di pittura veneziana*, Venice, 1946, pp. 37-8.

19. Estella Brunetti, *op. cit.*, p. 55.

20. Michael Levey, *Painting in XVIII Century Venice*, London, 1959, pp. 70-2.

21. Cesare Brandi, *op. cit.*, pp. 24-34.

22. Giuliano Briganti, 'La mostra del Bellotto a Vienna: diventò grande quando lasciò Venezia', *L'Espresso*, no. 31, 1965.

23. Raffaello Causa, *Pitloo*, Naples, 1956, pp. 33-8.

24. Alberto Martini, *op. cit.*, p. 84.

25. Germain Bazin, *L'Italia vista dai pittori francesi del XVIII e XIX secolo*, Catalogue of the Exhibition, February-March 1961, pp. 6-13.

26. Michael Florisoone, *Le Dix-huitième siècle*, Paris, 1948, pp. 94-7, 100.

ROME

...Among the beautiful churches must be included that built in honour of St. Agnes, virgin and martyr, who was brought to this place, where there was an enclosure known as the Circus Agonalis, and exposed to every kind of indecency, as in a public brothel. It is in Piazza Navona, and although it is not a large church, its five altars merit a glance, the largest of which has a bas-relief in marble, very beautiful, whereas the other altars are decorated only by statues...

In addition to the magnificent palace of Prince Pamphili and other palaces no less worthy of note which surround Piazza Navona, it is ennobled by three incomparable fountains, of which the central one is by the excellent sculptor the Cavaliere Bernini, in which four statues of white marble represent the four chief rivers of the world, the Danube in Europe, the Ganges in Asia, the Nile in Africa and the Rio de la Plata in the western Indies; in the midst of these rises a great rock surmounted by an obelisk which was brought here from the Circus of Caracalla and placed according to the instructions of Bernini. A plentiful flow of water falls from all sides into a large basin of stone, also designed and executed by the said Bernini. Another fountain close by is by Michelangelo Buonarroti, with a statue of Neptune and the Tritons, an estimable work both for its design and for the busts of alabaster. The third fountain corresponds to that of Neptune; this piazza, in short, fills everyone with enthusiasm.

Italienische Reise, 1740. JOHANN KASPAR GOETHE

1740

...The Capitol is a considerable building, with curiosities worthy of a traveller's attention. It was built in the Pontificate of Gregory XIII. The ascent to it is by a staircase of several flights, adorned on both sides with balustrades of freestone, at the bottom of which are placed two lions of a very dark stone, which form two fountains. At the top of the steps are firstly two great statues which represent Castor and Pollux, when they came to Rome with the news of the victory gained over the Tarquins. In the middle of the area bounded by three separate buildings, two of which are a kind of continuation to the building which faces the ascent, there is the equestrian statue in bronze of the Emperor Marcus Aurelius Antoninus, which is the most beautiful and perfect work that was ever made of this kind... The Capitol certainly contains a considerable treasure in ancient and modern statues, in bas-reliefs and in all sorts of fragments of antiquity. The buildings are according to the design of Michelangelo.

...Being in the neighbourhood of the Campo Vaccino, I cannot help giving you some account of it, not that I pretend to do so in detail because I have not sufficient learning. Here we see the admirable ruins of old Rome, which I cannot behold without pitying the condition they are in at present. You would have the same concern as I have, were you in the middle of a large square and could see nothing all round it but ruins; to see on one side the walls of the antient Capitol, on the other the arch of Constantine, erected with so much expense by the Senate and people of Rome, broken and half buried. Beyond that, the arch of Titus, in a condition still worse; on your left, the immense ruins of the Temple of Peace, the vestiges of the Temple of Antoninus and Faustina, on the architrave of which is this vain inscription: *Divo Antonino, Divae Faustinae*; on your right hand, the melancholy ruins of the Temple of Concord, which, to judge of it by the eight pillars that are still remaining, must have been very superb.

And what would you say, if you should go on till you come to the famous Coliseum, which Time, the destroyer of all things, had spared, but which was destroyed by men, and those

same men who were most concerned to preserve Rome? What would you think, if you saw that there was scarcely enough remaining of this stately edifice to give you an idea of what it once was? Its form on the outside is round, and it is built to a prodigious height, entirely of freestone. The court or arena is oval, there were three distinct rows of seats in the amphitheatre, the highest for the senators, the second for the knights, and the third for the common people. They say it contained eighty-five thousand people.

...From the Castle of Sant'Angelo you will please to follow me to the Palace of Monte Cavallo, which is travelling from one end of Rome to the other. Gregory XIII began this palace, and several of the succeeding popes have carried it on. It is much more spacious than magnificent, and yet only the Pope is well lodged in it; none of the other apartments is good for much.

This vast building forms a long square, with a great court in the middle, surrounded by arcades five hundred paces in length. The two cross buildings, of which that at the further end forms the main body of the edifice, are higher than those at the sides. On the façade of the main building there is a mosaic, designed by Carlo Maratti, of the Virgin and Child, an admirable work. The air of Monte Cavallo is said to be the best in Rome, and indeed no other reason could induce the popes to reside here rather than in the Vatican. The gardens belonging to it are very much admired by the Italians who have never travelled out of their country, where gardening is not in very great perfection.

Lettres et mémoires du Baron de Pollnitz, London, 1747. CHARLES LOUIS POLLNITZ
 September 1730

...You may guess what I felt at first sight of the city of Rome, which, notwithstanding all the calamities it has undergone, still maintains an august and imperial appearance. It stands on the farther side of the Tyber, which we crossed at the Ponte Molle, formerly called Pons Milvius, about two miles from the gate by which we entered. We passed along the road by which so many heroes returned with conquest to their country; by which so many kings were led captive to Rome; and by which the ambassadors of so many kingdoms and states approached the seat of empire, to deprecate the wrath, to sollicit the friendship, or sue for the protection of the Roman people. The space between the bridge and Porta del Po-polo, on the right-hand, which is now taken up with gardens and villas, was part of the an-tient Campus Martius, where the comitiae were held and where the Roman people inured themselves to all manner of exercises: it was adorned with porticos, temples, theatres, baths, circi, basilicae, obelisks, columns, statues, and groves. Authors differ in their opinions about the extent of it; but as they all agree that it contained the Pantheon, the Circus Agonis, now the Piazza Navona, the Bustum and Mausoleum Augusti, great part of the modern city must be built upon the antient Campus Martius. The Tyber in comparison with the Thames is no more than an inconsiderable stream, foul, deep, and rapid. It is navigable by small boats, barks, and lighters; and, for the conveniency of loading and unloading them, there is a handsome quay by the new custom-house, at the Porto di Ripetta, provided with stairs on each side, and adorned with an elegant fountain, that yields abundance of excellent water.

The Porta del Popolo (formerly Flaminia) by which we entered Rome, is an elegant piece of architecture, adorned with marble columns and statues, executed after the design of Buonaroti. Within-side you find yourself in a noble piazza, from whence three of the princi-pal streets of Rome are detached. It is adorned with the famous Aegyptian obelisk, brought hither from the Circus Maximus, and set up by the architect Dominico Fontana in the pon-

tificate of Sixtus V. Here is likewise a beautiful fountain designed by the same artist; and at the beginning of the two principal streets, are two very elegant churches fronting each other. Such an august entrance cannot fail to impress the stranger with a sublime idea of this venerable city.

...Nothing can be more agreeable to the eyes of a stranger, especially in the heats of summer, than the great number of public fountains that appear in every part of Rome, embellished with all the ornaments of sculpture, and pouring forth prodigious quantities of cool, delicious water, brought in aqueducts from different lakes, rivers, and sources, at a considerable distance from the city. These works are the remains of the munificence and industry of the antient Romans, who were extremely delicate in the article of water: but, however, great applause is also due to those beneficent popes who have been at the expence of restoring and repairing those noble channels of health, pleasure, and convenience. This great plenty of water, nevertheless, has not induced the Romans to be cleanly. Their streets, and even their palaces are disgraced with filth. The noble Piazza Navona is adorned with three or four fountains, one of which is perhaps the most magnificent in Europe, and all of them discharge vast streams of water: but, notwithstanding this provision, the piazza is almost as dirty as West Smithfield, where the cattle are sold in London. The corridors, arcades, and even staircases of their most elegant palaces, are depositories of nastiness, and indeed in summer smell as strong as spirit of hartshorn.

Modern Rome does not cover more than one-third of the space within the walls; and those parts that were most frequented of old are now intirely abandoned. From the Capitol to the Coliseo, including the Forum Romanum and Boarium, there is nothing intire but one or two churches, built with the fragments of antient edifices. You descend from the Capitol between the remaining pillars of two temples, the pedestals and part of the shafts sunk in the rubbish: then passing through the triumphal arch of Septimius Severus, you proceed along the foot of Mons Palatinus, which stands on your right hand, quite covered with the ruins of the antient palace belonging to the Roman emperors, and at the foot of it, there are some beautiful detached pillars still standing. On the left you see the remains of the *Templum Pacis*, which seems to have been the largest and most magnificent of all the temples in Rome. Further on is the arch of Constantine on the right, a most noble piece of architecture, almost entire; with the remains of the *Meta Sudans* before it; and fronting you, the noble ruins of that vast amphitheatre, called the *Colossaeum*, now Coliseo, which has been dismantled and dilapidated by the Gothic popes and princes of modern Rome, to build and adorn their paultry palaces. I suppose there is more concealed below ground than appears above. The miserable houses, and even garden-walls of the peasants in this district, are built with these precious materials, I mean shafts and capitals of marble columns, heads, arms, legs, and mutilated trunks of statues. What pity it is that among all the remains of antiquity, at Rome, there is not one lodging-house remaining. I should be glad to know how the senators of Rome were lodged. I want to be better informed touching the *cavaedium*, the *focus*, the *ara deorum penatum*, the *conclavia*, *triclinia*, etc. I am disgusted by the modern taste of architecture, though I am no judge of the art. The churches and palaces of these days are crowded with pretty ornaments, which distract the eye, and by breaking the design into a variety of little parts, destroy the effect of the whole. Every door and window has its separate ornaments, its moulding, frize, cornice, and tympanum; then there is such an assemblage of useless festoons, pillars, pilasters, with their architraves, entablatures, and I know not what, that nothing great or uniform remains to fill the view; and we in vain look for that simplicity of grandeur, those large masses of light and shadow, which characterise the edifices of the antients.

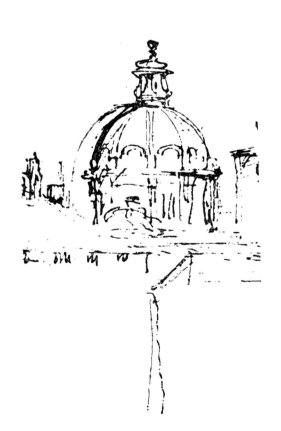

...The piazza of St. Peter's church is altogether sublime. The double colonnade on each side extending in a semi-circular sweep, the stupendous Aegyptian obelisk, the two fountains, the portico, and the admirable façade of the church, form such an assemblage of magnificent objects, as cannot fail to impress the mind with awe and admiration: but the church would have produced a still greater effect, had it been detached entirely from the buildings of the Vatican. As to the architecture of this famous temple, I shall say nothing; neither do I pretend to describe the internal ornaments. I was not at all pleased with the famous statue of the dead Christ in his mother's lap, by Michael Angelo. The figure of Christ is as much emaciated, as if he had died of a consumption: besides, there is something indelicate, not to say indecent, in the attitude and design of a man's body, stark naked, lying upon the knees of a woman. Here are some good pictures, I should rather say copies of good pictures, done in Mosaic to great perfection; particularly a St. Sebastian by Domenichino, and Michael the Archangel, from a painting of Guido Rheni. I am extremely fond of all this artist's pieces. There is a tenderness and delicacy in his manner; and his figures are all exquisitely beautiful, though his expression is often erroneous, and his attitudes are always affected and unnatural. In this very piece the archangel has all the air of a French dancing-master.

...I was much disappointed at sight of the Pantheon, which, after all that has been said of it, looks like a huge cockpit, open at top. The portico which Agrippa added to the building, is undoubtedly very noble, though, in my opinion, it corresponds but ill with the simplicity of the edifice.

...The Colossaeum or amphitheatre built by Flavius Vespasian, is the most stupendous work of the kind which antiquity can produce. Near one half of the external circuit still remains, consisting of four tiers of arcades, adorned with columns of four orders, Doric, Ionic, Corinthian, and Composite.

...It would employ me a whole month to describe the thermae or baths, the vast ruins of which are still to be seen within the walls of Rome, like the remains of so many separate citadels.

...With respect to the present state of the old aqueducts, I can give you very little satisfaction. I only saw the ruins of that which conveyed the aqua Claudia, near the Porta Maggiore, and the Piazza of the Lateran.

Travels through France and Italy, London, 1766.

TOBIAS SMOLLETT
March 1765

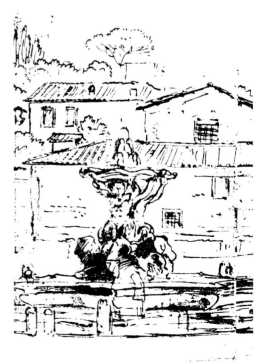

...It is impossible to approach this city, the capital of the world, for such it still is with respect to the arts, without sensations which no other situation can excite. The remains of antiquity, like the Sibyl's works of old, become of greater value the less there is of them. At a traveller's first entrance into Rome, every stick, half devoured by time, or stone incrusted with moss, is so interesting, that his curiosity is not to be satisfied but by a most minute examination of it; lest the precious fragments of some venerable pile, or the memorial of some illustrious achievement, should be passed unnoticed.

The Present State of Music in France and Italy, London, 1771.

CHARLES BURNEY
September 1770

...Magnificence, hypocrisy, and sadness, reign here; the number of fine palaces, of beautiful churches, of superb fountains, of the treasures of art, and venerable remains of antiquity, give an air of grandeur to Rome which is not to be found in any other country.

The want of public entertainments, the little population in proportion to the extent of the city, and its situation surrounded by hills which prevent a free circulation of air, added to the oppressive weight of the Scirocco wind, seem to me the chief causes of its real sadness; but what increases this apparent gloom, is the air of sanctity which Romans affect, and the general dress of the country, which is black. The habit of an abbé is the court dress; and as it is also the cheapest, every one wears it.

Letters from an English Traveller, London, 1778
MARTIN SHERLOCK
October 1778

...The centre of the Roman Carnival is the Corso. This street contains and determines the public entertainments on these days; anywhere else the festivities would be quite different, so we must first describe the Corso.

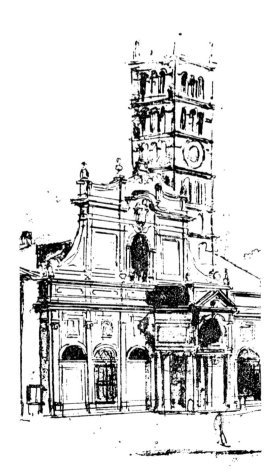

Like many long streets in other Italian cities, it takes its name from the *corsi*, or horse-races, which in Rome conclude the proceedings of each day of Carnival and which elsewhere form part of other solemn celebrations such as the feast-day of the patron saint or the consecration of a church. The street runs in a straight line from Piazza del Popolo to Piazza Venezia. It is about 3,500 paces in length and is lined with tall buildings, the majority of which are also of some magnificence. Its width is not proportionate either to its length or to the height of the buildings which enclose it. On either side the footpaths for pedestrians diminish the width by 6 or 8 feet. The space left in the centre for carriages is in some parts no more than 12 or 14 feet wide. From this it may be perceived that at the most the width is sufficient for the passage of only three carriages at a time.

During Carnival the obelisk of Piazza del Popolo and Palazzo Venezia mark the upper and lower limits of the Corso respectively. The Corso in Rome is in any case animated and thronged with people every Sunday and feast day. Rich and distinguished Romans, for an hour and a half before nightfall, pass up and down the street in their carriages. When the weather is fine, the carriages from Piazza Venezia, keeping to the left side of the obelisk, pass through the Porta del Popolo and continue down the Via Flaminia sometimes as far as Ponte Molle. When the carriages eventually return, they keep to the other side of the street and in this way the two streams of carriages pass one beside the other in excellent order.

As soon as the evening bells ring, this order is broken: everyone drives where they will and seeks the shortest route to do so, so that often they get in the way of other carriages, which are thus detained and impeded in the small space that is available.

This evening promenade, which in all Italian cities is a brilliant spectacle and which is imitated even in small towns where there may be only a few carriages, brings many pedestrians to the Corso: all go, to see or to be seen.

...Not far from this church, which is small and modest, there stands another of far greater importance, dedicated to the great apostle: this is the church of St. Paul's outside the Walls, which is built with splendid spoils from ancient monuments assembled with great art. The entrance alone to this church conveys an impression of solemnity; the mighty columns support high, painted walls which rise to a ceiling of carved wood and this, to our rather over-

indulged eyes, gives one the feeling of being in a barn, although when on great occasions it is all covered with carpets and hangings the effect of the whole must be very imposing. There are carefully preserved here some architectural fragments, rich and grandiose ornaments and capitals, which were removed, and thus rescued, from the palace of Caracalla which once stood in this neighbourhood and has now almost completely disappeared.

The Circus which continues to bear the name of this emperor, although it is largely a ruin, still gives us some idea of its vast area. If an artist were to place himself to the left of the competitors' exit, he would have, high on his right, above the ruined seats of the spectators, the tomb of Cecilia Metella, with more recent buildings around it; turning back, the eye follows the ruins of the *spina*, and any one gifted with architectural imagination can, with a little boldness, reconstruct in his mind's eye those distant days. A scene of ruins such as this which lies before us could always, if an intelligent and informed artist were to set himself to such a work, give rise to a fine picture; which, however, would have to be twice as wide as its height. We paid our respects, on this occasion only with the eye, to the pyramid of Cestius and to the ruins of the Baths of Antoninus or of Caracalla, of which Piranesi has given us so many representations in a rather sensational manner, but which, seen close at hand, have given no joy to the eye, being too familiar through pictures.

In the piazza of S. Pietro in Montorio we saluted the cascade of the Acqua Paola which, gushing in five jets from openings in a triumphal arch, fills a large basin to the brim. This water, following an aqueduct restored by Paul V, runs for 25 miles from the Lake of Bracciano by an interesting zigzag route imposed by the hills which close around its course to this point, providing necessary power and water for various mills and works on the way, and finally spreading through Trastevere.

...Towards evening I climbed to the top of Trajan's column to enjoy the superb view. As the sun sets, the prospect below is splendid, of the Colosseum, the Campidoglio close by, the Palatine Hill and the city in that direction. I returned home late and slowly. The Piazza di Montecavallo, with its obelisk, is truly noteworthy.

...We set off towards the church of St. Peter, which was beautiful in the light from a clear sky, illuminated and distinct in all its detail. We abandoned ourselves to the enthusiasm of those who are prepared to enjoy this magnificence and this grandeur, without permitting ourselves to be diverted this time by over-fastidious or over-erudite criteria, and keeping at a distance over-severe judgments. We enjoyed all that was enjoyable.

Finally we climbed to the roof of the basilica, where can be seen as it were a model of a well-built town: houses, storehouses, fountains (or so they seem), churches and a large temple, all in mid-air, and in the centre a fine promenade. We climbed also to the top of the dome and gazed towards the Apennines, smiling and flooded with light, Mount Soracte and, towards Tivoli, the volcanic hills, Frascati, Castel Gandolfo, the plain and, in the distance, the sea. Near to us and before us lies the whole city of Rome, grand, with its palaces on the hills, its domes etc. There was not a breath of wind, and in the copper globe on the dome of St. Peter's it was like a hot-house. After we had contemplated all these things intently, we descended a stage and had opened for us the doors which lead to the galleries of the dome, the drum and the nave. It is possible to walk right round the church and see it all from above. While we were in the gallery of the drum, the Pope passed below on the way to his afternoon devotions.

Italienische Reise (1786-1788), Berlin, 1835. JOHANN WOLFGANG GOETHE
 1787-1788

42

1. GASPAR VAN WITTEL: *The Campo Vaccino from the Capitol*. Rome, Colonna Collection.

The view is from behind the Senatorial Palace. On the left is the loggia erected in 1544 under Paul III, designed by Giacomo Vignola. Beyond the steps which lead to Santa Maria in Aracoeli can be seen San Luca, the Forum and the Farnese gardens.

2. GASPAR VAN WITTEL: *The Piazza and the Palace of Monte Cavallo*. Rome, Galleria Nazionale.

The painting shows the piazza (now Piazza Quirinale) as it was before Alessandro Specchi began work on the Papal Stables, completed by Fernando Fuga in 1730. The statues of Castor and Pollux were removed in 1782 but later replaced in their original positions.

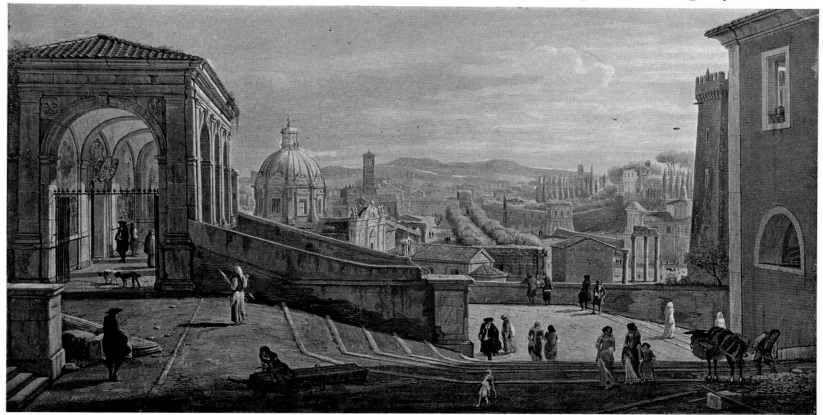

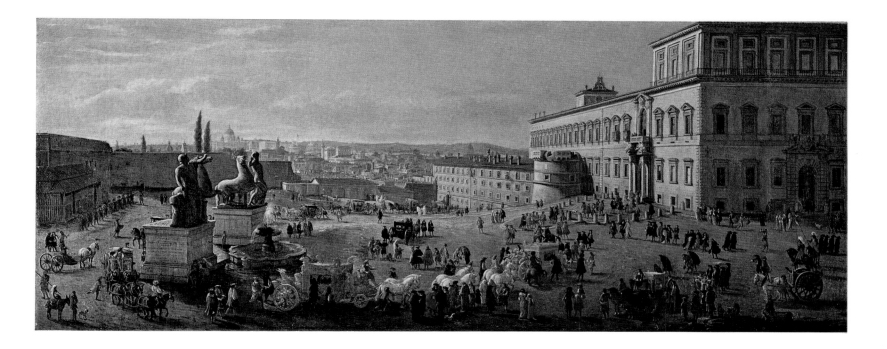

3. GASPAR VAN WITTEL: *St. Peter's from the Prati di Castello*. Rome, Patrizi di Montoro Collection.
The view is from the road leading across the fields north of Castel Sant'Angelo to the Porta Castello, which can be seen at the extreme left of the painting. Beyond the walls of the Città Leonina can be seen the buildings of the Borghi, St. Peter's and the Vatican Palace.

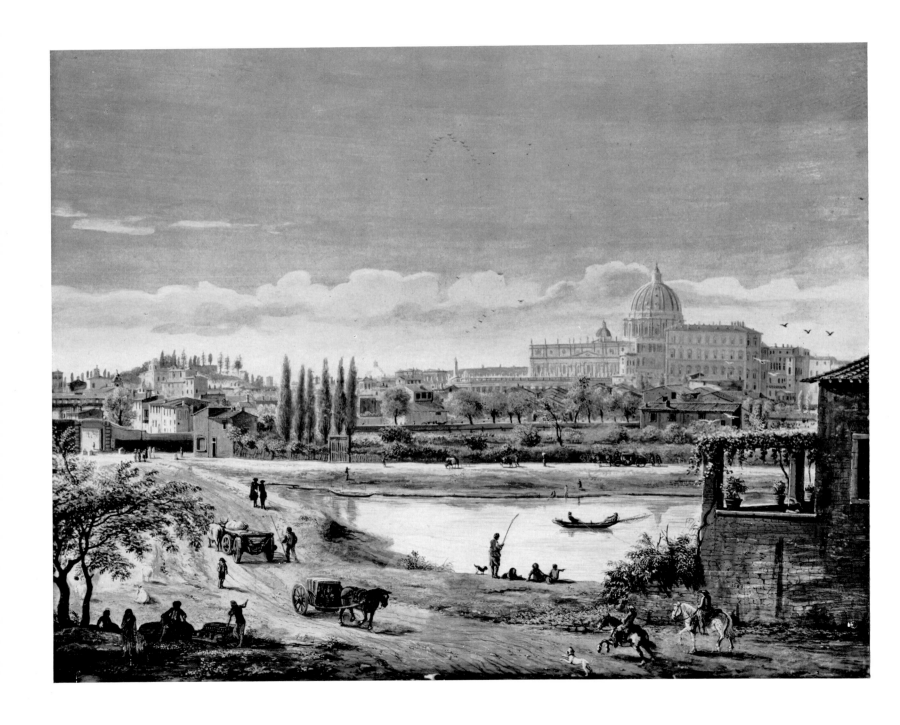

4. GASPAR VAN WITTEL: *The Porto di Ripa Grande* (detail). Rome, Accademia di San Luca.

The view shows the ramps of the quay of Ripa Grande by the Customs-house, and the Pamphili *palazzina* and garden further along the river bank. This group of buildings was pulled down a few years later to give place to the Ospizio di San Michele.

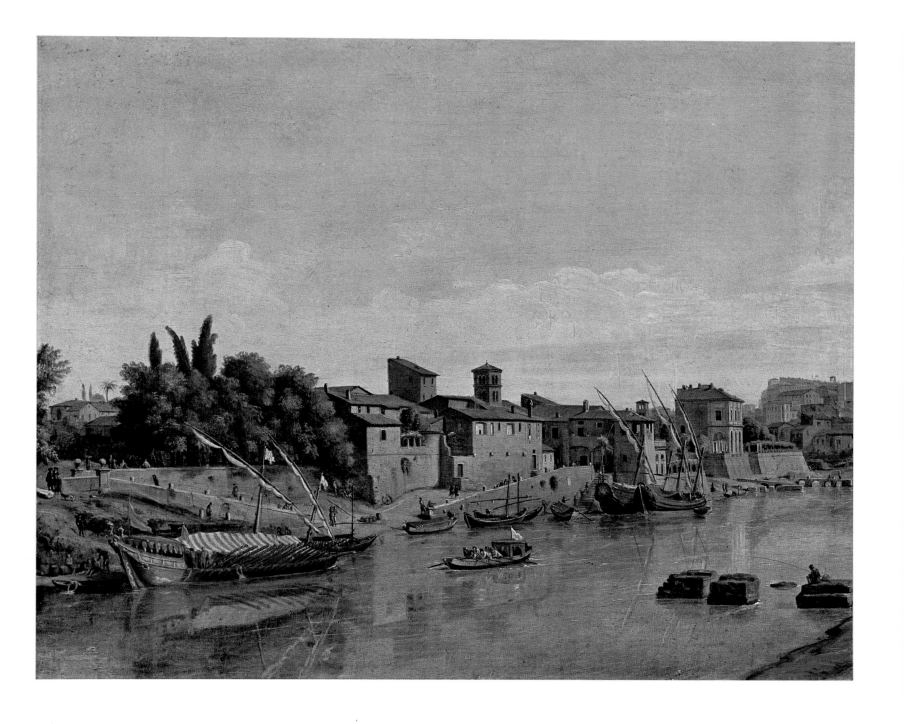

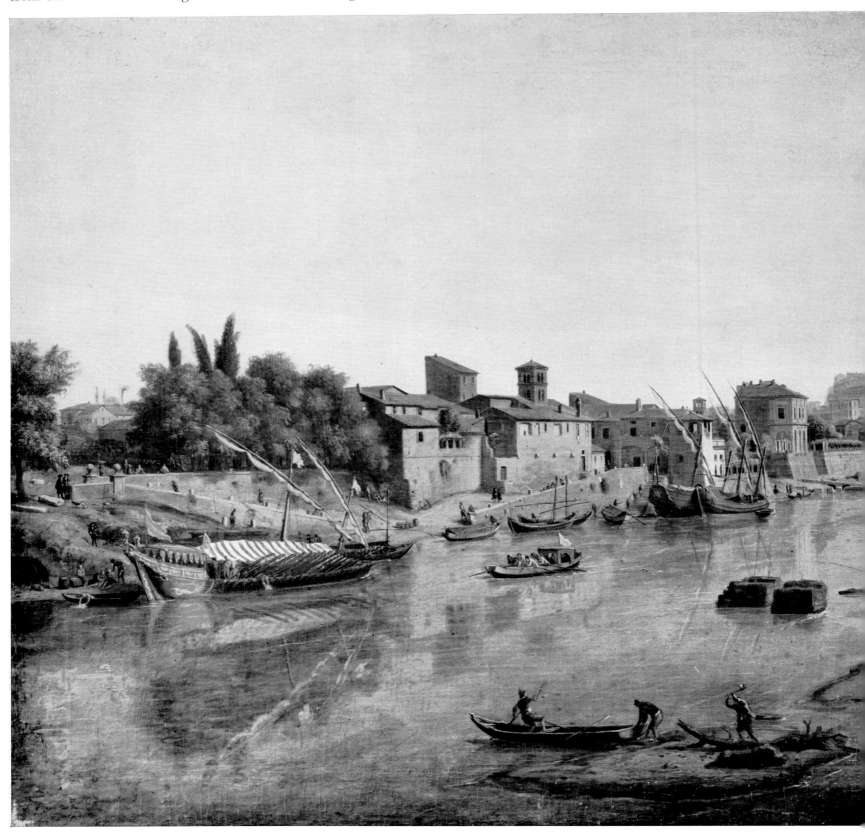

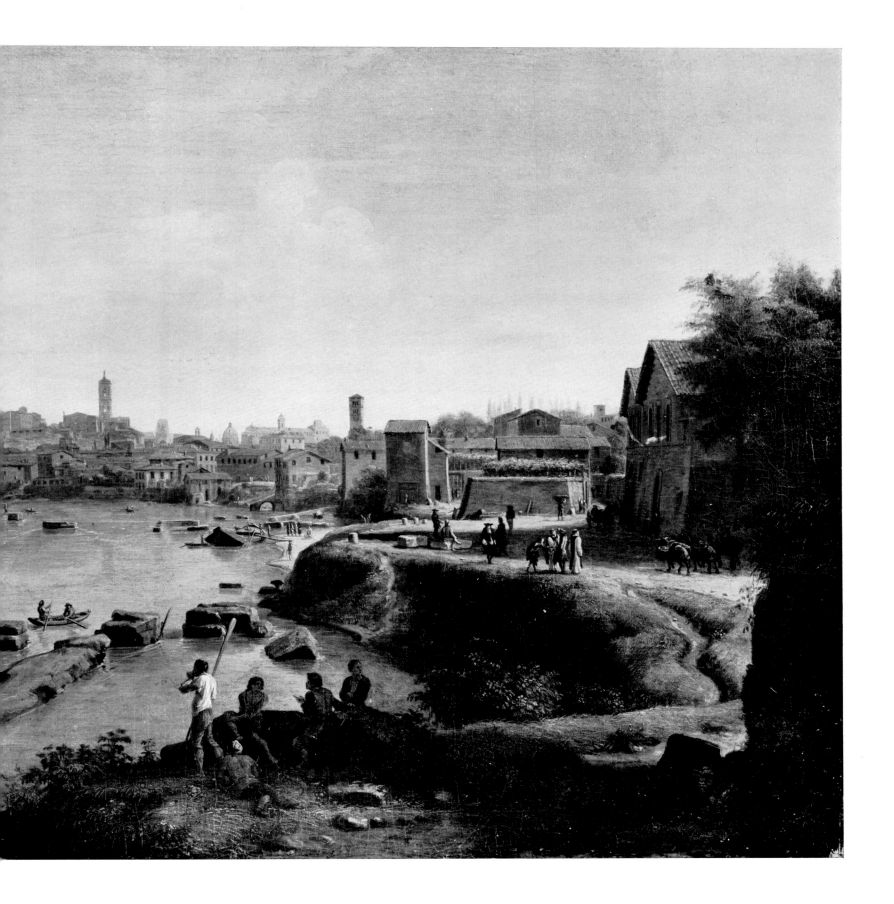

6. GASPAR VAN WITTEL: *The Tiber at San Giovanni dei Fiorentini*. Rome, Collection of Marchese Sacchetti.

The view is from the right bank of the river by the garden of the Ospedale di Santo Spirito. In the foreground is the floating mill moored to the ruins of the ancient bridge of Nero. On the far side of the river is the Church of S. Giovanni dei Fiorentini and a perspective view along Via Giulia. On the right bank are the Palazzo Salviati and the houses of Trastevere at the foot of the Janiculum.

7. UNKNOWN ARTIST, EIGHTEENTH CENTURY: *Rome from the Pincio*. Formerly London, Private collection.

This is one of the finest views of eighteenth-century Rome, and one of the most modern in style. It is painted from the Pincio at the height of Villa Medici, facing the Church of San Carlo, which is in the centre of the composition.

8. HENDRIK FRANS VAN LINT: *View of Santa Maria in Aracoeli*. Rome, Museo di Palazzo Venezia.

The view is taken from the top of one of the *palazzi* at the end of the Corso, in Piazza Venezia. In the foreground is the Palazzetto Venezia, whose courtyard and loggia can be seen, in the centre the tower of Paul III, with a side view of the Aracoeli and the Palazzo dei Conservatori to the right. This is the exact site of the present monument to Vittorio Emanuele II.

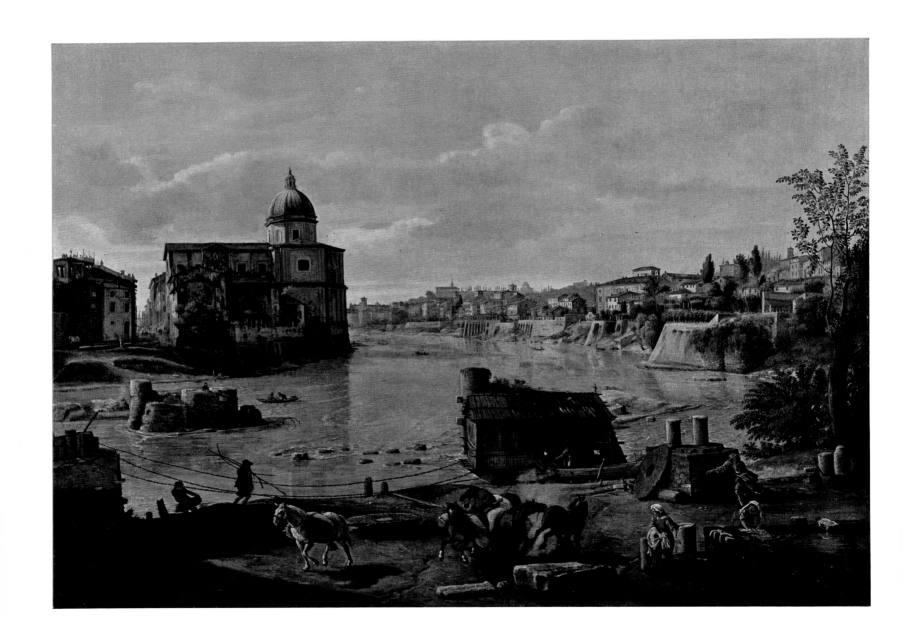

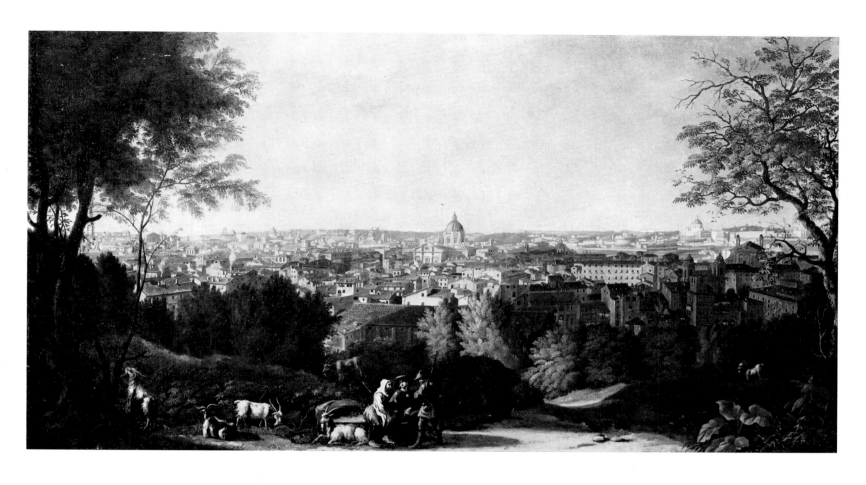

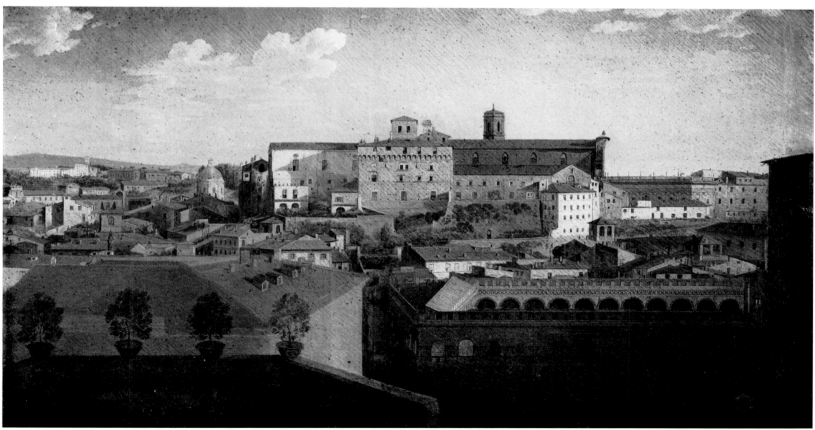

9. GASPAR VAN WITTEL: *View of Tivoli* (detail). Rome, Accademia di San Luca.

The road which leads to the centre of Tivoli and Via Valeria, following the river Aniene before it reaches the waterfalls.

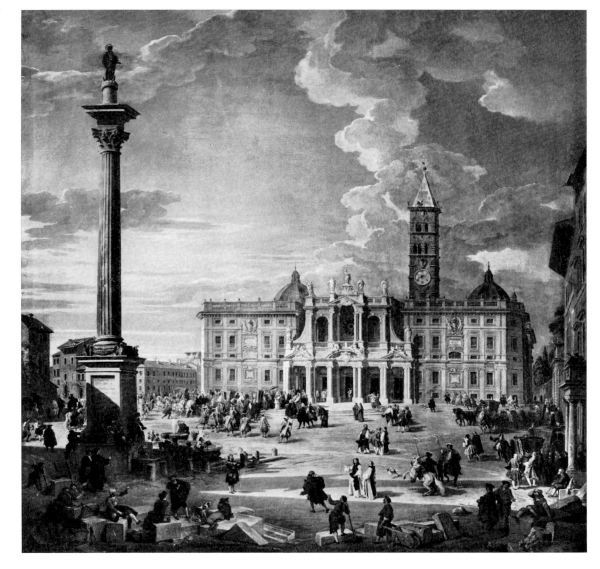

10. GIOVANNI PAOLO PANINI: *Piazza Santa Maria Maggiore*. Rome, Palazzo del Quirinale, Coffee House.

This painting and one of Piazza Quirinale were commissioned from Panini by Pope Benedict XIV to decorate the Coffee House which had just been completed by Fernando Fuga. The new façade of Santa Maria Maggiore was nearing completion in 1742.

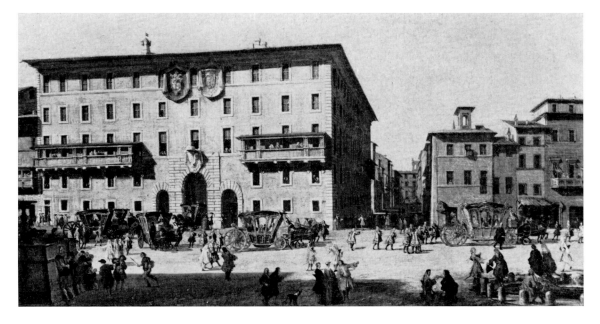

11. GIOVANNI PAOLO PANINI: *Festivities at the Spanish Embassy* (detail). London, Wellington Museum, Apsley House.

Commissioned from Panini by Cardinal Bentivoglio, the Spanish Ambassador, to commemorate the celebrations in front of the Spanish Embassy on the occasion of the birth of the Infanta on 23 September 1727. The painting shows the palace of the Spanish Embassy, Via Borgognona and some houses which have now been demolished.

12. GIOVANNI PAOLO PANINI: *Piazza Navona* (detail). Nantes, Musée des Beaux-Arts.
Formerly attributed to Canaletto and, by Ashley and Constable, to Bellotto, this painting is an early work by Panini, close in style to Van Wittel. It is one of the artist's best view paintings.

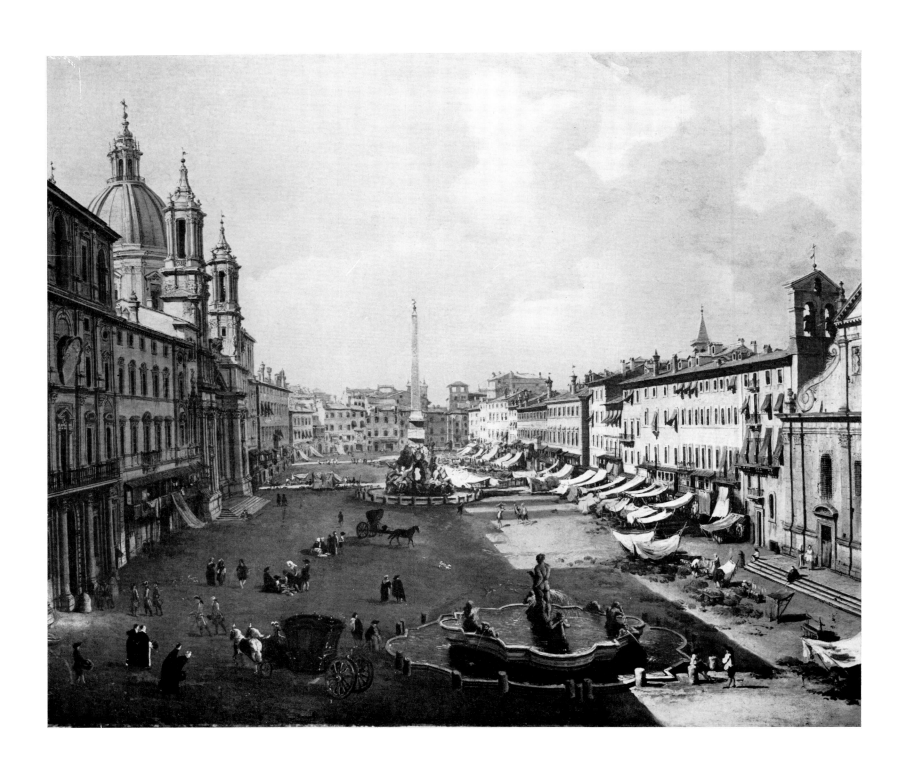

13. CANALETTO: *Piazza San Giovanni in Laterano* (detail). London, Collection of Mrs. Clifford Curzon.
On the left is the Scala Santa, in the centre the obelisk and fountain and the Lateran Palace, on the right part of the north side of the Basilica. Although it follows very closely the two drawings by Canaletto at Windsor and in the British Museum, the latter of which dates from Canaletto's first stay in Rome in 1719, this painting has been attributed to Bellotto, who is known to have been familiar with his uncle's Roman drawings. It should be noted that the viewpoint is not raised, as in Van Wittel and Panini, but at ground level, which gives the view a more realistic and immediate character.

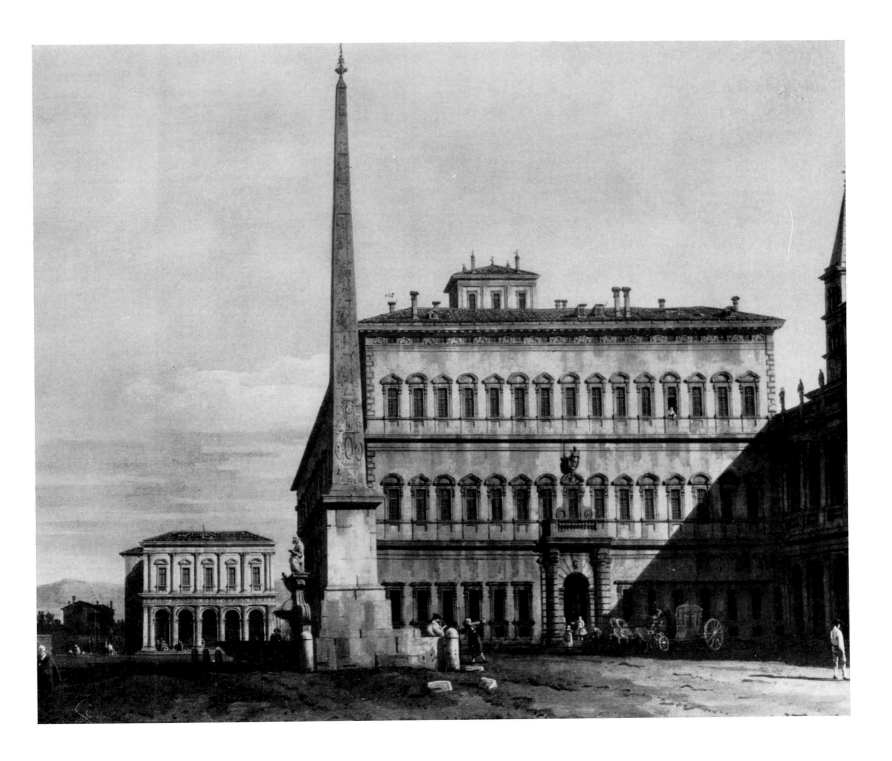

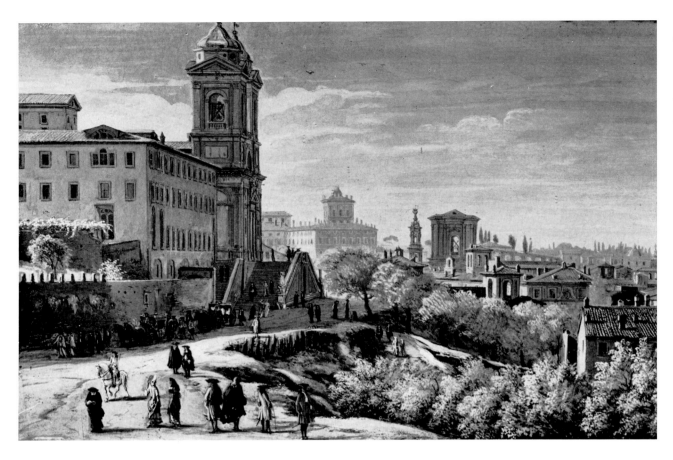

14. GASPAR VAN WITTEL: *Trinità dei Monti, Rome*. Rome, Colonna Collection.

Companion to a view of Villa Medici, this painting is dated 1681. On the left is the garden, the convent and the Church of the Trinità. Beyond the church can be seen the Palazzo del Quirinale, now obscured by the buildings of the Via Gregoriana. The campanile and the cupola of Sant'Andrea delle Fratte can also be seen, and in the far distance the Capitol.

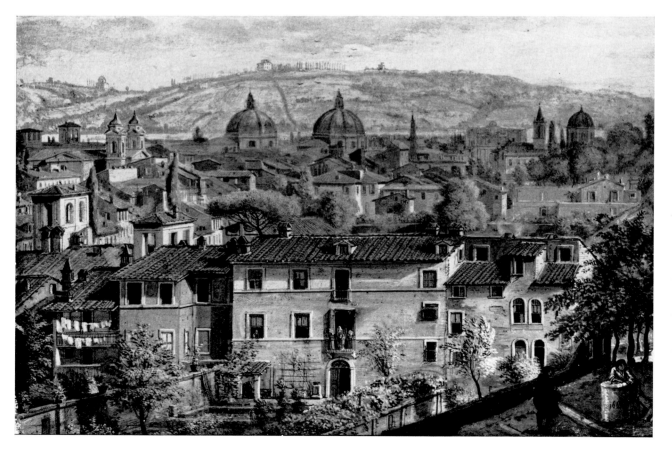

15. GASPAR VAN WITTEL: *View of Rome from Trinità dei Monti* (detail). Rome, Galleria Nazionale.

The view is taken from the top of the steps of SS. Trinità dei Monti. The houses in the foreground of this detail correspond to the old Orto di Napoli. Beyond them can be seen the Greek church, the two domes and the obelisk of the Piazza del Popolo, the gate and the Church of Santa Maria del Popolo.

16. PIER LEONE GHEZZI: *Piazza Colonna*. Rome, Private collection.
This tempera painting, which on stylistic grounds can be attributed to Pier Leone Ghezzi, gives an exact impression of Piazza Colonna as it was in the first half of the eighteenth century.

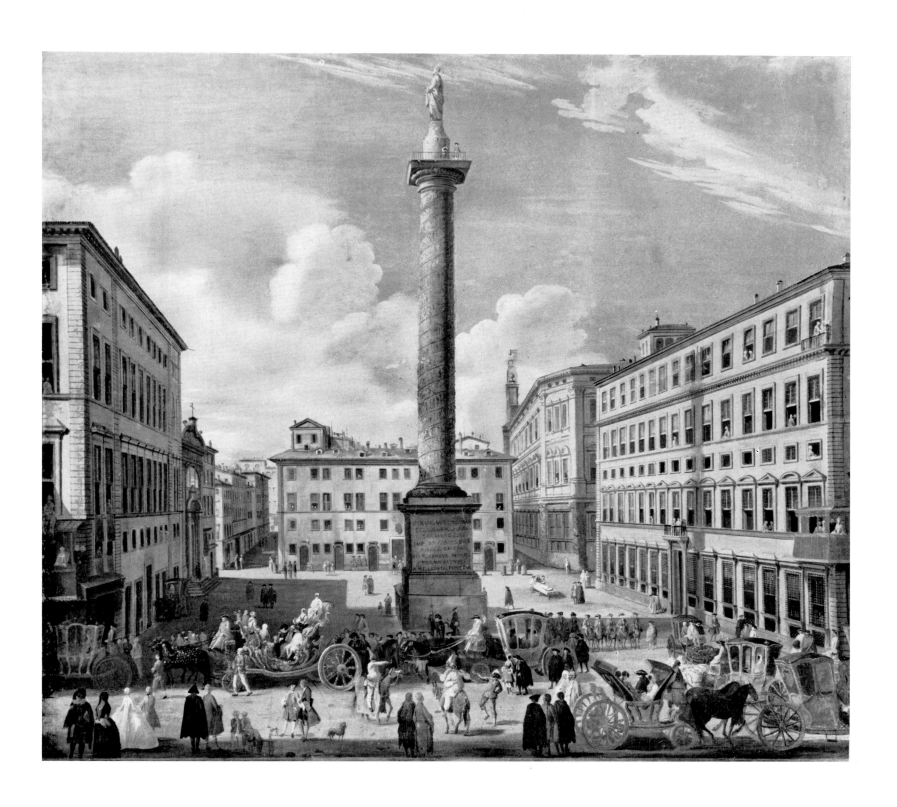

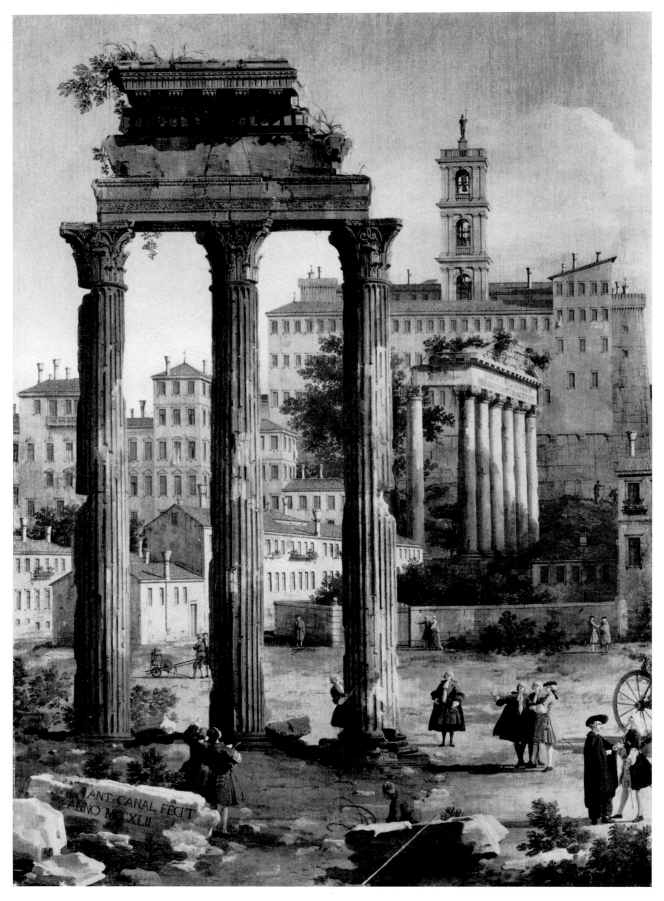

17. CANALETTO: *The Roman Forum*. Windsor Castle, Royal Collection. This is one of five canvases at Windsor, of similar style and size, signed and dated 1742. They were painted in Venice, probably soon after a second visit to Rome, for Joseph Smith, the English Consul at Venice, who was a friend of the painter and his agent for business matters with England. The view, painted from notes and memory, is from the Temple of Castor and Pollux looking towards the Capitol.

18. CANALETTO: *View of the Roman Forum* (detail). London, Private collection.
In the left foreground are the columns of the Temple of Castor and Pollux and on the right the fountain of Juturna. In the background are the Temple of Saturn and the Capitol, with the houses which then occupied the area between the Capitol and the Church of Santa Maria Liberatrice, of which the façade, destroyed in 1902, can be seen here. The painting is a replica of one of the views of the Forum at Windsor.

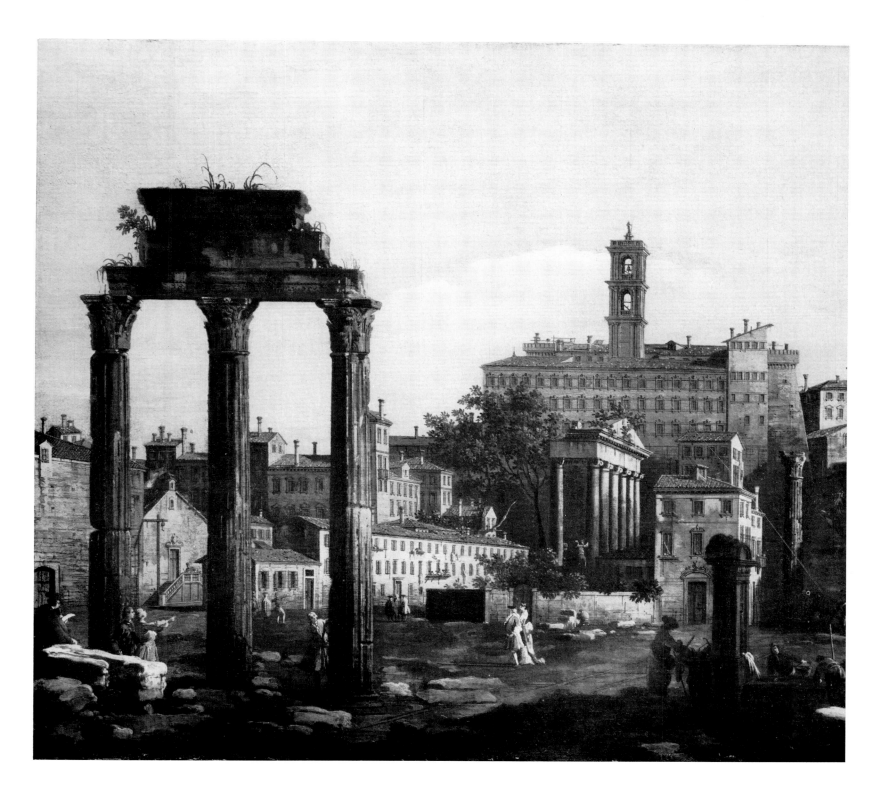

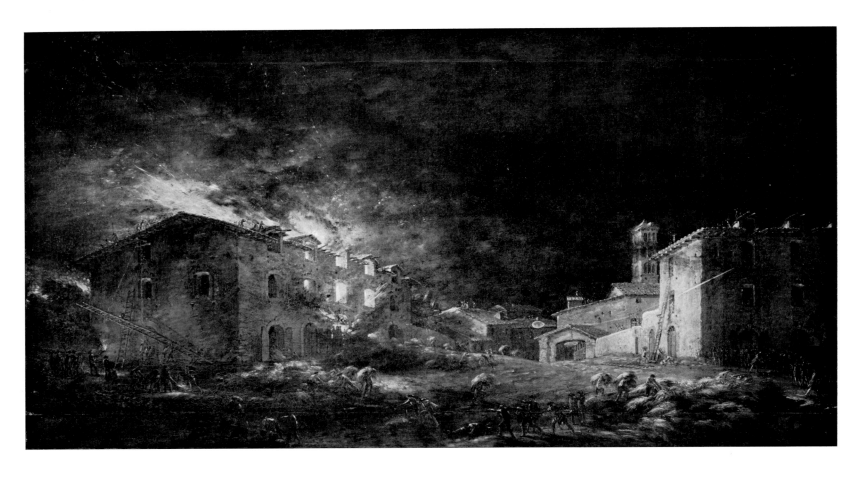

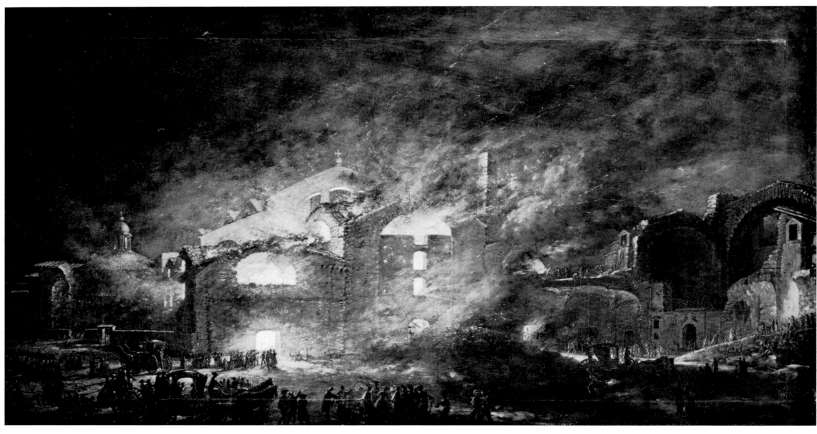

19. ALESIO DE MARCHIS: *A Fire in the Granaries near Santa Maria in Cosmedin*. Rome, Galleria Nazionale.

20. ALESIO DE MARCHIS: *A Fire in the Baths of Diocletian*. Rome, Galleria Nazionale.

Lanzi relates that 'in order to paint fires with more veracity De Marchis set alight a hay-loft' and was punished with several years imprisonment.

21. PAOLO ANESI: *Villa Aurelia on the Janiculum*. Rome, Galleria Pallavicini.

The Villa Aurelia, now the residence of the Director of the American Academy, is in the centre. The view is from the piazza of the Acqua Paola and part of the fountain can be seen on the left. This is one of a series of four tempera paintings.

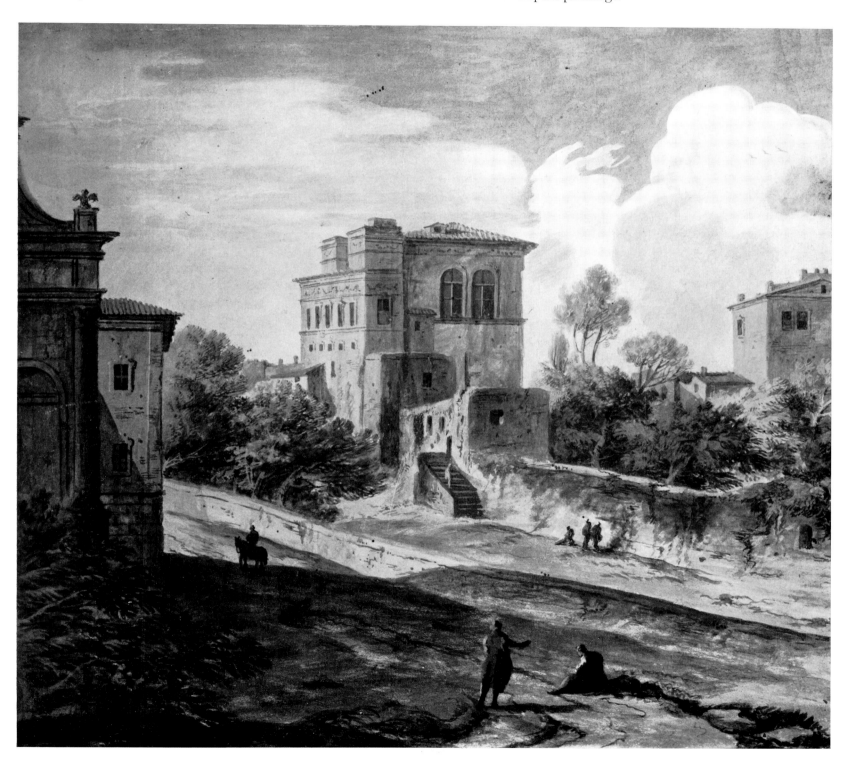

22. CLAUDE-JOSEPH VERNET: *A Contest on the Tiber near Castel Sant' Angelo* (detail). London, National Gallery.
The best of Vernet's Roman paintings. It was executed during his stay in Rome (1734-53), commissioned by the Marquis de Villette and exhibited in the Salon of 1750. The building on the left is a fantasy but the rest of the painting is an accurate view of Castel Sant'Angelo, the bridge and the left bank between Palazzo Altoviti and San Giovanni dei Fiorentini.

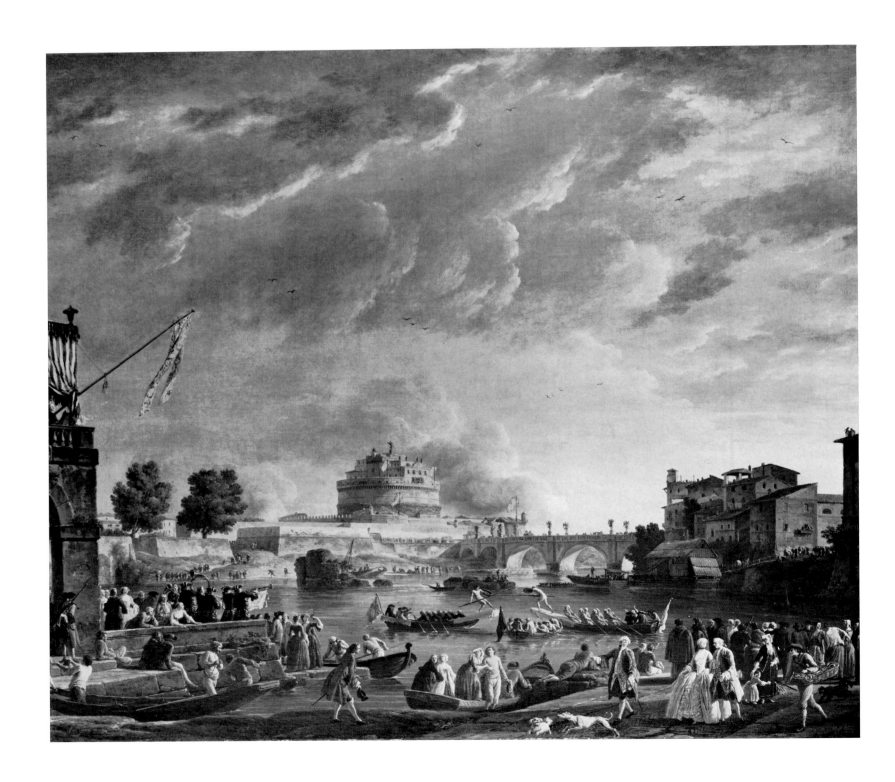

NAPLES

...Now I must give an account of the marvels of this city and I shall divide those within the city from those without. I shall begin, therefore, with what is to be seen within Naples, particularly the churches, giving by way of introduction a general idea of the city... I will begin my impression of Naples, which, as I have already said, besides being very large is everywhere very beautiful: broad, straight streets paved with square slabs of stone, which according to some were taken from the Via Appia; and with superb houses and many palaces along either side of them, which together make a majestic sight... The streets are so full of carriages, chaises and sedan-chairs that it is not all comfortable to walk in them. As for the churches, there are some extremely beautiful ones, and everywhere there are architectural and artistic works of great value. Pavements, pillars, whole walls, of marble, alabaster, porphyry, frescoes, paintings, all arranged and disposed with great artistry and intelligence, so that the eye sees nothing but masterpieces.

...One day I went to the top of the fine and noble monastery of San Martino, which was formerly a royal residence used by the king for the diversions of the chase and was later handed over to the Carthusian order and turned into a religious house, being brought to its present magnificent state by royal munificence. These Carthusians are indeed well-housed, as monarchs rather than as monks, and no other site could surpass this one. From here one can see a wide expanse of sea, and the island of Capri, the place where the Emperor Tiberius had his seraglio, the whole city and its surroundings, mountains, valleys, woods, villages, the fearsome Vesuvius, hills, villas, towns, plains, cottages, and the prosperous countryside, so that the Neapolitans are not wrong when they claim that there is no prospect like it in all Europe. The church is one of the most beautiful in Naples, and apart from the very fine marble work, it has panels which are the most famous in Italy. It has thirteen altars, and the ceiling is adorned with a most beautiful gilded painting by the Cavaliere Lanfranco. There are many paintings in oil, and in all there are more than a hundred works in the royal monastery.

Italienische Reise, 1740. JOHANN KASPAR GOETHE

...This city, which is the metropolis of a kingdom of the same name, stands on the shore of the sea where it forms a basin, which the town encompasses in form of a half moon. From there it rises like an amphitheatre towards hills which are covered with vineyards and delightful gardens, from whence is the finest prospect that can be imagined. Upon one of these hills is the famous castle of Sant'Elmo, built by Charles V, which is a fortress that commands the whole city.

Naples is the see of an archbishop, whose metropolitan church is dedicated to St. Januarius... The Viceroy's palace is one of the noblest structures in the world; the beauty of the architecture and the disposition of the apartments give the same pleasure to the spectator as the magnificent prospect the Viceroy has from a balcony, to which I never saw anything equal for its extent or its agreeable variety. The fine gardens, the harbour, the arsenal, the lofty hills, the terrible mount Vesuvius, in short, the whole city of Naples, all contribute to the prospect from the Viceroy's palace.

Lettres et mémoires, London, 1747. CHARLES LOUIS POLLNITZ
 April 1731

...It is not surprising that Virgil should make such fine verses at Naples: the air there is so soft and so pure, the sun so brilliant and so warm, and the face of nature so rich and so diversified, that the imagination feels a vivacity and vigour which it scarce ever perceives in other countries.

I am not a poet, but I am very fond of verses, and I have never read them with more

pleasure than here. Every time that I go to my window, I feel myself electrified, my spirits revive, my imagination warms, and my soul becomes susceptible of the softest and sublimest impressions. This will not surprise you when I have only mentioned the objects which here present themselves to my view.

On the right is the hill of Posilipo, whose form is most agreeable; it is semi-circular, and adorned to the summit with trees and pleasure-houses; from its point, which loses itself in the sea, this mountain increases insensibly till it arrives behind the centre of Naples, and on its summit is seen a vast tower, which overlooks the city and crowns the scene. On the left appears a chain of very high mountains which surround the other side of the gulph, and whose rugged boldness forms a most happy contrast with the elegant and cultivated beauties of Posilipo: — Shakespeare and Corneille would always have looked on the side of Vesuvius; Racine and Pope on the side of Posilipo.

The Volcano is the most interesting of those mountains by its form which is a very beautiful cone, by its height, and above all by its vicinity to the city: it smokes incessantly, and seems always to threaten Naples with the fate of Sodom, to consume it with fire and brimstone. At its foot is Portici, and all along the coast are towns hanging from the mountains which form the portion of a circle of ninety miles.

The sea is under my window; and besides the ideas which it presents itself, as the most interesting object in nature next to the sun, by its grandeur, beauty, and the variety of its appearances, it here shows all the riches of commerce by large ships which are passing every moment. I often rise before day to enjoy the breath of the morning, and the superb description which the illustrious Rousseau gives of the rising of the sun. In no horizon does he appear with so much splendor, no where else does he so well deserve the epithet of 'golden'. He rises behind Vesuvius to illuminate the pleasantest hill of Posilipo, and the bosom of the most beautiful gulph in the universe, smooth as a mirrour, and filled with vessels all in motion. The object which terminates the perspective is the island of Capréa, famous for the retreat of Tiberius and the rocks of the Sirens: on viewing it, one remembers that near those rocks the prudent Ulysses stopped his ears; and that, not far from hence, the less wise Hannibal gave himself up to the pleasures of harmony, and to the caresses of the seducing Camilla.

Letters from an English Traveller. MARTIN SHERLOCK
 February 1779

...The bay is about thirty miles in circumference and twelve in diameter; it has been named Crater, from its supposed resemblance to a bowl. This bowl is ornamented with the most beautiful foliage, with vines; with olive and mulberry and orange trees; with hills, dales, towns, villas and villages. At the bottom of the bay of Naples, the town is built in the form of a vast amphitheatre, sloping from the hills towards the sea. If, from the town, you turn your eyes to the east, you see the rich plains leading to mount Vesuvius, and Portici. If you look to the west, you have the Grotto of Pausilippo, the mountain on which Virgil's tomb is placed, and the fields leading to Puzzoli and the coast of Baia. On the north, are the fertile hills, gradually rising from the shore to the Campagna Felice. On the South, is the bay confined by the two promontories of Misenum and Minerva, the view being terminated by the islands Procida, Ischia and Caprea; and as you ascend to the castle of St. Elmo, you have all these objects under your eye at once, with the addition of a great part of the Campagna.

A View of Society and Manners in Italy, London, 1781. JOHN MOORE
 1779

...The road ran among volcanic hills where limestone rocks seemed to be quite absent, except here and there. At last we entered the plain of Capua, and then Capua itself, where we rested towards midday. In the afternoon we crossed a beautiful plain, the road leading between fields of corn of a stupendous green, the stalks reaching a span in height. The fields were surrounded by poplars, and from one to another of these hung festoons of grape vines. Thus one approaches Naples, across a countryside of fertile, light soil, diligently cultivated, where the vines, as strong as you could wish, stretch from poplar to poplar, forming a kind of network. Vesuvius was continuously present on our left, smoking mightily, and I was silent, savouring the pleasure of being able to gaze at this wonderful phenomenon. The sky became increasingly bright until the sun came through on our right and flooded with light our temporary, restricted but mobile habitation. The air became purer as we approached Naples, and at last we found ourselves truly in another country.

...The houses, with their flat roofs like terraces, indicate a different climate but nevertheless I do not find them very pleasing. Everyone sits in the sun to enjoy it while it shines. The Neapolitans believe that they possess Paradise, and have a very sorry idea of northern lands. 'Always snow', they say, 'wooden houses: great ignorance but plenty of money'. This is the unflattering picture they have of our countries. The first impression of Naples is happy, animated, gay: the innumerable crowds jostle in confusion, the King is hunting, the Queen is expecting, things could not be better.

Italienische Reise (1786-1788). JOHANN WOLFANG GOETHE
 Spring 1787

...Returning towards Naples, I was struck by some small one-storey houses built in a strange fashion, without windows, the rooms lit only by the door of the house which opens on to the road. From early morning to late at night the inhabitants sit outside the doorways, retiring at last into their caverns.

...One has only to wander in the streets with one's eyes open to see scenes that are inimitable. On the Molo, one of the noisiest places in the city, I saw yesterday a Pulcinella in combat with a little monkey on a stage of boards, and above on a balcony a beautiful girl offering her charms to the highest bidder. And near the stage a charlatan was offering his secret remedies, valid against all ills, to the crowd which had gathered around him.

...Via Toledo is like a theatre where a great display of superabundance is in progress. All the shops are decorated with comestibles, which hang in garlands almost from one side of the street to the other. The sausages are partly gilded, and decked with red ribbons; all the turkeys have a red flag stuck into them — 30,000 of them were sold yesterday, to which can be added those which are fattened at home. The number of donkeys laden with capons, and those carrying oranges — the piles of these golden fruit spilling out over the pavement — amaze me. The most beautiful sight is however afforded by the shops selling vegetables, where raisins, melons, figs, are displayed for sale, all so pleasingly arranged that it delights both eye and heart. Naples is a country where God often provides his blessing for the delectation of the senses.

(Letter from Tischbein to Goethe, July 1787).

...Our journey hither was through the most beautiful part of the finest country in the world... Our road was through Velletri, Cisterna, Terracina, Capua, and Aversa, and so to Naples. The minute one leaves his Holiness's dominions, the face of things begins to change from wide uncultivated plains to olive groves and well-tilled fields of corn, intermixed with ranks of elms, every one of which has its vine twining about it, and hanging in festoons

between the rows from one tree to another. The great old fig-trees, the oranges in full bloom, and myrtles in every hedge, make one of the delighfullest scenes you can conceive; besides that, the roads are wide, well-kept, and full of passengers, a sight I have not beheld this long time. My wonder still increased upon entering the city, which, I think, for number of people, outdoes both Paris and London. The streets are one continuous market, and thronged with populace so much that a coach can hardly pass...

Your maps will show you the situation of Naples; it is on the most lovely bay in the world, and one of the calmest seas: It has many other beauties besides those of nature. We have spent two days in visiting the remarkable places in the country round it, such as the bay of Baiae, and its remains of antiquity; the lake Avernus, and the Solfatara, Charon's grotto.

Correspondence, London, 1775.
THOMAS GRAY
June 1740

...The Crater of Naples is indeed a marvellous sight, and no pen can convey to the mind the amenity, the amplitude, the variety of these fair shores, for a single glance surpasses any such attempt. The buildings follow one after another so that from Baia to Castellamare they seem to form an almost or indeed a quite unbroken line of vast city, which is taken up again at Sorrento, reaching as far as the promontory of Ateneo. Smoking Vesuvius stands imperious, its lower slopes covered with gleaming white houses and its upper slopes with dark purple lava. Naples climbs the steep slope of the Ermean hill with a line of buildings, and the castle of Sant'Elmo crowns it. Echia stretches out to sea, along it runs the road of Chiaia, once the Olympia of Naples and famous for the Greek games so well illustrated by the learned Ignarra. What shall I say of Posilipo and Mergellina, celebrated by Sannazzaro, by Flamminio and by Pontano? The brushes of the most famous landscape painters, the verses of the most noble poets, present but a feeble image of so blessed a shore, which surpasses all colours of the imitating art, the many words of inspired poetry.

From across the sea a strong smell of bitumen assails the nostrils, indicating the presence of the petroleum which, with sulphur and iron, feeds the fires of Vesuvius and which supplied even more generously the volcanoes of ancient times, the vestiges of which can be seen all along these shores. As I gaze at the mountains around, which descend steeply to the sea, forming the walls of the immense crater, it seems to me that the great basin itself was carved out by the action of volcanic eruptions. Sometimes I like to indulge my vivid imagination, fancying myself transported to the darkness of the remotest times and seeing a harvest of volcanoes rise from the water, seething and heaving and thundering horribly, now heaping up with great force and now tearing away the slopes of the wooded Apennines, opening gulfs, raising promontories, detaching islets and reefs, until, after the passage of an infinite number of days, the chemical ferment ceased and the coast assumed the appearance which today renders it full of pleasures and delight; and down from the Apennines came the first inhabitants, later-comers spreading to Ischia, to Cumae, to Paestum, to Capri, bearing the names Chalcideans, Euboici, Sybarites, Teleboi. The mind absorbed in such physical and historical contemplation embraces an immense space of centuries, an immense scene of change, an immense chain of cause and effect, which enlarge it through its own activity, making it conscious of its celestial origin and immortal nature by which it is destined to join in unity with the uncreated principle, abandoning the transience of the body which renders it for a few moments a pilgrim on this earth: 'Let this prison wherein I am enclosed fly open'...

Giornale del viaggio in Inghilterra, Venice, 1824.
CARLO GASTONE DELLA TORRE DI REZZONICO
1793-1794

23. UNKNOWN ARTIST, EIGHT-
EENTH CENTURY: *View of the
Largo di Palazzo*. Rome, Private
collection.

This is a view of the so-called
'Largo di Palazzo', the piazza in
front of the Royal Palace. On the
left can be seen part of the palace,
designed by Domenico Fontana,
the triple-arched fountain by
Pietro Bernini and Michelangelo
Naccherino which is now in Via
Nazario Sauro, outside the Hotel
Excelsior, the colossus of Jupiter
known as 'the Palace Giant', pla-
ced there in 1668 and removed in
1807, and the group of conventual
buildings comprising the Church
of San Marco dei Tessitori and the
convents *della Croce* and *della Tri-
nità*, all of which have been demo-
lished.

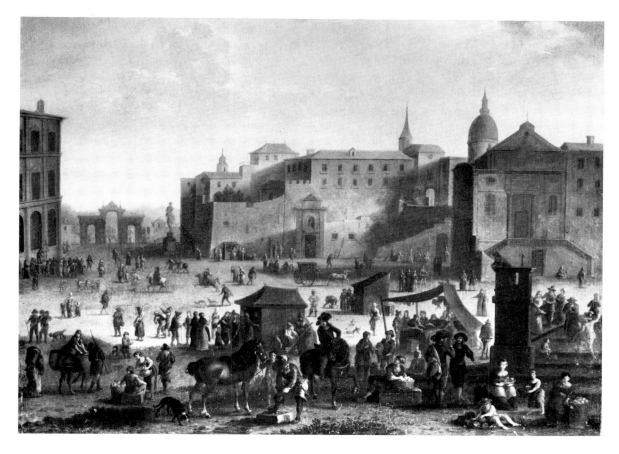

24. UNKNOWN ARTIST, EIGHT-
EENTH CENTURY: *View of the
Porta Capuana*. Rome, Private col-
lection.

A view of the Porta Capuana, built
by Ferdinand I of Aragon, from
La Vicaria (Castel Capuano), and
of the Church of Santa Caterina a
Formiello. The column bearing a
statue of San Gennaro was erec-
ted in 1707 to commemorate the
eruption of Vesuvius and provides
an earliest date for this interesting
painting.

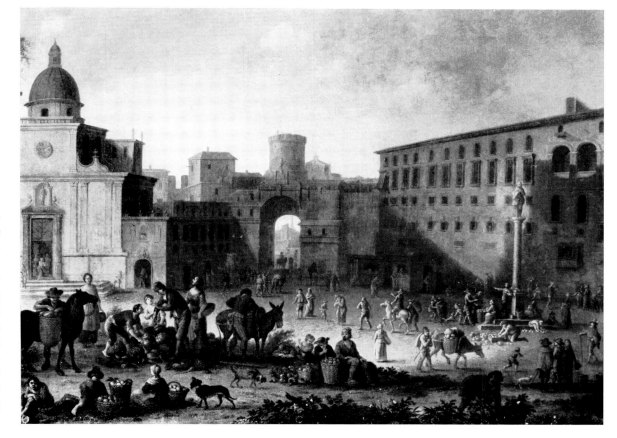

25. UNKNOWN ARTIST, EIGHTEENTH CENTURY: *Santa Lucia from the sea* (detail). Naples, Museo di San Martino.

A fine and realistic view which may be by Leonardo Coccorante. It is taken from a point off the Santa Lucia shore below Pizzofalcone, where the quarters of the Spanish garrison and the palace of the Prince of Iacci can be seen. In the foreground is the little Church of Santa Lucia a Mare and two of the fountains, now gone, which were erected in the last years of the seventeenth century by the Viceroy, the Duke of Medina Coeli.

26. GASPAR VAN WITTEL: *Naples and the Castel dell'Ovo from the sea* (detail). Florence, Palazzo Pitti.

This is one of Van Wittel's finest paintings, a view from the sea off the Chiaia shore. In the centre is the Castel dell'Ovo, with its long jetty out to sea; above the castle is the great building of Pizzofalcone, which since 1651 had been used to house the Spanish garrison. On the right can be seen the building in the garden of the Royal Palace, the storehouses of the Naval Harbour and Castel Nuovo.

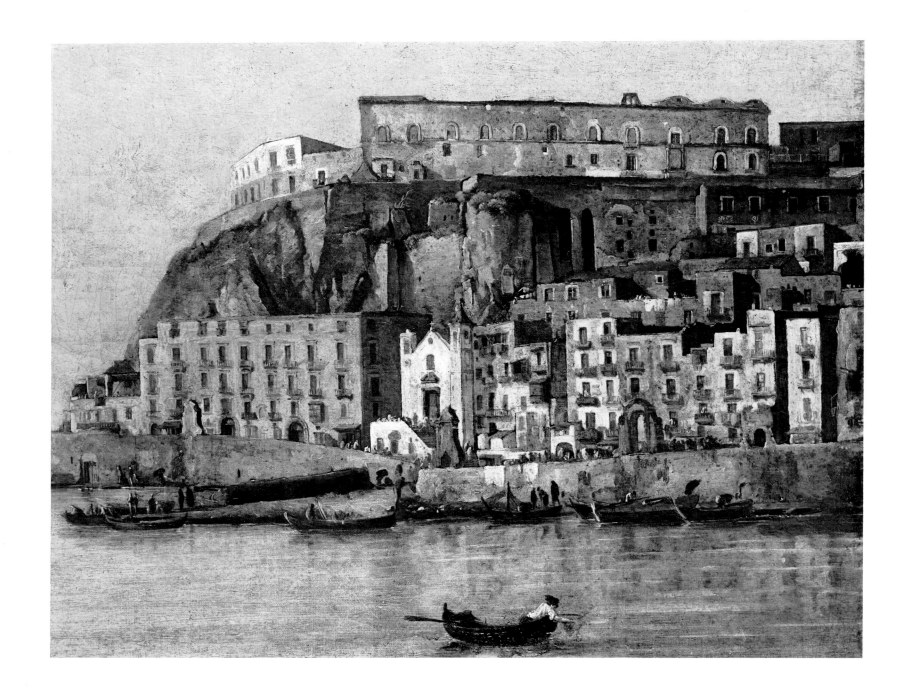

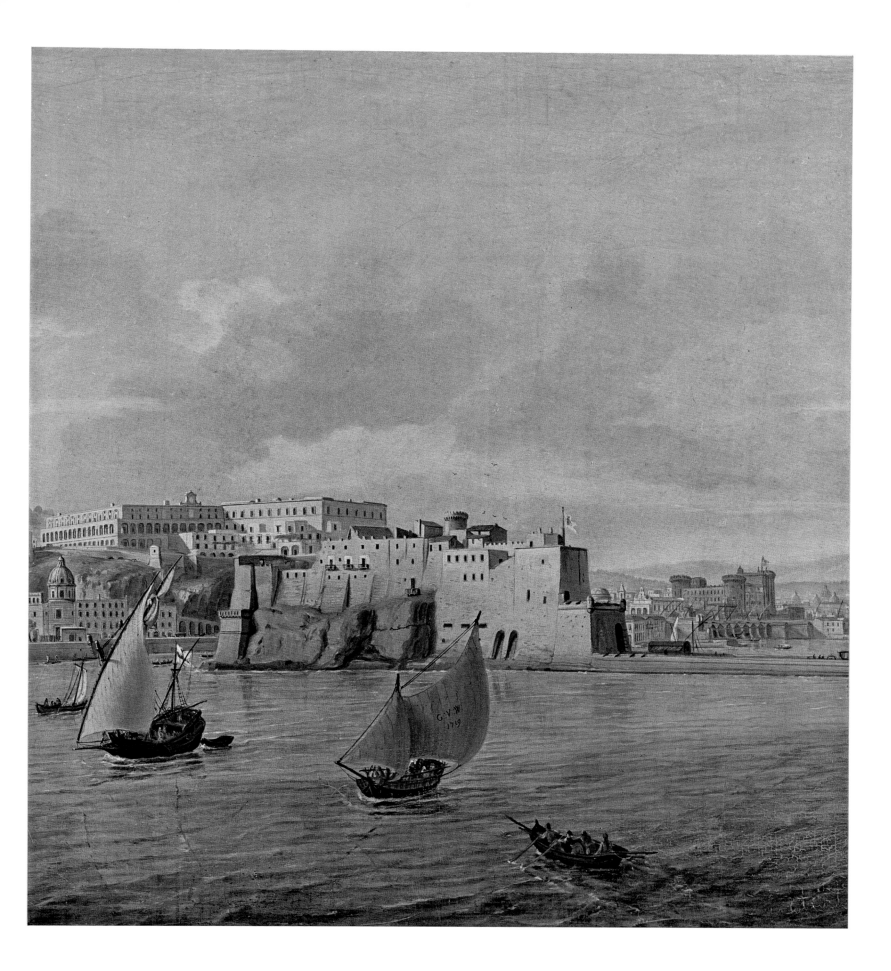

27. ANTONIO JOLI: *The Molo Grande*. Beaulieu, Collection of Lord Montagu.

The Molo Grande, or Molo Angioino, seen from below the lighthouse. The trees were cut down in 1779. At the end of the avenue is the Church of San Giacomo.

28. ANTONIO JOLI: *Piazza del Mercato*. Beaulieu, Collection of Lord Montagu.

The vast Piazza del Mercato, looking towards the Church of Santa Maria del Carmine, whose façade was completed by Giovanni del Gaizo in 1766. Along the church runs the street leading to the Porta del Carmine, and on the right is the keep of the Castel del Carmine.

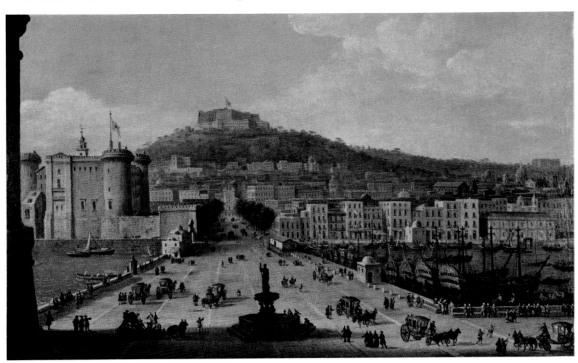

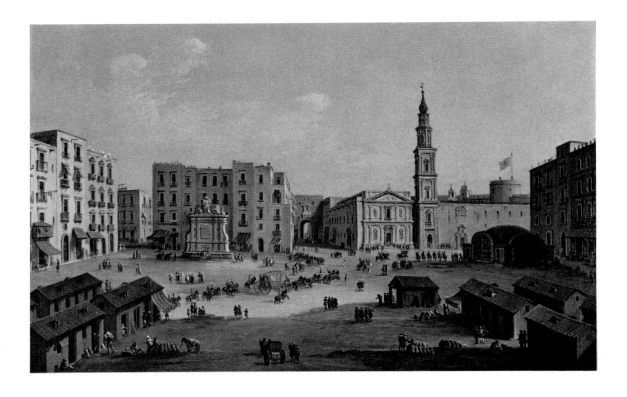

29. ANTONIO JOLI: *The Embarkation of Charles III*. Madrid, Prado.

The painting commemorates the king's embarkation for Spain on 6 October 1749. The wide panorama over the Bay of Naples and the Molo Grande includes in the foreground the Minister, Tanucci, in his coach. Off-shore lies the Spanish fleet.

30. ANTONIO JOLI: *San Carlo all'Arena and the Albergo dei Poveri*. Rome, Private collection.

On the left is the Church of San Carlo all'Arena, built at the beginning of the seventeenth century, on the right the vast Poor-house begun in 1751, designed by Ferdinando Fuga. Next to the Poor-house is the garden which is today the Botanical Garden. In the coach in the centre, Queen Maria Carolina is showing to the people one of her numerous children.

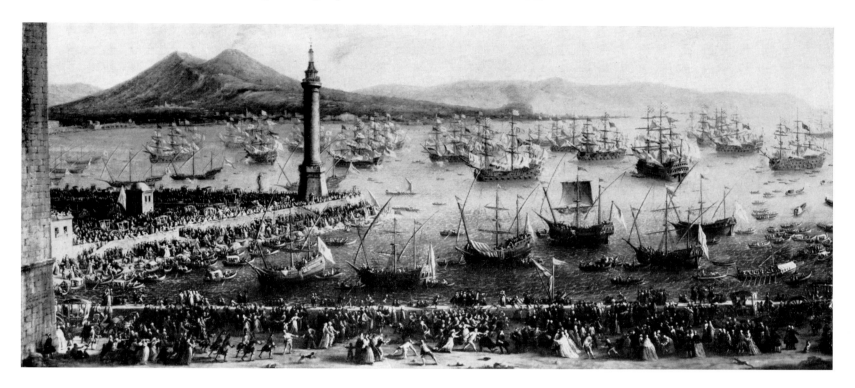

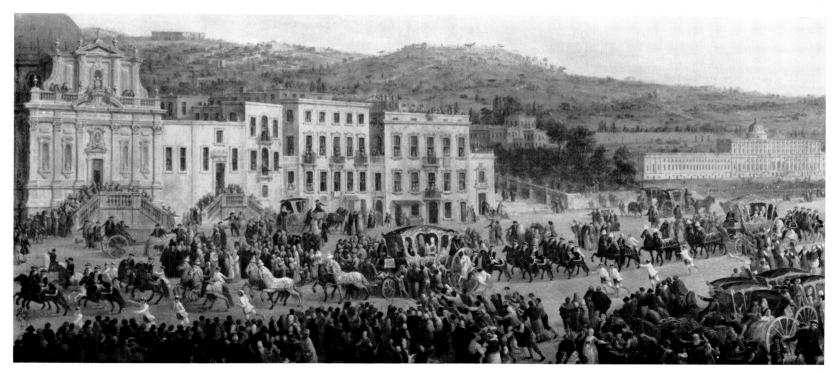

31. ADRIEN MANGLARD: *Naples from Posillipo*. Vienna, Harrach Gallery.
This is a view which became very conventional in the second half of the eighteenth century and throughout the nineteenth century. Naples, with Pizzofalcone and Castel dell'Ovo prominent, is seen from Posillipo, with Vesuvius in the background.

32. PIETRO FABRIS: *The Embarkation of Charles III from the Darsena*. Rome, Private collection.
The painting commemorates the king's departure for Spain. It is interesting for its accurate portrayal of the old Naval Harbour.

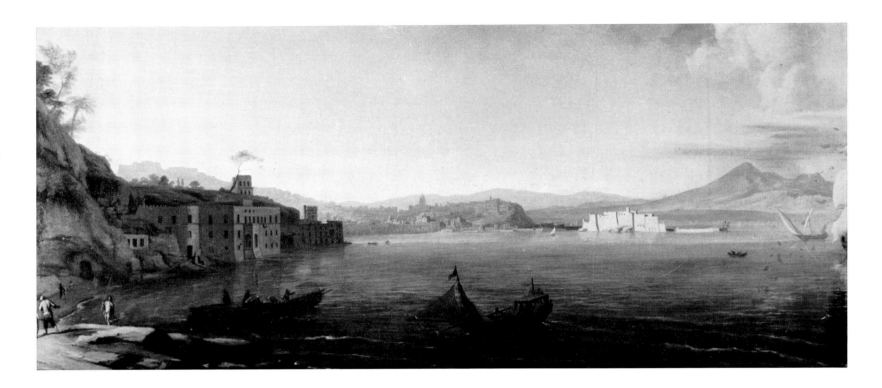

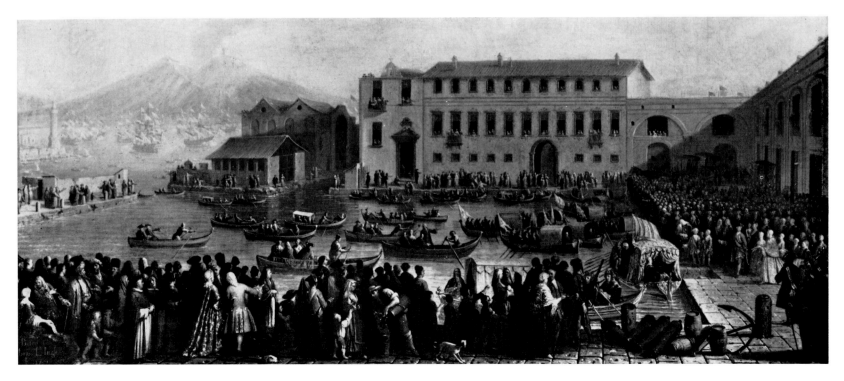

VENICE

...Were I to describe to you all the curiosities of this city as fully as I have done until now, I should not have time to write them down, and indeed I do not know that they would always merit your attention; so that I shall choose the most outstanding and remarkable, and begin with the bridge of the Rialto, worthily included among the wonders of the world. It is halfway along the Grand Canal, by which the city is divided into two parts. It has but a single arch, all of white marble, and it is crossed by three paths; on either side of the central way there are twenty-four shops, selling pretty things. From the inscription carved upon it, one learns when it was built and also, if the account is correct, the origins of the city: it runs *Paschale Ciconia venetiarum duce*, etc. And as Venice stands upon seventy-two islands, so they are joined by four hundred bridges, so that you may go on foot from one place to another, if you wish.

Italienische Reise, 1740.

JOHANN KASPAR GOETHE

...The view of Venice, at some little distance from the town, is mentioned by many travellers in terms of the highest admiration. I had been so often forewarned of the amazement with which I should be struck at first sight of this city, that when I actually did see it, I felt little or no amazement at all. You will behold, said those anticipators, a magnificent town, — or more frequently, to make the deeper impression, they gave it in detail — You will behold, said they, magnificent palaces, churches, towers and steeples, all standing in the middle of the sea. Well; this, unquestionably, is an uncommon scene; and there is no manner of doubt that a town surrounded by water is a very fine sight; but all the travellers that have existed since the days of Cain will not convince me that a town surrounded by land is not a much finer. Can there be any comparison, in point of beauty, between the dull monotony of a watery surface, and the delightful variety of gardens, meadows, hills and woods?

...The arsenal at Venice is a fortification of between two and three miles in compass. On the ramparts are many little watch-towers, where sentinels are stationed. Like the arsenal at Toulon, it is at once a dockyard and repository for naval and military stores. Here the Venetians build their ships, cast their cannon, make their cables, sails, anchors, etc. The arms are arranged here as in other places of the same kind, in large rooms divided into narrow walks by long walls of muskets, pikes and halberts.

The Bucentaur is kept under cover, and never taken out but for the espousals. It is formed for entertaining a very numerous company, is finely gilt and ornamented within, and loaded on the outside with emblematical figures in sculpture. This vessel may possibly be admired by landsmen, but will not much charm a seaman's eye, being a heavy, broad-bottomed machine which draws little water, and consequently may be easily overset in a gale of wind. Of this, however, there is no great danger, as two precautions are taken to prevent such an accident; one of which seems calculated to quiet the minds of believers, and the other to give confidence to the most incredulous. The first is used by the Patriarch, who, as soon as the vessel is afloat, takes care to pour into the sea some holy water, which is believed to have the virtue of preventing or allaying storms. The second is entrusted to the Admiral, who has the discretionary power of postponing the marriage ceremony, when the bride seems in the smallest degree boisterous. One of the virtues of the holy water, that of allaying storms, is by this means rendered superfluous. But when the weather is quite favourable, the ceremony is performed every Ascension Day. The solemnity is announced in the morning by the ringing of bells and firing of cannon. About mid-day the Doge, attended by a numerous party of the senate and clergy, goes on board the Bucentaur; the vessel is rowed a little way into the sea, accompanied by the splendid yachts of the foreign Ambassadors,

the gondolas of the Venetian nobility, and an incredible number of barks and gallies of every kind. Hymns are sung, and a band of music performs, while the Bucentaur and her attendants slowly move towards the Lido, a small island two miles from Venice. Prayers are then said, after which the Doge drops a ring, of no great value, into the sea, pronouncing these words: *Desponsamus te, Mare, in signum veri perpetuique dominii.* The sea, like a modest bride, assents by her silence, and the marriage is deemed valid and secure to all intents and purposes.

A View of Society and Manners in Italy, London, 1781. JOHN MOORE
1779

...So much has already been written and said of Venice that I will not linger over describing it: I will say only how it appeared to me. What struck me most was the people, a vast throng which leads the life it has to lead. This people did not seek refuge on this island for amusement; it was not of their own will that those who came later joined those who were already here: necessity taught them to seek safety in the most disadvantageous site, a site which proved itself favourable and made them progress when the northern world was still shrouded in darkness. The increase in their numbers and their riches was a natural consequence. The houses were crowded one against another, sand and marsh were replaced by stone, the houses sought the light like plants growing enclosed between walls, so that they tried to gain in height what they lacked in area. Sparing of every inch of ground, and from earliest times crowded into confined spaces, they allowed the lanes no width more than what was strictly necessary to separate houses which faced each other and to permit, with difficulty, the passage of the citizens. For the rest, water was there to take the place of streets, of squares, of promenades. The Venetian had to become a particular kind of person who, like Venice itself, can only be compared with himself. The Grand Canal, which bends and twists among the palaces, yields to no street in the world, and nothing can approach the area which lies before St. Mark's.

...It is evident that the eye is educated according to the objects which it observes from childhood, and for this reason the Venetian painter must see everything more clearly and more serenely than other men. When, with the sun high in the sky, I crossed the lagoon, observing the gondoliers aboard their gondolas moving with such agility, with their many-coloured clothing, intent upon their craft, and I noted how they stood out against the azure background of the sky, I seemed to be looking at the best and most lively painting of the Venetian school. The sunlight gave a dazzling emphasis to the special colour of the place, and the parts that lay in shadow were so luminous that they could, in a way, have served as sources of light. The same could be said of the light from the green waters of the sea. Everything was painted in brightness upon brightness, so that the curling waves and the reflections of light were necessary to put the finishing touch. The cupolas and vaults and the lateral fronts of St. Mark's Cathedral are richly decorated with variously coloured figures on a gold background — mosaic work. Some of them are very beautiful, others less so, according to the ability of the painters who prepared the cartoons.

...After supper I hastened to equip myself with a comprehensive view of the city, and I launched forth, without a guide except the stars, into that labyrinth of a city which, although it is cut asunder at every turn by canals large and small, is nevertheless joined together again by large and small bridges. It is impossible to imagine without having seen it, the narrowness of these streets, the closeness of one house to another. Generally one can measure the width of the former by stretching out the arms, and for some merely the elbows suffice, with one's hands on one's sides. There are, to speak truth, some wider

streets, and here and there small squares, but on the whole everything is narrow, hemmed in. I found the Grand Canal with ease, and the chief bridge, that of the Rialto, formed by a single arch in white marble. From the apex of the bridge the view is stupendous — the canal furrowed by boats, bringing from the mainland the necessities of life, which for the most part stop to unload at this point; and among these boats, a flotilla of gondolas. And today especially, the feast of Michaelmas, the spectacle, the view, were marvellous indeed; but in order to give any precise idea, it is necessary to add a few details.

The two principal parts of Venice, separated by the Grand Canal, are united by no other bridge than this single one of the Rialto, but at other points communication is provided between the parts of the city by public boats which continually cross the canal at certain determined points.

...All the bridges are raised to a certain height and they are crossed by means of steps; thus not only gondolas but boats of greater capacity may pass beneath the arches. Many houses rise from the water itself. Here and there, however, there are well-paved pathways between the water and the churches and palaces. Particularly pleasant is the long stone path on the north side whence the view of other islands, and especially Murano, another smaller Venice, can be enjoyed. The lagoon between these islands is continually animated by the coming and going of gondolas.

...I climbed the tower of St. Mark from where a unique spectacle can be enjoyed. It was about midday, the sun shone clearly so that without need for a telescope the eye could discern objects at a great distance. The lagoons were covered by the water and when I turned my gaze towards what is called the Lido, a narrow tongue of land which closes the lagoon, I saw for the first time from Venice the sea, and some sails upon it. In the lagoon there were galleys and frigates which were intended to join Cavaliere Emo, who is commanding the war against the Algerians, but which were detained here by contrary winds. The hills of Padua, of Vicenza, and the mountains of the Tyrol bounded the horizon, between west and south, of this superb panorama.

Italienische Reise (1786-1788). JOHANN WOLFGANG GOETHE
 September 1786

...Venice is a large city, unusual and unique for both political and physical reasons, worthy to be seen and studied not only on account of the strange and marvellous manner of its construction but also for its wise government: it is exceedingly pleasing and admirable as much for its rare qualities as for its beauty and magnificence and the rich treasures it possesses, both in science and in all the arts. In the midst of a great lagoon, lapped by the waves of the sea, a great and proud city rises from the water, full of elegant domes, high towers, splendid temples, majestic palaces, and many sumptuous buildings. A multitude of diverse and well-peopled islands are scattered around it on all sides, and serve as a noble crown to the sovereign queen of these seas. From whatever direction one approaches, she cannot be reached but by water, and from afar off one sees her raise her royal head; and as he sails along the shores of delightful islands, while yet at a distance she begins to amaze and enchant the foreigner who gazes upon her. Without moats or ditches, without walls and ramparts, without drawbridges, gates or soldiers, without guards or sentinels or any other military apparatus, and with no outward show of the kind which impedes the entry into other cities, one enters Venice tranquilly and freely, as into a temple and haven of peace and liberty.

But when one enters the city and passes along her canals and streets, what new and unexpected sight is there which does not meet one's eyes? However much you may have heard about Venice, and however many descriptions you may have read, you cannot form a true

idea of how it lies and is built, and you will certainly not attain to it however much I attempt to present it to your imagination, painting it with lengthy description. I will say only, that Venice is a collection of seventy-two islands very close one to another, and united each with another by one or more bridges; which has an infinite number of canals winding their way between these islands; that one may count four hundred bridges by which it is possible to pass from one island to another, and that upon these islands stand the buildings, the streets and the squares. Almost the whole of Venice can be reached by water, and for this purpose there are fixed places called *traghetti* which are like small ports where you may embark, either to cross to the island opposite, where there is a kind of landing-place, or to make a longer voyage and go to alight at some house or some street which you wish to reach with speed and comfort. Without interruption by water various fairly wide alley-ways link up with other spacious areas that are here called *campi*, and to which one can in fact give the name of piazza. Among these alley-ways there are some which are known as a *fondamenta* and which are a special kind of paved walk running along the canals; sometimes one sees them only on one side of the canal, and sometimes they run along both sides. The bridges, as I have said, amount to about four hundred, and as they do not have to carry the weight of carts, coaches, animals or any heavy load, they are very lightly built, but still strong and solid enough to bear the continual passage of people. These bridges for the most part are not very large, but the celebrated bridge of the Rialto is indeed wide; it is the only one across the Grand Canal, since on account of its breadth they did not wish to make more than one bridge, but that that one should be of great value. The canals are like so many streets, one passes along them and transacts business as one does in streets upon land. All those who move about in gondolas, which are as many, or more, as go in coaches in other cities, all cargoes of foodstuffs and merchandise and everything that has to be transported, all this passes along the canals in gondolas, in *burchielli* and other small boats used for goods, and keeps the canals very crowded and animated, and makes them the scene of great activity and gaiety.

This strange and unique situation, this unusual sight not to be seen elsewhere, amazes and astonishes the foreigner the first time that he sees it; but his wonder increases when he sees such splendid places, such magnificent temples, such grand buildings, and when he considers that all these are built, so to speak, upon water.

What an immense quantity of materials must have been thrown down to form their foundations, to raise safely and solidly such great edifices on such marshy ground in the midst of such a wide expanse of waters! What treasure must have been buried below ground to sustain such majestic buildings, which themselves cost much treasure to erect!

Cartas familiares del abate D. Juan Andrés a su hermano, Madrid, 1790
<div align="right">JUAN ANDRÉS
November 1788</div>

...This increased the animation which in any case prevailed in all parts of this noisy but pleasant and varied city. Nowhere else did strangers flock in such numbers as to this fair city, attracted there largely by the singularity of the sights which it offers, the like of which is not to be found in the universe... No city ever drew so great a number of strangers to it as Venice, for whichever way one approaches it, by land or by sea, the view is equally strange and unparalleled. It is seen from afar, floating upon the surface of the water, so circled about by a forest of masts belonging to ships and other craft that its principal buildings, and in particular those in the piazza of St. Mark, can hardly be seen.

Mémoires secrètes des Cours et des Gouvernements, Paris, 1793.
<div align="right">GIUSEPPE GORANI
1768</div>

33. GASPAR VAN WITTEL: *The Bacino di San Marco* (detail). Florence, Private collection.
The viewpoint is the centre of the Bacino di San Marco, between the island of San Giorgio and the Molo. The view shows, from the left, the Fontegheto della Farina, the old public granary, and on the quay, the fish market and the Ponte della Pescheria, a group of buildings which stood on the site of the present Royal Garden. On the right is the façade of the Old Library, facing the Piazzetta, and the two columns.

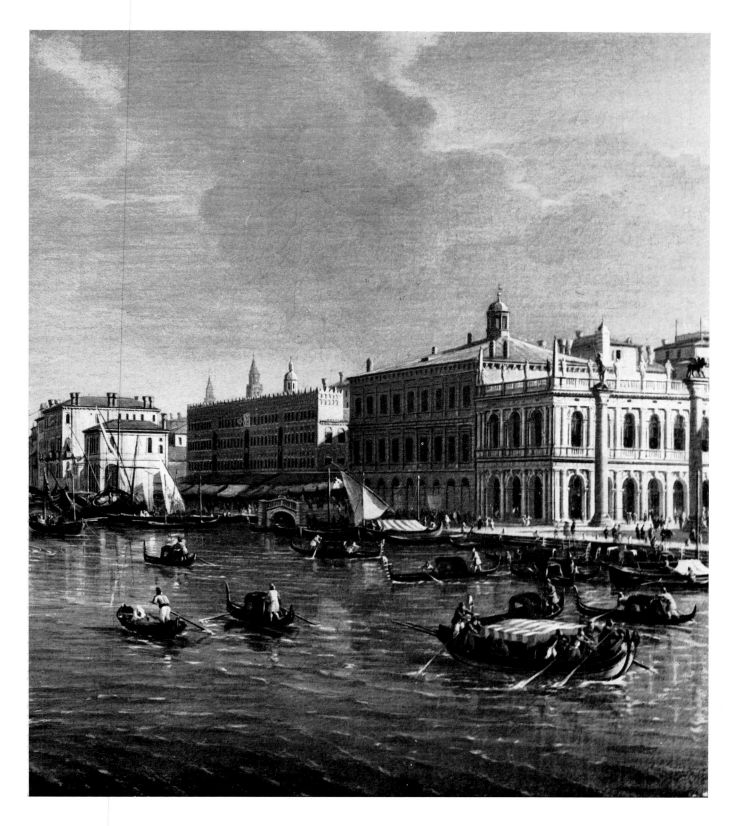

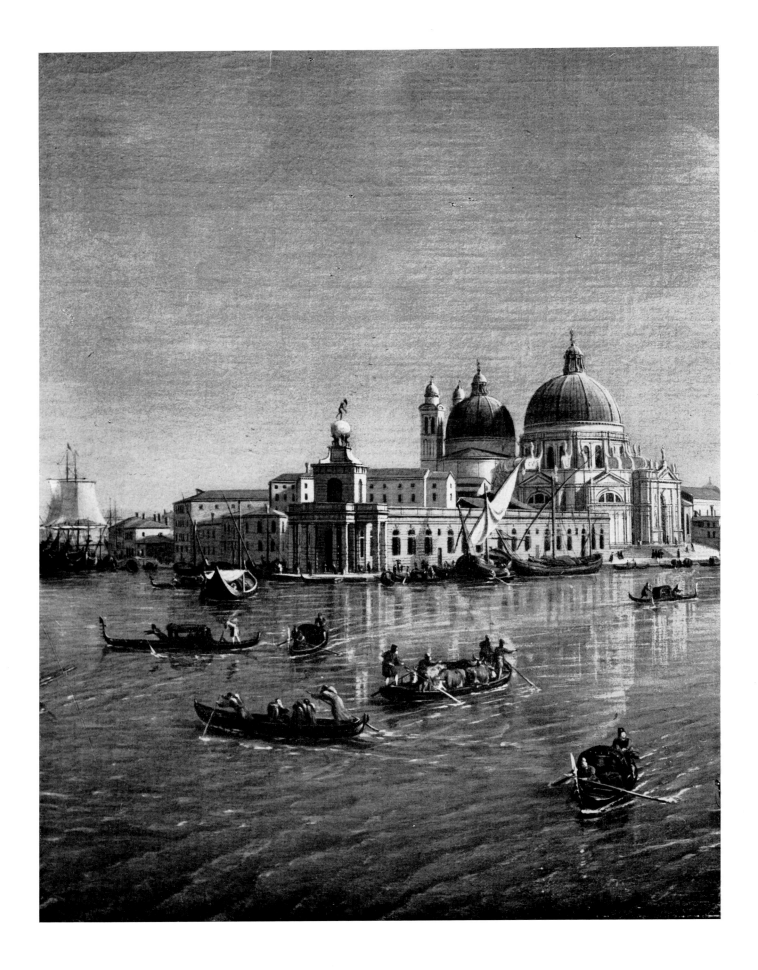

34. GASPAR VAN WITTEL: *The Bacino di San Marco* (detail). Florence, Private collection.

Another detail from the painting from which the preceding detail is also taken, to the left of it, showing the Customs-house (the Dogana) and Santa Maria della Salute.

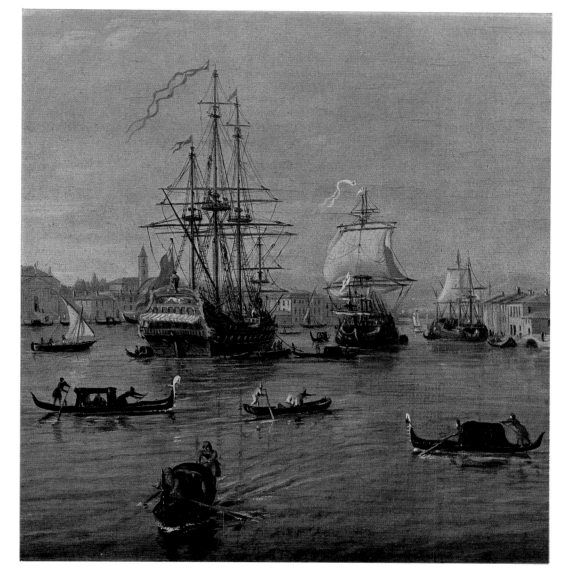

35. GASPAR VAN WITTEL: *The Bacino di San Marco* (detail). Rome, Galleria Doria.

A detail from the left of the painting, showing ships at the entrance to the Giudecca canal.

36. LUCA CARLEVARIJS: *The Piazzetta from the Riva degli Schiavoni* (detail). Birmingham, City Art Gallery.

A detail from the central section of the painting portraying the arrival of the English Ambassador, the Earl of Manchester, at the Doge's Palace on 22 September 1707. It was commissioned from Carlevarijs by the ambassador himself.

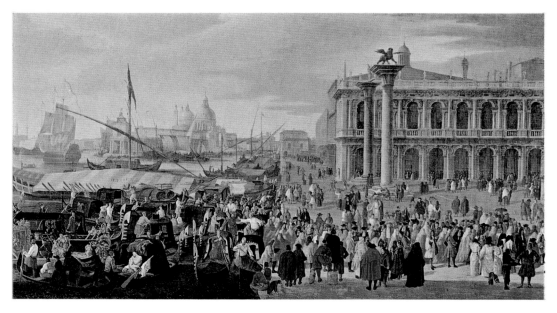

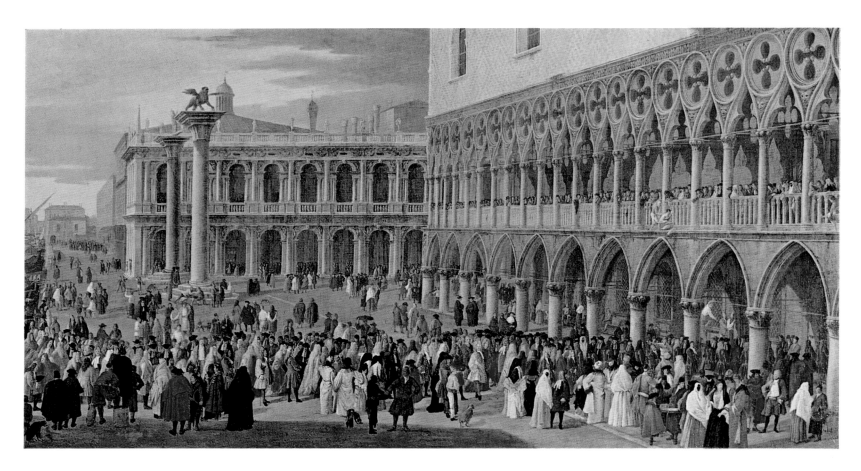
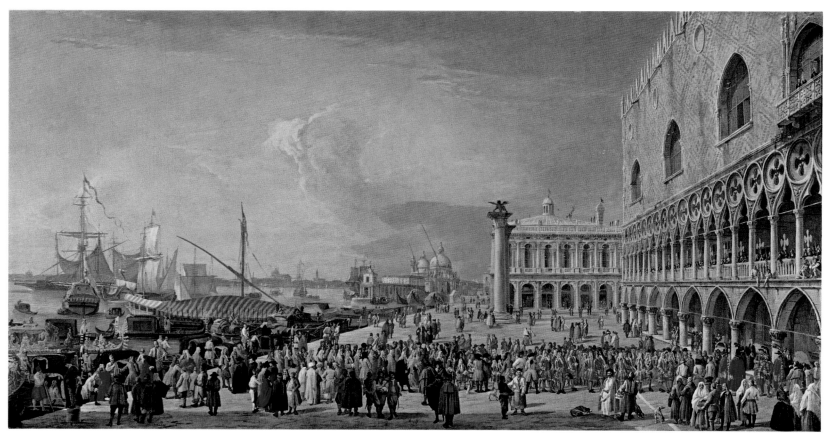

37. LUCA CARLEVARIJS: *The Doge's Palace and the Piazzetta from the Riva degli Schiavoni* (detail). Birmingham, City Art Gallery.

A detail from the righthand section of the same painting, showing the ambassador and his suite entering the Palace.

38. LUCA CARLEVARIJS: *The Arrival of the Imperial Ambassador, the Count of Colloredo-Waldsee, at the Doge's Palace*. Dresden, Gemäldegalerie.

This is the latest datable work by Carlevarijs. After an interval of twenty years he treats once more the subject of an ambassadorial reception, this time from a different viewpoint and with a considerably wider angle of vision.

39. LUCA CARLEVARIJS: *A little Square*. Formerly London, Private collection.

An unpublished view of a corner of Venice and its everyday life which deserves a place among the artist's best work for its freshness and spontaneity.

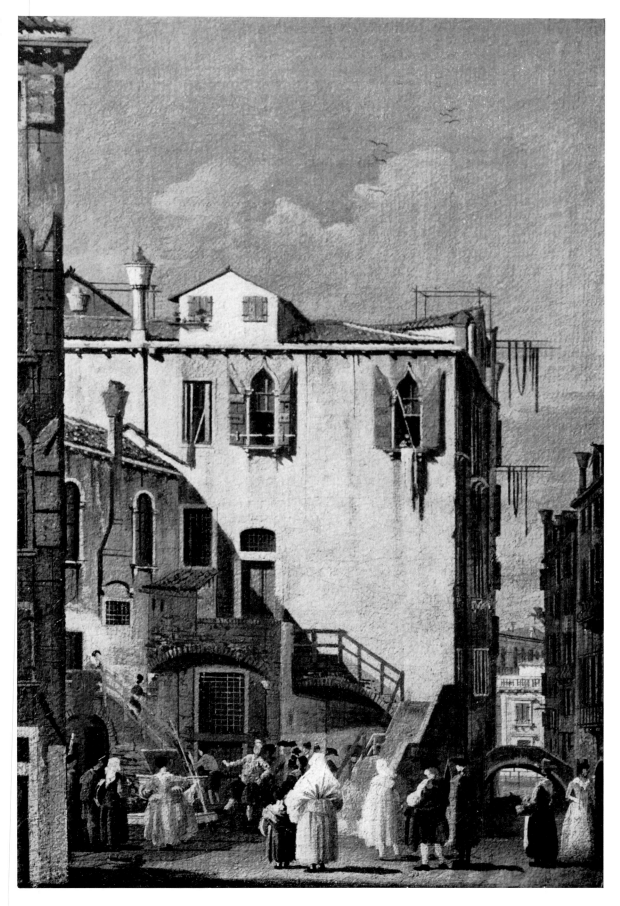

40. LUCA CARLEVARIJS: *The Piazzetta* (detail). Oxford, Ashmolean Museum.
One of the finest of Carlevarijs' late works, outstanding for the characterization of the figures which animate the scene. The drawing for the figure of the bookseller reading is in the Victoria and Albert Museum.

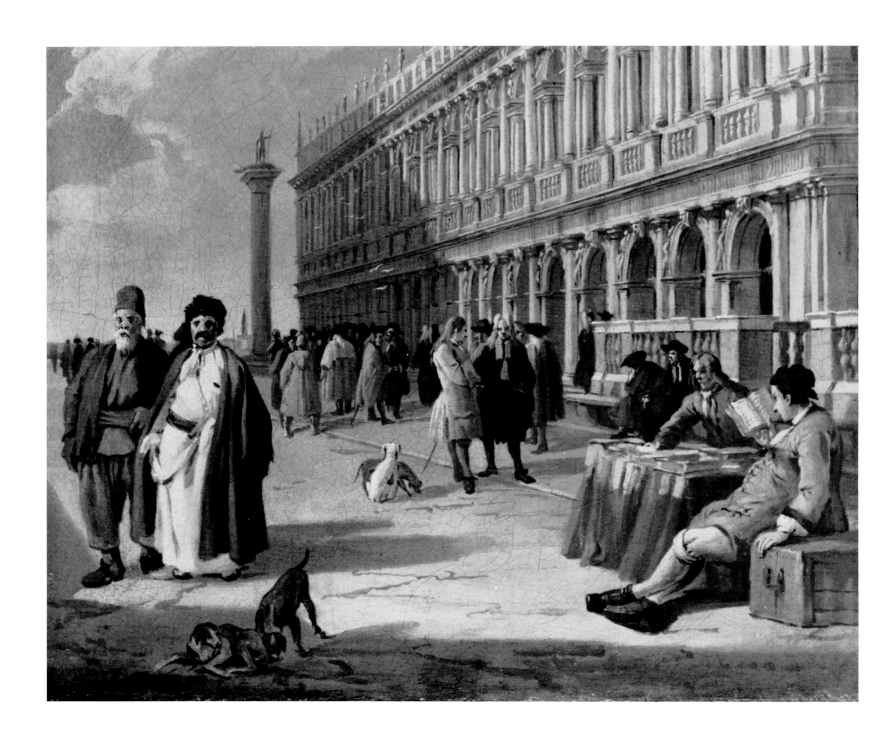

41. CANALETTO: *The Stonemason's Yard* (detail). London, National Gallery.

The painting takes its title from the stonemason's yard which occupies the whole of the foreground of the composition, beside the Grand Canal on the site of the present Campo San Vitale. On the other side of the canal is the Church of Santa Maria della Carità, closed in 1807, whose site is now occupied by the Accademia delle Belle Arti, and its tower, now demolished. Beside it is the Scuola di Santa Maria della Carità, whose façade was rebuilt in the neoclassical period and now serves as the entrance to the Accademia. Further to the right is the campanile of San Trovaso.

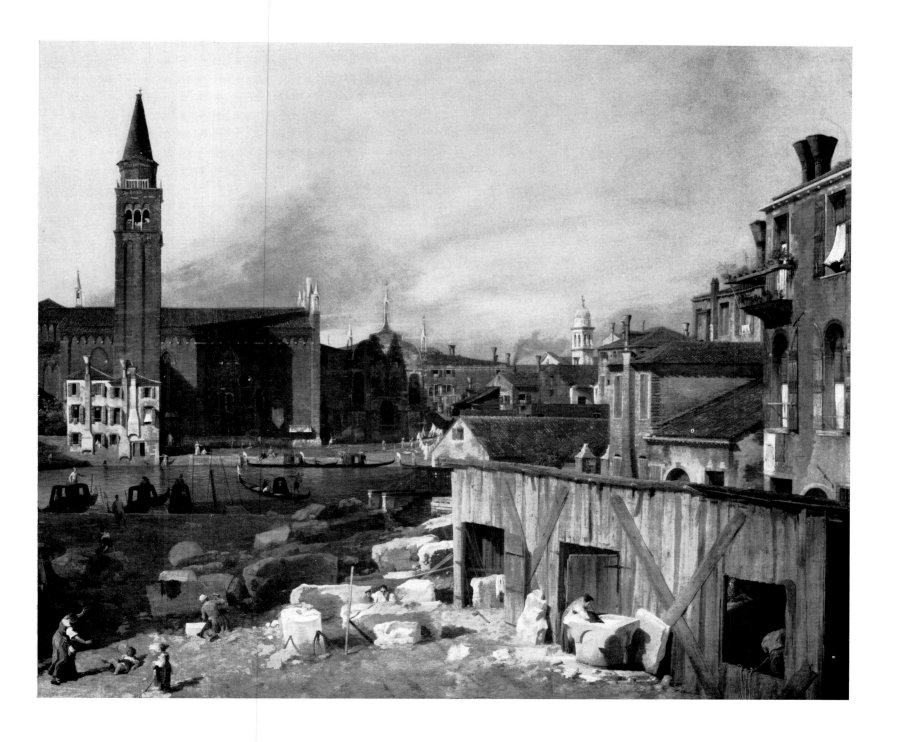

42. CANALETTO: *The Bacino di San Marco* (detail). Cardiff, National Museum of Wales.
On the street flanking the Giudecca canal a lady and a gentleman walk along in conversation. This is an incidental sketch of a kind rare in the work of Canaletto.

43. CANALETTO: *Piazza San Marco and the Colonnade of the Procuratie Nuove* (detail). London, National Gallery.
A late work, painted after Canaletto's return from England. The entire length of the arcade is seen in perspective from beneath one of the arches of the Procuratie Nuove. In the foreground is the Caffè Florian, opened by Floriano Francesconi in 1720.

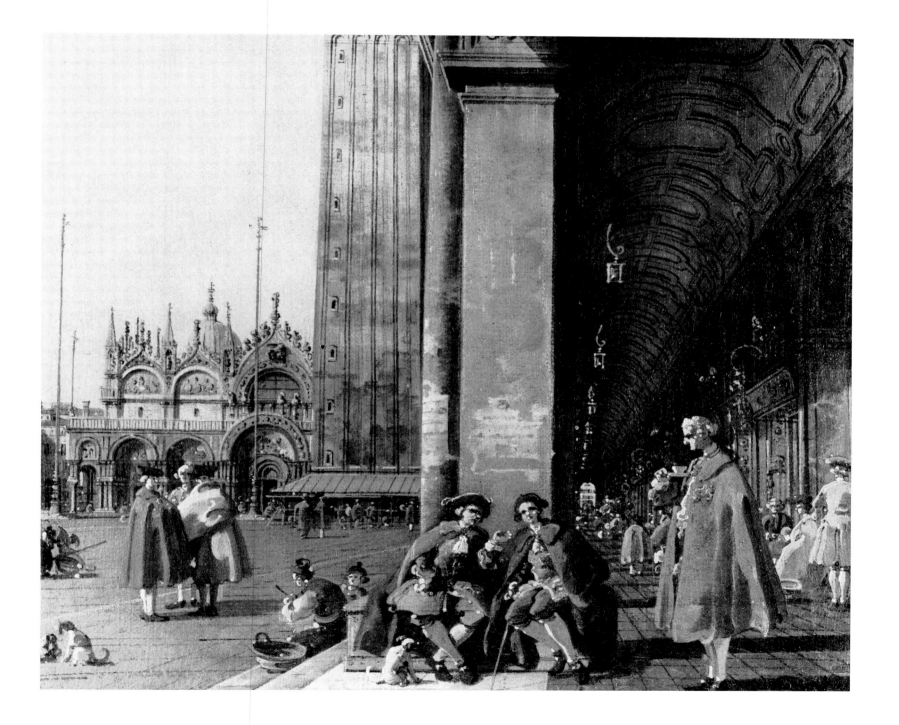

44. CANALETTO: *The Campo dei Santi Giovanni e Paolo*. Dresden, Gemäldegalerie.
On the left is the Rio dei Mendicanti and the Ponte del Cavallo, in the centre the Scuola di San Marco, on the right the Church of SS. Giovanni e Paolo and the monument to Bartolomeo Colleoni. It is an early work by the artist, painted before 1730.

45-46. CANALETTO: *The Bacino di San Marco*. Milan, Aldo Crespi Collection.
The view extends from the Molo to the Riva degli Schiavoni and includes the Mint (Zecca), the Old Library with the Campanile behind it, the Piazzetta, the Doge's Palace and the Prisons. Opposite the Palace, the Bucintoro, with a numerous escort of boats, is about to leave for San Nicolò di Lido for the magnificent ceremony of the Betrothal of the Sea, which was celebrated every year on Ascension Day. The detail shows the balconies of the Ducal Palace.

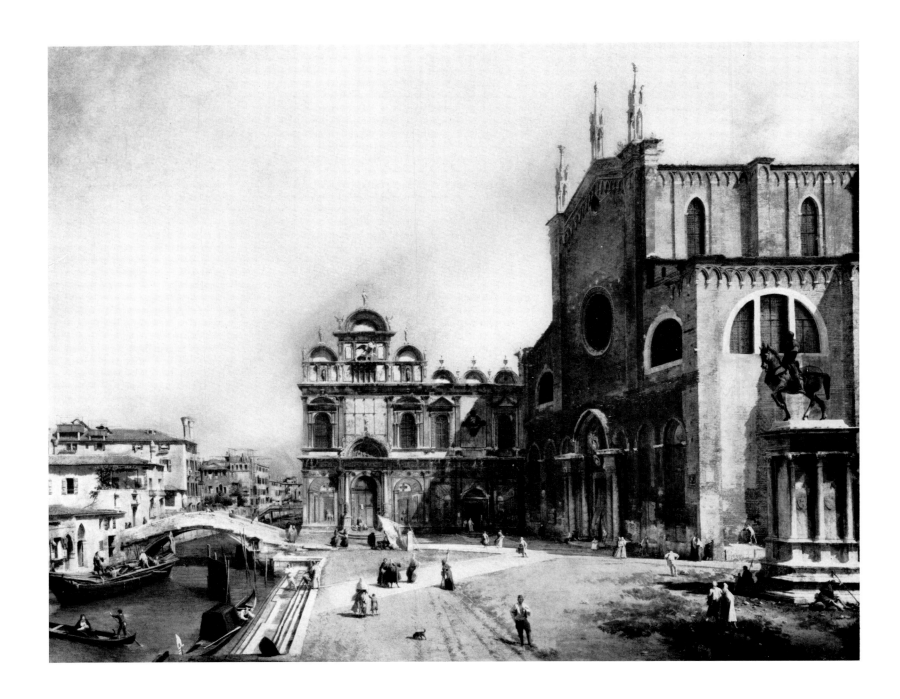

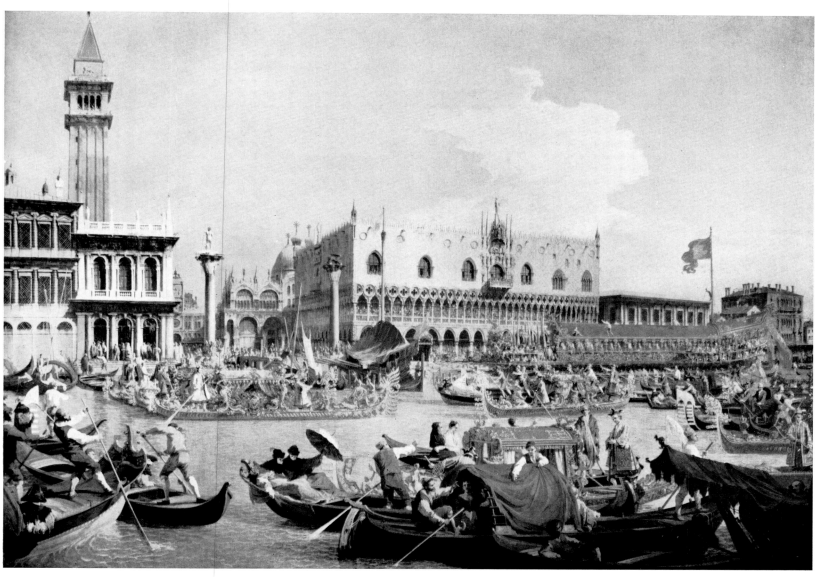

47-49. CANALETTO: *The Bacino di San Marco* (details). Milan, Aldo Crespi Collection.

The painting of the Bacino di San Marco on the Feast of the Ascension is companion to another view of the Molo and the Doge's Palace showing the reception of the Imperial Ambassador, Count Bolagno, in 1729. The two works were executed probably in the same year or at the latest in consecutive years. They are significant in marking the beginning of a change in Canaletto's style which characterizes the works of the fourth decade of the eighteenth century.

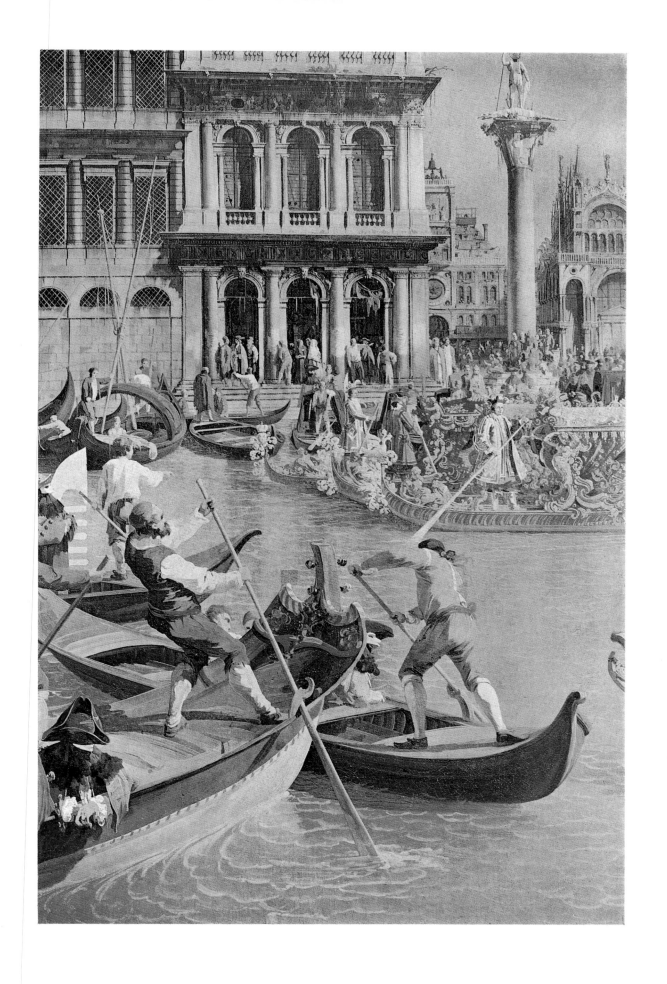

50-51. CANALETTO: *San Giacomo di Rialto*. Dresden, Gemäldegalerie.

The earlier of two known views of the same subject, this painting must date from before 1730. It depicts the Campo of San Giacometto and the church which gives it its name and which popular tradition named as the oldest in Venice. On the right is the Ruga degli Orefici, the interior of the Rialto bridge, and some buildings on the far side of the Grand Canal, dominated by the spire of San Bartolomeo. In the square, a scene of everyday life: among the pedlars an artist is displaying his canvases.

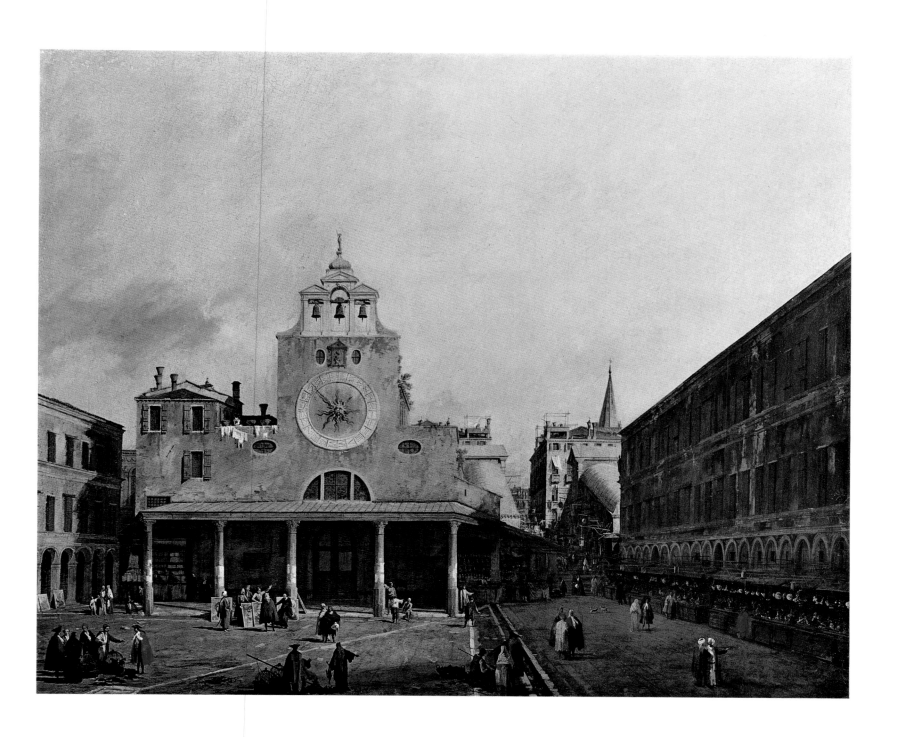

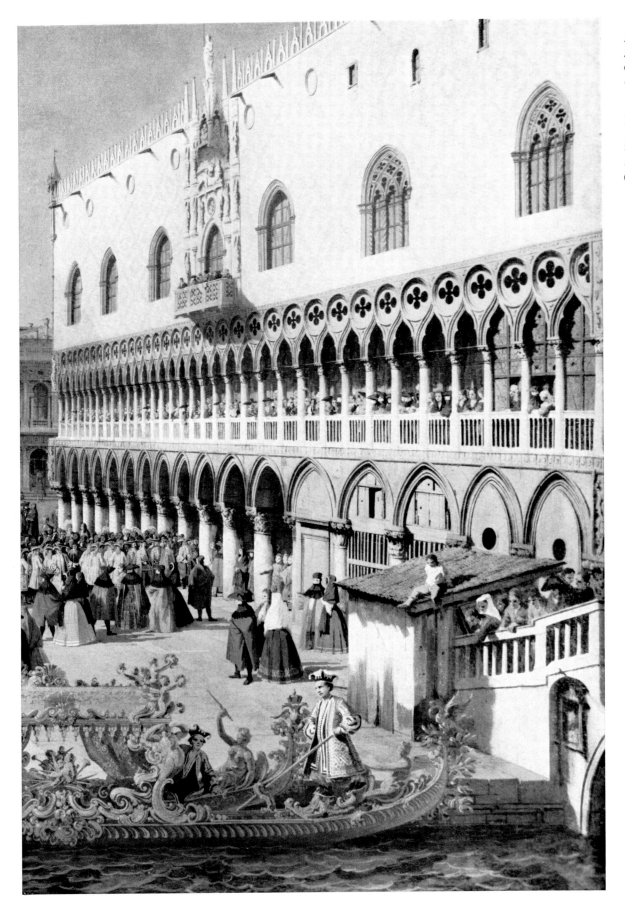

52. CANALETTO: *The Reception of the Imperial Ambassador Count Bolagno* (detail). Milan, Aldo Crespi Collection.

The event took place on 16 May 1729, the probable year of the painting. Canaletto had previously painted a similar scene to commemorate the arrival of the French Ambassador on 4 November 1726 (now in the Hermitage, Leningrad).

53. CANALETTO: *The Bacino di San Marco from the Piazzetta* (detail). Milan, Mario Crespi Collection.

This painting is one of a series of eight formerly in the Liechtenstein Collection and datable about 1730. Beyond the corner of the Doge's Palace is the Molo and the Bacino full of ships. In the background, behind the forest of masts and yards, is the end of the Riva degli Schiavoni with the Church of San Nicolò, now demolished, and in the distance the campanile of San Pietro a Castello.

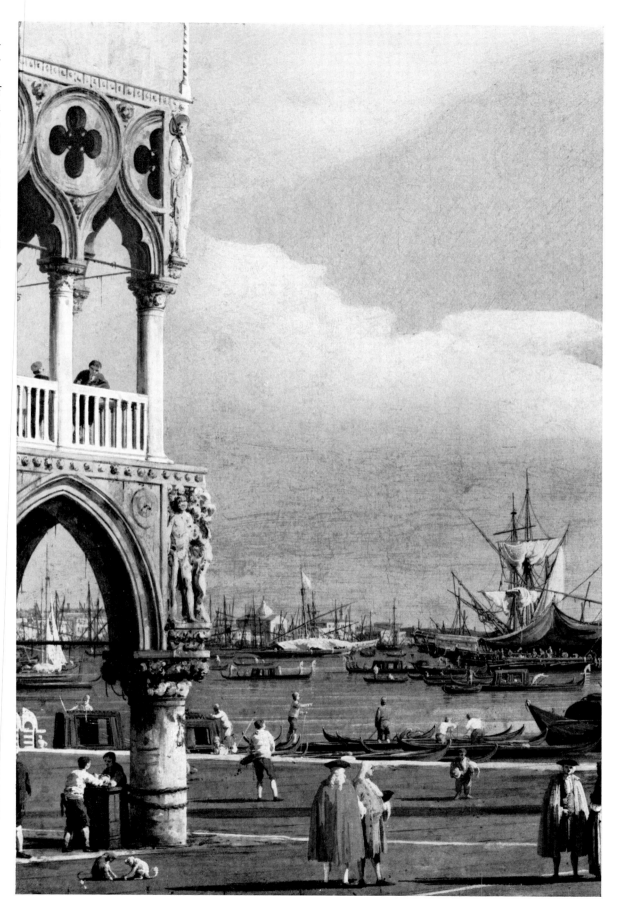

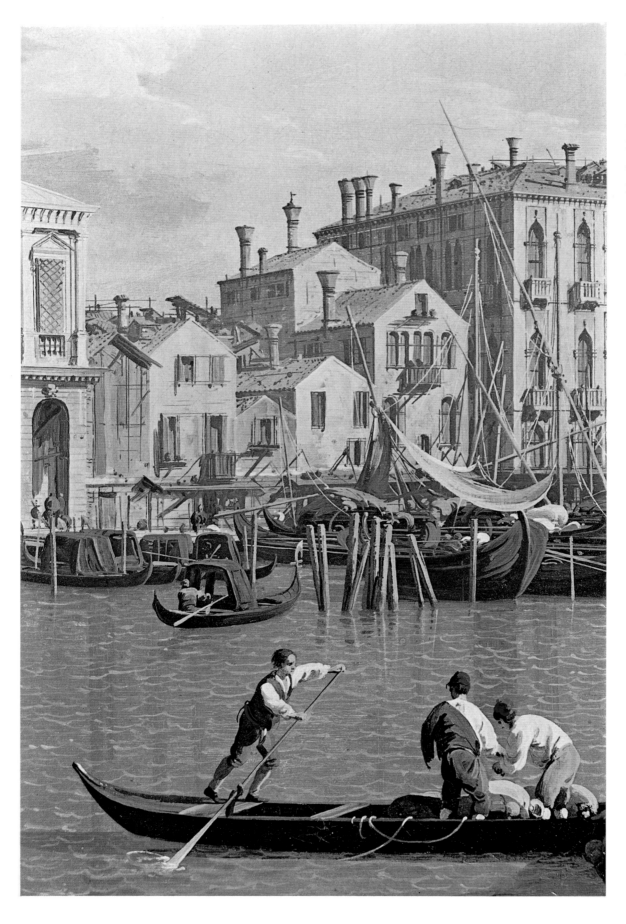

54. CANALETTO: *The Riva delle Prigioni* (detail). Toledo, Ohio, Toledo Museum of Art.

One of the paintings of the Liechtenstein Collection. The detail shows part of the Bacino di San Marco opposite the Riva delle Prigioni, with a group of houses which lay between the Prisons and Palazzo Dandolo (now the Danieli Hotel), part of which can be seen on the right. The houses no longer exist.

55. CANALETTO: *The Dogana and the Riva delle Zattere*. Milan, Mario Crespi Collection.
Another of the Liechtenstein series. The view, which is a rather unusual one, shows the Riva delle Zattere and the Giudecca canal from the Punta della Dogana, to be seen on the extreme right. In the background, behind the anchored ships, is the island of Giudecca and the Church of San Giacomo, now demolished.

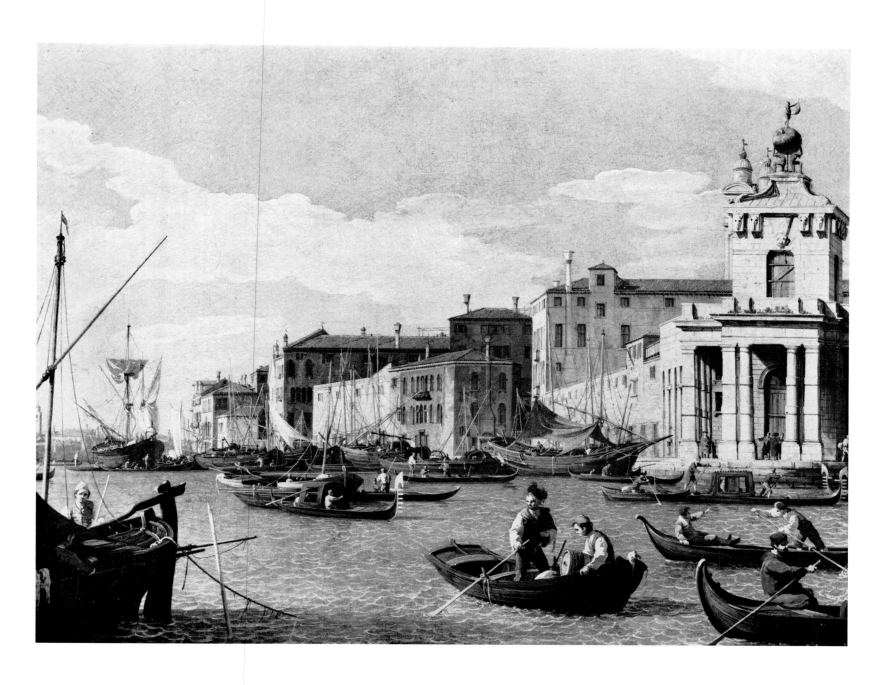

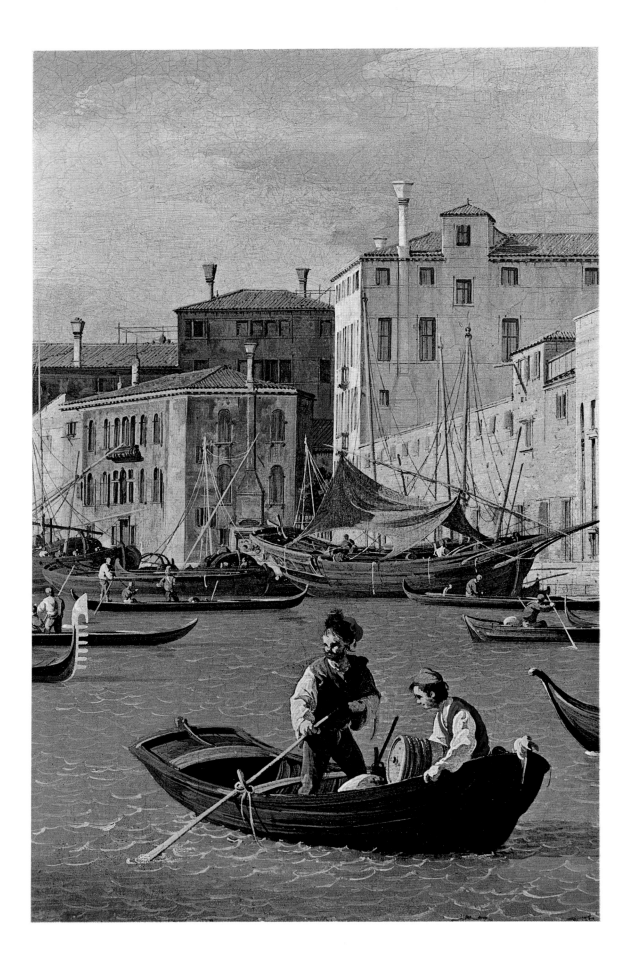

56. CANALETTO: *The Riva delle Zattere* (detail). Milan, Mario Crespi Collection.

A detail of the preceding illustration showing the first houses on the Riva delle Zattere separated from the Customs-house by the Rio della Salute.

57. CANALETTO: *The Giudec- ca from the Punta della Dogana* (detail). Vienna, Kunsthistori- sches Museum.

A detail from the picture which follows, showing the calm wa- ters of the Lagoon off the Pun- ta della Dogana. On the left is part of the island of San Gior- gio and on the right the end of the Giudecca with the Church of San Giovanni Battista, now demolished.

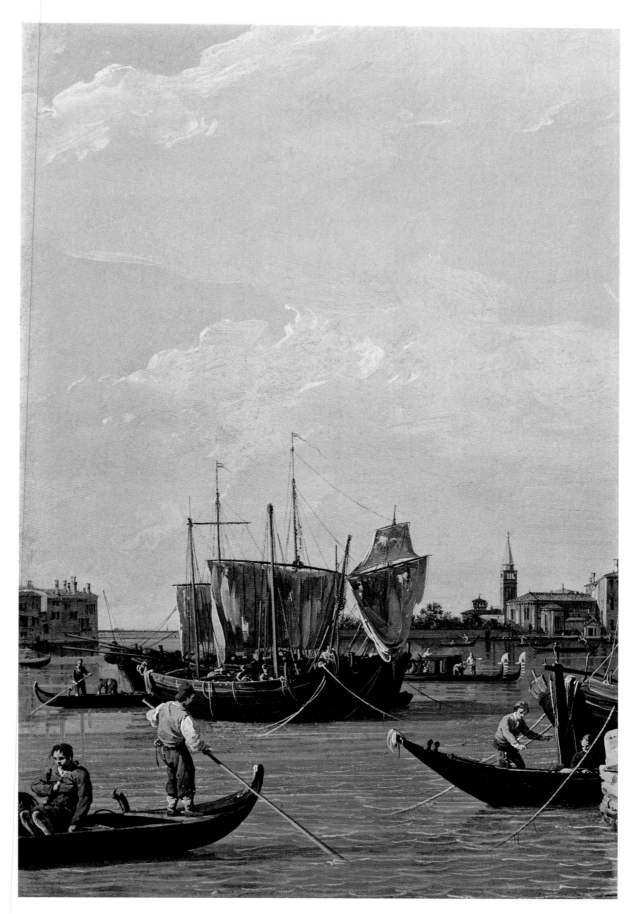

58. CANALETTO: *The Punta della Dogana*. Vienna, Kunsthistorisches Museum.
Another of the Liechtenstein series, from which the same Museum also possesses a view of the Riva degli Schiavoni. The Punta della Dogana is seen from the Grand Canal with the Giudecca in the background, from the Church of San Giovanni Battista to that of the Zitelle.

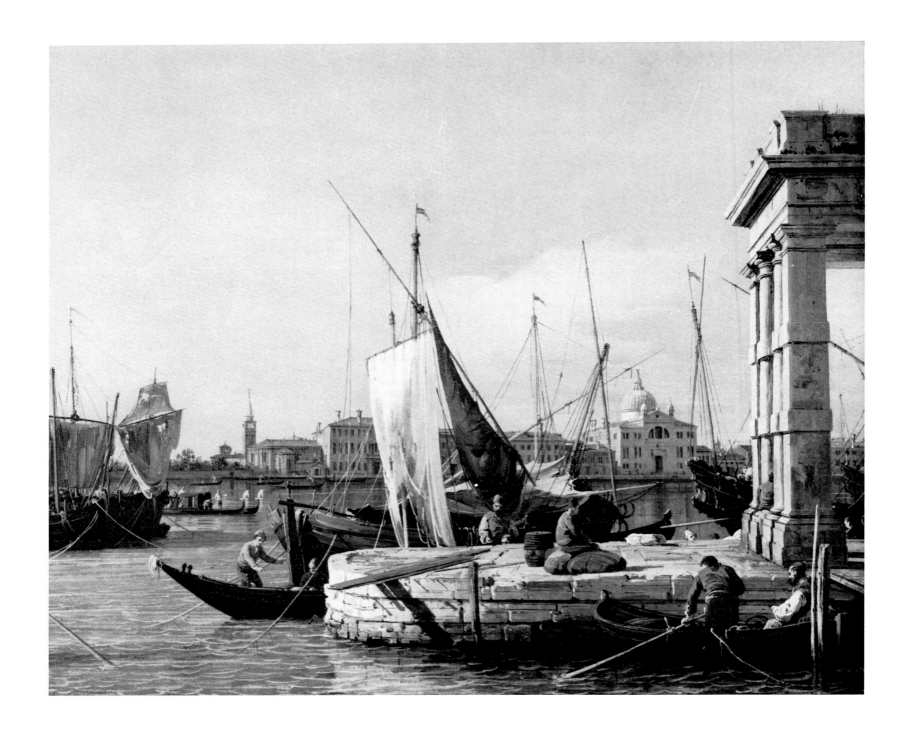

59. CANALETTO: *The Campo di Santa Maria Formosa* (detail). Woburn Abbey, Collection of the Duke of Bedford.
One of a series of 24 views which Canaletto painted in 1731 and 1732 for the fourth Duke of Bedford and which are still in the place for which they were intended. The Campo is one of the most characteristic squares in Venice, and the painting shows, in the centre, the Church of Santa Maria Formosa rebuilt in 1492 to the design of Moro Coducci, and the seventeenth-century campanile. On the left, beyond the bridge of Ruga Giuffa, is Palazzo Malipiero-Trevisani.

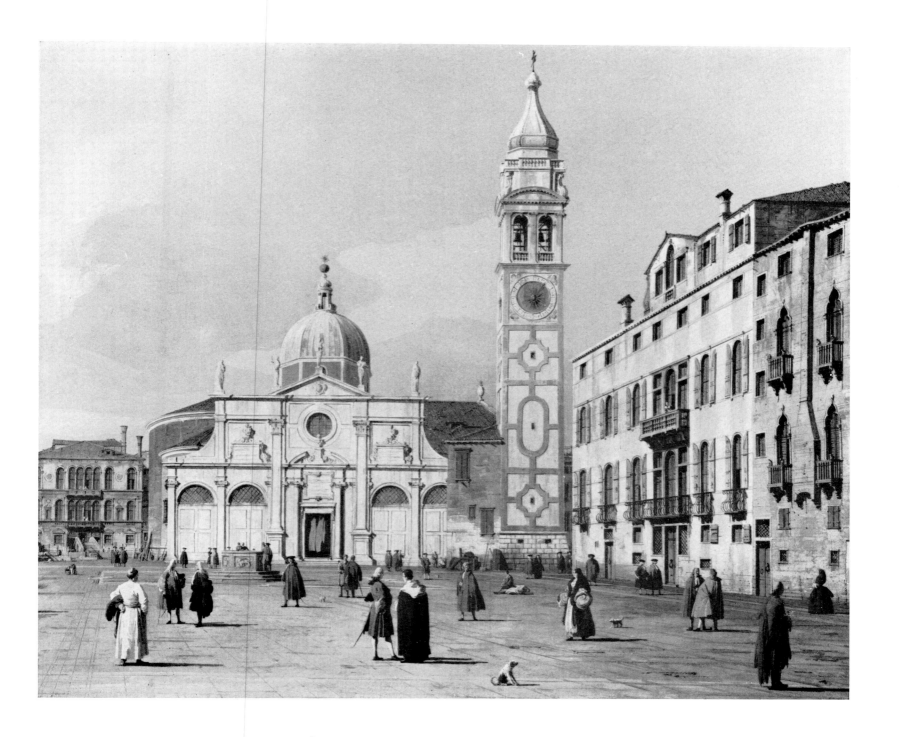

60. CANALETTO: *The Bacino di San Marco*. Boston, Mass., Museum of Fine Arts.

The view from the Punta della Dogana shows the whole extent of the Bacino di San Marco from the public granaries, where the Royal Garden is now, the entire length of the Riva degli Schiavoni to the point of Sant'Elena, and, towards the south, the Lido in the distance, the island of San Giorgio and the beginning of the Giudecca on the right of the painting. It is a very extensive view, such as today would require a wide-angle lens, which draws the spectator into the vivid reality of the scene. Painted probably in the early seventeen-thirties, it is one of Canaletto's greatest achievements. Stylistically, this view heralds the famous London paintings.

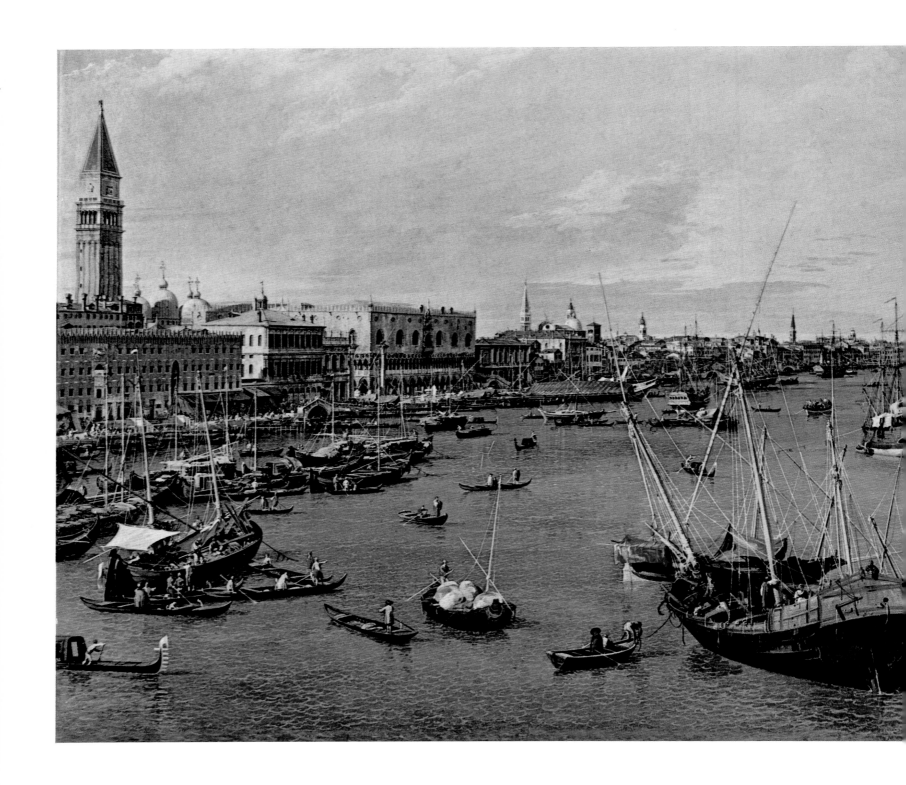

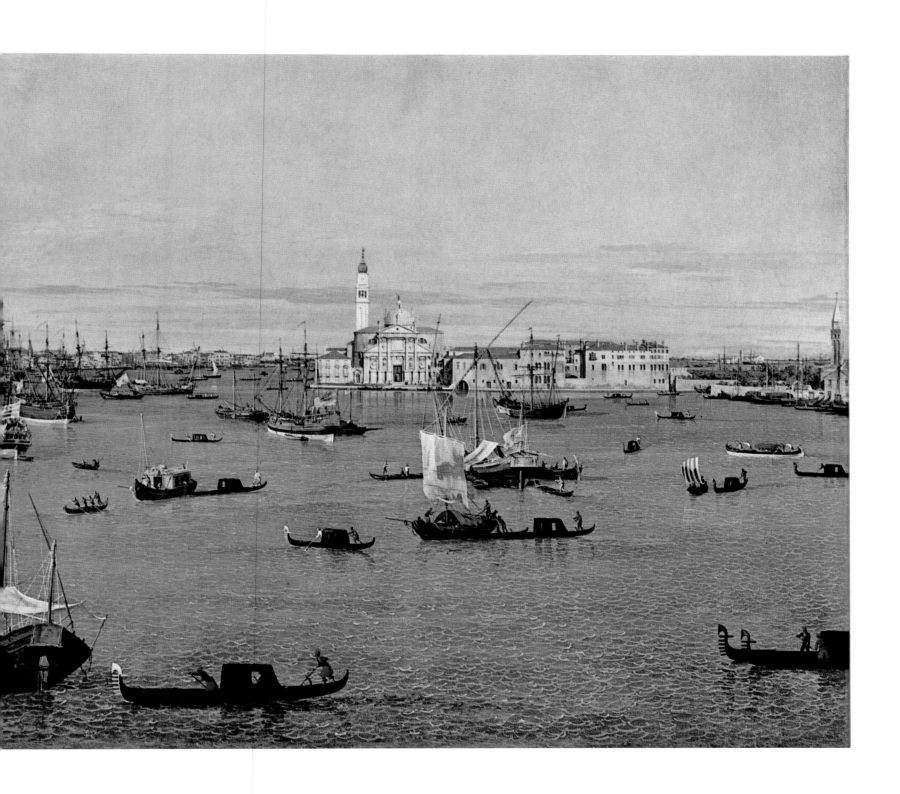

61. CANALETTO: *The Fontegheto della Farina* (detail). Venice, Giustiniani Collection.

The chief feature of this view is the old public granary, the Fontegheto della Farina, across the bridge over the Rio della Luna. Behind the building can be seen Palazzo Vallaresso, later Palazzo Erizzo and now the Hotel Monaco. On the left, on the other side of the entrance to the Grand Canal, is the Punta della Dogana and the campanile of Santa Maria della Salute. The part of the Molo from which this view is taken is now the Royal Garden. A relatively early work, the painting is datable to the late 1720s or early 1730s.

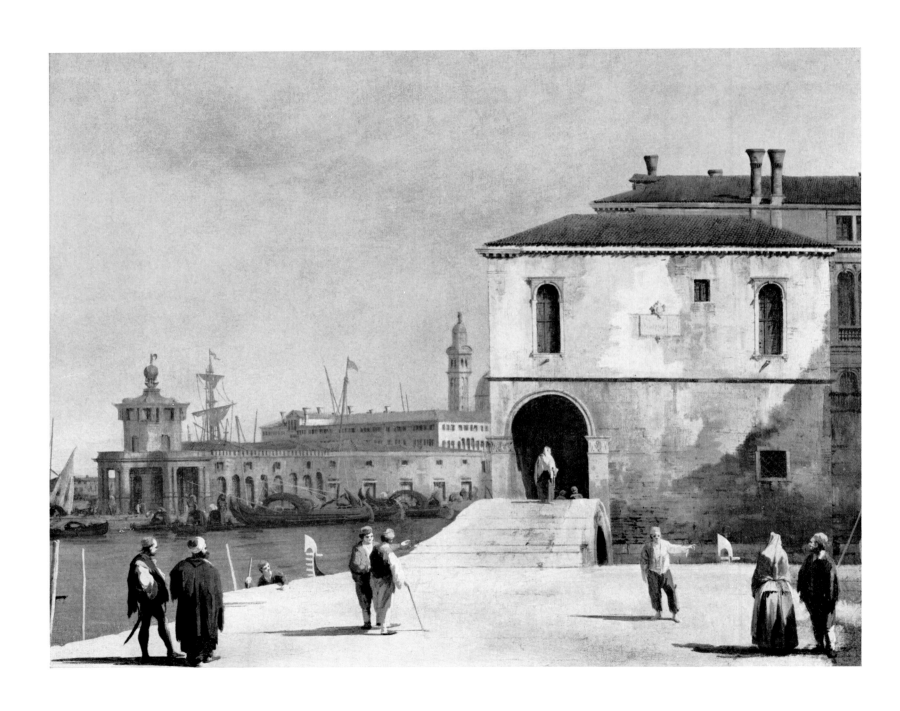

62. CANALETTO: *The Riva degli Schiavoni, looking West*. Vienna, Kunsthistorisches Museum.

One of the Liechtenstein views. It is an unusual aspect of the Riva degli Schiavoni seen from the neighbourhood of the Arsenal, near the Church of San Biagio. Beyond the bridge which crosses the Rio dell'Arsenale are the Military Bakeries and the towers of the churches of San Giovanni in Bragora and San Giorgio dei Greci. In the background is the Molo, with the Doge's Palace and the campanile of San Marco. On the left, behind the ships at anchor, is Santa Maria della Salute.

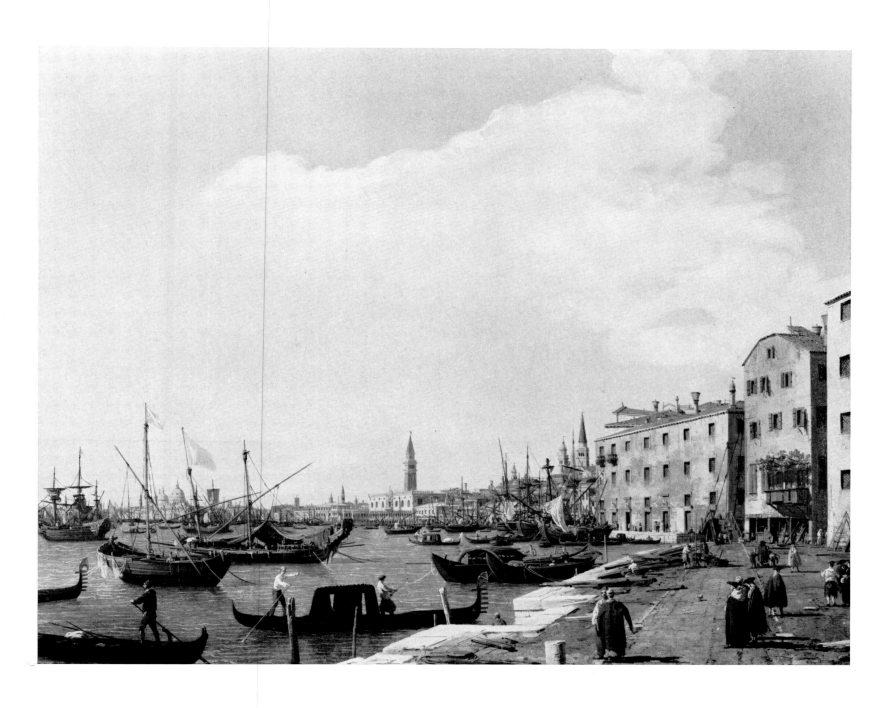

63-64. CANALETTO: *The Riva degli Schiavoni, looking West* (detail). Vienna, Kunsthistorisches Museum.

The painting dates from about 1730, like the other works in the Liechtenstein series, all of which show successive views of the Bacino di San Marco.

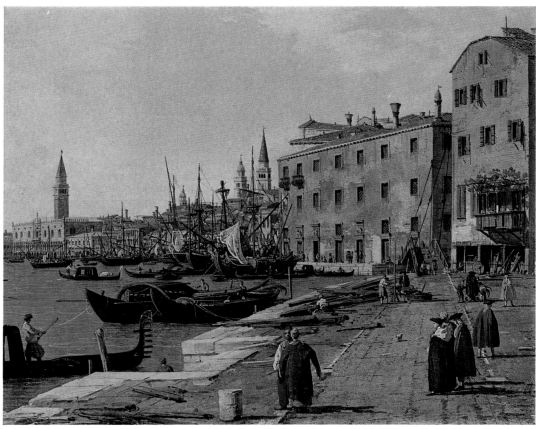

65. CANALETTO: *Santa Maria della Salute and the entrance to the Grand Canal*. Houston, Texas, Museum of Fine Arts.
A receipt for two paintings, of which this is one, was given by Consul Joseph Smith in 1730, so that it must have been painted in that year or shortly before. The paintings were for the collection of Hugh Howard. The view shows the Church of Santa Maria della Salute from the entrance to the Grand Canal, which can be seen as far as its first curve, level with the campanile of Santa Maria della Carità, later demolished.

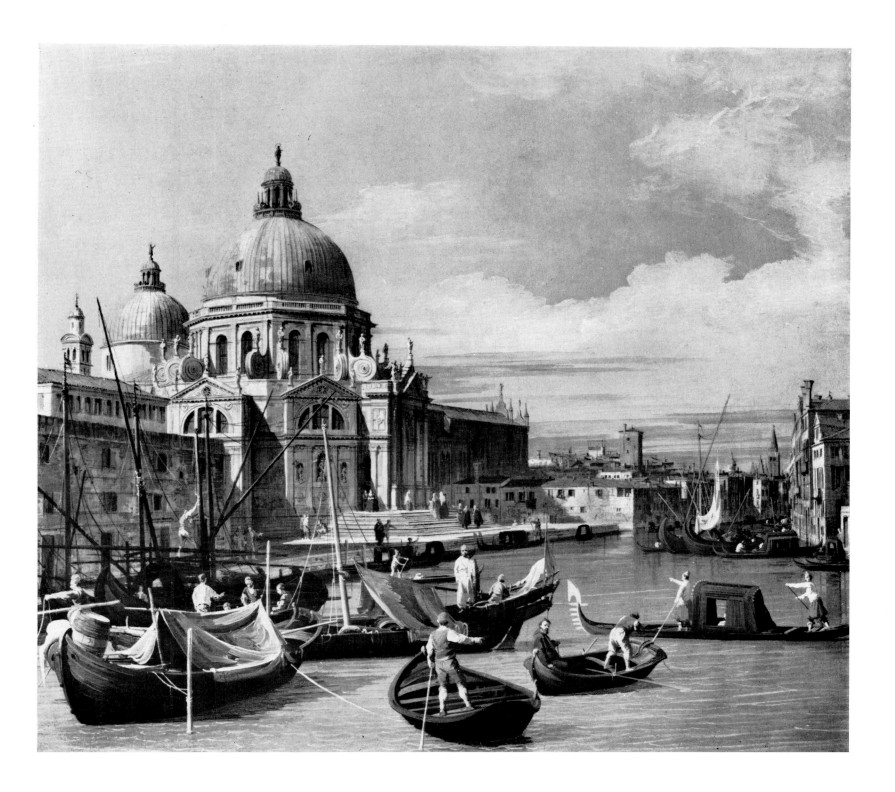

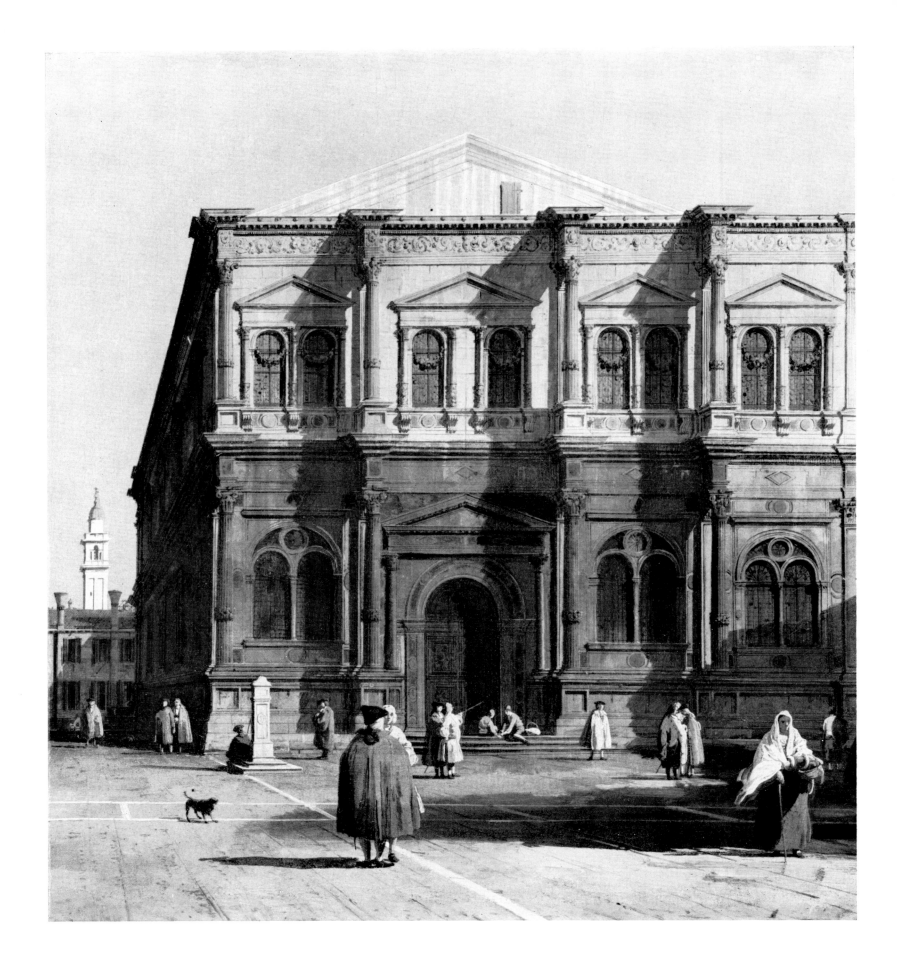

66-67. CANALETTO: *The Scuola di San Rocco* (details). Woburn Abbey, Collection of the Duke of Bedford.

Another of the 24 views painted by Canaletto for the fourth Duke of Bedford in 1731 and 1732 (see Plate 59). The artist had his back to the side wall of the Church of Santa Maria dei Frari; the façade of the Scuola di San Rocco is in the centre and in the background to the left is the campanile of San Pantaleone.

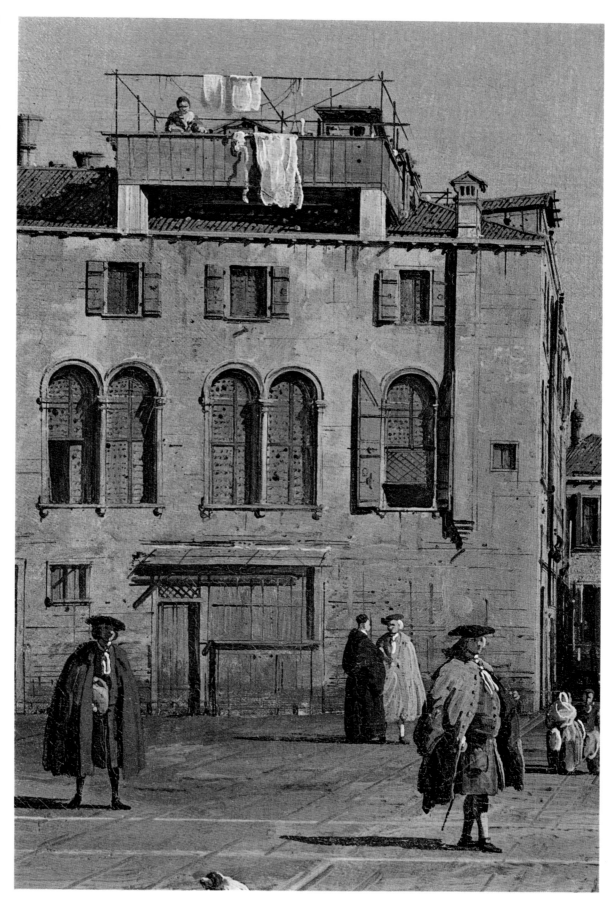

68-69. CANALETTO: *The Grand Canal by Palazzo Bembo* (view and detail). Woburn Abbey, Collection of the Duke of Bedford. Another of the series of 24 views and one of many paintings of the Grand Canal by Canaletto, this shows one of the less usual aspects. The viewpoint is close to the entrance to the Cannaregio and on the right bank can be seen Palazzo Bembo, now demolished, with its façade in the shade and the side of the building in full light. On the left bank is the unfinished Palazzo Querini, later Palazzo Contarini, and Palazzo Grimani, now Palazzo Vendramin Calergi.

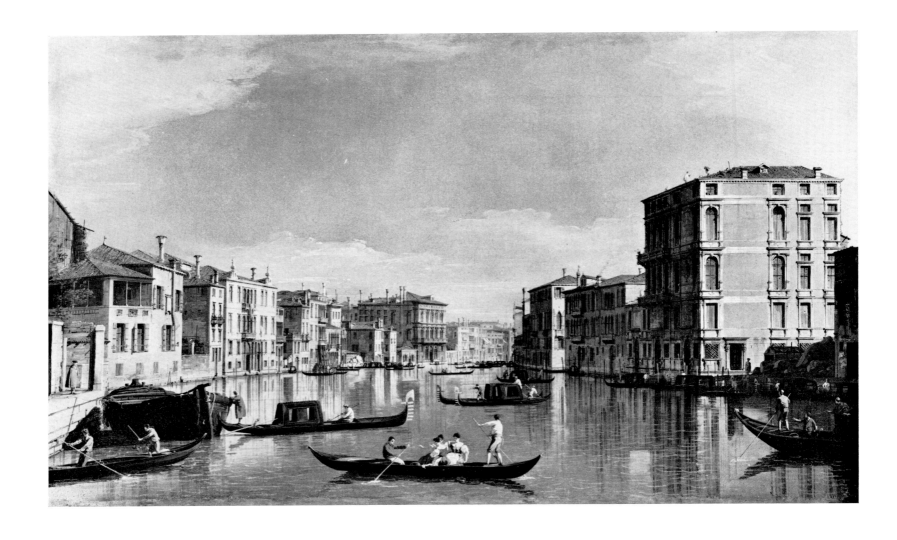

70-72. CANALETTO: *San Nicolò di Castello* (view and details). Milan, Private collection.

One of a series of 21 views formerly in the Harvey Collection, London, which were painted between 1730 and 1735. This shows a corner of Venice which has disappeared, in the neighbourhood of the Arsenal from the end of the Riva, the location of the present Viale Trieste, with the Bacino at the viewer's back. On the right is the Church of San Nicolò di Castello, demolished in 1807 and in the centre, beside the bridge across the Rio di San Giuseppe, is the Church of San Giuseppe di Castello which still exists. At the beginning of the nineteenth century the Napoleonic Gardens were planted on the site of San Nicolò.

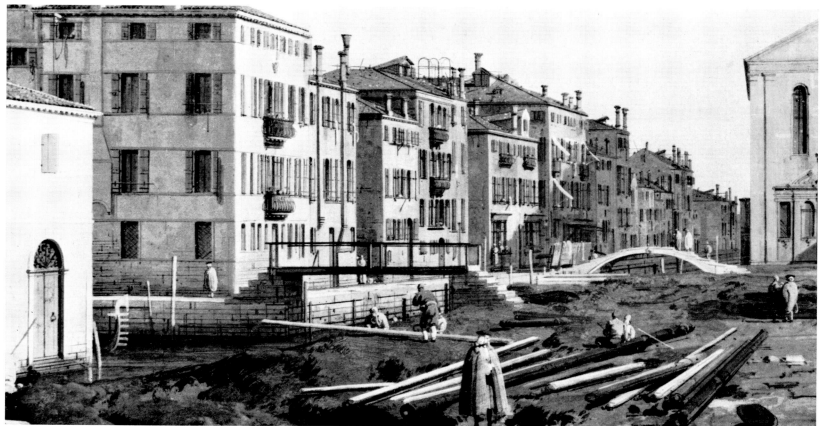

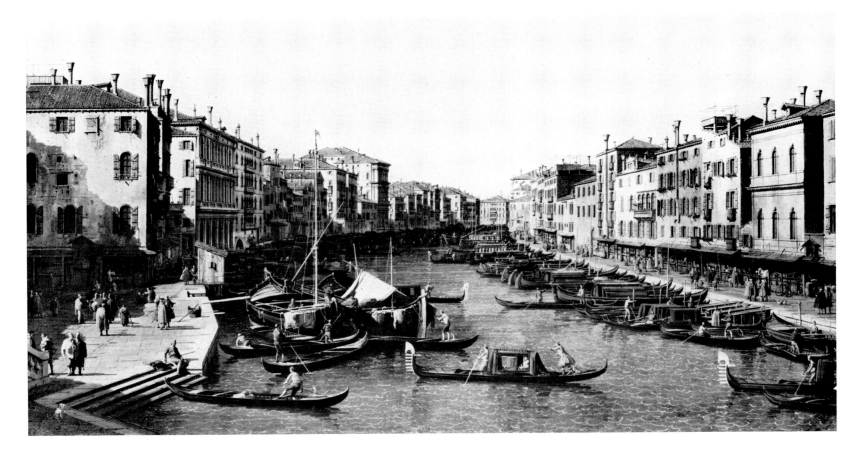

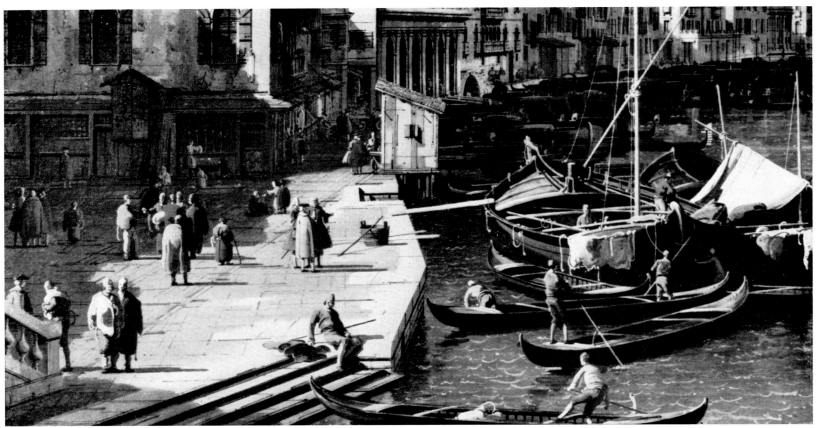

73-75. CANALETTO: *The Grand Canal from the Rialto Bridge* (view and details). Rome, Galleria Nazionale.

One of a series of four views belonging to the Corsini Collection and originally from the Torlonia Collection which were formerly attributed to Bellotto but are now considered to be by Canaletto and datable to shortly after 1730. The view is from the Rialto bridge, looking towards Ca' Foscari. On the left are the Riva del Carbon, Palazzo Dolfin-Manin (now the Banca d'Italia), Palazzo Bembo and, in the distance, Palazzo Grimani; on the right, the Fondamenta del Vin and Palazzo Barbarigo.

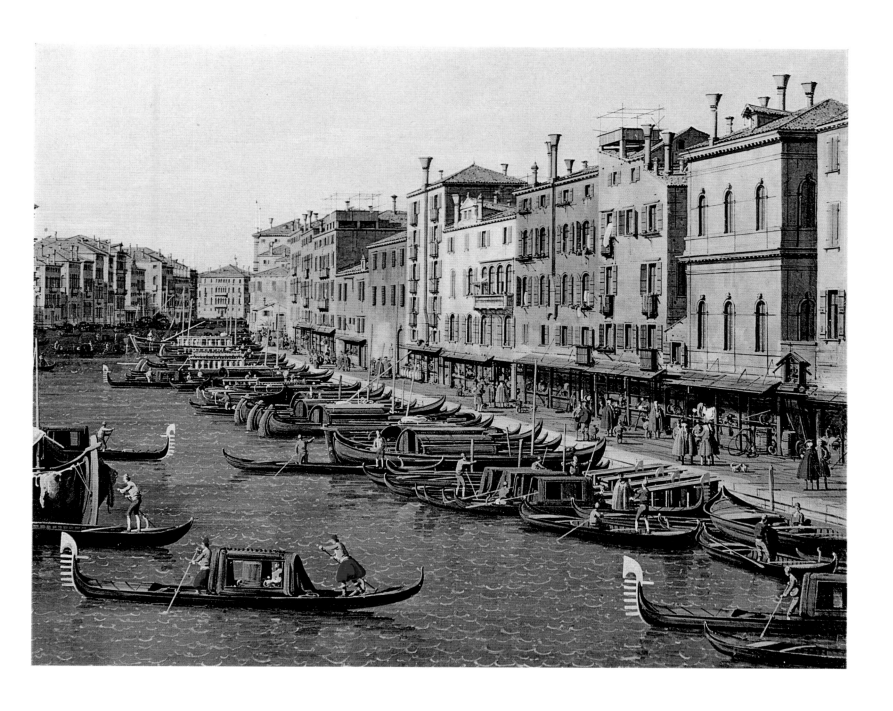

76. FRANCESCO GUARDI: *The Grand Canal and San Geremia*. Baltimore, Museum of Art.

Formerly attributed to Marieschi, together with the companion painting of Santa Maria della Salute, this is now recognized as one of Guardi's earliest works, datable to about 1750. It is a view of the Grand Canal with the entrance to the Cannaregio, showing in the centre the campanile of San Geremia and Palazzo Labia.

77. FRANCESCO GUARDI: *The Balloon*. Berlin-Dahlem, Staatliche Museen.

The painting, from the portico of the Dogana, commemorates the balloon ascent of Count Francesco Zambeccari in 1783.

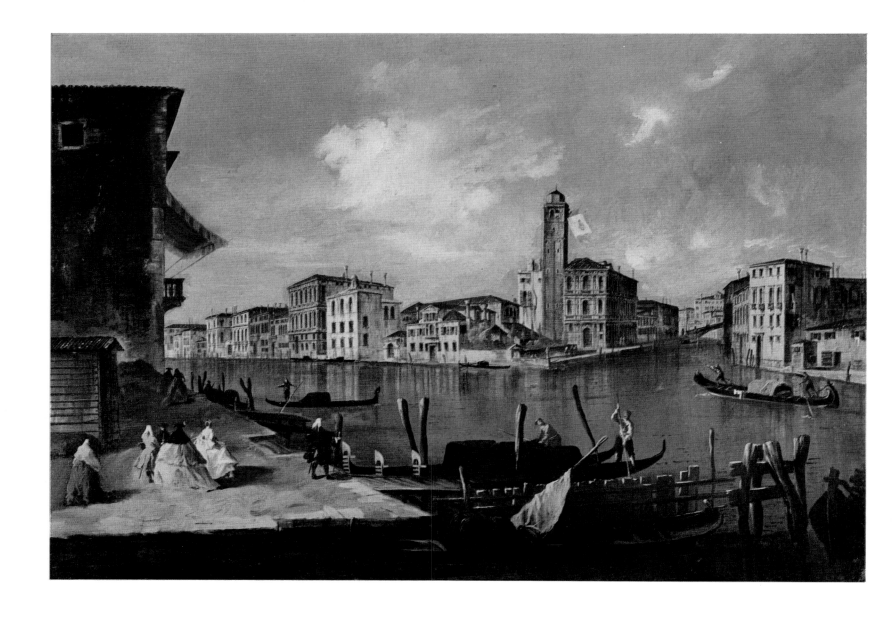

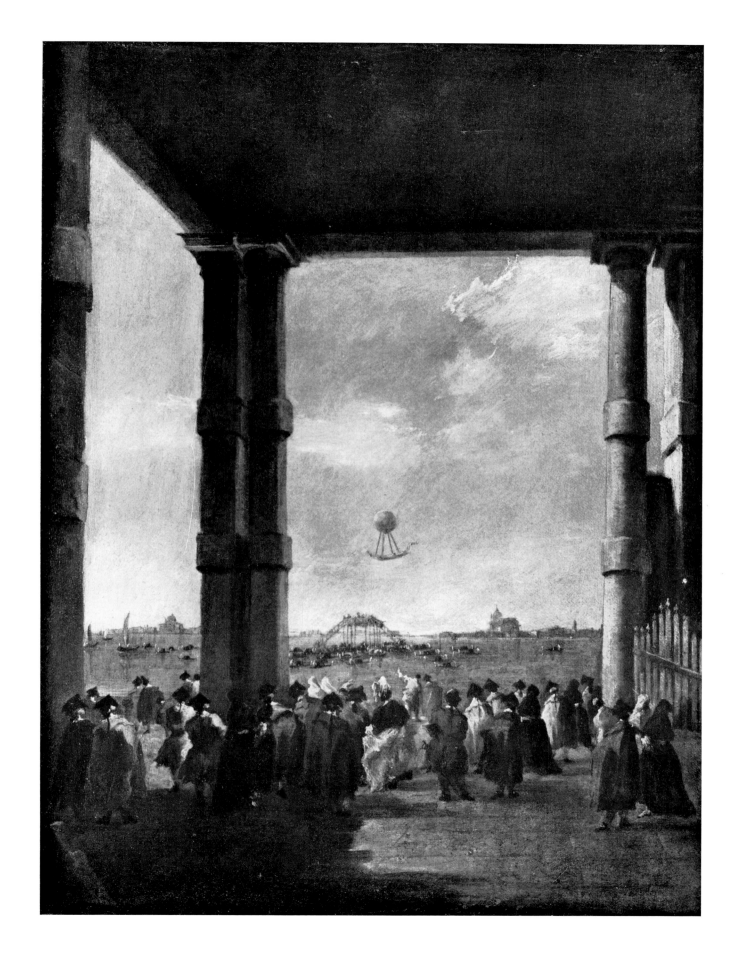

78. FRANCESCO GUARDI: *San Giorgio and the Giudecca*. Toledo, Ohio, Toledo Museum of Art.
Perhaps the finest of the several versions of this scene by Guardi. The perspective is extended and unrealistic but the quality of the light and the atmospheric harmony of sky and lagoon make it one of the most poetic achievements of Guardi's maturity.

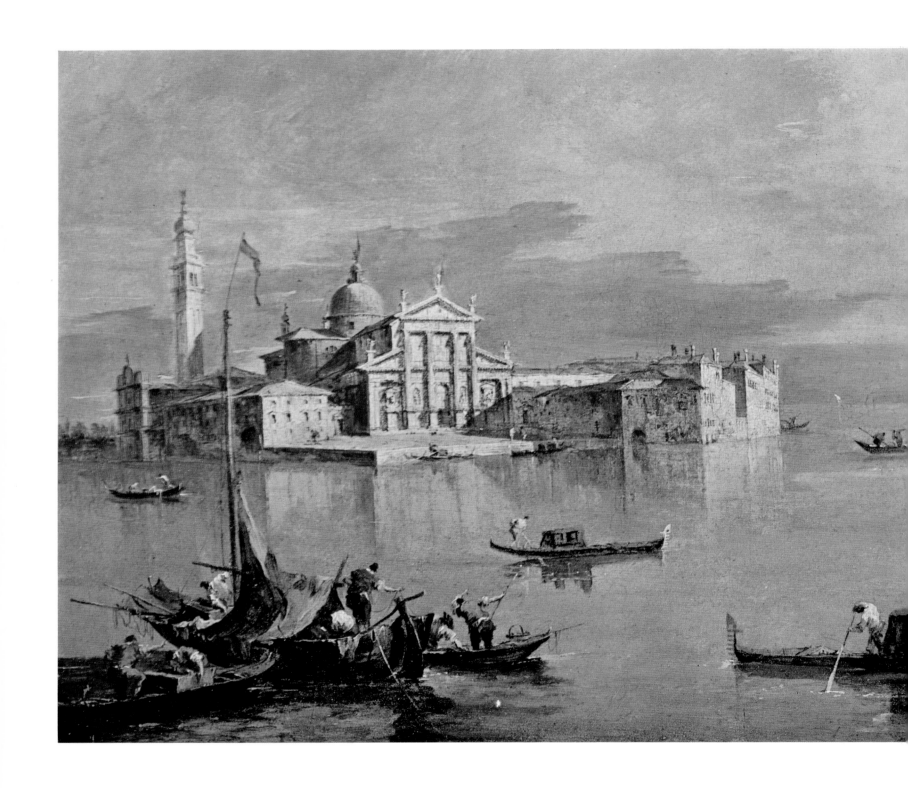

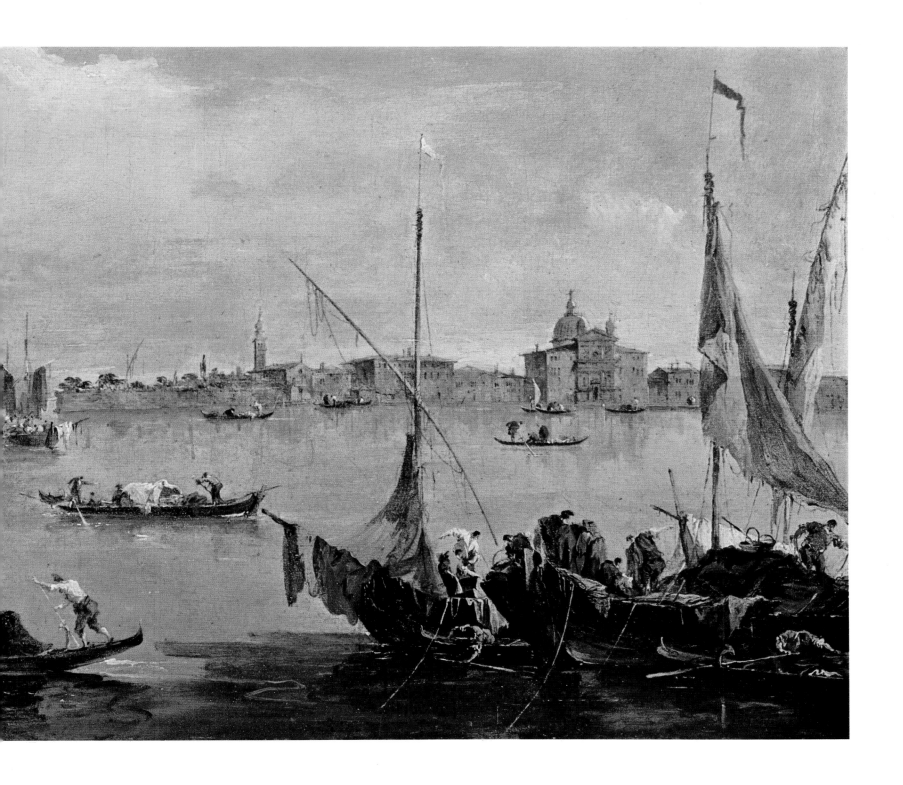

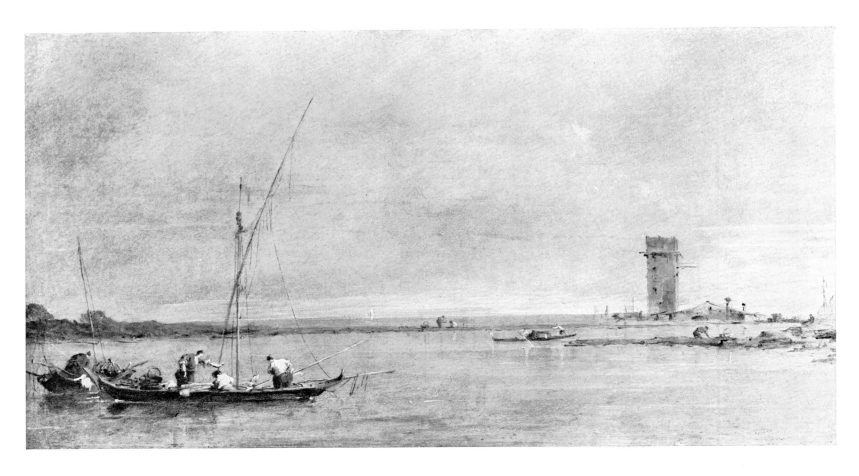

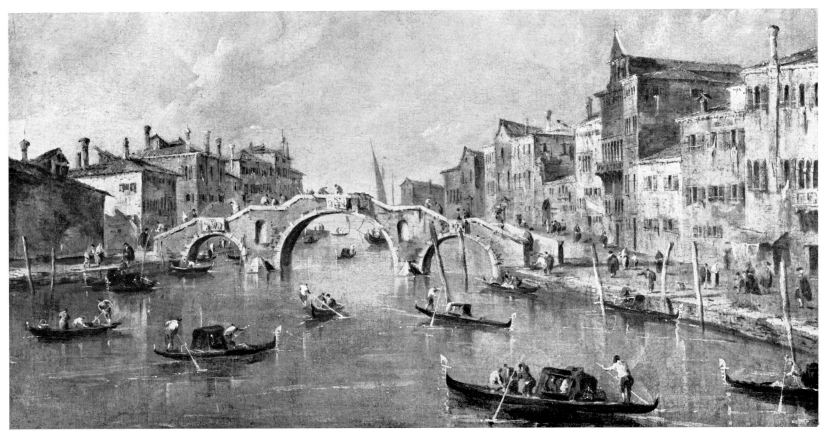

79. FRANCESCO GUARDI: *The Tower of Malghera*. London, National Gallery.

The tower of Malghera, near Mestre, a relic of the ancient fortifications of Venice, was destroyed probably during the nineteenth century and certainly before 1842. It became a popular subject largely owing to the engraving by Canaletto in the series printed for Consul Smith from 1741 to 1746. The impression of light conveyed by this view of the Lagoon places it among Guardi's finest works.

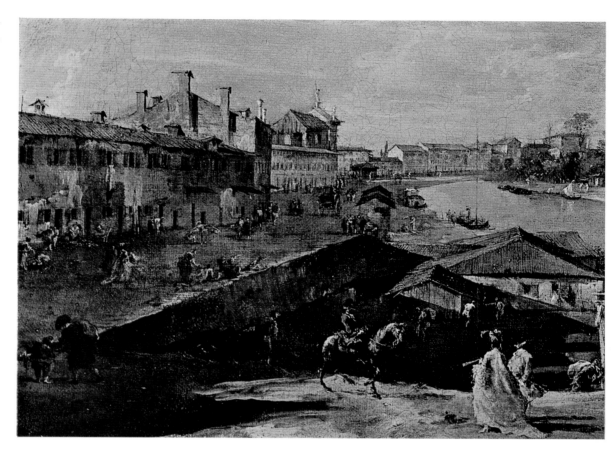

80. FRANCESCO GUARDI: *The Three-arched Bridge*. Washington, National Gallery of Art Samuel H. Kress Collection.

The triple-arched bridge over the Rio di Cannaregio was built by Andrea Tiroli in 1688. The painting belongs to Guardi's later years.

81-82. FRANCESCO GUARDI: *View of Dolo* (details). Detroit, Institute of Arts.

A similar view of Dolo, on the Brenta Canal, was painted by Canaletto about 1730 (in the Ashmolean Museum, Oxford), from which an engraving was made. Guardi painted two versions, showing no variation in composition or perspective, both based on the Canaletto view. The other is in the Gulbenkian Foundation, Lisbon; both are datable to about 1770.

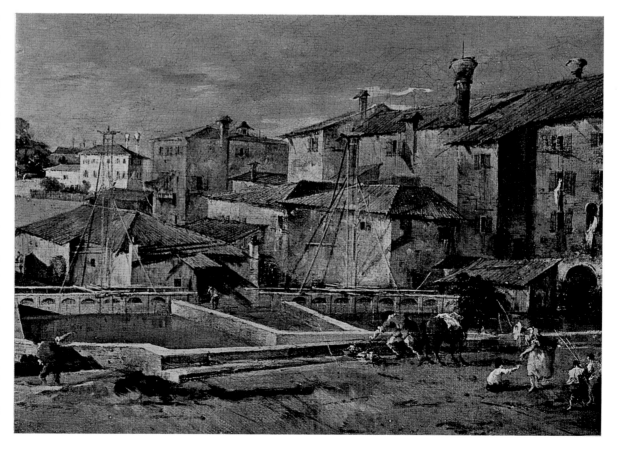

83. FRANCESCO GUARDI: *San Pietro di Castello*. Oeiras (Lisbon), Gulbenkian Foundation.
A view of the island of San Pietro di Castello, in the extreme north-east of Venice, with the church which gives it its name and which was until the fall of the Republic the cathedral of the city, the title passing to San Marco in 1807. This is a late work of Guardi, dating from between 1770 and 1780, and it is certainly one of his masterpieces.

84. FRANCESCO GUARDI: *The Feast of the Ascension*. Oeiras (Lisbon), Gulbenkian Foundation.
The painting shows Piazza San Marco during the Feast of the Ascension. Wooden structures with porticoes were erected on the Piazza in which wares of various kinds were sold. In 1776 the type of these structures was changed (the work of Meccaruzzi), and the altered appearance of the Piazza is shown in another of Guardi's paintings, now in the Kunsthistorisches Museum, Vienna. Another painting, similar to the present one with a few slight variations, is also in the Gulbenkian Foundation in Lisbon.

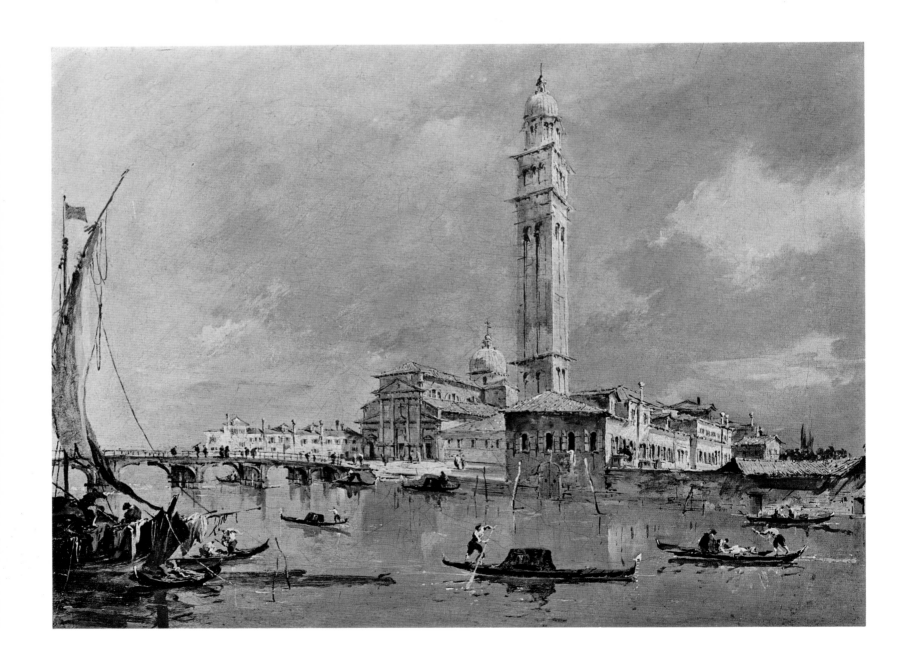

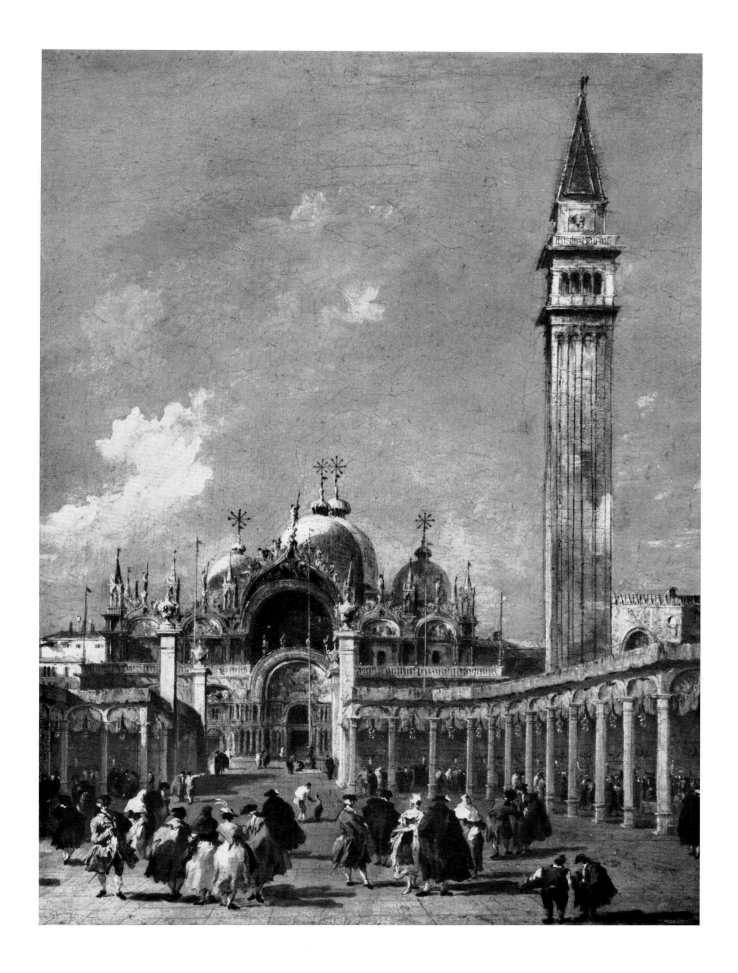

85. CASSAS: *View of the Grand Canal, Trieste*. Trieste, Fondazione Scaramangà.
The drawing reproduced here is one of a series of views of Trieste by Cassas now in the Fondazione Scaramangà and shows the entrance to the canal, filled with sailing vessels and boats, with sailors at work unloading cargo.

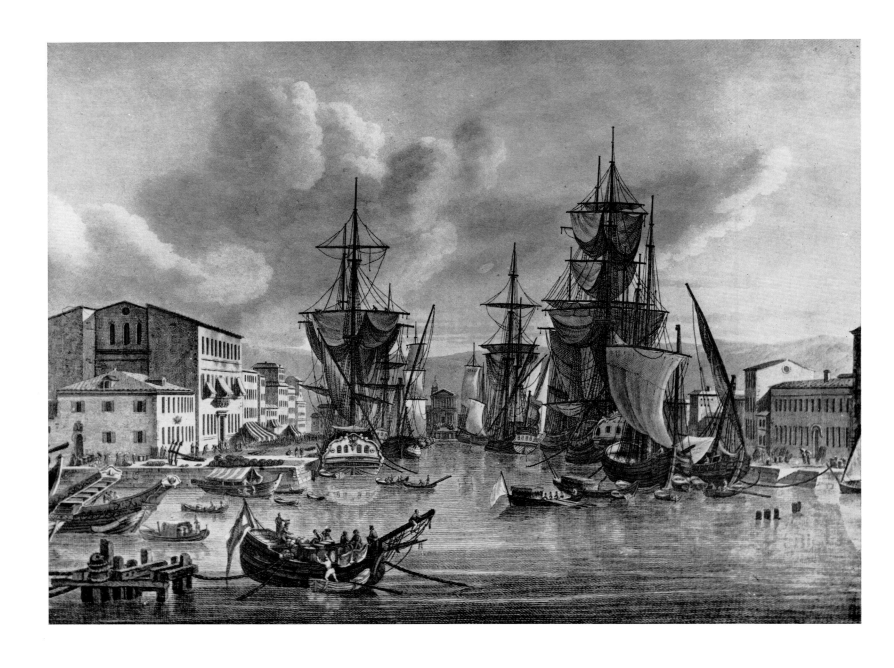

TURIN

...It is a city divided into two parts, the old and the new city, with bastions and outworks, well faced, and a citadel very regularly fortified. It stands eighteen miles from the Alps, in a plain which has the Po on one side and the Dora on the other.

...Nothing can be more regular than that part of Turin which is called the new city. The houses are of brick, and three stories high. The streets are wide, straight, and well-paved. It has fine churches, particularly the cathedral, or the chapel of the Holy Shroud, which is also the Royal Chapel and may be reckoned a masterpiece of architecture. It is in the form of an octagonal cupola, all faced, including the vault, with black marble. The altar is in the centre of the dome, and there is preserved the relic of Our Lord's Holy Shroud. The King's palace makes no great appearance, nor indeed is it quite finished; nevertheless the apartments are well contrived. The furniture is rich, there are excellent pictures and magnificent ceilings. This palace is surrounded by gardens which are artfully disposed as fortifications, according to fine plans, but apart from this they are not much adorned.

The finest and most perfect thing in Turin, and perhaps in all Europe, in modern architecture, is the front of the palace of the late queen, the King's grandmother. This palace is contiguous to the King's palace, and communicates with it by a gallery.

Lettres et mémoires, London, 1747. CHARLES LOUIS POLLNITZ
 November 1731

MILAN

...The city of Milan, for beauty and conveniency, is not to be compared with Turin, most of the streets being narrow and winding. The paper windows are likewise more common here than at Turin or Florence, and make a worse appearance, as even in the houses of noblemen, glass and paper, the latter being stuck on to supply the place of a broken pane, are often seen in the same window. All the houses here are covered with pantiles, and in many of the cross streets, and at the stations where the public processions stop, statues are erected to the number of sixty, some of marble, but most of brass. What Milan wants in beauty, it makes up in largeness, being within the walls no less than ten Italian miles in circuit; but great numbers of gardens are included, which lie between the ramparts and the houses...

Formerly the area before the cathedral was much frequented as an evening walk; but of late none but the common people are seen there, persons of quality in their coaches, and other people of fashion on foot, resorting to the rampart betwixt Porta Orientale, and Porta Tosa, a merchant having planted it on both sides with white mulberry-trees, which, upon his decease, became the property of the city. These walks are in a direct line, and of a breadth sufficient to admit four carriages abreast. Upon one side is a prospect of a fine country, and on the other, of the kitchen-gardens and vineyards between the ramparts and the houses. But the pleasantest part of the ramparts is behind the church of S. Maria della Passione.

...With regard to the outside of this church (the cathedral), the eastern part, or that belonging to the choir, is already finished. The part most exposed to view, particularly the front towards the great square, is in a bad condition, and possibly not without design, that persons of fortune and of a liberal disposition, being affected by such a sight, may be incited to contribute largely towards completing the church, and embrace the opportunity of securing their eternal salvation. It is already four centuries and a half since this church has been begun, and the whole square behind it is filled with workmen employed in sawing, cutting, and polishing the marble. The number of statues increases every year; yet there is reason to believe that something or other will always remain to be done...

Opposite to the cathedral stands the archbishop's palace, a very spacious building consisting of two courts. In one of these are the statues of St. Charles Borromeo and St. Ambrose, the latter with an iron rod in his hand, as an emblem of his heroic opposition to the Emperor Theodosius. The palace has a communication with the cathedral, by a subterraneous passage.

Travels through Germany, Bohemia, Hungary, Switzerland, Italy and Lorraine, London, 1756
<div align="right">JOHN GEORGE KEYSLER
1729</div>

VERONA

...Towards sunset I climbed to the rim of the amphitheatre to enjoy the beautiful view over the city and its surroundings. I was completely alone, and far below, on the wide pavement of Piazza Brà, the crowd was promenading: men of all conditions, women of the middle classes. The latter, seen in this bird's-eye perspective and in their black clothes, looked rather like mummies.

...The people here move around in the most lively confusion, especially in some streets where shops and workshops stand close together and all is very gay. There are no doors before the shops or the workshops, they are open the whole width of their frontage, and everything that happens within can be seen. The tailors sewing, the shoemakers pulling their thread and hammering their leather, almost in the middle of the street; you might say that the shops themselves are actually part of the street. In the evening when the lamps are lit, it all has a most lively air.

On market days the squares are full of people; there is an endless supply of fruit and vegetables, garlic and onions to one's heart's delight. And besides, they shout and sing and laugh all day, there is confusion and bustle all day. The mild climate, the cheap food, allow an easy life, and as far as possible, life is lived in the open air.

Italienische Reise (1786-1788)
<div align="right">JOHANN WOLFGANG GOETHE
September 1786</div>

BOLOGNA

...Towards evening in this ancient, dignified and learned city, I freed myself from the crowd under the arcades which run along almost every street, the crowd which strolls to and fro protected here from the sun, from rough weather, who stare, buy, and conduct their business. I climbed to the top of the tower and delighted in the cool, free air. The view is magnificent. To the north can be seen the hills near Padua, then the Swiss, Tyrolean and Friulian Alps and the whole northern range, which on this occasion was shrouded in mist. To the west the horizon is boundless, against which rise only the towers of Modena. To the east, a level plain which stretches to the Adriatic sea, visible at sunset. To the south, the cultivated foothills of the Apennines, green with vegetation up to the summit, dotted with churches, villas, palaces, similar in this to the hills of Vicenza. The sky was clear, without a single cloud, only a kind of haze on the horizon. The guardian of the tower assured me that this mist has not dispersed in the last six years but that formerly, with the aid of a telescope, he used to be able to distinguish quite well the hills around Vicenza, their houses and churches, which he can now do only occasionally on the clearest days. This mist tends to form along the northern slope of the mountains and transforms our dear country into a veritable land of the Cimerians. The man also pointed out the salubrious situation and air of the city, and how the roofs seemed new and the tiles were not corroded by humidity and moss. It is true that the roofs are all clean and handsome, but the good quality of the tiles may contribute to this. In other ages excellent ones have been made in this region.

The leaning tower is an unpleasant sight, and besides it is quite probable that it was deliberately built in this way.

Italienische Reise (1786-1788).

<div align="right">JOHANN WOLFGANG GOETHE
September 1786</div>

...This city is not interesting because it is beautiful. For the most part the streets are extremely narrow and not very straight, the arcades which flank them, rather than adorn them, make them stifling. The squares are wretched. But one stands amazed in front of a fountain where a Neptune seems to rule the waters: he has the majesty of a god and at the same time he is, I must say, very much a man. You would shield yourself with your fan but the ladies of Bologna do not do so. On the pedestal four Tritons hold aloft enormous shells which emit as many jets of water. Below these four naiads astride dolphins squirt water from their nipples which they press with their hands. They are very beautiful, and graceful in their attitude. The fountain is by the excellent sculptor Giovanni da Bologna.

In another square stands a tower which strikes fear into the heart of the passer-by who has not been forewarned. It overhangs by nine feet. But the famous meridian line begun and completed in 1655 by the immortal Cassini certainly surpasses this curiosity. This wonderful solar quadrant is drawn in the church of St. Petronius and is 122 feet long.

Of all the theatres I have been able to see until now, excepting the great, unequalled theatre of Parma, that of Bologna takes prime place. The hall is in the form of a semicircle, the rows of seats rise in many tiers and at the upper levels there are three tiers of boxes of varied and beautiful design; the proscenium is elegantly decorated, the staircase broad, the corridors wide and well-lit, the exits numerous: everywhere comfort and order reign.

Voyages d'Italie et de Hollande, Paris, 1775.

<div align="right">GABRIEL FRANÇOIS COYER
1775</div>

FLORENCE

...Early in the morning of the 23rd, at about ten o'clock, we emerged from the pass through the Apennines and saw Florence lying in the middle of a wide valley, which is cultivated to an incredible degree and bestrewn with villas and houses.

In a short while I had seen the whole city, the Cathedral, the Baptistery. Here a new world opens before me, unknown to me, and I do not wish to linger. The Boboli garden is situated in a delightful position. I hurried out of it as I had hurried into it. The appearance of the city reveals the wealth of the people who have built it, and from it one can infer that it has enjoyed the good fortune of being ruled by a succession of successful governments. Everywhere the eye is struck in an especial way by the grace and grandeur with which public works in Tuscany are endued: streets and bridges. Everything is at the same time solid and beautiful, gracefulness is blended with utility, everywhere is evident the care which gives life to everything. The Papal State, on the other hand, appears to stand only because the earth does not wish to swallow it up.

Italienische Reise (1786-1788).

<div align="right">JOHANN WOLFGANG GOETHE
October 1786</div>

PISA

...Pisa is a fine old city that strikes you with the same veneration you would feel at sight of an antient temple which bears the marks of decay, without being absolutely dilapidated. The houses are well built, the streets open, straight, and well paved; the shops well fur-

nished; and the markets well supplied: there are some elegant palaces, designed by great masters. The churches are built with taste, and tolerably ornamented. There is a beautiful wharf of free-stone on each side of the river Arno, which runs through the city, and three bridges thrown over it, of which that in the middle is of marble, a pretty piece of architecture: but the number of inhabitants is very inconsiderable; and this very circumstance gives it an air of majestic solitude, which is far from being unpleasant to a man of a contemplative turn of mind. For my part, I cannot bear the tumult of a populous commercial city; and the solitude that reigns in Pisa would with me be a strong motive to choose it as a place of residence. Not that this would be the only inducement for living at Pisa. Here is some good company, and even a few men of taste and learning. The people in general are counted sociable and polite; and there is great plenty of provisions, at a very reasonable rate. The air in summer is reckoned unwholesome by the exhalations arising from stagnant water in the neighbourhood of the city, which stands in the midst of a fertile plain, low and marshy: yet these marshes have been considerably drained, and the air is much meliorated. As for the Arno, it is no longer navigated by vessels of any burthen... This noble city, formerly the capital of a flourishing and powerful republic, which contained above one hundred and fifty thousand inhabitants, within its walls, is now so desolate that grass grows in the open streets; and the number of its people do not exceed sixteen thousand. You need not doubt but I visited the Campanile, or hanging-tower, which is a beautiful cylinder of eight stories, each adorned with a round of columns, rising one above another. It stands by the cathedral, and inclines so far on one side from the perpendicular, that in dropping a plummet from the top, which is one hundred and eighty-eight feet high, it falls sixteen feet from the base.

...In the cathedral, which is a large Gothic pile, there is a great number of massy pillars of porphyry, granite, jasper, giallo and verde antico, together with some good pictures and statues: but the greatest curiosity is that of the brass-gates, designed and executed by John of Bologna, representing, embossed in different compartments, the history of the Old and New Testament. I was so charmed with this work, that I could have stood a whole day to examine and admire it. In the Baptisterium which stands opposite to this front, there are some beautiful marbles, particularly the font, and a pulpit, supported by the statues of different animals.

Between the cathedral and this building, about one hundred paces on one side, is the famous burying-ground, called *Campo Santo*, from its being covered with earth brought from Jerusalem. It is an oblong square, surrounded by a very high wall, and always kept shut. Within-side there is a spacious corridor round the whole space, which is a noble walk for a contemplative philosopher. It is paved chiefly with flat grave-stones: the walls are painted in fresco by Giotto, Giottino, Benozzo Gozzoli, Buffalmacco, and some others of his contemporaries and disciples, who flourished immediately after the restoration of painting. The subjects are taken from the Bible. Though the manner is dry, the drawing incorrect, the design generally lame, and the colouring unnatural; yet there is merit in the expression: and the whole remains as a curious monument of the efforts made by this noble art immediately after her revival. Here are some deceptions in perspective equally ingenious and pleasing; particularly the figures of certain animals, which exhibit exactly the same appearance, from whatever different points of view they are seen. One division of the burying-ground consists of a particular compost, which in nine days consumes the dead bodies: in all probability, it is no other than common earth mixed with quick-lime.

Travels through France and Italy, London, 1766. TOBIAS SMOLLETT

86-87. BERNARDO BELLOTTO:
The old Bridge over the Po at Turin
(view and detail). Turin, Galleria
Sabauda.

In 1745 Bellotto received from
Carlo Emanuele III the commis-
sion to paint the two views of Tu-
rin which are now in the Galleria
Sabauda. The present view, from
the right bank of the Po near the
old bridge, whose broken arches
can be seen, shows on the left the
Monte dei Cappuccini and the
church by Vitozzi beyond the old
houses of the Borgo di Po. On the
right bank in the distance can be
seen the four towers of the Ca-
stello del Valentino, shown in its
first state before later additions
were made.

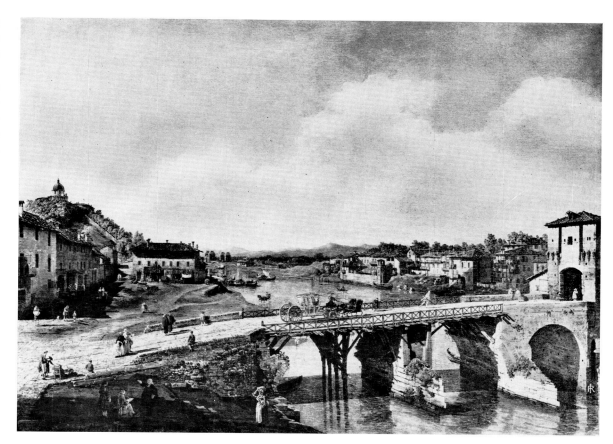

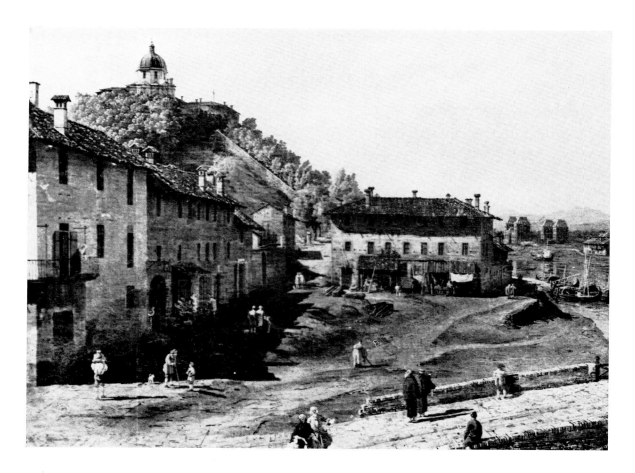

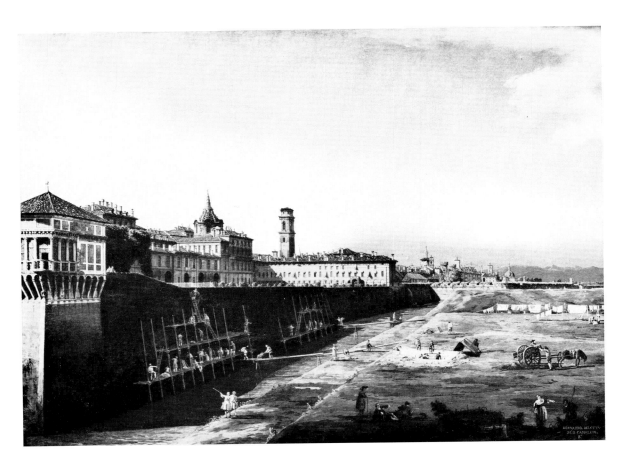

88-89. B E R N A R D O B E L L O T T O :
View of Turin from the Giardino Reale (view and detail). Turin, Galleria Sabauda.

This is the other painting commissioned from Bellotto in the summer of 1745 by Carlo Emanuele III. It shows, from the left, the Garittone (Look-out) del Bastion Verde, the north side of the present Palazzo Reale with the cupola of the Chapel of the Holy Shroud; beyond is the east front of the Palazzo di San Giovanni, behind which rises the campanile of the cathedral. In the foreground repairs are being made to the curtain of the Bastion Verde, along which stretches the 'old' garden. Below, the fields towards the river Dora and part of Turin in the distance.

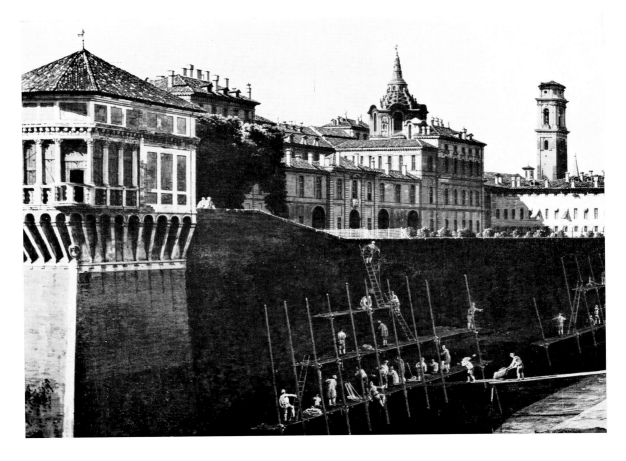

90. BERNARDO BELLOTTO:
The old Bridge over the Po at Turin (detail). Turin, Galleria Sabauda.

The viewpoint of this painting is slightly raised so that the perspective is widened and deepened by the succession of houses along the banks of the river. The view is closed in the foreground by the bridge, with its reinforced piers and the wooden fences which replace the parapet where it has crumbled.

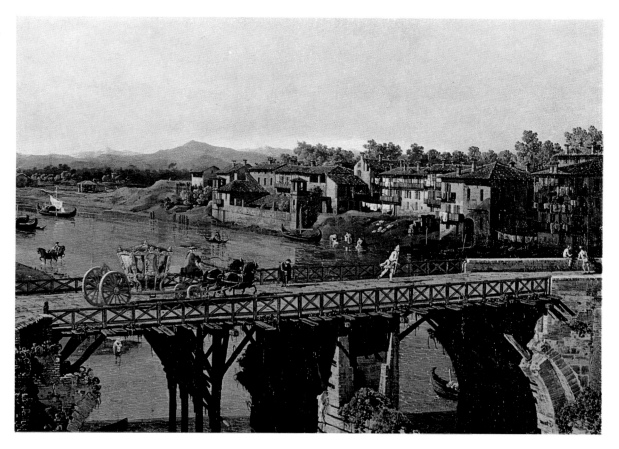

91. BERNARDO BELLOTTO:
View of Turin from the side of the Giardino Reale (detail). Turin, Galleria Sabauda.

This detail shows in the distance the dome of the basilica of SS. Maurizio e Lazzaro, built by Lanfranchi, the campanile of San Domenico and that of Sant'Agostino, and the Porta Palatina. Also visible are the Romanesque tower of Sant'Andrea and the dome of La Consolata, erected in 1679.

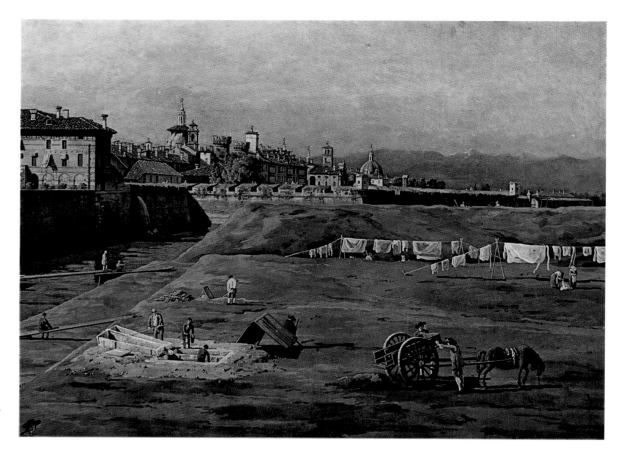

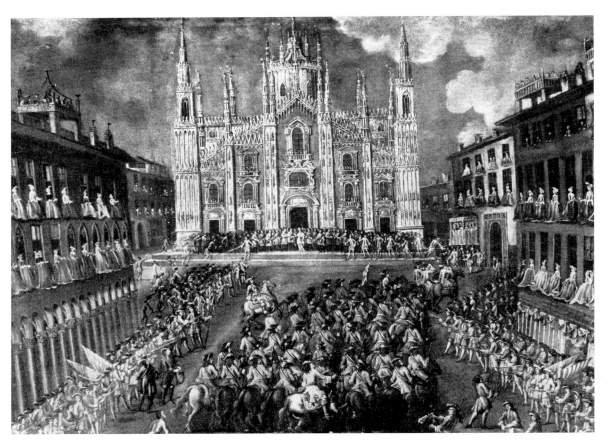

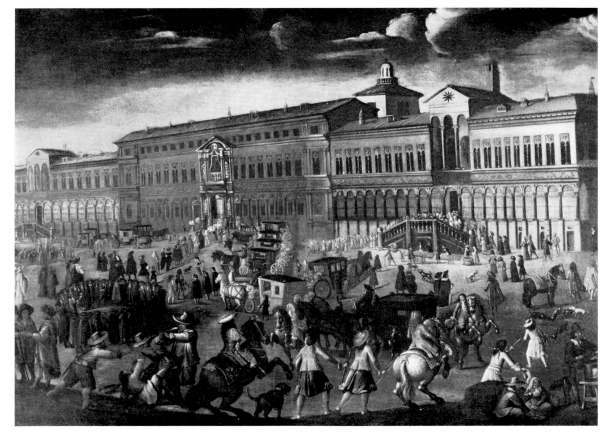

92. UNKNOWN ARTIST, EIGHT-
EENTH CENTURY: *The Reception
of Prince Eugene of Savoy in the
Piazza del Duomo, Milan*. Milan,
Museo di Milano.

Prince Eugene of Savoy received
a ceremonial welcome in Milan on
27 September 1708. The painting
shows the ecclesiastical authorities
in front of the cathedral, while the
civic dignitaries salute the prince
from a platform.

94. GASPAR VAN WITTEL: ▷
Vaprio d'Adda. Rome, Private
collection.

The painting is dated to 1719 and
was made from a drawing, now
lost, which was certainly executed
during the last years of the seven-
teeth century. The view shows
the canal which runs beside the
Adda at a higher level, and the
Villa Melzi on the left, and on the
right the clergy house of Vaprio,
with a Romanesque campanile.

93. UNKNOWN ARTIST, EIGHT-
EENTH CENTURY: *The Ospedale
Maggiore in Via Festa del Perdono*.
Milan, Museo di Milano.

The façade of the Hospital shown
with crowds gathering for the
Festa del Perdono.

95. GASPAR VAN WITTEL: ▷
Verona. Florence, Palazzo Pitti (at
present in the Museo di Castel-
vecchio, Verona).

The view from the left bank of the
Adige shows the two towers of
Porta San Giorgio, the Church of
San Giorgio in Braida with its
dome by Michele Sanmicheli and,
on the right, the Visconti castle on
the hill, destroyed by the French
in 1801. On the extreme right is
the Cathedral.

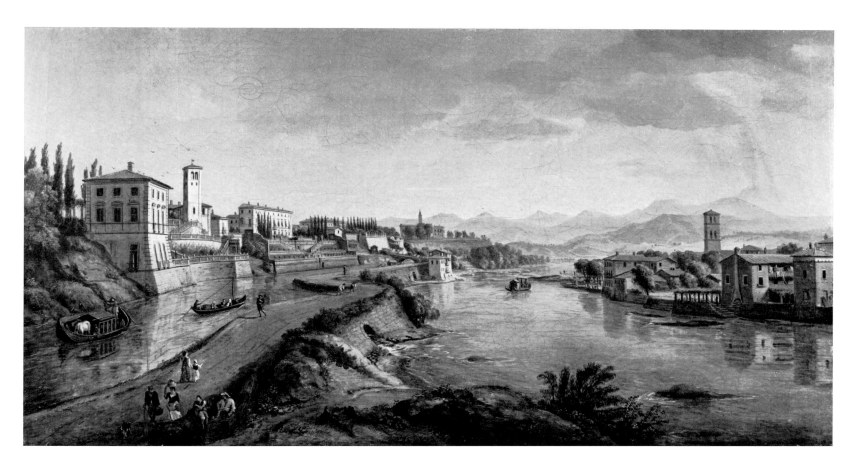

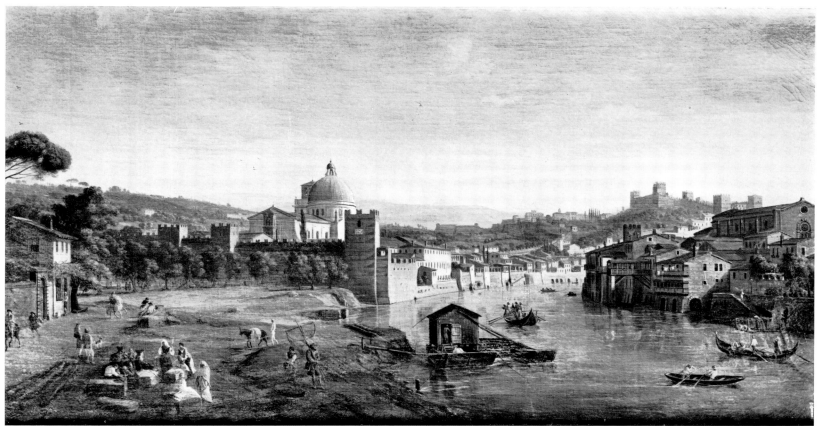

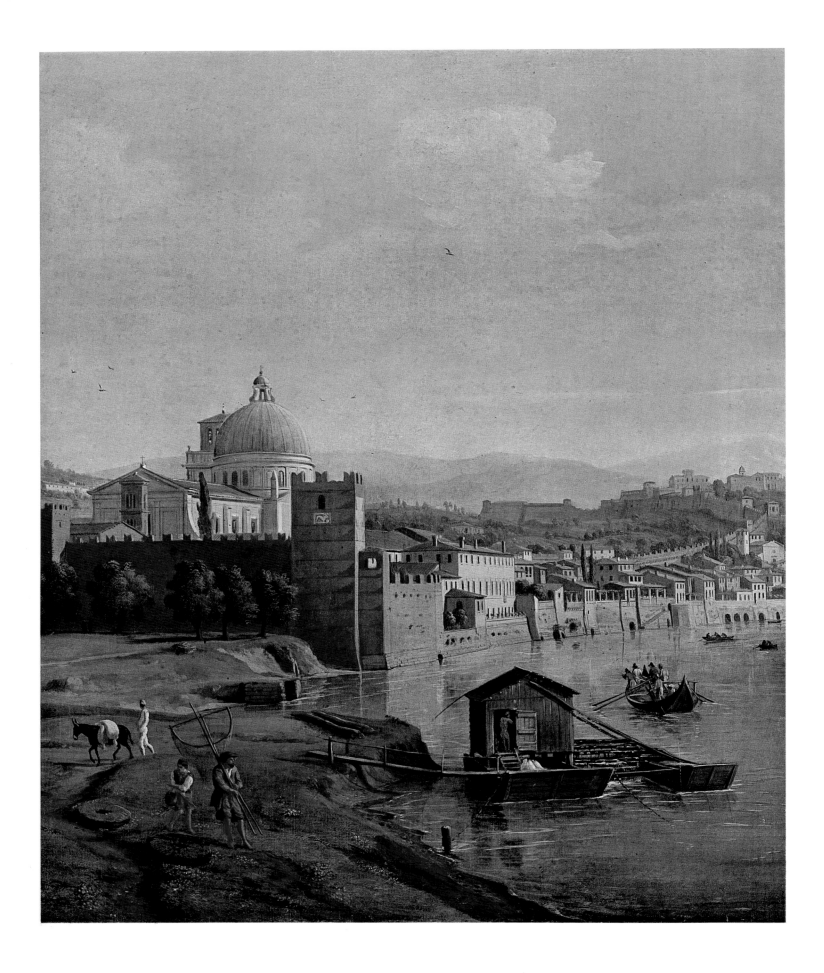

96. GASPAR VAN WITTEL: *Verona* (detail). Florence, Palazzo Pitti.
This view provides valuable evidence for the original appearance of the walls of Verona, built by Can Grande della Scala, between the Bastione delle Boccare and the Bastione di San Giorgio, which were destroyed by the Austrians in the nineteenth century.

97. BERNARDO BELLOTTO: *Vaprio d'Adda* (detail). New York, Metropolitan Museum of Art.
Painted at about the same time as his two views of Gazzada di Brera, this view of Vaprio is from a point not far from that of Van Wittel's painting. The figures on the right do not appear to be by the hand of Bellotto.

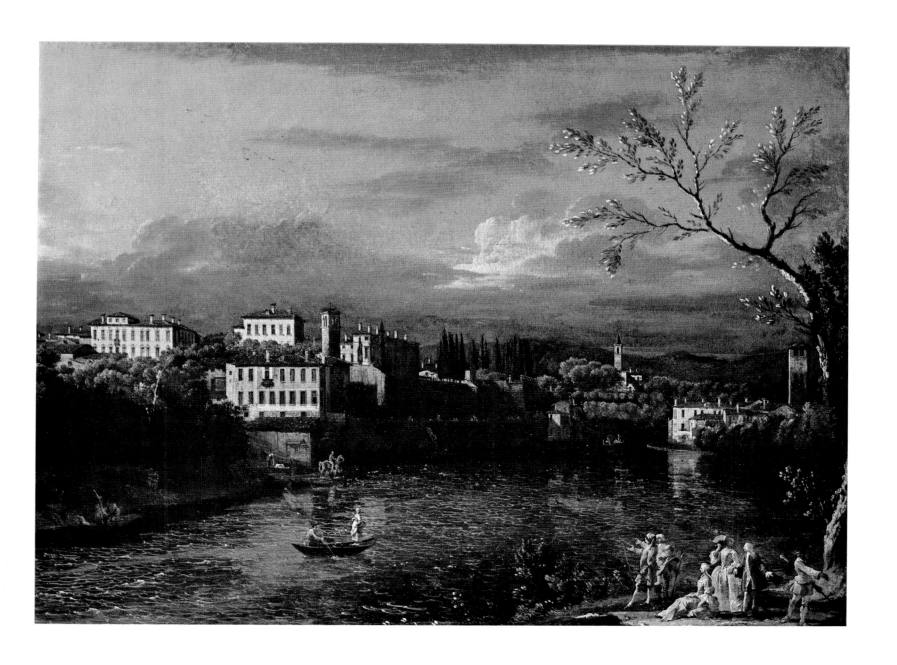

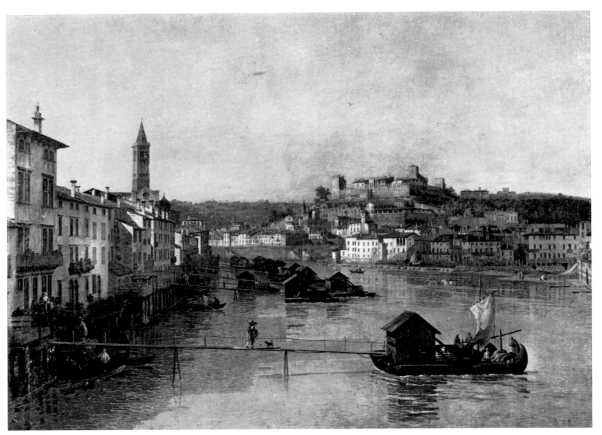

98. BERNARDO BELLOTTO: *Verona* (detail). Dresden, Gemäldegalerie.

Painted shortly after Bellotto's arrival in Dresden, obviously from a drawing made on the spot. The view over the Adige is from the Ponte delle Navi and shows the campanile of Sant'Anastasia on the left.

100. GASPAR VAN WITTEL: ▷ *Porta Galliera, Bologna*. Mariano Comense, Vitali Collection.

Van Wittel was in Bologna in December 1694, the date borne by the drawing for this view from the slopes of the Montagnola above the Rio del Navile and looking towards the Porta Galliera which was built in 1661.

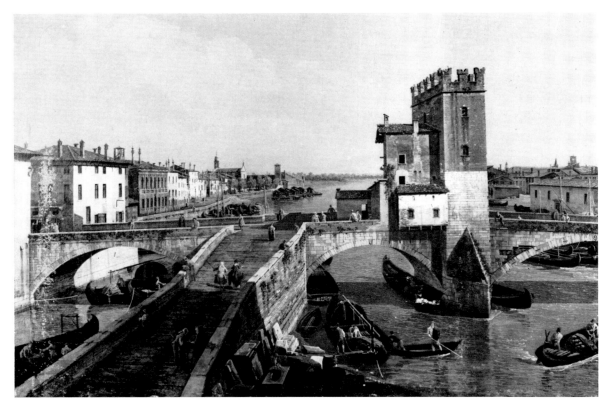

99. BERNARDO BELLOTTO: *The old Ponte delle Navi at Verona* (detail). Dresden, Gemäldegalerie.

Like the preceding painting, this is datable to 1747-8. In the centre of the view is the old Ponte delle Navi over the Adige, which was destroyed by a flood before 1757.

101. GASPAR VAN WITTEL: ▷ *Florence from the Cascine*. Florence, Bruscoli Collection.

A view from the right bank of the Arno, in the Cascine, facing the weir of Santa Rosa. In the centre is the Ponte alla Carraia, to the right the Oltrarno with the medieval walls which encircled the city to the west, and the Porta San Frediano. Behind the walls can be seen the Church of Castello.

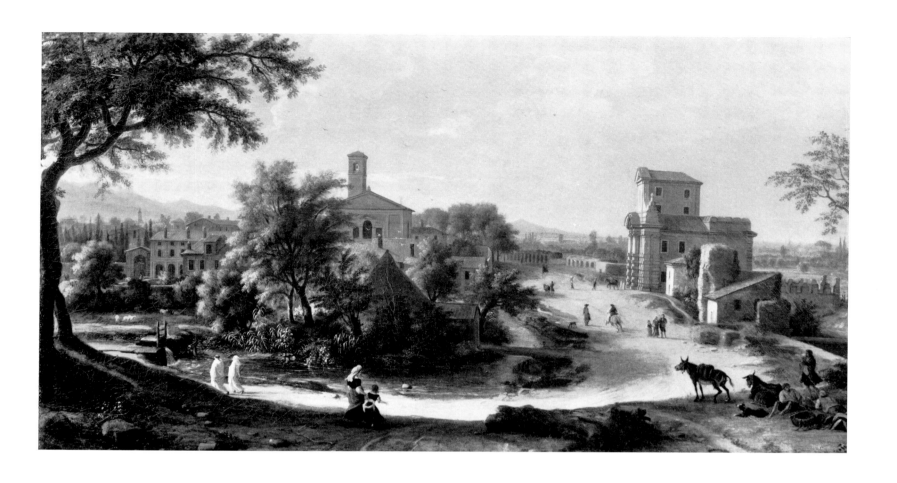

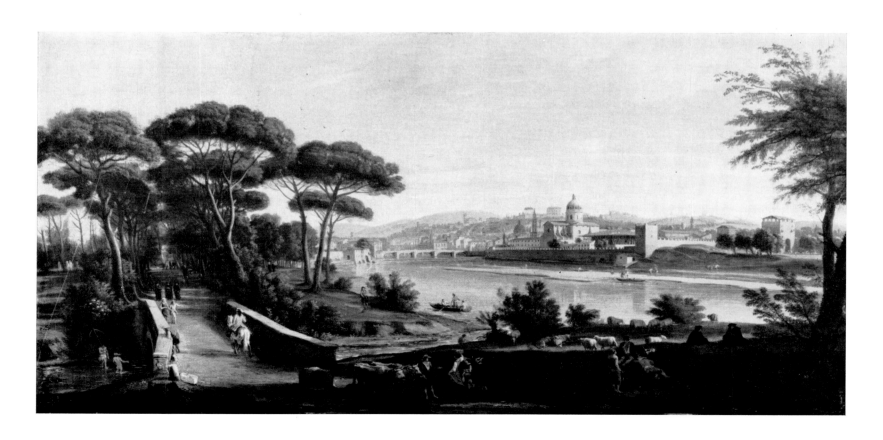

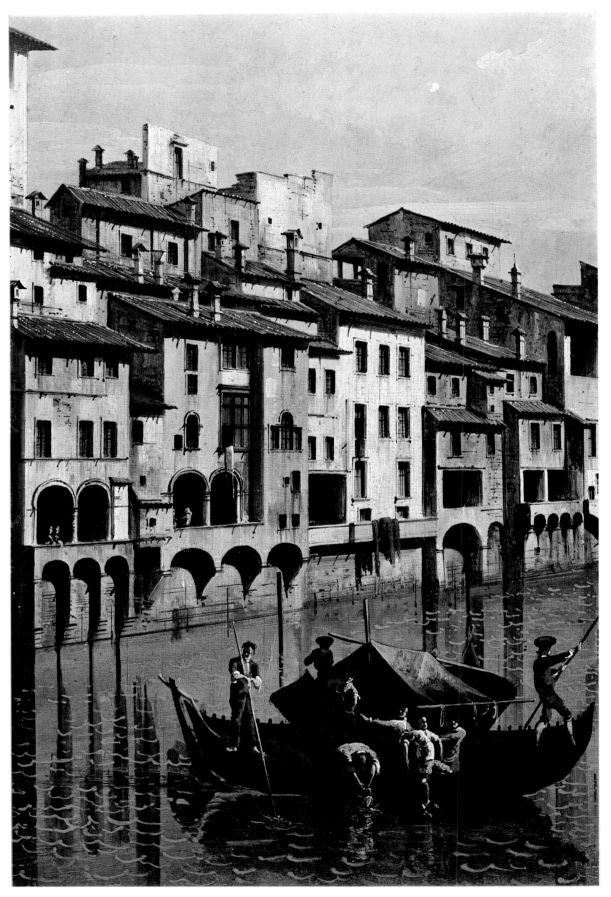

102-103. BERNARDO BELLOTTO: *The Arno towards Ponte di Santa Trinita* (view and detail). Budapest, Museum of Fine Arts.

Bellotto's views of Florence were painted in 1745. This view of the Arno is from the Ponte Vecchio close to the right bank, along which can be seen the houses of Lungarno Acciaiuoli in the shade, and in the distance the crenellated wall of Palazzo Ferroni. On the left bank are the houses of Borgo San Jacopo and the campanile of San Jacopo sopr'Arno, and behind the houses the spire of Santo Spirito.

104. GIUSEPPE ZOCCHI: *The Hospital of Santa Maria Nuova*. Rome, Private collection.

The Hospital, designed by Bernardo Buontalenti and completed by Giulio Parigi, is on the left. In the background is Via Sant'Egidio.

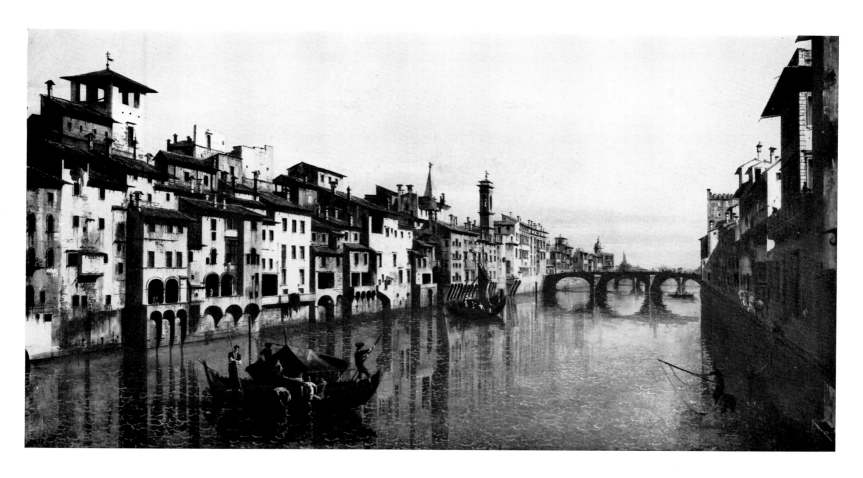

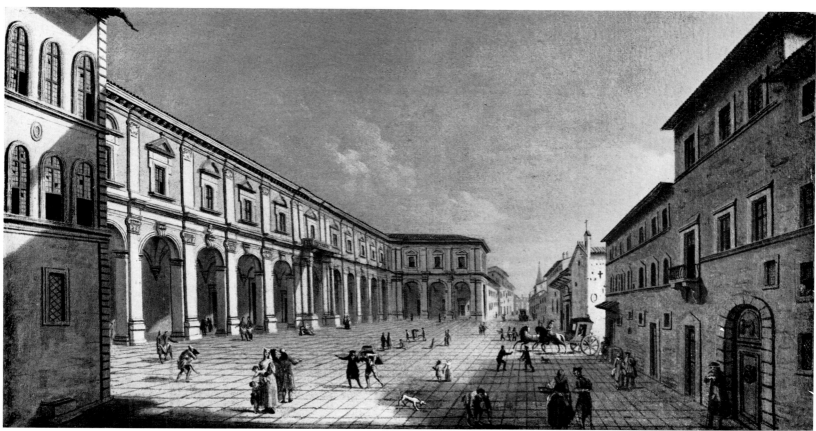

105. BERNARDO BELLOTTO: *Piazza della Signoria* (detail). Budapest, Museum of Fine Arts.
The view of the Piazza della Signoria is companion to the painting of the Arno (Pl. 103) and must be dated to 1745. The detail shows the part of the Piazza between the equestrian statue and Via Calzaiuoli, including a group of houses which have been demolished.

106. WILLIAM MARLOW: *The Arno towards the Ponte alle Grazie*. Milan, Private collection.
The view from the Ponte Vecchio looking upstream towards the Ponte alle Grazie on which can be seen the little rooms built over the piers which served as cells for two monasteries. On the left is the loggia of the Uffizi, in the centre the tower of San Niccolò.

107. GIUSEPPE ZOCCHI: *The Piazza del Campo, Siena*. Rome, Private collection.
The painting shows the Piazza del Campo during the Palio. It was the companion to another painting of the Campo by night with illuminations, and they were probably part of the series of paintings in which Zocchi, according to Lanzi, 'depicted in oils the Sienese festivities for the arrival of Duke Francis I of Tuscany; a work which was accurate in proportions and very pleasing for the number of figures he introduced'.

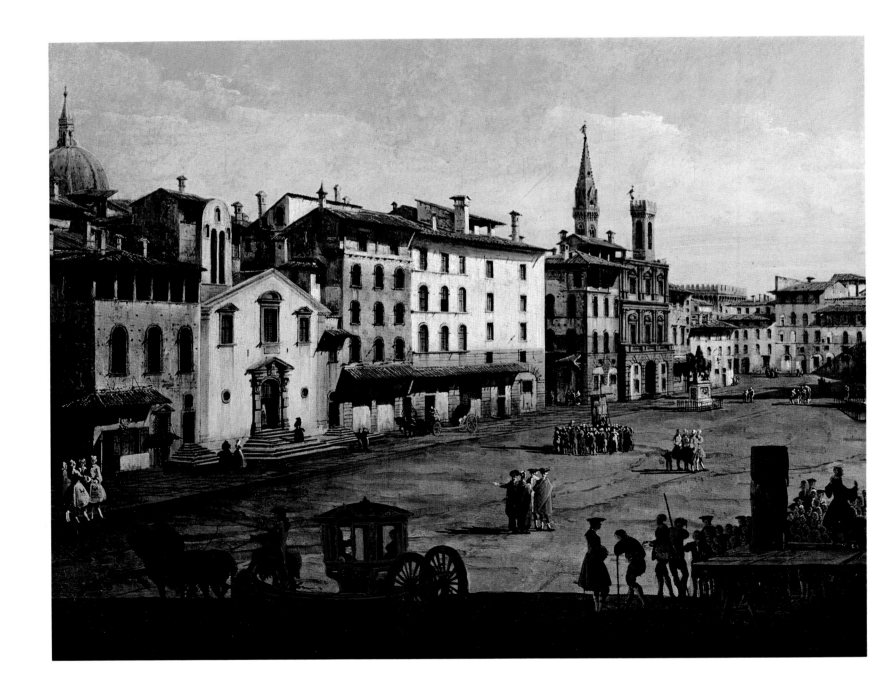

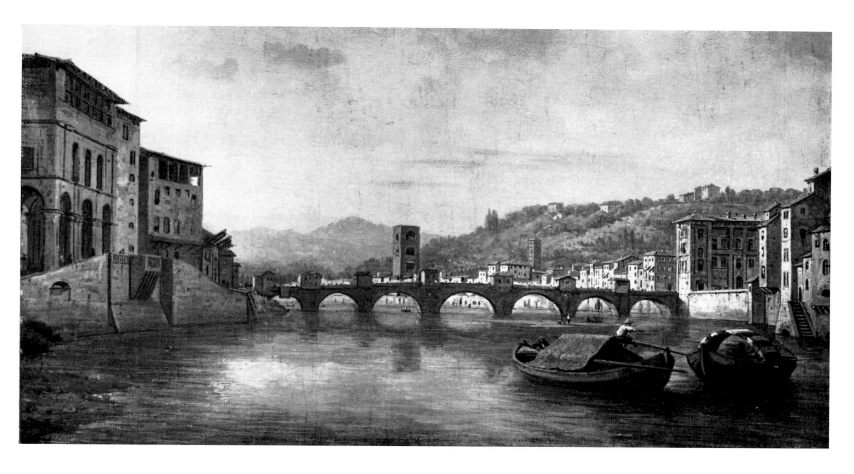

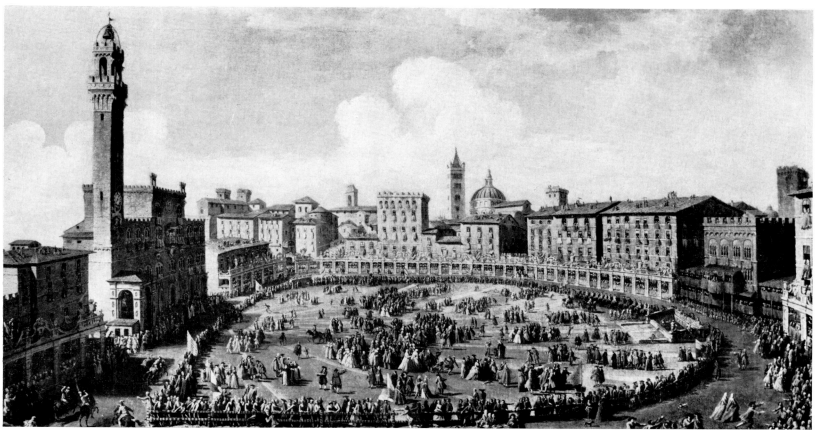

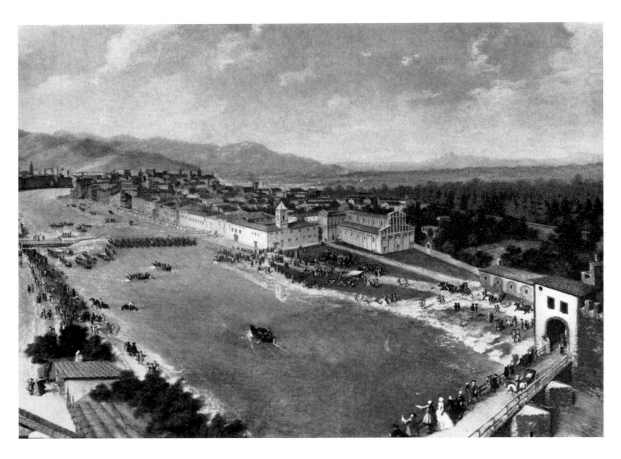

108. UNKNOWN ARTIST, EIGHT-EENTH CENTURY: *Pisa* (detail). Hartford, Conn., Wadsworth Atheneum.

A panoramic view of Pisa from the Torre Guelfa, looking towards the city. The detail shows the left bank of the Arno from the Ponte del Mare to the Church of San Paolo at Ripa d'Arno and as far as Santa Maria della Spina. The painting, which has been attributed erroneously to Panini, is companion to a view of Leghorn from the Sanctuary of Montenero.

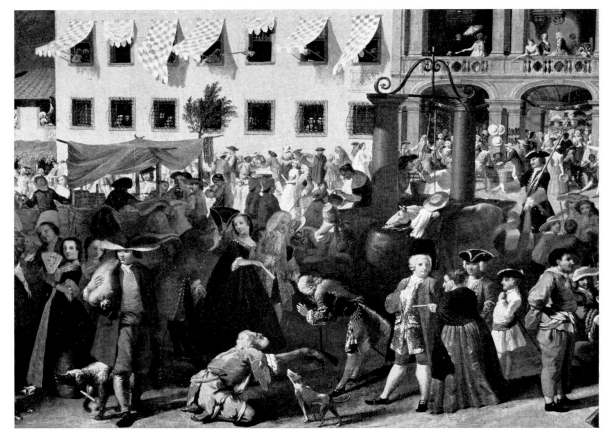

109. UNKNOWN ARTIST, EIGHT-EENTH CENTURY: *The Sanctuary of Montenero* (detail). Buffalo, N.Y., Albright-Knox Art Gallery.

This detail, showing the crowded entrance to the Sanctuary of Montenero, is taken from the companion view of Pisa. Both works are of excellent quality but have not yet been attributed with any certainty, the traditional opinion that they are by Panini being untenable and the suggestions in favour of Bottani, Battaglioli and Patch remaining without confirmation.

MADRID

...This city is not to be seen till one comes just upon it, because it stands in a hollow on the banks of the famous Manzanares. The entrance into Madrid bears a faint resemblance, for a little way, to the entrance into Rome through the Porta del Popolo: three streets, in the shape of a bird's foot, lead to the centre of the city. I took that on the right, which led me to the Plaza de Santo Domingo, where was a French inn to which I had been recommended.

Lettres et mémoires, London, 1747.

CHARLES LOUIS POLLNITZ
1747

...Madrid is fair, rich, flourishing and populous, and although it is not entirely flat, the streets are straight, the squares wide, the houses tall; majesty reigns in the temples, wealth in the palaces, magnificence in the court, and splendour among the people; there are 600 public highways, 14 squares, 18 parishes, 58 religious houses, 27 hospitals; every year about 50,000 sheep are eaten, together with 12,000 oxen, 60,000 kids, 16,000 calves, 13,000 pigs, besides countless fowl, both game and domestic. To conclude, whichever way the eye turns it sees sparkling the rays of grandeur, abundance and luxury. And if it should happen that, here or there, it chances to fall upon some picture of poverty or meanness, yet this too is nonetheless decently upheld by majestic gravity, which here is ever to be seen even though it be lean, gnarled, and enveloped in rags. Indeed! Everything is filthy, everything is revolting, everything stinks; wherever you go, indoors or in the street, in sun or shade, on foot or in a carriage, it is always like being in a privy. And in this boiling heat, whoever walks through the city finding himself continually amid swirling dust, must perforce swallow some of it, and feed by day upon what was his superfluity of the night before; this I tell you from experience. Here are of no avail sweet-smelling waters, such as those called *Regina*, or *Mélisse*, or *Sans-pareille*, nor the essences of Florence, nor all the perfumes of Arabia. Our most fragrant, most scented and most well-prepared Lombard ladies, if they came here, would be unable to protect themselves from this brave stench which at all times makes its presence felt. Nevertheless, one lives, one endures...

In order to give you a description of the Escurial, after the many which have already been made, without being constrained to particularize, I shall begin by telling you that many of the noblest arts, and especially painting and architecture, have contributed to the adornment of this magnificent place...

Spain, Italy and France all believe that they gave the Escurial its architect, each country claiming for itself the fame to which it considers itself entitled of recognition as the mother of great men - a game usually played by cities... The Spaniards pride themselves correctly on their Juan Bautista Monegro, who was helped by Juan de Herrera and by Antonio Villacastin, a lay-brother of the Escurial itself.

The great monarch who with more justification than Augustus could call himself Master of the World drew to his service, with the promise of large rewards, the most expert men in all the necessary arts to help in the great work which was to be the fulfilment of a vow made for victory. From among these worthy craftsmen he chose Monegro as his principal architect, perhaps because he was a Spaniard, but certainly also because he considered him the person most capable of effecting a vast design, as indeed he proved to be.

...The whole building is disposed in the shape of a gridiron, the instrument of the martyrdom of the saint to whom it is dedicated. Although the principal front is, as I have said, unfortunate, it is no less pleasing, majestic, noble, than the rest of the edifice. At each of its two extremities there is a tower with its appurtenances, and at the corners behind these there are two more identical towers, so that each of the principle corners has its tower.

One enters by three large doorways, the largest in the centre, and all three are flanked by large half-columns of the Doric order, four on either side, with intercolumnation and niches, which have windows above them. The windows of the Escorial amount to 4,000, and with the 1,000 doors make as many as 12,000 openings.

...Entering by the main doorway and crossing a large and well-arranged vestibule, above which is the library, one passes into a great courtyard of such majesty and harmonious proportions that the eye cannot tire of contemplating it...
Five well-spaced windows open above five arches, between which rise tall columns; these support huge stone statues of the six most worthy kings of the Old Testament.

...There is no need for me to describe the church to you at great length since, as I have said, this is built on the plan of St. Peter's in Rome, although St. Laurence is smaller and crowded with defects that the other does not possess. What does infinite harm to the plan of the church, and is at once noticeable, is the ill-conceived position of the choir. Although this is raised with admirable mastery on only four pillars, it nonetheless seems to fall on your head as you enter, and covers you so that you seem to be entering a dark cavern rather than a well-lit temple.

Lettere di un viaggiatore italiano ad un suo amico, Lucca, 1759. NORBERTO CAIMO

...My lodgings would have been excellent were it not for the lack of a fire, since the cold was dry and more piercing than in Paris, in spite of the forty degrees of latitude. The reason for this is evident: Madrid is the highest city in Europe. From whichever point of the coast one chooses to enter Spain, to reach this capital one climbs almost imperceptibly until one arrives at one's destination. Moreover the city is surrounded at a distance by high mountains such as the Guadarrama, and more closely by smiling hills which ensure that the least wind from the north or east comes to play around the city. The air is appalling for anyone who does not live here, because being pure and thin it is not suited to the constitution of those who are inclined to corpulence. It is only propitious to the Spanish, who in general are thin, frail, dry and feel the cold to the point of always going about wrapped up, even when it is extremely hot, the well-to-do in a wide black cape and the poor folk of the people in a black arab cloak, especially in the countryside.
The men of this country are full of prejudices and the women, although they are ignorant, feel very intensely the life of the spirit; the people of both sexes are possessed by desires and passions as strong as the air they breathe and as burning as the sun beneath which they live. Every Spaniard detests a foreigner merely because he is not a Spaniard, since they cannot explain their hatred any other way; the ladies, however, who recognize the injustice of this hatred, avenge us by loving us, yet fencing themselves about with precautions, because the Spaniard, who is jealous by nature, likes to have also an evident reason for being so. His honour depends on the least stain upon the woman who belongs to him. Gallantry in this country must be shrouded in mystery because it tends to absolute power and is strictly prohibited. From this result the secrecy, the intrigue, the uncertainty of mind, vacillating between the duty imposed by religion and the force of passion which opposes it. The men are more often ugly than handsome, although there are numerous exceptions, whereas the women are generally pretty and not a few of them are beautiful. The blood which boils in their veins makes them ardent in love and always ready to participate in any intrigue which may deceive those people who are always about them to spy out their comings and goings. The lover who is most ready to risk danger is always the most favoured. During walks, in church, in the theatre, they speak with their eyes to whomever they please,

and they know how to use this language to perfection. The man to whom it is addressed, if he knows how to seize his opportunity and make use of it, is always sure to be fortunate, and he must not expect any resistance: if he neglects this opportunity and if he does not profit by it, no one will ever offer him another.

Mémoires (1763-1774). GIACOMO CASANOVA
 1767

...The Spanish are by no means naturally a serious, melancholy nation: misery and discontent have cast a gloom over them, increased, no doubt, by the long habit of distrust and terror inspired by the Inquisition; yet every village still resounds with the music of voices and guitars; and their fairs and Sunday wakes are remarkably noisy and riotous. They talk louder, and argue with more vehemence than even the French or Italians, and gesticulate with equal, if not superior eagerness... Like most people of southern climates, they are dirty in their persons, and over-run with vermin. I was surprised to find them so much more lukewarm in their devotion than I expected; but I will not take upon me to assert, though I have great reason to believe it, that there is in Spain as little true moral religion as in any country I ever travelled through, although none abounds more with provincial protectors, local Madonnas, and altars celebrated for particular cures and indulgences: Religion is a topic not to be touched, much less handled with any degree of curiosity, in the domains of so tremendous a tribunal as the Inquisition... The burning zeal, which distinguished their ancestors above the rest of the Catholic world, appears to have lost much of its activity, and really seems nearly extinguished.

Travels through Spain, London, 1779. HENRY SWINBURNE
 June 1776

...As I approached Madrid I had occasion to compare it with Berlin. The modern capital of Spain is built upon sand, and in this city when it does not rain one is suffocated by dust; but as one goes further from it into the surrounding country, there are quite fertile fields. Coming from Barcelona one enters Madrid by the Puerta de Alcalá de Henares, a gate which is truly splendid... Having seen many capitals and royal residences which are strongly fortified, I was at once struck as I entered Madrid to see only walls of earth, and instead of a great river a little stream called the Manzanares, across which Philip II caused to be thrown a large and magnificent bridge; which has given rise to various witty sayings and has caused more than one to observe that 'the King should have sold the bridge to buy a river for his capital'. This capital was only a small town when Charles V, recovering from a quartan fever which had long troubled him, decided to found a great city here and to transfer to it the royal residence. And indeed he did not err. Madrid enjoys a pure, light air, but it is at certain times cold, due to the proximity of the mountains. On the other hand, there is abundance of everything here. Madrid is situated in the middle of a fertile countryside, on a height surrounded by well-cultivated hills, and almost at the centre of Spain, being 110 leagues distant from Lisbon, 105 from Cadiz and 106 from Barcelona.

Mémoires secrètes des Cours et des Gouvernements, Paris, 1793. GIUSEPPE GORANI
 November 1764

...As one travels towards Madrid, the new highway offers on either side a fine prospect of pine woods, and groves of oak and other kinds of trees. In the two leagues before Galapagar some villages are to be seen and, on the right, the Escorial and part of the extensive royal forests. In the stretch between Galapagar (where the road is joined by the new and equally magnificent road from the Escorial) and las Rozas, which is three leagues, although

the ground is well cultivated and sown with corn, yet there is a great scarcity of trees, as happens in other regions of Castile, a factor which makes the journey less pleasant and in hot weather very uncomfortable, in spite of the excellence of the new road. By this one reaches Madrid in two leagues more, leaving on the left the royal palace of La Zarzuela and then, to the right, the country villa called the Casa de Campo, its woods, gardens and palace. Before entering the charming Paseo de la Florida, which from the gate of St. Vincent leads for almost two leagues to the royal palace of the Pardo, one crosses the river Manzanares by the Segovia bridge and then, somewhat further on, by another stone bridge, which is decorated with two statues, of St. Ferdinand and St. Barbara. This district, like others near to the capital of Spain, has been made beautiful by planting new trees.

If I were to give a historical account of the metropolis and speak of the antiquity which has been attributed to the city by some writers, I should be obliged to go back in time to an age full of obscurity and fictions and to rely upon vague facts and uncertainties... But to suggest that Madrid, situated in territory that is fertile and abundant in the necessities of life, where the air is very pure, was from the beginning a town of some importance and that it was considered strong even after it had been conquered by the might of the Saracens; that the ancient kings came to reside there for a time and to hold their court, or national assembly, there; and, finally, that it became the metropolis and fixed residence of the sovereigns of Spain only in the time of Philip II, who enlarged and adorned the ancient royal palace, or Alcazar; all this seems to me not far from the truth nor from what we have been told by the most credible writers.

Descrizione odeporica della Spagna, Parma, 1793.

ANTONIO CONCA
1793

...Madrid lies in good measure on a sloping ground, which makes it appear to great advantage from that side by which I came. Its form approaches the circular, and its diameter is a little more than two English miles. The numerous spires and cupolas promise well at a distance, and several ample edifices fill your sight as you approach. I entered it by the magnificent stone bridge built by Philip II over the river Manzanares. A French traveller has made himself very merry at the expense of that bridge, and cracked some jests upon the disproportion of it to the water that runs under. But Frenchmen, like other people, will easily catch at opportunities of being censorious in other people's countries. The fact is, that the Manzanares becomes sometimes a considerable river by the sudden melting of the snow on the neighbouring hills, and is often half a mile broad in winter. Philip therefore did a very proper thing when he built a large bridge over it, and ridiculous are those who pretend to ridicule him on this account.

From the bridge to the gate of the town there is a straight and wide avenue of fine trees, which renders the entrance on that side very noble. But it is impossible to tell how I was shocked at the horrible stink that seized me the instant I trusted myself within that gate! So offensive a sensation is not to be described. I felt a heat all about me, which was caused by the fetid vapours exhaling from numberless heaps of filth lying all about. My head was presently disordered by it, and the headache continued very painful from that moment. ...The few streets which I have seen as I was coming to the inn, are all straight and wide, and many of the houses and churches very sightly. Was it not for the abominable ordure that scarcely leaves a passage to foot-passengers along-side the walls, I should judge Madrid to be one of the noblest cities in Europe: but the shocking stink has made me repent I came to see it.

A Journey from London to Genoa, London, 1770.

JOSEPH BARETTI
October 1760

110-111. MICHEL-ANGE HOU-
ASSE: *View of the Escorial* (details).
Madrid, Prado.

There is evidence that Michel-
Ange, the son of René-Antoine
Houasse who was director of the
Académie de France in Rome, was
at the court of Philip V in Madrid
in the years 1715 to 1730. Besides
this painting, other small paintings
of the same artist depicting va-
rious aspects of the palace-monas-
tery of the Escorial are kept in the
Moncloa palace. The view shows
the main façade of the building
with the plain in the background.

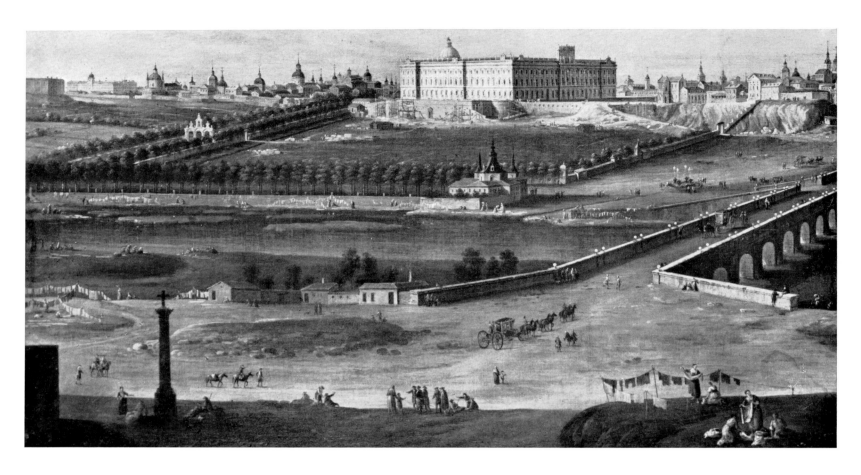
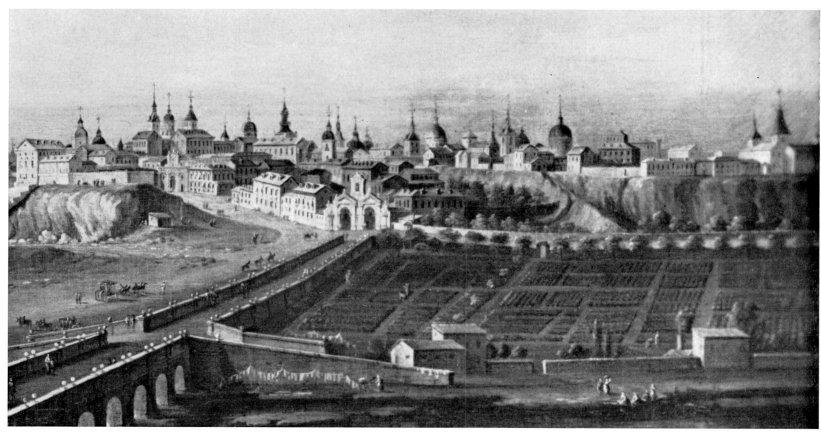

112-113. ANTONIO JOLI: *View of Madrid* (details). Private collection.

One of a series of four views of Rome, London, Vienna and Madrid. The view is from the far side of the bridge over the Manzanares and shows the vast edifice of the Palacio Real and the gardens sloping down to the river, with the spires and domes of the churches of Madrid in the background.

114-115. FRANCISCO GOYA: *La Pradera de San Isidro* (details). Madrid, Prado.

A view of the meadows outside Madrid on 15 May, the feast of San Isidro. Beyond the Manzanares is a panoramic view of Madrid, with the Palacio Real and the Church of San Francisco el Grande.

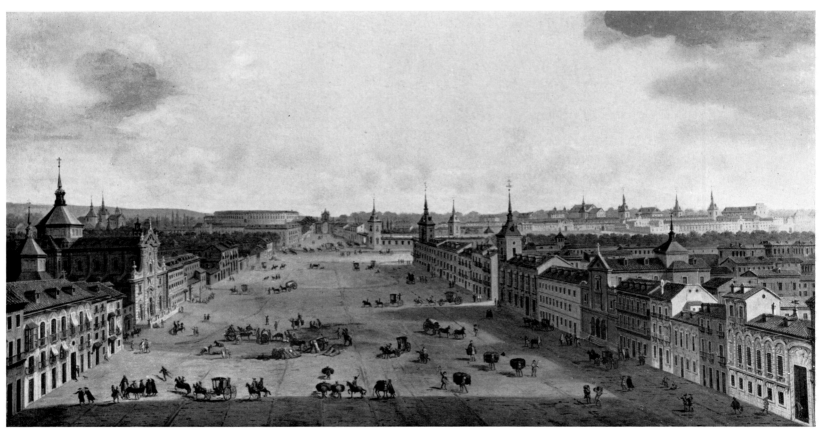

116. FRANCISCO GOYA: *La Pradera de San Isidro*. Madrid, Prado.

In this masterpiece of landscape painting Goya depicts the crowds who have gathered for the feast of San Isidro and in the distance, on the far side of the river, a view of the city lit by a pale, spectral light which makes it seem detached from the festivities in the foreground.

117. ANTONIO JOLI: *The Calle de Alcalá, Madrid*. Madrid, Collection of the Duchess of Alba.

Joli was in Madrid about 1750, where he worked as scene-painter in the Teatro del Buen Retiro. He also painted views of the city, of which the paintings of the Calle de Alcalá are among the most important. This view shows the road looking towards the Plaza Mayor and the Puerta del Sol.

118. ANTONIO JOLI: *A View of Madrid, Calle de Alcalá*. Madrid, Collection of the Duchess of Alba.

This second view of the Calle de Alcalá, the chief street of old Madrid, shows the city from the direction of the Puerta de Alcalá, the many spires of its religious and municipal buildings standing out against the background.

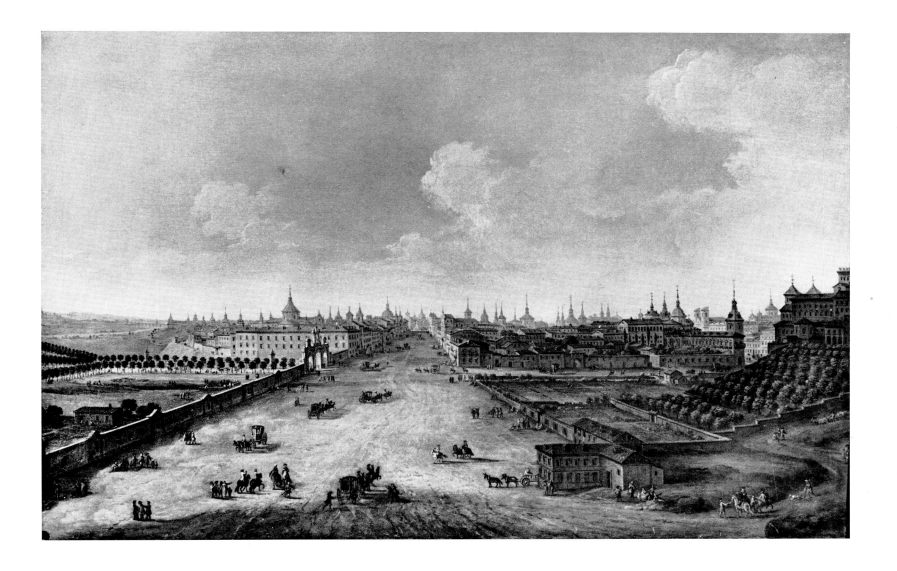

119. ANTONIO JOLI: *A View of Madrid, Calle de Alcalá* (detail). Madrid, Collection of the Duchess of Alba.
Many small figures, most of them in motion, enliven the painting of the Calle de Alcalá enclosed by the long boundary wall and by a succession of buildings arranged in a kind of theatrical perspective.

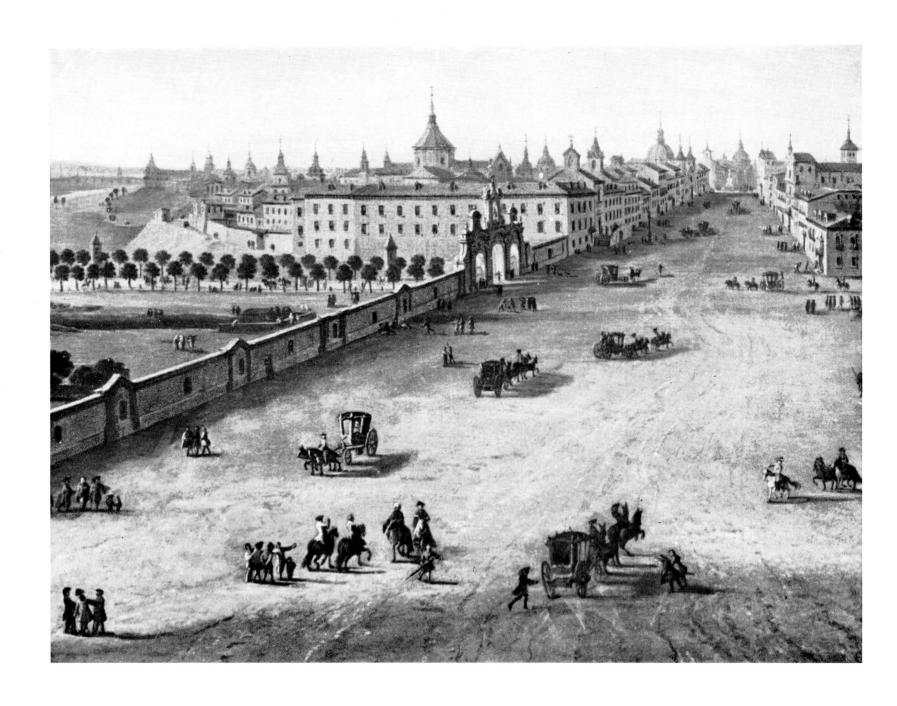

VIENNA

...The cathedral church, which is dedicated to St. Stephen, is an old building, very magnificent, but dark. The city stands upon the Danube, an arm of which separates it from the suburb called Leopoldstadt...

The Imperial palace is large, but has nothing else to boast of... Were a stranger to see the palace of Vienna, and to have no notion of what it is beforehand, he would scarce imagine it to be the residence of the first prince of Europe. The palace of La Favorita in a suburb of Vienna, where the Emperor spends the summer, is even inferior to that in the city...

...On the other side of the city is another suburb, which is very considerable, and the walks there are very fine. The Prater, for example, is a place which is much frequented: it is a wood on an island formed by the Danube, where there is a surprising concourse of people in fine weather, so that it may well be called the Bois de Boulogne of Vienna. As one returns out of this walk we come to another called the Emperor's Garden. Here was formerly a beautiful palace, but now there is nothing of it to be seen but the ruins.

Lettres et mémoires, London, 1747. CHARLES LOUIS POLLNITZ
 December 1729

...Two days ago the ice and snow suddenly began to melt and the whole district has become a marsh. This change of temperature, which heralds the season of fair weather, gives impetus to the martial preparations which keep these unsettled regions in a state of ferment. Nothing is to be seen in the streets but newly-levied soldiers, baggage trains, artillery, ammunition and other such niceties destined to the destruction of the human race.

...Here we have, as you have there, all the entertainments of Carnival upon us — drama and melodrama, German and Italian, feasts and banquets and parties unceasingly, public balls both heroic and popular; but all this does not produce in this calm nation the same epidemic gaiety which in our more lively climate spreads as though it were an advantage, even in those who do not wish for it, who try to avoid it. And at the same time my companions achieve not a little if they succeed in withstanding the third horrible winter which this year seems to be producing again and again like the liver of Prometheus. It is quite certain that without the effective defence of our beneficent stoves we should have at this moment to be classed with those excellent hams, no doubt known to you, which without need of salt become delicious and incorruptible by being buried beneath the deep snows of La Mancha or the Sierra Morena, I cannot remember which.

...The cold and snow which you are suffering in Rome are sufficiently suggested by those of Vienna. Not a week passes but one hears of some poor peasant or traveller overcome by the cold and found dead in the countryside. Here in the city we walk upon ice three spans deep, packed harder than stone. The snow which falls continually crumbles and becomes reduced to such fine powder that it flies about in the air like dust in August. Yet there are some fools who go about at night in sledges. As for me, in order to keep upright on my feet I have had to put felt soles on my shoes, because taking the single step necessary to climb into my carriage I have landed with my bottom firmly on the ground, without however damaging the mechanism...

...The letter from you to which I am replying is of the 12th of last month — a date which it shares with our bad weather — not that the cold has returned, but the sky is continually stormy and threatening rain. This spoils for us a promenade, which had already begun, frequented by a concourse of all kinds of people, not readily to be believed by one who has not seen it. A few paces from one of the gates of the city there is an ancient and extensive wood, watered on either side by two branches of the Danube, its delightful irregular shape adorned by long and broad avenues, populated in astonishing numbers by wild boars and

stags, and enclosed for the imperial hunt. This used to be opened every year at the beginning of May for a few weeks only, and solely for the nobility and those who could have themselves drawn there in coaches, who were permitted to promenade there on condition that they did not leave the avenues; and to those unfortunates who go on foot it was prohibited territory. But now our young and adored Emperor... has decreed that this wood should be open all the year round, that the avenues should be watered each day up to the gates of the city, and that people of all conditions may go there, on foot, in their carriage, or on horseback, as they will...

Lettere disperse e inedite, Bologna, 1883. PIETRO METASTASIO
 February 1777

...The streets of Vienna are very narrow and winding. The imperial court has the privilege of quartering soldiers in the second story of the citizens' houses, which is a great diminution of the rents to the owners. As the fronts of the houses, besides this inconveniency, are very narrow, the citizens endeavour to make up these disadvantages by the height of the buildings; so that there are houses at Vienna six and seven stories high. One of those in the square, called the Hof, has on one side seven, and on the other eight stories. The houses at Paris are more magnificent than those at Vienna; but by reason of the walls and gates of the courts or areas before them, which are generally shut, they make no great appearance in the street. The palaces at Vienna, are, indeed, for the most part, almost hid in narrow streets; but in splendor and magnificence, they greatly surpass the hotels of Paris, especially if one takes into account the magnificent buildings in the suburbs of Vienna...
Among the ecclesiastical buildings at Vienna, the principal is St. Stephen's church; it is a Gothic structure and adorned with a great many pieces of sculpture, representing saints, beasts, flowers, pyramids, &c... The roof is covered with glazed tiles of various colours. If the tower at Strasburg is looked upon to be the most curious, and that of Landshut to be the highest in Europe, this of St. Stephen is unquestionably the strongest, which as well as the church, is built with large square blocks of free stone, fastened together with iron braces or cramps...
Of all the buildings at Vienna, the palace of Prince Eugene in the suburbs, is undoubtedly the finest. It has a suite of eleven rooms in a direct line in front, and towers at the angles, with another of seven rooms in the wings... The garden lies on a slope, and on that account is very convenient, for the elegant water-works exhibited there. In that part of the garden on the left called Paradise, is a spacious aviary made of curious wire-work, and also beautiful walks and gilt summer-houses, which render it extremely pleasant. The orangery is likewise worth seeing, where some of the trees remain in the open air all Winter, with only a cover over the tops of them.

Travels through Germany, Bohemia, Hungary..., London, 1756 JOHN GEORGE KEYSLER
 July-August 1730

...The city of Vienna, properly so called, is not of very great interest; nor can it be enlarged, being limited by a strong fortification. This town is very populous. It is thought to contain above seventy thousand inhabitants. The streets in general are narrow and the houses built high. Some of the public buildings and palaces are magnificent; but they appear externally to no great advantage, on account of the narrowness of the streets. The chief are the Imperial Palace, the Library and Museum, the palaces of the Princes Lichtenstein, Eugene, and some others, which I know you will excuse me from enumerating or describing.
There is no great danger that Vienna will ever again be subjected to the inconvenience of a siege. Yet, in case the thing should happen, a measure has been taken, which will prevent

the necessity of destroying the suburbs: No houses without the walls are allowed to be built nearer to the glacis than 600 yards; so that there is a circular field of 600 paces broad all around the town, which, exclusive of the advantage above mentioned, has a very beautiful and salutary effect. Beyond the plain, the suburbs are built. They form a very extensive and magnificent town of an irregular circular form, containing within its bosom a spacious field, which has for its centre the original town of Vienna.

A View of Society and Manners in France, Switzerland and Germany, London, 1779. JOHN MOORE
1779

...Of all the buildings in Vienna I know only St. Stephen's, the Library building and the theatre adjoining it. The two latter form part of the palace...
Vienna being a fortified city, the dwellings are cramped; rarely does a single individual occupy a whole house as in Paris. One of the reasons for this is that the second floor of many houses belongs to the Emperor, and many persons of the court lodge there. We were living above a very close relative of the Prince of Kaunitz. The suburbs of Vienna are more extensive than the city itself. They were built a considerable distance from the city because of the fortifications. The impressive plain that lies between Leopoldstadt and Vienna has barracks on either side of it, for the city has a garrison of four or five regiments. At one time these barracks were fine monasteries, but Joseph II found that it would be better to have his soldiers there than his monks. The streets of Vienna are rather dirty and are flanked by pavements which, since they are level with the road surface, only serve to make walking difficult. I saw the festivities held in honour of the coronation of the Emperor. Many triumphal arches were set up, illuminated with coloured lamps. These were made with transparent sheets of paper decorated with mottoes and emblems; an extravagance of oil and wit alike. The main triumphal arch was decorated with fluted columns, gilded, carved, painted in tempera and mounted upon overlarge bases. The Emperor was borne along in a coach at one end of which was, religiously enough, a small, roughly-made bell-tower. The merry-making of the populace is as noisy as in France, but the Germans are less extroverted. As one walks down the street, no whistling or singing is heard. The cobbler of the well-known story was not a German.
...Nowhere is a stranger made so welcome as he is in Vienna. Here one encounters the hospitality of the Germans of old. Society seems to be more closely knit in Vienna than in Paris, for what Versailles represents to our capital is provided here by the ministers' residences. On Mondays one calls on Princess B., on Thursdays the Count of H., on any day Prince K... Whether by custom or by inclination, the existence of the Germans consists in showing themselves.
The stoves in the apartments, which provide them with a truly royal amount of heat, do not bring people together like the fireplaces in France, but disperse them into various groups scattered all over the salon. The salon has the air of a café: liveried men-servants bring in a succession of ices, lemonades, barley-waters and sweetmeats, merchants set up shop in the middle of the room and display jewels to those who have nothing to say or who wish to buy things at a price which is double their actual value. In Vienna people meet often on the same days in the same places. This accounts for the fact that although society is large in numbers one is always under observation as in provincial circles. Every intrigue is brought to light and becomes common knowledge, a fact which, among other things, presupposes a state of immense tedium — for one must have time to waste in order to occupy oneself with the affairs of other people. The ladies devote little time to the upbringing of their children, and this is understandable because they have an aristocratic attitude in all matters;

I know some ladies here who would feel at ease even in the most exclusive society of Paris. In Vienna the young people live their lives independently of the adults. Where, indeed, are they able to meet? They take no part whatever in society gatherings. In this place one might think one was living in another age, for in society there are only old people to be seen.

Outside Vienna, etiquette is merely a word. The various ranks are distinguished by the number of those who precede the carriages on foot. There is nothing so absurd as to see in the muddy streets, and even in winter, a footman in white stockings walking in front of a mediocre lordling, full of arrogance. His presence proclaims that the person following is at least an Excellency. This announcement is confirmed by two tassels attached to the heads of the horses, which only persons of a certain social standing have the right to display. These tassels are known as 'fiocchis', which leads me to think that they are to be found elsewhere. The barriers between the German nobility and the people, and between the German nobility and itself, are insurmountable.

Voyages à Constantinople, etc. Paris, 1794.

...Vienna, situated on the Danube, which divides into several arms and is neither broad nor deep, would be small indeed without its suburbs, which are really quite large. One can walk around the city proper in fifty minutes at a normal pace. The river flows between the city and the suburbs; for part of the year it is practically dry, but it frequently overflows, causing serious damage.

All the houses in the city (there are about 1,300 of them) have a number; the numbers are not repeated and so it is easy to find the house one seeks with the aid of a map of the town and a special book for the purpose. Because of its position the weather in Vienna is rather cold, the town being situated in a sort of basin; after the warmest days the evenings are very cool and it is necessary to take precautions. In contrast with those of German cities the streets of this town are very well paved, and the pavements are of Melck granite; but they are of little use for, as they are on a level with the road, carriages often drive on them. The suburban streets are not paved at all.

Between the city and the suburbs there is a space of about 600 paces which is for the most part empty. There are only some wooden shops, which would be dismantled at once in case of a siege; it is here that the markets of horses and heavy goods are held. Atrocious muddiness in the winter, and dust, which is even more vexing, in the summer, render this connecting way most unpleasant. The amount of traffic around the city gates is incredible — over 100,000 people come from the suburbs to work in the city and return home in the evening. The city is well fortified and all the buildings are well kept.

...Promenades. The most pleasant one is the Prater, outside the city, extending among the meadows as far as the Danube; in fact it is a large meadow, crossed by many fine avenues along which people pass in coaches or on horseback; there are herds of deer which are not frightened at all; the number of people there is considerable, especially on Sundays. Langarten is a lovely place, in a village close to the Prater; the gardens are extensive and very pleasant, with a terrace overlooking the Danube, and many inns, but for which the inhabitants of Vienna would be in less haste to betake themselves thither. The ramparts offer the only accessible walk in the city, apart from the Graben, where one can stroll in the evening when the weather is fine. The Graben is a street, or rather an elongated square, in the centre of the city, and is also the fashionable district and therefore the most sought-after residential quarter — it is Vienna's Palais-Royal.

Voyages de deux Français en Allemagne, Danemark, Suède, Russie et Pologne faits en 1790-1792, Paris, 1796.

120-121. BERNARDO BELLOTTO: *Vienna from the Belvedere Palace* (details). Vienna, Kunsthistorisches Museum.

The wide view of Vienna is from the north-west pavilion of the Upper Belvedere. The first detail shows part of the gardens and the building of the Lower Belvedere, with the dome of the Salesian church on the Rennweg. The second shows the Karlskirche and the Schwarzenberg Palace, with Vienna in the distance. The views of Vienna and the Imperial palaces were painted by Bellotto between 1758 and 1761.

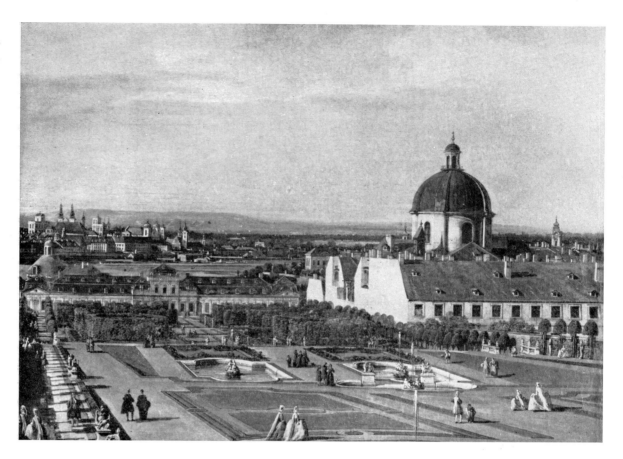

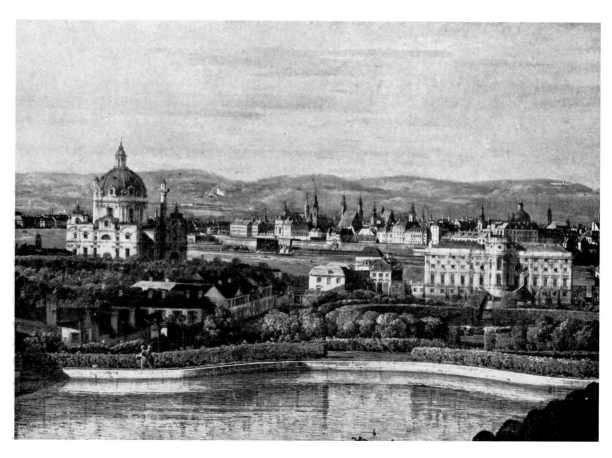

122-123. BERNARDO BELLOTTO: *Lobkowitzplatz* (view and detail). Vienna, Kunsthistorisches Museum.
The view from a first-floor window in the Augustinian convent. On the left is the Lobkowitz Palace, built by the Imperial architect Giovanni Pietro Tencalla in 1685-7. Beyond the palace projects the choir of the Dorotheum, and in the centre is the wall and entrance to the Capuchin convent, behind which rises the tower and spire of the cathedral.

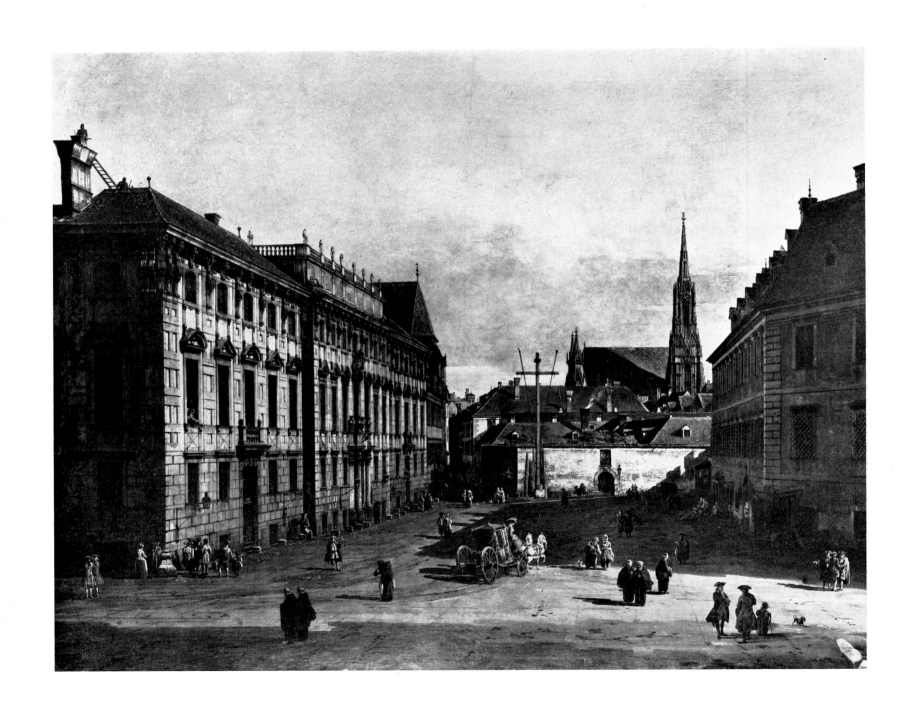

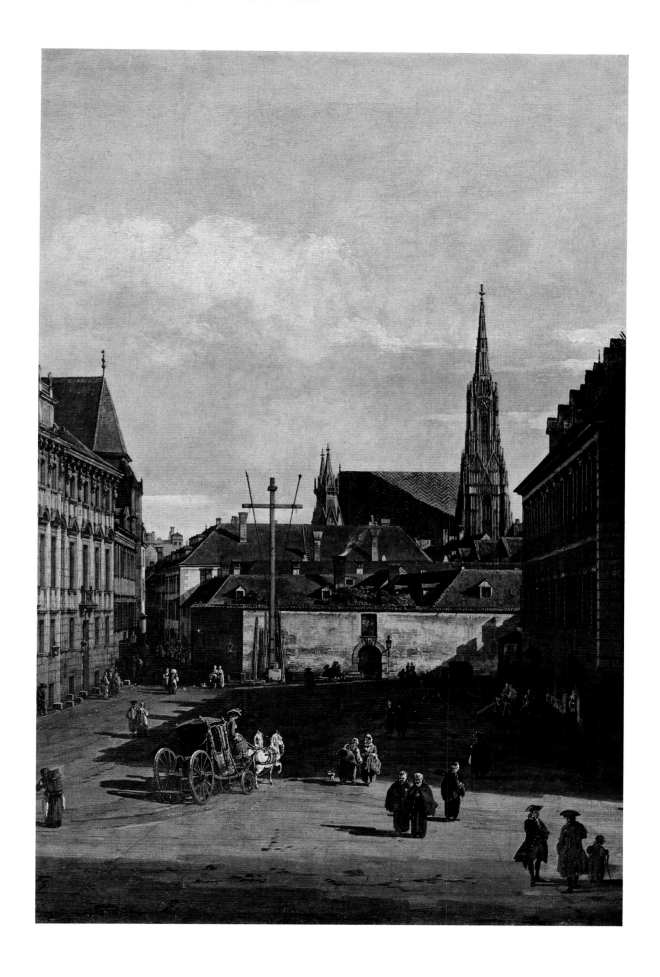

124-125. BERNARDO BELLOTTO: *The Freyung from the north-west* (view and detail). Vienna, Kunsthistorisches Museum.

This view of the Freyung, the triangular open space in old Vienna, is from the window of a building in Schottengasse. On the left is the façade of the Schottenkirche, built between 1638 and 1648 by Andrea Cellio and Silvestro Carlone. In the distance are the sixteenth– and eighteenth-century houses on the Freyung, which include the Batthyany-Schönborn Palace, the houses 'zum golden Strauss' and 'zum rothen Mandl' and, beyond another house seen in perspective, the Heidenschuss, is the entrance to the Tiefer Graben. On the right is the garden pavilion of the Harrach Palace, built in 1715 and destroyed in 1945.

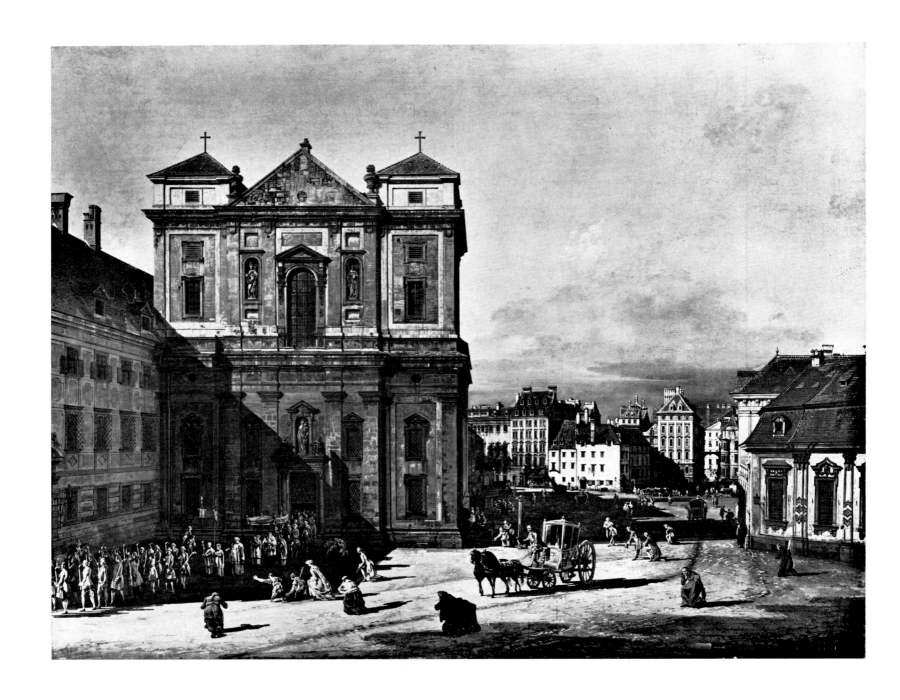

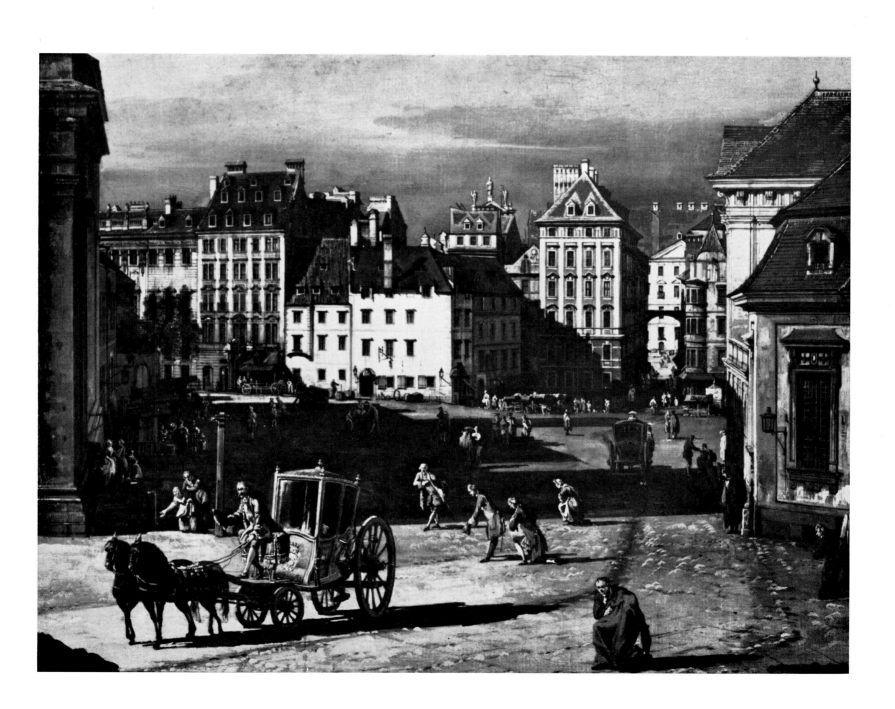

126. BERNARDO BELLOTTO: *The Freyung from the south-east*. Vienna, Kunsthistorisches Museum.

Another view of the Freyung from the opposite end, from the first floor of a house on the corner between the Heidenschuss and Schau-flergasse. On the left is the Harrach Palace, built in 1690 by Domenico Martinelli, in the centre is the Schottenkirche with the tower built in 1732, and on the right are the houses 'zum golden Strauss' and 'zum rothen Mandl', on the corner of the Tiefer Graben.

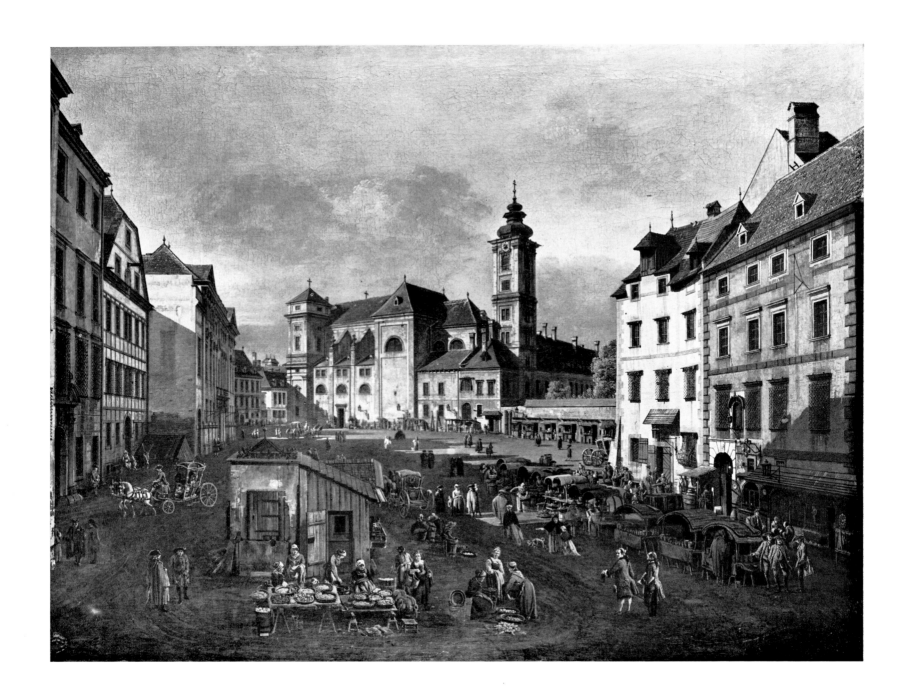

127. BERNARDO BELLOTTO: *The Universitätsplatz*. Vienna, Kunsthistorisches Museum.
The view from a window in the Jesuit College. In the centre is the 'Aula' of the Old University, built to the plan of Jadot de Ville Issei in 1753, on the left is Bäckerstrasse and on the right the façade of the Jesuit Church (1627).

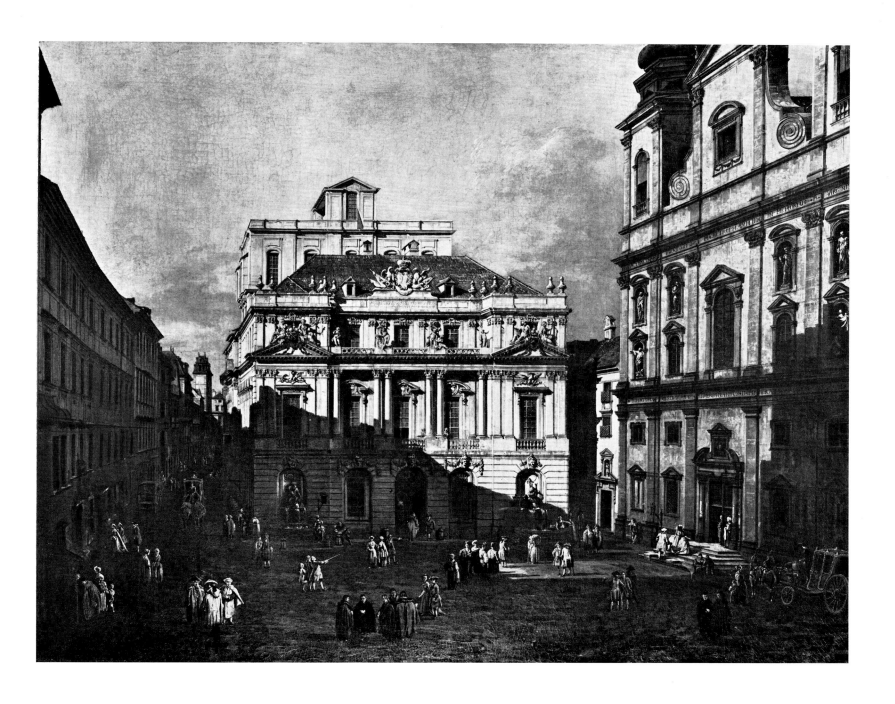

128. BERNARDO BELLOTTO: *The Dominican Church*. Vienna, Kunsthistorisches Museum.
Another characteristic corner of old Vienna. On the left is the façade of the Dominican church built in 1631-4, on the present Post-gasse. In the background is the collegiate house of the Jesuits with its observatory tower, and on the right is the long range of the Jesuit College.

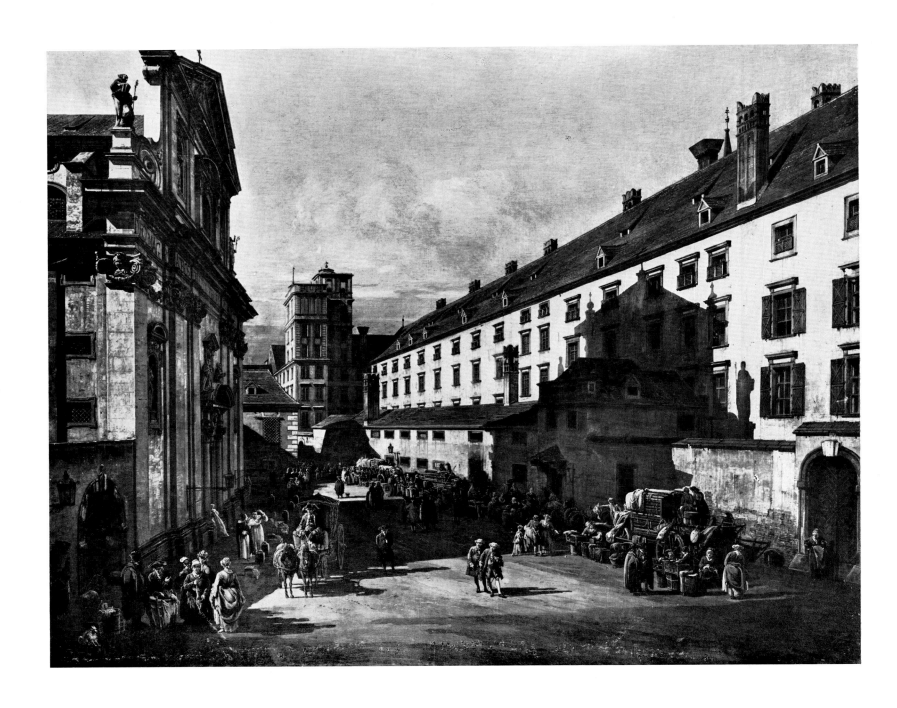

129. BERNARDO BELLOTTO: *The Imperial Palace of Schönbrunn* (detail). Vienna, Kunsthistorisches Museum.
A view of the courtyard side of the Schönbrunn Palace. The painting shows the reception given by the Empress Maria Theresa on 16 August 1759 in honour of Count Kinsky who, with twenty postilions, brought the news of the victory of the Austrian and Russian armies over the Prussians at Kunersdorf.

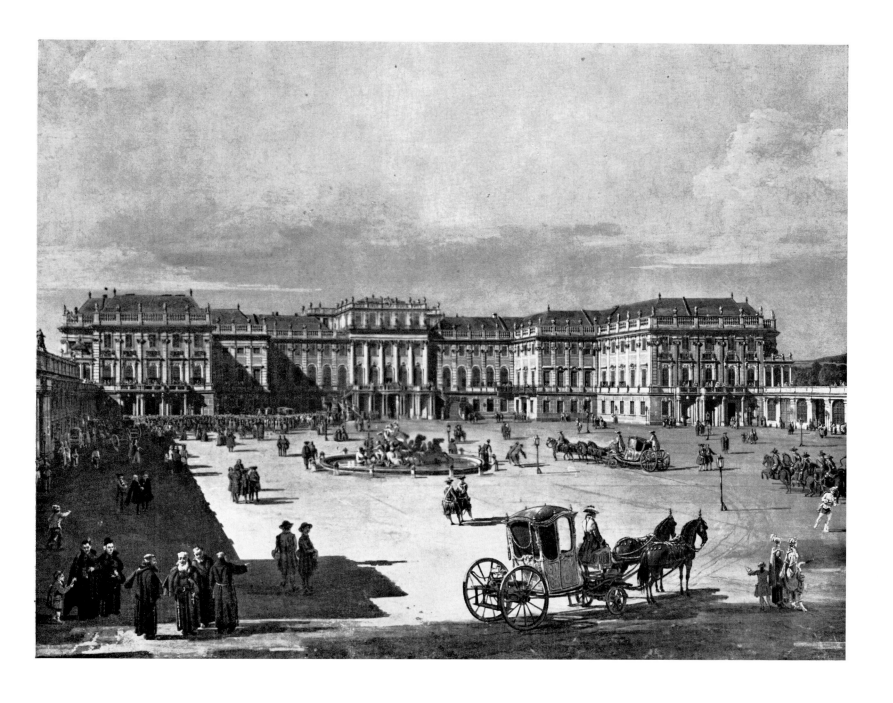

130, 132. BERNARDO BELLOTTO: *The Imperial Palace of Schönbrunn* (view and detail). Vienna, Kunsthistorisches Museum.
A view of the palace from the garden side, from the hill on which stands the Gloriette. In the distance on the right is a panoramic view of Vienna in which the outline of St. Stephen's Cathedral and the mass of the Karlskirche can clearly be distinguished.

131. BERNARDO BELLOTTO: *The Imperial Palace of Schönbrunn from the Courtyard side*. Vienna, Kunsthistorisches Museum.
The Palace of Schönbrunn takes its name from a spring, 'schöner Brunnen', in the park of the hunting lodge of the Emperor Maximilian II. After the old building had been destroyed by the Turks, Leopold I commissioned a new building from the architect Fischer von Erlach in 1695, intending it as a residence for his son and successor Joseph I. It was built according to the architect's second plan in 1695-1700. The present building, which is shown in Bellotto's painting, is the result of the modifications made by Maria Theresa, who employed Nicola Pacassi to alter Fischer's building between 1743 and 1749.

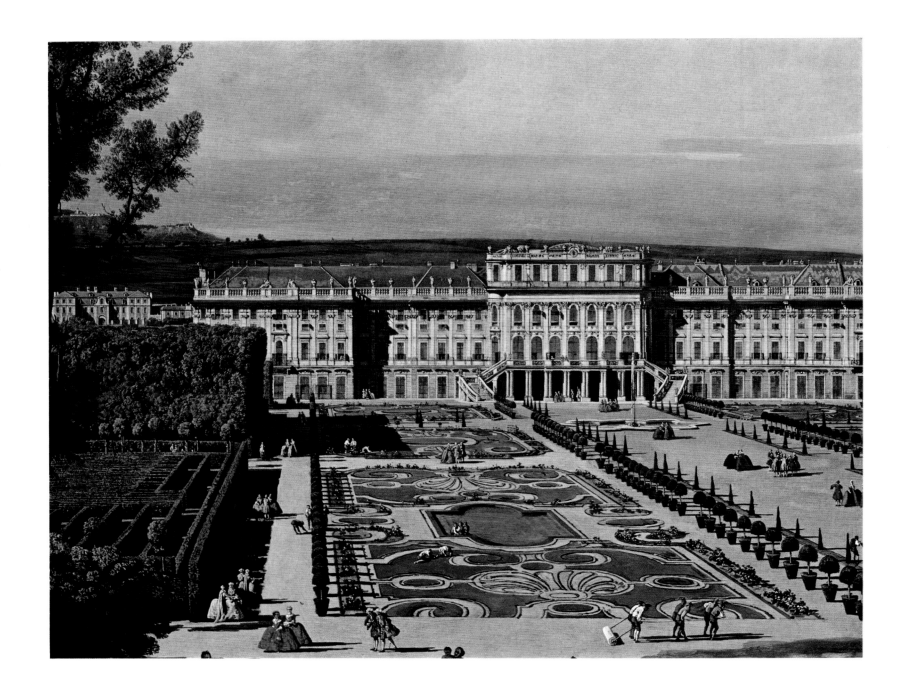

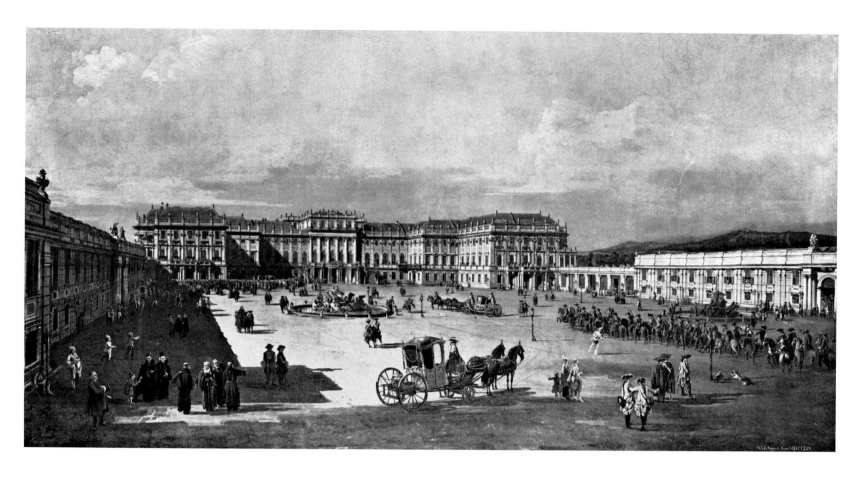

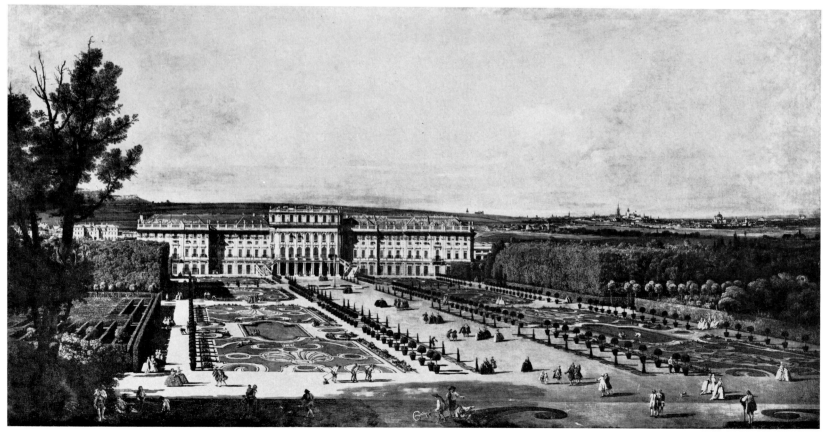

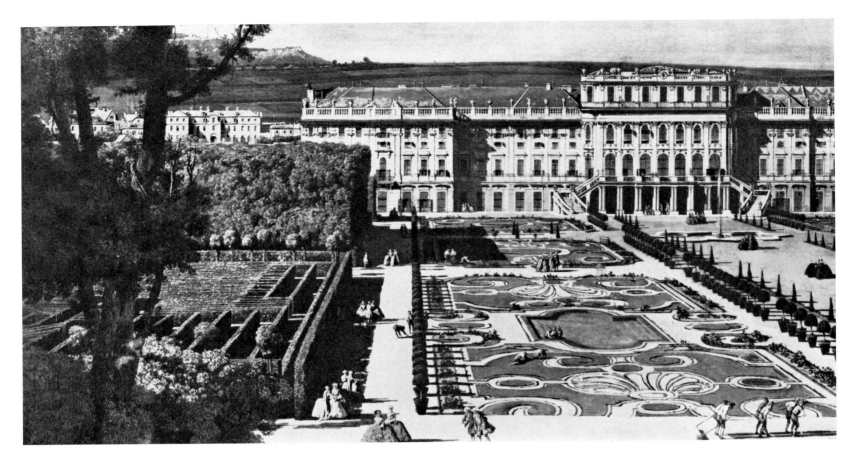

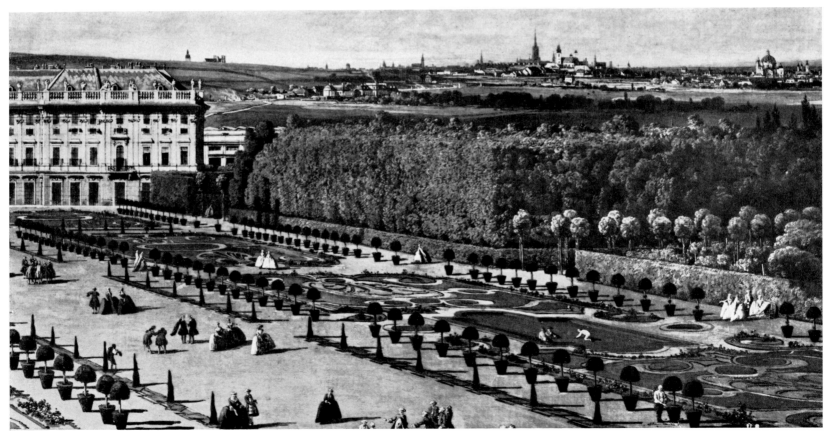

133-134. BERNARDO BELLOTTO: *The Imperial Palace of Schönbrunn* (details). Vienna, Kunsthistorisches Museum.

The view of the palace is so disposed that the silhouette of the hills to the north of Schönbrunn which descend towards the west appears to be above the roofs of the palace. Bellotto painted the gardens before the rearrangement ordered by Maria Theresa in 1765, which remains today. Only the geometrically arranged flower beds along the sides have continued unaltered.

135. ANTONIO JOLI: *Vienna*. Private collection.

One of a series of four views, of Rome, London, Vienna and Madrid. This is not a real view, in the Bellotto sense of the word, but an imaginary panorama painted in the studio from notes and sketches made on the spot. The viewpoint is taken as a raised position to the south of the city, approximately in the position of the Wiener Festspielhaus, over the bridge which in the eighteenth century crossed the Wien river, which at that point is now underground. On the left is the city, dominated by St. Stephen's within its walls. On the right are the Karlskirche and the Schwarzenberg Palace.

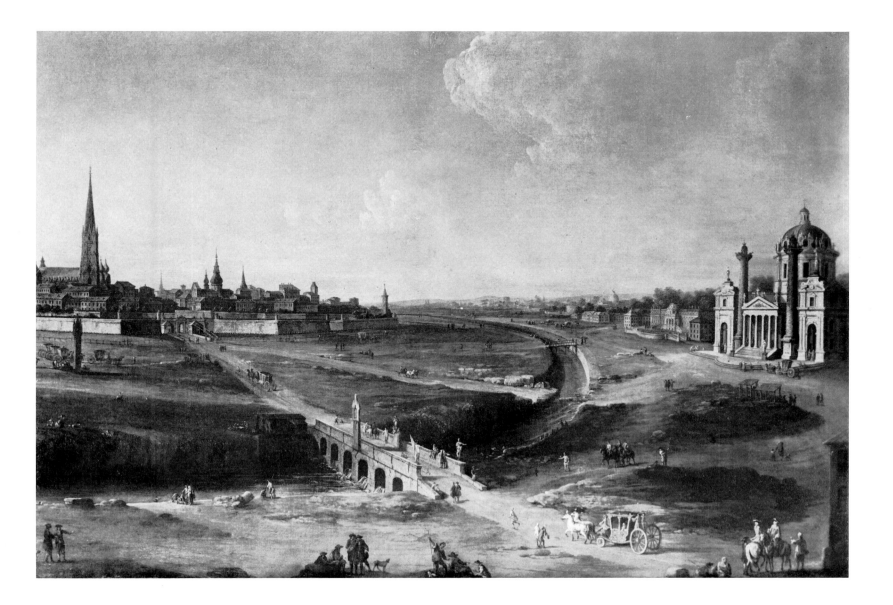

136. Antonio Joli: *Vienna* (detail). Private collection.
A detail from the preceding view, showing the city of Vienna within its old walls, the dome of the Church of St. Peter and Paul, St. Stephen's Cathedral and the Franciscan church.

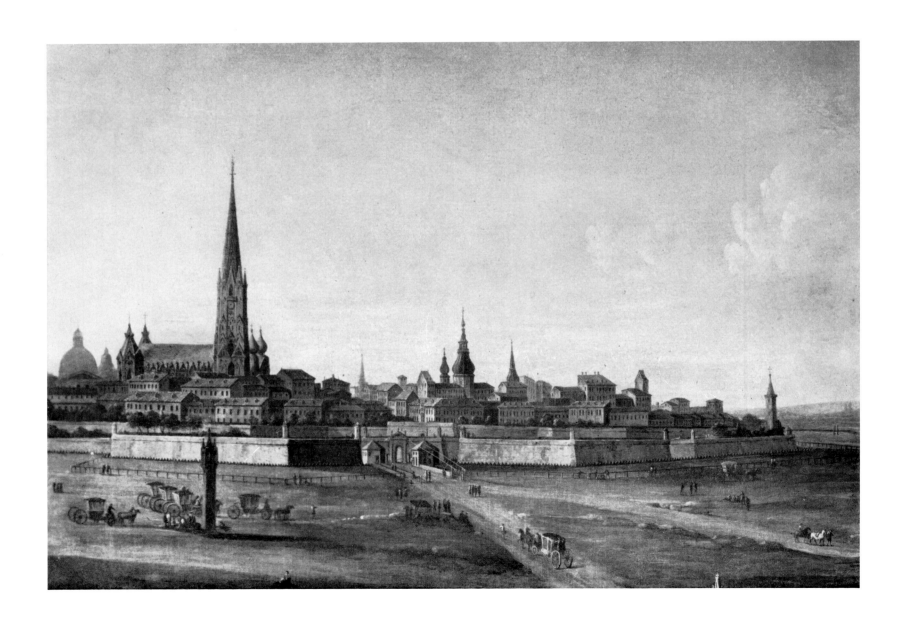

MUNICH

...The city of Munich, in the German tongue München, stands in the middle of a large plain in the centre of Bavaria, of which it is the capital city. The walls of it are washed by the river Isar. It is a small town, but well built, for within these few years several fine houses have been raised in it. The Elector's palace is one of the largest buildings in Europe, but it is not as handsome as Misson and many other writers have maintained; its magnificence consists principally in its bulk. The main front which looks towards a very narrow street has the appearance of a fine convent, to which the image of the Virgin over the gate contributes not a little. There is a secret passage from the palace through little galleries to all the convents and churches in the city. The nearest church is that of the Theatines, which together with their convent was built by Maria Adelaide of Savoy, the wife of Ferdinand Maria. The church of Our Lady is the parochial church of Munich. Although the houses of Munich are all very well built, there are few which can be called palaces.

Lettres et mémoires, London, 1747.

CHARLES LOUIS POLLNITZ
January 1730

...The Elector's palace consists of four courts, of which the finest is that called the Prince's, being adorned with several brass statues; and the Emperor's court, the latter of which is so constructed, that combats of wild beasts may be exhibited in it. The kitchen court is the largest, and at the last nuptials a very magnificent tournament was holden there. The old Barbican, in comparison with the other three, passes for the meanest. The ascent to the Emperor's hall is a flight of wide and beautiful red marble steps; the hall itself is one hundred and eighteen feet long, and fifty-two broad. The greatest curiosity in it is a statue of Virtue made of a single block of porphyry: but it is a pity that this stately chamber and the others contiguous to it have no ceilings. The Elector's bath consists of a grotto and three rooms...

Gustavus Adolphus was so taken with the city of Munich, that he said he wanted nothing but rollers to move it to another place, being thoroughly sensible, that there was no keeping possession of this country. But if he had seen Munich as it is now, having broad streets extending themselves in a direct line, and numerous stately buildings of all kinds, in which it rivals most places in Europe, he would have been even more charmed by this capital...

Of the ecclesiastic buildings the churches of St. Anne and the Theatines deserve to be seen, on account of the stucco-work with which they are decorated. In the church of Our Lady, which has two large towers, is the stately black marble monument of the Emperor Lewis of Bavaria, with six large and several lesser statues of brass; where is also a large organ of box-wood. Not far from one of the doors is a stone with a mark on it, and to him who stands there the multitude of pillars takes away the sight of every window of the church. It must however be owned to be something dark, and it is certainly more advantageous to a church to be very lightsome, than to have no windows.

The palace and the electoral buildings, together with the brew-houses, sixteen monasteries, churches, and such religious structures, take up near half of the city. The precinct of the Augustins alone, consists of several streets, which bring them in an annual rent of three thousand guilders. The arsenal is not at present in a very good condition, having been near exhausted in the late war. Some descriptions of the city of Munich mention a tower

just by the old court, terminating in a cave above and below, but this is no more than a common balcony; and the whole account a ridiculous misrepresentation.

Travels through Germany, Bohemia, Hungary,... London, 1756. JOHN GEORGE KEYSLER
June 1729

...You will see that Munich has more to be said for it than foreigners generally suppose, and you will find there not a few of those things for which you would search other German cities in vain and which are so pleasing to curious travellers such as you are yourself. ...Be sure to ask to see the Residenz, or Electoral Palace. This is an enormous edifice, constructed with regal lavishness at the beginning of the last century by Duke Maximilian, he himself being the architect. The first thing which you must be sure to see are the apartments in which not long ago lived the Prince and Princess Royal of Saxony, and the others which were intended for the Princes Albert and Clement. You should glance also at the theatre of the Court, since no visitor should neglect to look over this sort of building, for with us, as once to the Greeks and Romans, they count amongst the principal adornments of a city. The fountain decorated with bronze statues which you will pass on leaving the palace would certainly merit a place in one of our finest piazze in Italy. The four huge lions in metal which from their marble pedestals guard the two main gates of the Residenz, and the gigantic bronze statues which stand so nobly on their bases, are also ornaments designed by the worthy Peter Candid, to whom Bavaria is as much indebted for things of beauty as was he to Italy for his good taste, and the elegance and beauty of Florence.

The church of Our Lady, not very far from the square, is a great Gothic temple built in 1468 by Duke Sigismund. Spaciousness and vastness alone can give to buildings the appearance of magnificence: ornamentation can only embellish them; of which this church gives proof, for although it has none, yet you will find it imposing and commanding of respect. The church of the Theatines is a fine piece of architecture by our own Agostino Barella of Bologna. Nothing whatever could be said against this magnificent temple were it not for the quantity of stucco-work and endless Angels which adorn, or rather encumber, its walls and friezes, even the dome and vaulting.

Then there is the Jesuit church, an eternal monument to the piety of Duke William V and to the protection which he accorded the Society of Jesus... It is claimed that the building of this church cost the nation a fortune, which is quite conceivable, considering its beauty and solidity. I can think of no modern temple in Germany which surpasses it, with the exception of the Royal chapel at Dresden; nor do I remember ever having seen any church that had, in proportion, a wider vault or one with less support... Beautiful is the paved floor entirely made of marble, lovely are the chapels and altars, and no less so the paintings which adorn them... The main front is embellished with many bronze statues, the most perfect of which is the Archangel St. Michael between the two great doors...

While going round the city, observe that the fronts of almost all the private houses are decorated with frescoes; indeed, some of the older ones are the work of very accomplished masters, Christopher Schwartz in particular.

...Nymphenburg is only three Italian miles away, and is reached by an avenue lined with trees along the side of a wide artificial canal. Notice here and there, that all the terrain through which you are passing is a mixture of shingle and alluvial sand. At one time the Isar undoubtedly flowed this way, and if you look closely you will still be able to discern the rise of its former banks and the abandoned river-bed. Nowadays, however, the Isar is far away, on the other side of the city.

Although the Nymphenburg palace is extremely large and its interior very ornate, I venture to tell you candidly that the gardens are vastly superior to it in beauty and taste. I have heard some who would put them on a par with the gardens of Versailles, but such people either have not seen them or are making fun of us. For one who has eyes to see, Versailles far surpasses all the delights of Europe, just as Nymphenburg easily surpasses all the gardens in Germany... There are but two things there that I wish to indicate to you, which I am most anxious that you should not miss. One is Amalienburg, a small palace in extremely good taste, built by Charles VII for purposes of pleasure, and in honour of his consort, the Empress Amalia; the other is the very fine Baths which were constructed in another corner of the gardens, with all the comforts which luxury, pleasure and decadence can inspire, by the Elector Maximilian Emmanuel. These baths won considerable fame in the chronicles of love and letters of that period.

Lettere al Marchese Filippo Hercolani... Lucca, 1763.

GIAN LUDOVICO BIANCONI
November 1762

...Munich I think without exception the finest city in Germany; Dresden, while in its grandeur, I am told surpassed it, and some parts of Berlin are very beautiful; and all things considered, they now yield to this place. It is situated on the river Isar which, dividing into several channels, waters all parts of the town, so that little streams run through many of the streets, confined in stone channels, which has a most clean and agreeable effect. The streets, squares and courts are spacious, and airy, which sets off the buildings much, and makes them appear finer than others much more costly in other cities. The streets in particular are so straight that many of them intersect each other at right-angles, and are very broad, and extremely well built. There are sixteen churches and monasteries in it, many of them very handsome edifices; these, with the electoral palace and other public buildings, take up near half the city: so that it may easily be supposed the place is in general very well built.

The principal of all these publick edifices is the electoral palace, which is rather a convenient than an elegant building. It is very large, having four courts in it and all of them large, but there is a want of finishing in the insides of all the places in Germany that cannot fail disgusting an Englishman who has been used to see the houses of the nobility in his own country finished to the garrets, as compleatly as a snuff-box; and certainly it is a most agreeable circumstance. In the palace of Munich, the finest room, which is the grand hall, being 118 feet long by 52 broad, is open to the roof, so as entirely to destroy the effect which would result from such a size if finished; birds fly about in it as in a barn, and drop their favours on the heads of the company as they pass. I have in Germany seen many instances of unfinishing equal to this. There is a great profusion of marble in the several apartments, but it is not wrought in an agreeable manner. The furniture is in general old; it has been very rich, but has nothing in it striking; nor is the collection of pictures comparable to many others in Germany.

The Jesuits' college is among the finest buildings belonging to the church; it is very spacious. The great church, and the Franciscan monastery, are also worth seeing; the latter order is possessed of very great revenues. Several palaces of the nobility make a very good figure, and the town-house is better than many I have seen. The number of inhabitants is computed at fifty thousand.

...The palaces most worth seeing are the Elector's country ones of Sleissheim and Nymphenburg, near Munich. Sleissheim is a fine building, and much better furnished than that

of Munich; the portico supported by marble pillars is fine. In the apartments, which are furnished in an agreeable manner, is a very good collection of pictures, but they are chiefly by Flemish masters. Nymphenburg exhibits the German taste of gardening in perfection; the Bavarians holding them to be the finest in the empire. The situation, wood, and water would admit of something beautiful, but here is nothing but the old-fashioned fountains, statues, monsters &c.

Travels through Holland, Flanders, Germany, Denmark, Sweden, Lapland, Russia, the Ukraine and Poland in the years 1768, 1769, 1770, London, 1772-6. JOSEPH MARSHALL
July 1770

...Munich, a beautiful city, has a population of about 36,000 inhabitants and is the seat of the Prince Elector. The grounds of the court are public, but gloomy and monotonous, and all around it there runs an extremely fine riding track, magnificently adorned and 300 feet in length. The churches have nothing of interest, but one may enjoy a splendid view from the top of the towers of the Church of Our Lady, the cathedral; the church of the Theatines is quite pretty.

The hospitals are well-endowed, but badly run. The theatre and the barracks are extremely undistinguished. Munich is on the Isar; the course of this river has been diverted and the works are very impressive and very extensive, as is everything that has to do with the canals. ...The castle of the Elector, half a league from Munich, has a fine entrance, and the main front has one hundred and thirty-five casement windows, more or less projecting, not counting two pavilions at the extremities of this front and in line with it, thirty-seven windows on each side, and many other pavilions which project forward from the line of the façade, and ten small pavilions in the courtyard.

...The gardens are superb, with wonderful fountains and playing water; there is a large number of statues and gilded vases, but they are made of lead and in bad taste. There is a very pretty jet of water in the main basin, and if one wishes, another similar one may be seen close to the hydraulic mechanism, which is extremely simple.

...General Thompson began the laying-out of another garden in the English manner, situated by the gateway from the courtyard; it is the most beautiful one he made, and it is the only walk outside the city that is practicable in the summer.

Two years ago the whole of this area was a marsh; next to it are the gardens which the soldiers cultivate for their own needs... In the grounds there are four pavilions decorated in different styles. Pagodenburg has an undistinguished ground floor, while the upper apartments are very pretty. Magdalenburg has no distinctive features and the Hermitage is not very well kept up, the interior contains nothing in particular and is decorated with shells. Amalienburg is the prettiest of the four pavilions and is more sumptuously decorated; in the centre there is a rotunda thirty-six feet in diameter which together with the parts surrounding it forms a truly splendid whole. All the mouldings are plated with silver and inspire wonder in the beholder. In the garden there are golden pheasants brought from China. On the way to and from Nymphenburg one must pass through the deer park.

Voyages de deux français... en 1790-1792, Paris, 1796.

137-138. BERNARDO BELLOTTO:
The Castle of Nymphenburg from the City side (details). Munich, Residenz Museum.

Bellotto was in Munich in 1761, after his visit to Vienna, and he painted several views of the city and of Nymphenburg. This view of the castle is from the road which leads to the city and shows, beyond the great fountain, the central building designed by Agostino Barelli (1664) and the Porcelain Manufactory.

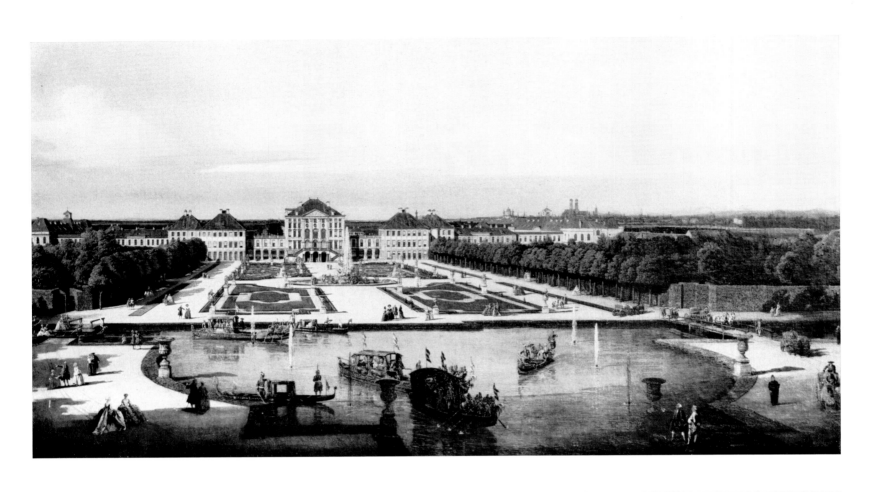

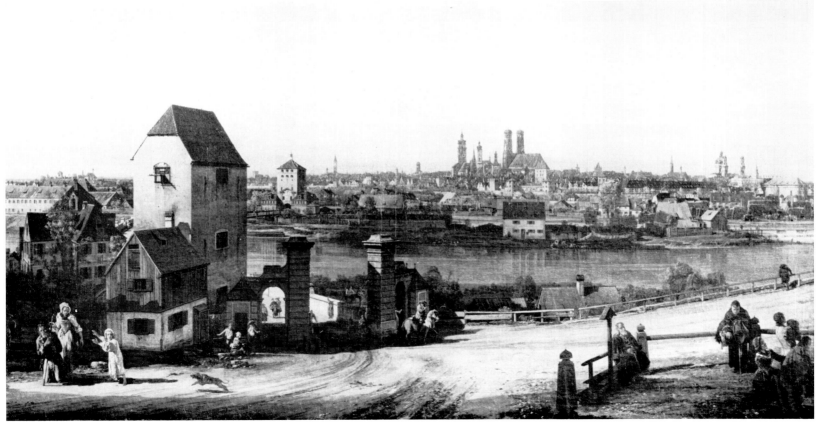

139,141. BERNARDO BELLOTTO:
The Castle of Nymphenburg from the Garden side (view and detail).
Munich, Residenz Museum.

The garden of the Nymphenburg was laid out by Carbonet and Girard. The viewpoint for this painting is exactly opposite that of the preceding view.

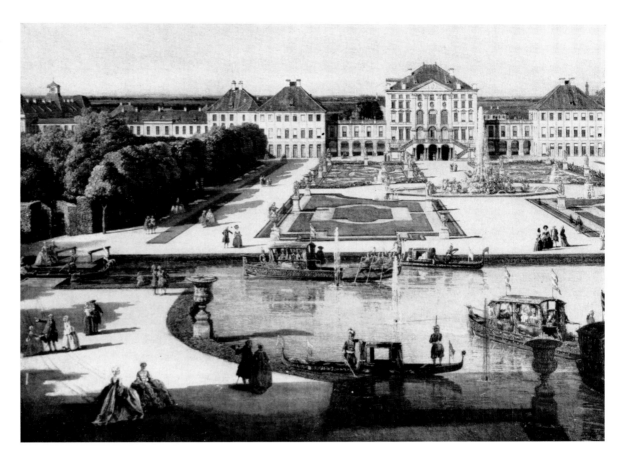

140,142. BERNARDO BELLOTTO:
Munich from Haidhausen (view and detail). Munich, Residenz Museum.

In the foreground, on the near side of the river, is the Brückentor, beyond which is the Isar and a view of the whole city. To the left of the Brückentor is the Customs-house and to the right of it, across the river, is the 'Red Tower' and the Isar gate and the fortifications above which rise the churches and towers of the city. In the centre is the Frauenkirche (1468-88) and beside it to the left, the tower of the old Rathaus (1470) and those of the seventeenth-century Heiliggeistkirche and the Peterskirche. To the right of the Frauenkirche are the tower of the Salvatorkirche, the cupola and towers of the Theatinerkirche (built by Barelli and Zuccali in 1663-75) and on the far right the little tower of the Residenz. This painting is signed and dated 1761.

143. GIACOMO QUARENGHI: *The village of Schwabing, near Munich*. Bergamo, Biblioteca Civica.
One of a series of views by Giacomo Quarenghi in five albums preserved at Bergamo. The drawings in the album which contains two views of the surroundings of Munich are datable to about 1810. The view shows the village of Schwabing, on the river Isar close to Munich, which is seen on the left, with the two towers of the Frauenkirche.

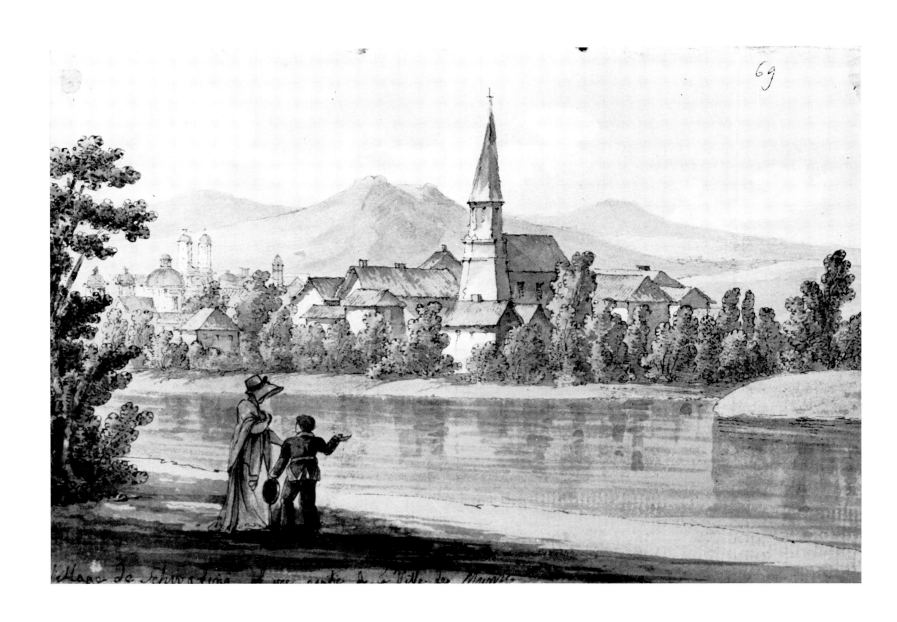

144. GIACOMO QUARENGHI: *Pasing, near Munich*. Bergamo, Biblioteca Civica.
Another drawing from Quarenghi's last album, datable to about 1810, shows the little village of Pasing, near Munich.

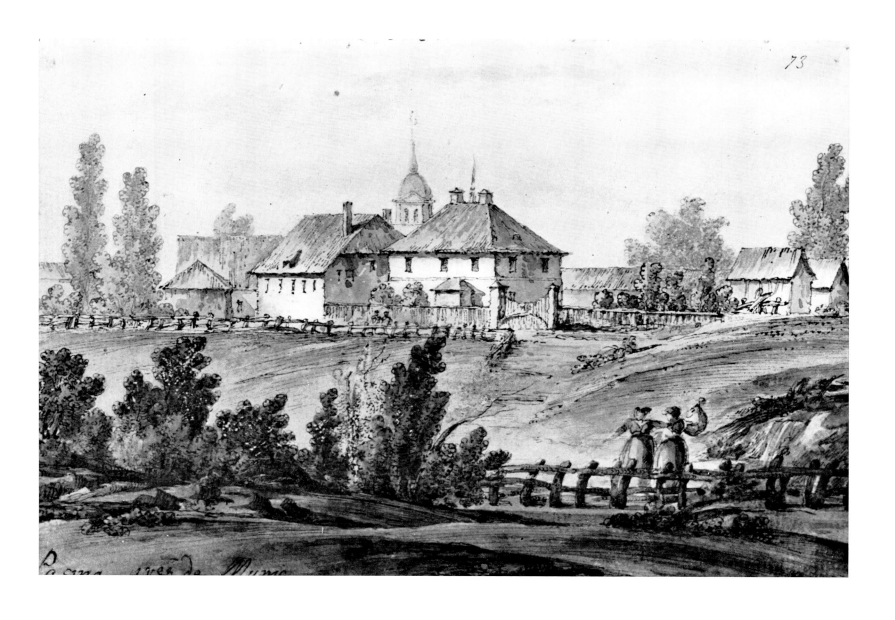

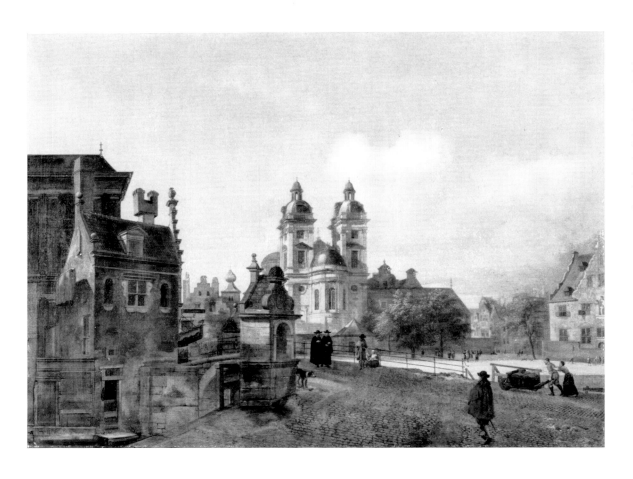

145-146. JAN VAN DER HEYDEN: *View of Düsseldorf*. The Hague, Mauritshuis.

This painting, signed and dated 1667, shows the Jesuit church at Düsseldorf. The figures are by Adriaen van der Velde. It was thought at one time that the church was of the Jesuits in Antwerp, but the precise location was identifed by W. Dahl, of Düsseldorf, at the end of the nineteenth century.

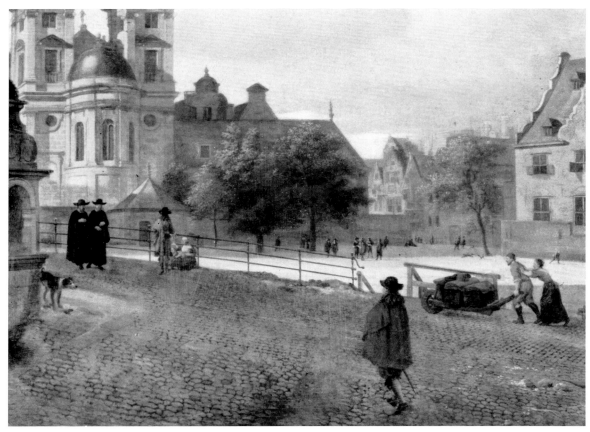

DRESDEN AND PIRNA

...Dresden is one of the smaller cities, fortified with art and regularity, and very well arranged. Its houses are high and substantial, the streets broad and straight, well-paved, clean, and well-lit at night. There are great squares in it, and the whole city is so well laid out that Dresden may be ranked among the finest in the world. The Elbe divides it into two parts, old and new Dresden, which are joined together by a bridge of stone. In order to give you a more precise idea of this city, I shall point out to you such things as I took most notice of. I shall begin with old Dresden, because it is the first we come to from Meissen. At the entrance to the town, on the right hand, there is a great building called the Palace of the Indies and of Holland, which the King bought some years ago from his Prime Minister, the Marshal Count Flemming... This magnificent palace has a garden surrounding it from whence can be enjoyed a fine view of the Elbe... It is adorned with statues of white marble which the King caused to be purchased in Rome. Near the Palace of the Indies stands that of the Cadets...

...Dresden is one of the finest towns in Germany for its situation and its structures; it is the capital of Misnia, in Upper Saxony. Charlemagne was the first to fortify it; it has been for a long time the ordinary residence of the Dukes and Electors of Saxony, who have caused its fortifications to be considerably augmented, and it is now a very strong place. The Prince's palace is in the old city; it was formerly a very fine building, but only a part of it remains, the rest having been destroyed by a fire. That part which still stands contains very fine apartments which the King has had adapted to modern taste, and they are very nobly furnished. Near the King's palace there is a fine garden called the Zwingergarten, which is surrounded by magnificent buildings in a horseshoe shape, with arcades above which runs an open gallery uniting three pavilions. In the centre one of these, on a level with the garden, there is a fine grotto. The upper storey contains a very beautiful salon, decorated with marble and with gilded decoration. The ceiling is superb, the windows have very fine glass. The rest of the building is of equal magnificence, but perhaps a little too much encumbered with sculpture.

Next to the garden there is nothing finer to be seen than the King's stables and riding-school. Over the stables there are very fine large rooms in which is kept all the furniture and trappings for the horses. In the same quarter there are also a number of stately buildings which render old Dresden a very agreeable place. The streets are broad, most of them well-paved and very clean. The old town is joined to the new by a beautiful stone bridge. The first thing one meets with entering the new Dresden is a building that belongs to the King, the palace of Holland, because all the china ware and furniture with which it is adorned come from that place. The gardens are very pleasant, and its situation most charming by reason of the river Elbe, which runs just by it.

Lettres et mémoires, London, 1747. CHARLES LOUIS POLLNITZ
 August 1729

...Dresden has long been famous for its superb palaces, straight and uniform streets, and splendid court; but in number of houses and inhabitants it must yield to several cities in Germany.

...Besides the gallery and apartments already described, the Zwinger house contains several saloons and other apartments which belong to the electoral family. The most elegant of

these is that called the ballroom. And indeed the gilding, painting and fine marble ornaments to be seen in this room, are very suitable to a place of festivity. In the pavement are two large oval pieces of marble, about six Dresden ells in the longest diameter; and between these is another piece of red and white marble cut out of a single block, which is four ells broad and eleven or twelve common paces in length... This saloon opens into fine walks made on the ramparts; from which one has a view of several boats, and the royal yacht called the *Bucentaurus*, in which her royal highness the electoral princess in the year 1719, sailed up the Elbe from Pirna to Dresden. On each side of this ballroom are several fine water-works, cascades, grottos, and baths... The garden is laid out in square form, each side of which is 2,600 common paces in length. The stables, which were repaired in 1729 with the addition of a second story, which may properly be called the old treasury, are full of such ornaments as are used to decorate the royal apartments on public days, rich habits, with the arms and furniture of foreign nations.

The bridge over the Elbe, which joins the old to new Dresden, has been lately enlarged and repaired, with so many additional ornaments, that it may be said to be the finest in all Europe. I speak of bridges over large rivers; and indeed many elegant small bridges, such as that over the Tiber near the castle of St. Angelo at Rome, cannot come in competition with it. The length of this building is 685 common paces, and the breadth 16 or 17 such paces, including the raised foot-way on both sides. There are several round projections with seats in them on each side of the bridge, and a fine iron balustrade all along. On the fifth pilaster on the right hand, in coming from the new city to the old, the arms of Poland and Saxony are neatly cut in stone; they are supported by two statues representing Poland and Saxony...

For the more convenient intercourse between the towns, a new gate has been built on the new Dresden side, near the old one; and carriages going toward the old town pass through the old gate, keeping on to the right-hand side of the bridge; and all that come towards new Dresden keep on the other side, and pass thro' the new gate. By observing this rule all stoppages and quarrels are prevented. This bridge consists of nineteen arches; and over every pier are four pedestals, with a stone urn on every pedestal. It is also very beautifully illuminated at night.

Travels through Germany, Bohemia, Hungary,... London, 1756. JOHN GEORGE KEYSLER
October 1730

...The 17th. I reached Dresden, which is only fifteen miles from Meissen, through the most beautiful line of country I have seen in Germany; it is all hill and dale, corn, vines and meadows along the banks of the Elbe, a continued picture; the river is every where seen to advantage, with the beautiful circumstance of the banks being high and woody; a more entertaining picturesque scene can hardly be viewed.

Dresden I easily conceive, was before the destruction of the suburbs, one of the finest cities in Europe; but the Prussians have much reduced the beauty by burning down a great part of the most beautiful quarters of it. The old city is fortified in a regular manner; the bastions are of stone; and there is a double ditch, but yet the strength of it is nothing, unless the garrison be very numerous: The river Elbe divides it into two cities, the old and the new. The bridge over that river, which is built of stone, is reckoned the finest in Germany, but no person who has seen that at Westminster will think there is either beauty or magni-

ficence in it. It is 540 feet long, 36 broad and consists of 19 arches. The electoral palace is not a very striking building for the beauty of architecture, but there are many fine and spacious apartments in it, very splendidly furnished.

The Romish chappel is one of the finest edifices at Dresden; it is a well-proportioned and magnificent building, most highly ornamented: It was built for the private use of the late King and his court.

...The chamber of curiosities has yet a great many very beautiful models and toys, which cannot fail entertaining any traveller; and the collection which they call the Kunstkammer, which is chiefly of natural rarities, equal to anything I have seen... The gallery of pictures is equal to most that are to be seen in Italy, and are kept in admirable preservation... The Indian palace, of which several writers have given long accounts, is in my opinion a very silly affair; and by no means even elegant. Count Brühl's famous palace suffered most severely in the war... The picture gallery is one of the finest rooms I have any where seen.

...The 12th I set out from Dresden, and got to Lentmeritz in Bohemia, in two days, passing through Pirna and by the famous castle of Koningstein. Pirna is a little place among the mountains, and Koningstein is a castle situated on the top of a rock, three hundred feet high, and half a mile in circumference... The country is in general very wild and romantic, and the views of the Elbe running through such a region of mountains extremely grotesque. There are some vineyards planted upon southern spots of these mountains, where the grapes ripen tolerably, but the wine is not drinkable to those who have been used to that which is good.

Travels through Holland, Flanders, Germany... in the years 1768, 1769, 1770, London, 1772-6.

JOSEPH MARSHALL
June-July 1770

...The country of Saxony is very beautiful, the city of Dresden very pretty, and the court one of the most amiable in Germany; strangers no where receive greater civilities: the women are mild, lively, and witty; the climate is fine; the environs pleasant; the fare delicious: it is indeed a charming country, and the Saxons would be too happy if they had not a hero for their neighbour. Ah! dreadful is the neighbourhood of a hero or a volcano! The situation of Dresden resembles that of Portici; and the inhabitants tremble at a menace of Frederick, like those of Portici at a rumbling of Vesuvius. An old woman spoke to me of the bombardment of the city in the last war, with the same horror of recollection, and almost in the same terms, as an old man of Portici spoke to me of the terrible eruption in 1768. Travellers in general make too short a stay at Dresden, and they are in the wrong. It is a country highly interesting to all who are fond of natural history, pictures, and the beauties of nature of every kind. If the Prussians are the Macedonians of Germany, the Saxons are its Athenians. I have scarcely seen a country where there is more taste, or more cheerful and agreeable society.

Letters from an English Traveller, London, 1778.

MARTIN SHERLOCK
1778

...Dresden is a delightful city. Situated in a plain, it is surrounded, at a distance of two or

three miles, by low hills, like the ring of Saturn, which reflect the rays of the sun and shelter it from the winds, so that the climate there is less severe than elsewhere in the vicinity. Vines grow and wine is made in this area around the city, although further south, towards Bohemia, the vines cannot withstand the harshness of winter. The wines commonly drunk here, however, are Rhenish wines, and they are excellent. Here also you may have sea fish, and oysters from the ocean into which flows the Elbe, which is like the Adda. This river divides the city into two parts which are united by a fine bridge, not a heavy construction such as the Germans usually build. The Catholic church, which belongs to the court, is beautiful. The city church, which is Protestant, is like S. Lorenzo in Milan. The houses are almost all solidly built of stone; they are well-furnished, and everything suggests a civilized nation. If you go into a shop to spend your money in Vienna, you are received as a nuisance, or worse: here the inhabitants are extremely solicitous, extremely polite, and although it is a law of nature that foreigners should be gulled, here at least one is gulled with civility and a good manner.

Carteggio di Pietro e di Alessandro Verri dal 1766 al 1797, Milan, 1923. ALESSANDRO VERRI

...Dresden, though not one of the largest, is certainly one of the most agreeable cities in Germany, whether we consider its situation, the magnificence of its palaces, or the beauty and conveniency of the houses and streets. This city is built on both sides of the Elbe, which is of a considerable breadth here. The magnificent and commodious manner in which the opposite parts of the town are joined adds greatly to its beauty.
There is an equestrian statue of King Augustus, in a kind of open place or square, between the old city and the new. The workmanship is but indifferent; however, I was desired by our Cicerone to admire this very much, because — it was made by a common smith. I begged to be excused, telling him that I could not admire it, had it been made by Michael Angelo. Few princes in Europe are so magnificently housed as the Elector of Saxony. The Palace and Museum have often been described... I will not enumerate the prodigious number of curiosities, natural and artificial, to be seen there. The picture gallery is famous. Several volumes would be needed to enumerate the individual merits of all the paintings to be seen there, and a greater knowledge of art would be necessary to appreciate them at their true worth. Many of the houses still lie in rubbish; but the inhabitants are gradually rebuilding, and probably all the ruined streets will be repaired before a new war breaks out in Germany.

A View of Society and Manners in France, Switzerland and Germany, London, 1779. JOHN MOORE
1779

...Dresden is not such an out-of-the-way place that I need to describe it. I can tell you that great is the cleanliness here, and no less the splendour of the court. And I know that the erudite eyes of Milady could find here much food for thought, to see the precious enamels, the many fine diamonds which shine in the treasury of the King; the beautiful porcelain from Japan, from China, and the local ware, preserved in a palace called Holland, which is one day to be covered with porcelain tiles, as are some buildings in China.

Opere scelte, Milan, 1823. FRANCESCO ALGAROTTI
1739

147. BERNARDO BELLOTTO:
View of Dresden (detail). Dresden,
Gemäldegalerie.

The view from the Japanese Palace looking over the Elbe to the old city (Altstadt). It shows the Augustusbrücke and the dome of the Frauenkirche on the left and the Hofkirche on the river, with the unfinished tower by Chiaveri. Bellotto painted this view in 1748.

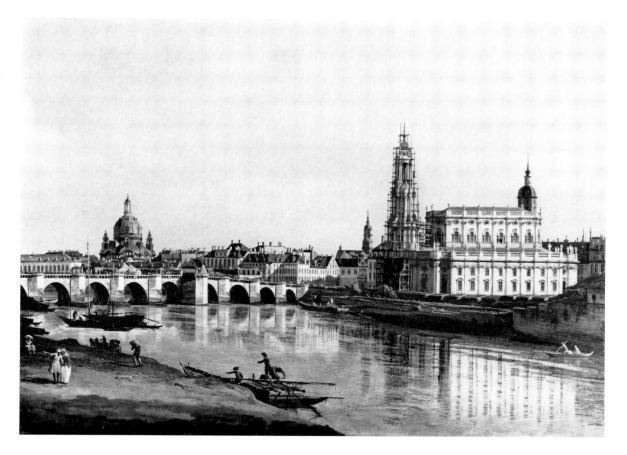

148. BERNARDO BELLOTTO:
View of Dresden (detail). Dresden,
Gemäldegalerie.

A view from the left bank of the Elbe showing the Hofkirche in the centre with the tower scaffolding still in place. On the left, beside the church, is the Royal Palace, which was rebuilt in 1717-19. The tower of the old sixteenth-century building remains, which dates from 1534. This painting also is of 1748.

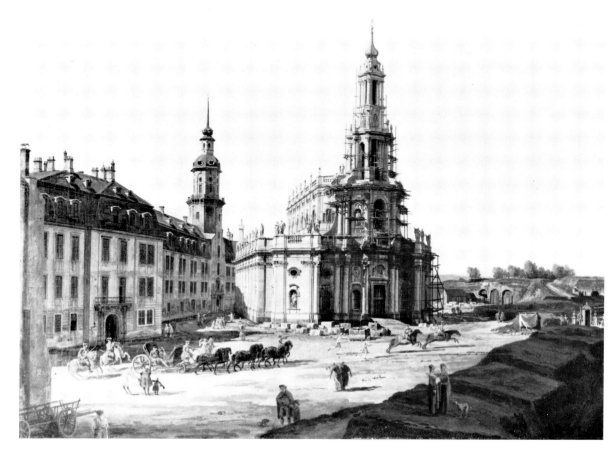

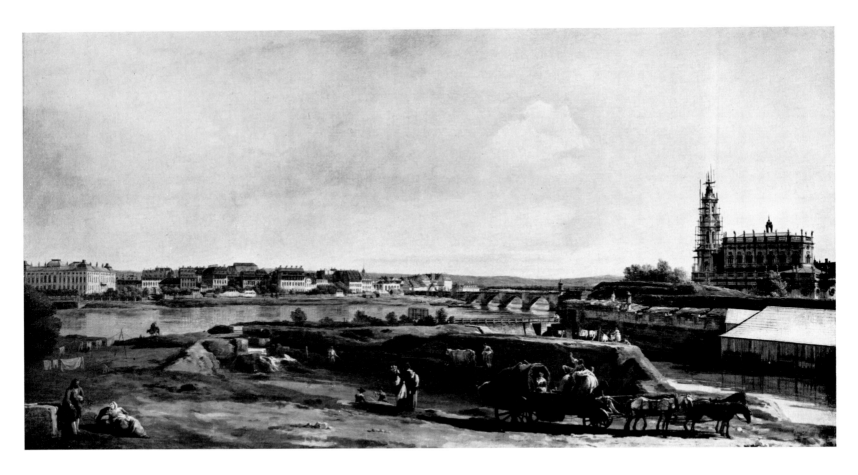

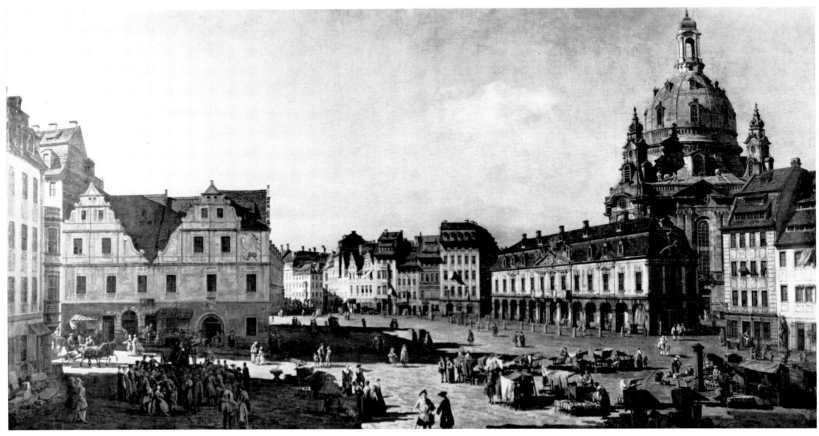

149. BERNARDO BELLOTTO:
View of Dresden. Dresden, Gemäl-
degalerie.

A view from the left bank of the
the river just outside the city. The
Neustadt is on the left, the Augu-
stusbrücke and the Hofkirche can
be seen on the right.

150. BERNARDO BELLOTTO:
*The Neumarkt, Dresden, from the
Moritzstrasse*. Dresden, Gemälde-
galerie.

On the right is the dome of the
Frauenkirche and in front of it the
Guardhouse by Fesch. On the left
are the twin gables of the ware-
house built in 1591-2 by Paul
Buchner, with stalls for butchers
and shoemakers. Both the ware-
house and the Guardhouse were
demolished in 1791. On the right
in the foreground is the so-called
Turkish Fountain.

151. BERNARDO BELLOTTO:
*The Courtyard of the Zwinger, Dre-
sden* (detail). Dresden, Gemälde-
galerie.

The view is from the Wallpavil-
lon looking towards the city. In
the centre is the Stadtpavillon
which was joined, by galleries and
arches, to the Deutscher Pavillon
on the left and to the Zoologi-
scher Pavillon on the right.

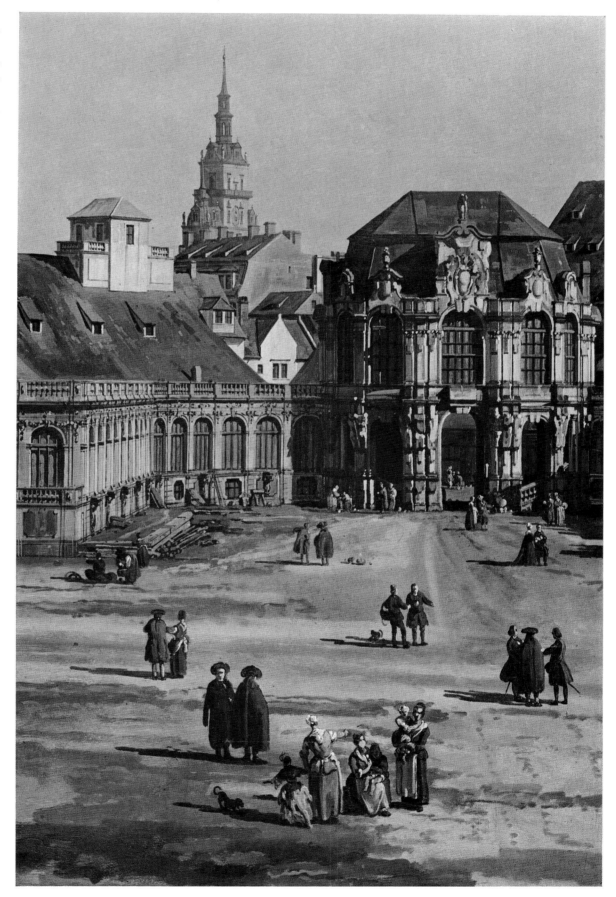

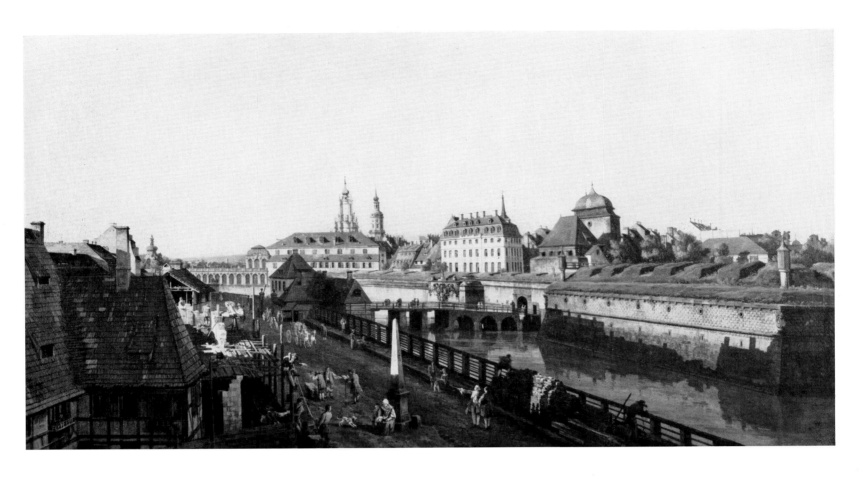

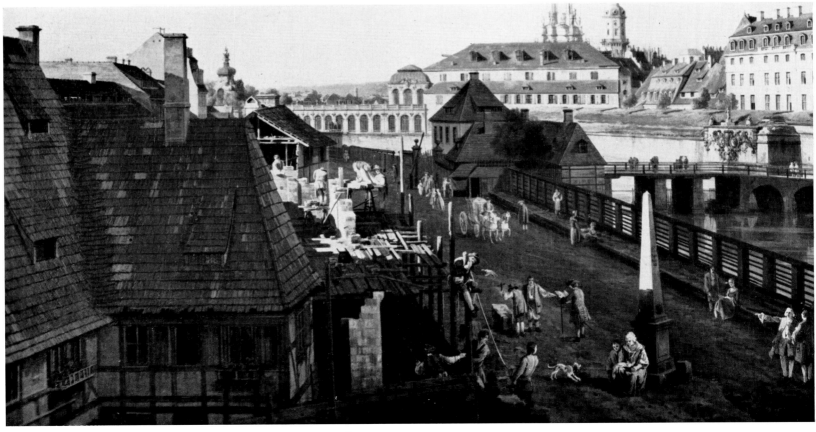

152-153. BERNARDO BELLOTTO:
The old Fortifications of Dresden
(view and detail). Dresden,
Gemäldegalerie.

The view from the south-west,
close to Annengasse, looking to-
wards the old fortifications. On
the right is the Saturnbastei. The
bridge over the moat leads to the
Wilsches Tor, to the left of which
can be seen the Adamisches Haus
(1744). On the left in the distance
is the Opernhaus built by Pöppel-
man in 1719, behind which rise
the towers of the Royal Palace and
the Hofkirche. On the left in the
foreground workmen are building
a house and on the road beside
the river is a milepost (1726).

154. BERNARDO BELLOTTO:
The Marketplace, Pirna (detail).
Dresden, Gemäldegalerie.

The marketplace is overlooked by
the Rathaus. The tower above the
east gable was built in 1718 to
replace one which had fallen into
ruin. Behind the Rathaus is the
Marienkirche, dating from the
first half of the sixteenth century.
The older, south-west, tower was
begun in 1466. The baroque style
of the belltower is very evident.
Opposite the viewer is the so-called
' house of Canaletto '; the gable
of the front is not the original
construction of 1520.

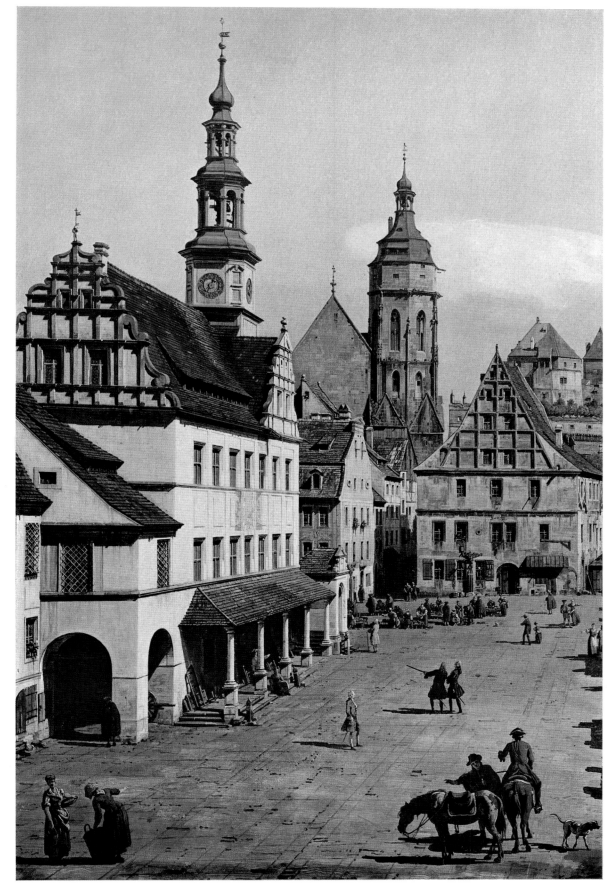

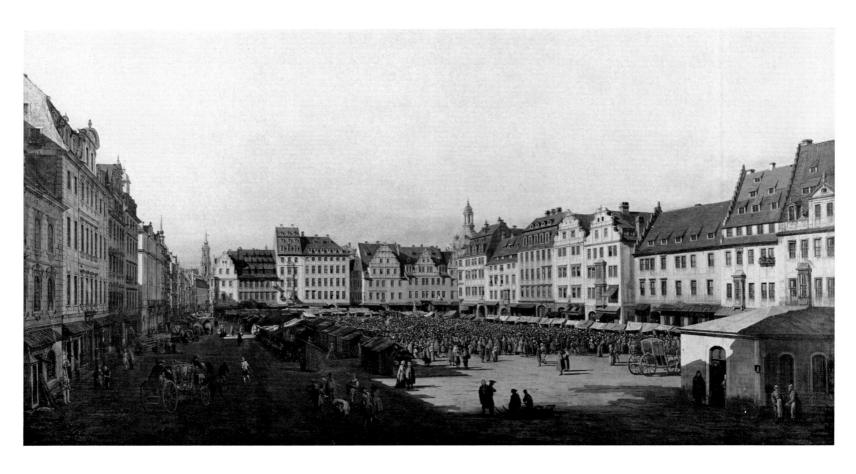

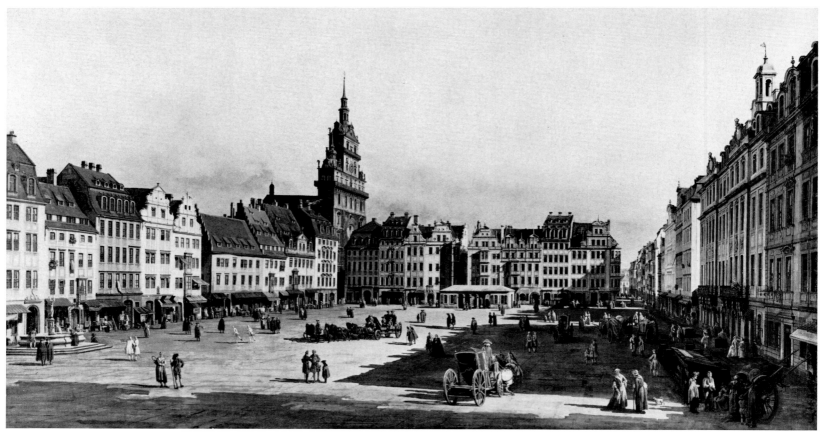

155,157. BERNARDO BELLOTTO:
The Altmarkt, Dresden, from See-strasse (view and detail). Dresden, Gemäldegalerie.

On the left of the vast Altmarkt is the Goldener Ring, the inn in which Peter the Great stayed. The street which leads away from the square in the background to the left is Schlosstrasse, at the end of which can be seen the Hofkirche. On the right, behind the corner of the square, the lantern of the Frauenkirche rises above the roofs of the houses. The low building in the right foreground is the Portechaisenhaus, and behind it is the oldest house in Dresden, the Marienapotheke, built before 1491. The crowd of people in the square are attending the weekly market.

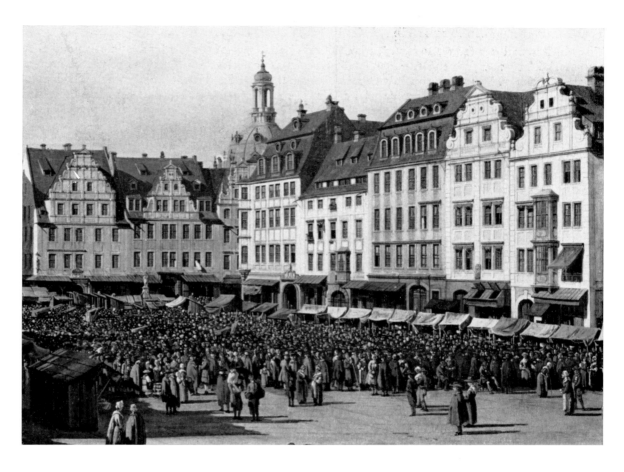

156,158. BERNARDO BELLOTTO:
The Altmarkt, Dresden, from Schlosstrasse (view and detail). Dresden, Gemäldegalerie.

The view is dominated by the Kreuzkirche on the left, with the tower built between 1579 and 1584. Seestrasse, on the right, leads into the distance. On the left in the foreground is the Fountain of Justice by Christoph Walther (1653) which was demolished in 1888. On the right, the west side of the old market, is the Municipal Palace, designed by Fehre and Knöffel, built in 1741-4. The Altmarkt, reconstructed after its destruction by bombing on 13 February 1945, adheres in its dimensions to the original plan of the square.

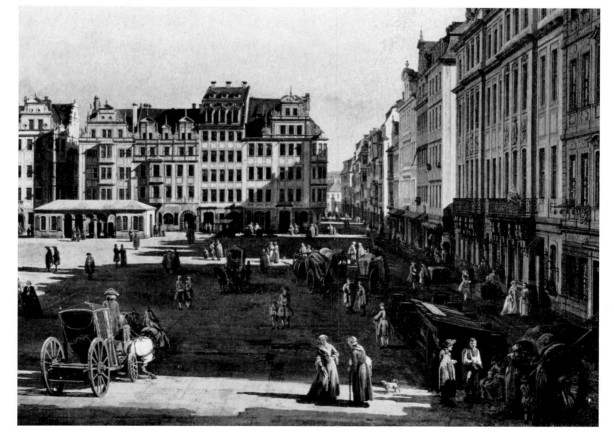

159. BERNARDO BELLOTTO: *The old Kreuzkirche, Dresden*. Dresden, Gemäldegalerie.
The old Kreuzkirche from the east. The medieval church was destroyed by fire in 1491 and rebuilding was begun at once. In 1584 the two-storied bell-chamber and the two-storied tower were erected on the ruins of the old tower. Above the bell-chamber can be seen pieces of artillery. In 1589 the sculptor Christoph Walther III decorated the doorway with statues and other ornamentation. In the background on the left is Kreuzgasse, and right of centre is the corner of Weissestrasse and the Witzthum-Rutowski Palace built by Pöppelmann in 1719. The painting was executed before 1754.

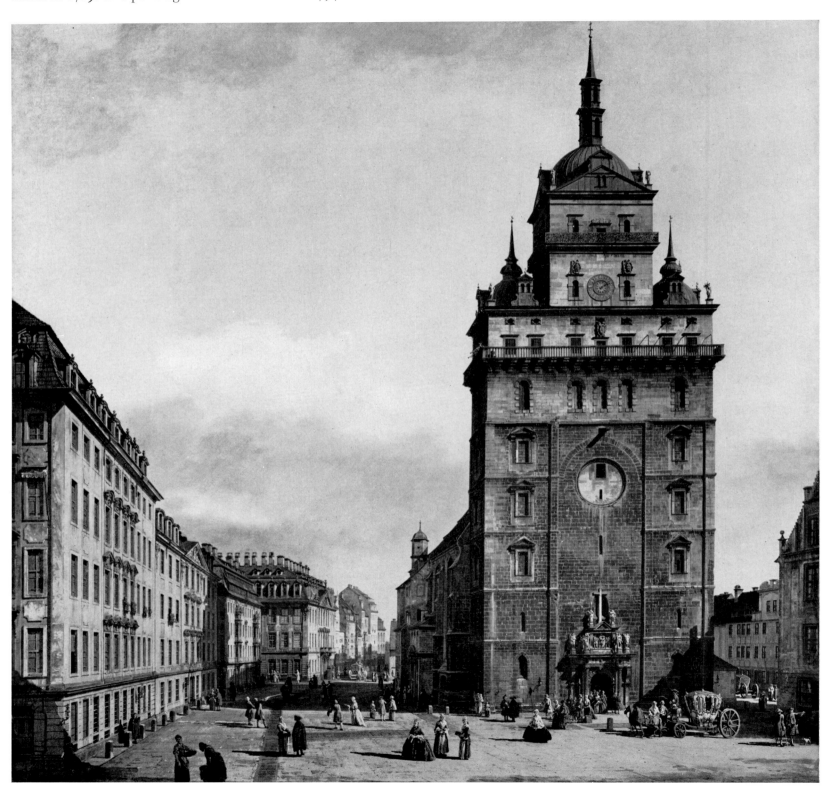

160. BERNARDO BELLOTTO: *The Ruins of the old Kreuzkirche* (detail). Dresden, Gemäldegalerie.
The painting is dominated by the ruins of the Kreuzkirche, whose choir and nave were destroyed by Prussian artillery fire in 1760, leaving intact the lower part of the tower. It was decided to rebuild the church in 1764, but in the following year the east part of the tower was destroyed. Bellotto shows in this view the pile of rubble during the strenuous work of demolition. The painting is signed and dated 1765.

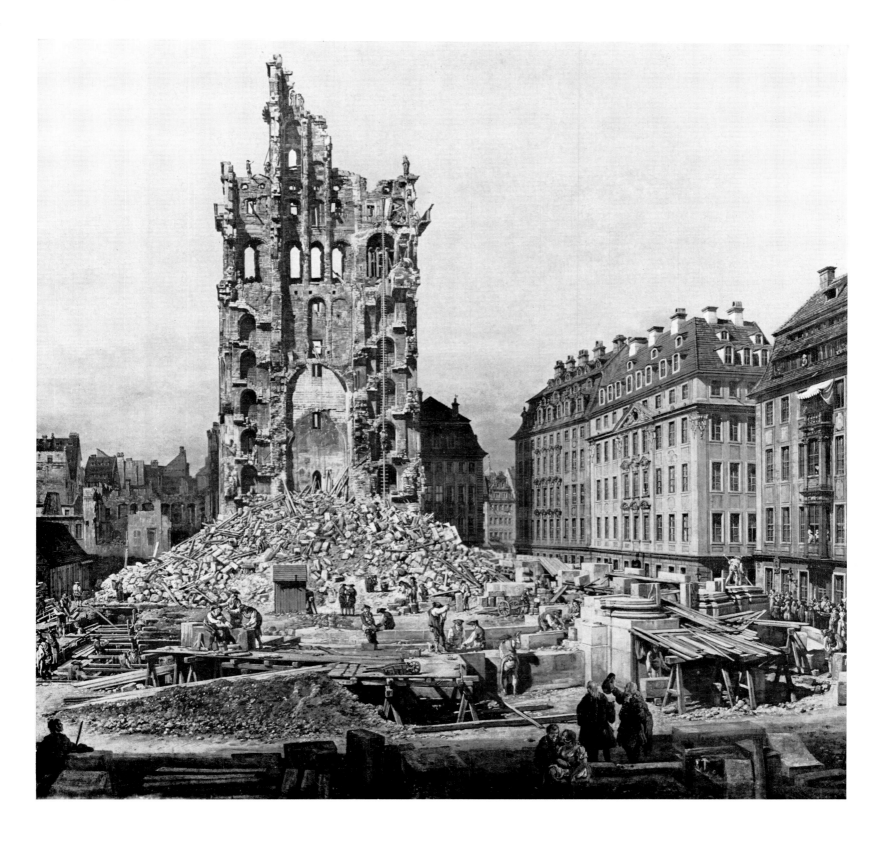

161. BERNARDO BELLOTTO: *The Frauenkirche, Dresden* (detail). Dresden, Gemäldegalerie.

The view from beside the Frauenkirche, which can be seen on the left. In the distance can be seen the Curlandia Palace, at the end of the Rampische Strasse, built by Knöffel in 1729. In the centre, beyond the Frauenkirche, is the Haus zur Glocke, built by Georg Bähr in 1711. In the right foreground is a group of choirboys from the Kreuzkirche. The painting was executed before 1754.

162. BERNARDO BELLOTTO: *The Sonnenstein Fortress near Pirna*. Dresden, Gemäldegalerie.

The view from the hills on the left bank of the Elbe near the fortress of Sonnenstein, which can be seen on the right. Pirna is hidden in the valley below, among the trees above which rises the Marienkirche. The wide view over the valley of the Elbe shows the towers of Dresden on the horizon. This canvas, like the other paintings of Pirna, was executed before 1755.

163. BERNARDO BELLOTTO: *Pirna seen from Posta*. Dresden, Gemäldegalerie.

The town of Pirna, about 15 kilometres south-west of Dresden, is shown from the village of Posta, on the right bank of the Elbe. On the left the fortress of Sonnenstein on its hill dominates the town, and at the foot of the hill is a village of boatmen. Among the buildings of Pirna stand out the Marienkirche and the tower of the Rathaus.

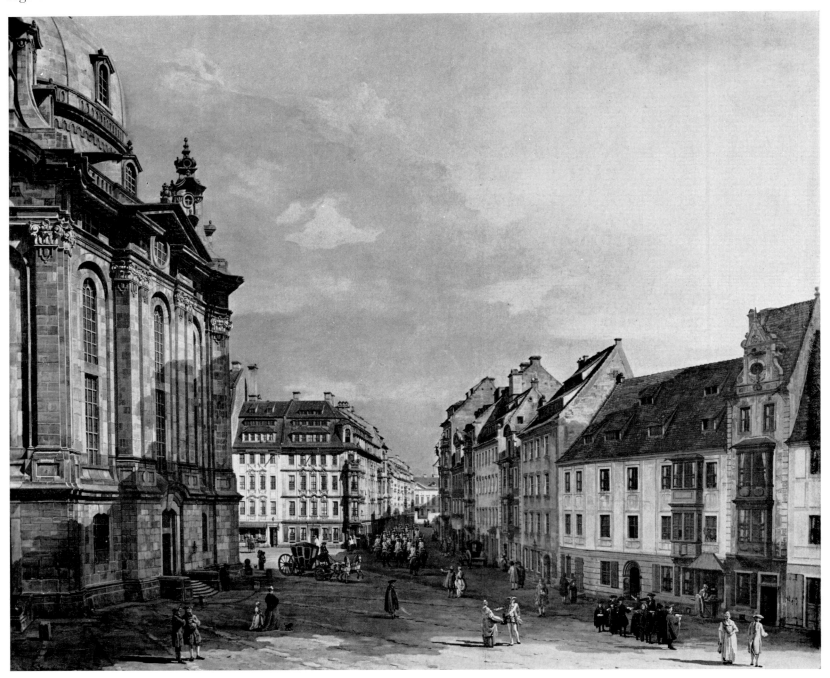

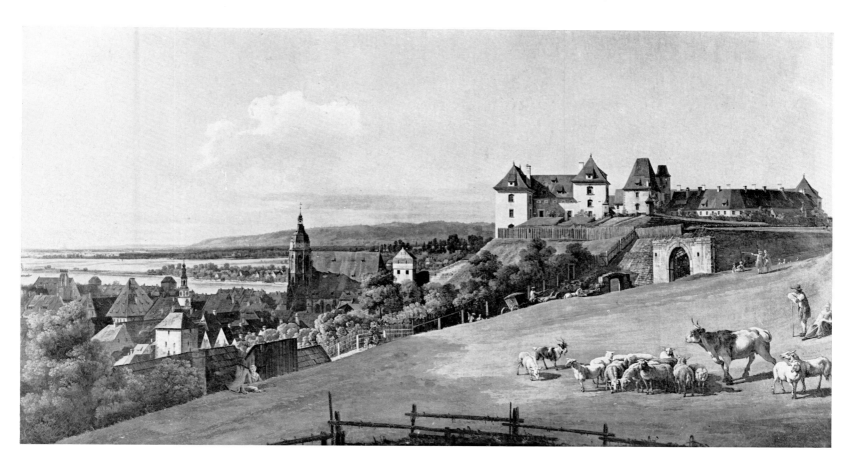

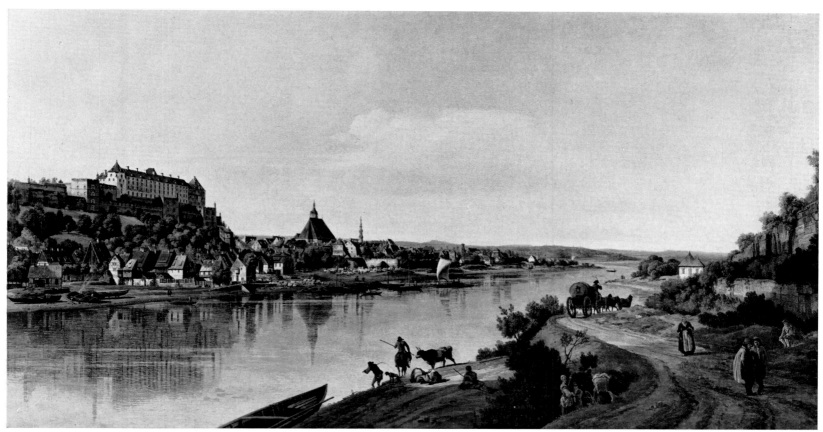

164. BERNARDO BELLOTTO: *Pirna, the boatmen's village* (detail). Dresden, Gemäldegalerie.
Painted between 1752 and 1755, the view shows the village of boatmen's houses outside the gate to which it gives its name, at the foot of the fortress. In the foreground is a little landing-place.

165-166. BERNARDO BELLOTTO: *Pirna from Kopitz* (view and detail). Dresden, Gemäldegalerie.
Pirna and the Sonnenstein fortress from the right bank of the Elbe near the suburb of Kopitz. The tower of the fortifications and the Krone can be seen in the town, behind them the pitched roof of the monastery, a fourteenth-century building, and to the left of the Krone is the tower of the Elbe Gate. The view was painted between 1752 and 1755.

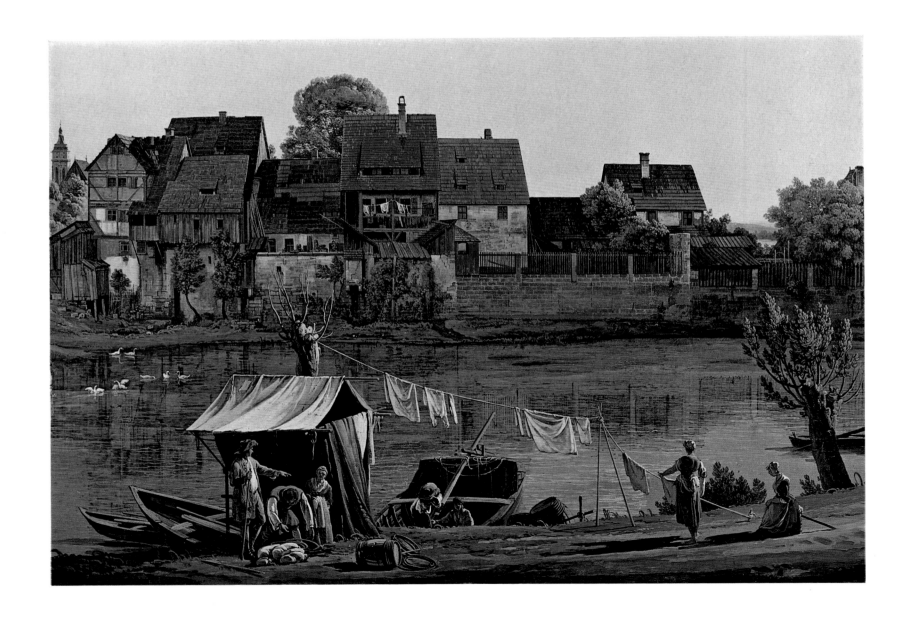

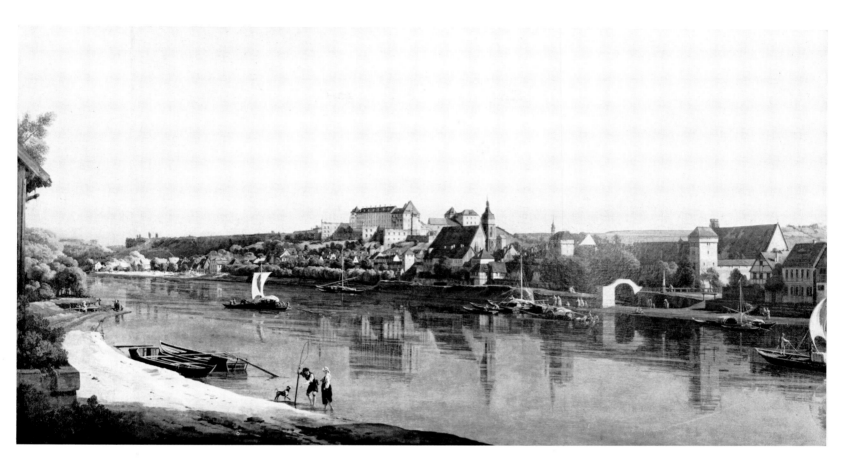

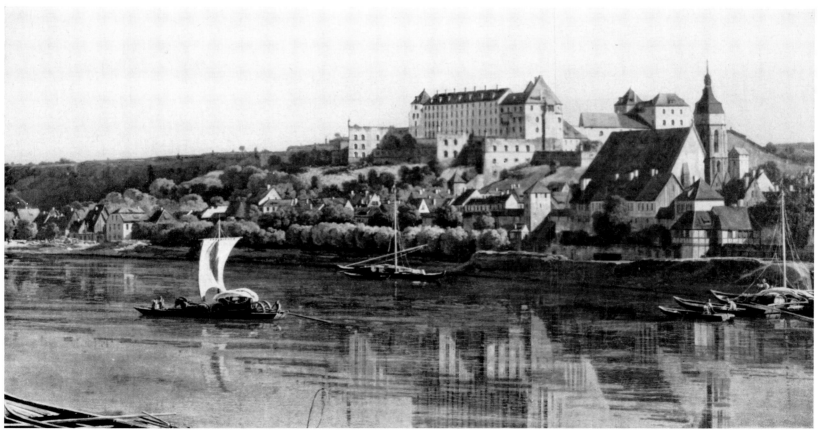

167. BERNARDO BELLOTTO: *Pirna from the vineyards near Posta* (detail). Dresden, Gemäldegalerie.
A detail from a general view of Pirna and the Elbe near the town, showing the boatmen's village and part of the town dominated by the Marienkirche and the tower of the Rathaus. Painted between 1752 and 1755.

168-169. BERNARDO BELLOTTO: *Pirna from the West* (view and detail). Dresden, Gemäldegalerie.
A view of the town from the west, showing the Dohnaisches Tor on the main road, to the left; the stone parapet surrounds the fortifications. Beyond the wall, among the trees, lies the town with its characteristic towers, and on the right, in full light, is the Sonnenstein fortress with the Kemnate to the left and the military headquarters to the right. The painting is of 1752-5.

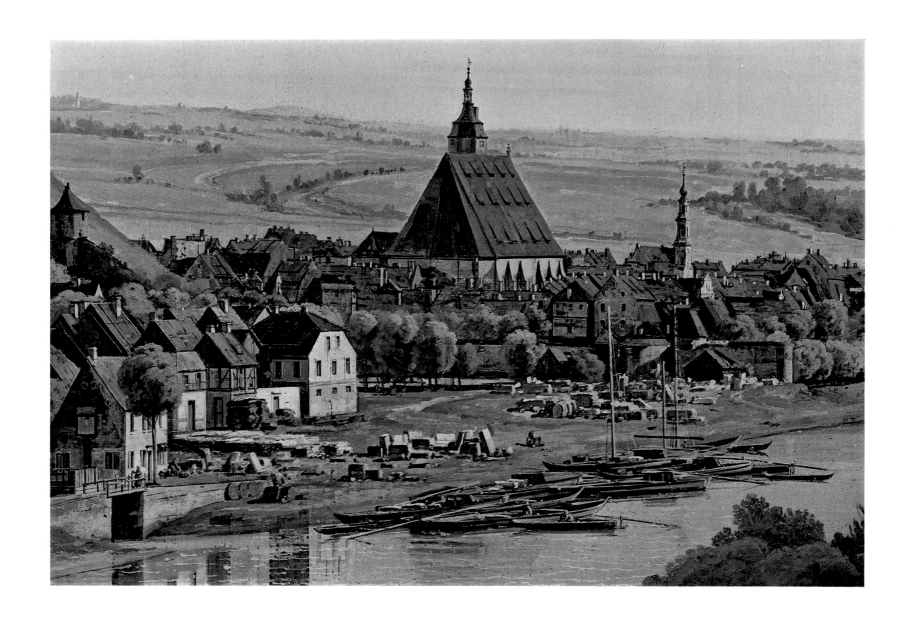

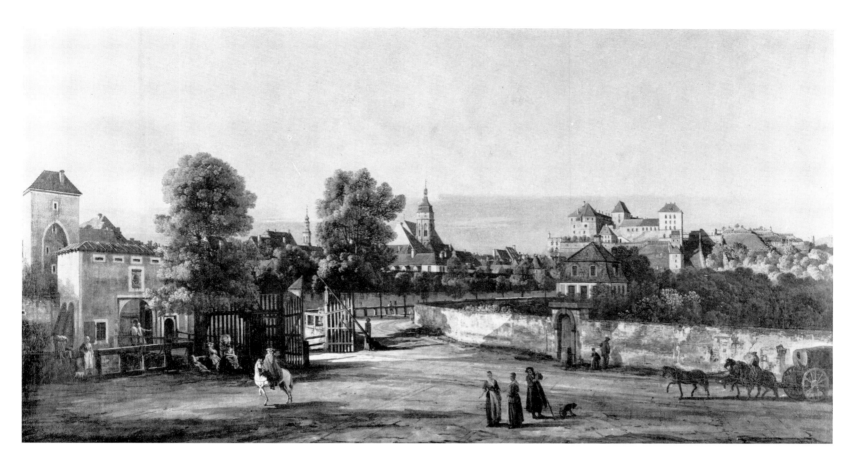

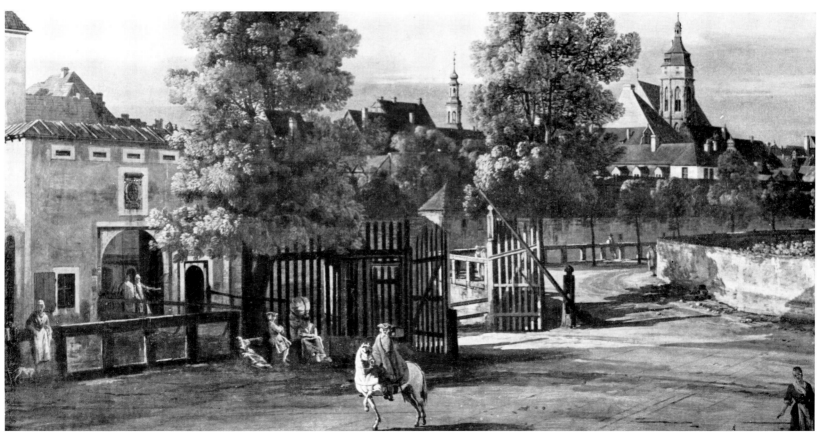

170-171. BERNARDO BELLOTTO: *The Breitegasse, Pirna* (view and detail). Dresden, Gemäldegalerie.
The view shows part of the Breitegasse outside the fortifications of the town, leading to the Dohnaisches Tor. On the right are the Son-nenstein fortress and the Marienkirche, in the left foreground is an obelisk milestone. This painting was executed between 1752 and 1755.

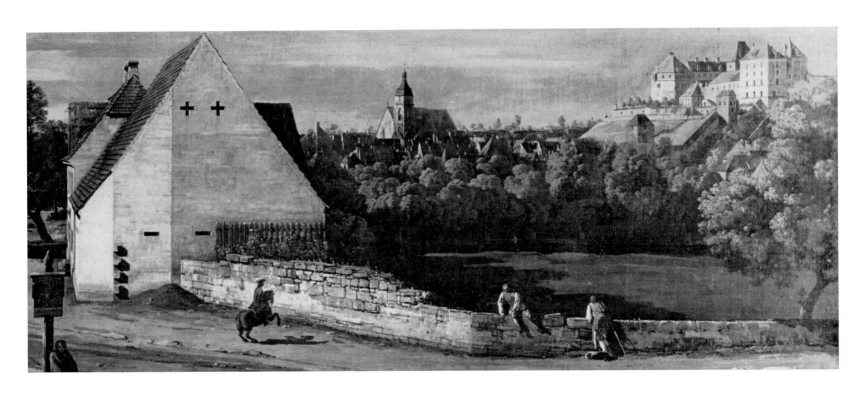

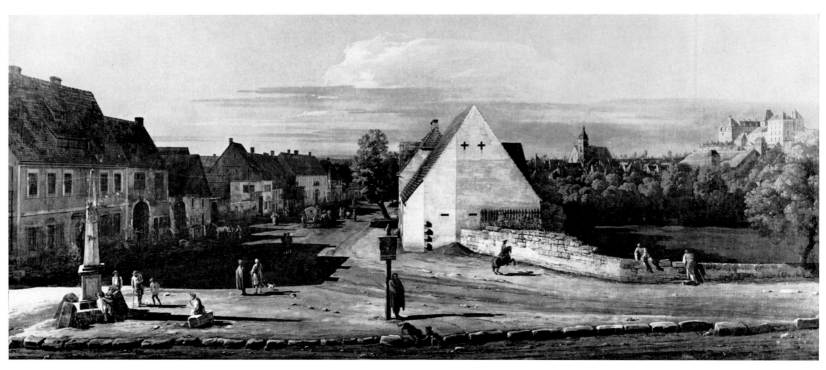

HAARLEM AND AMSTERDAM

...If the situation of Amsterdam is duly considered, it may be said to be one of the wonders of the world. It stands so low that it would be continually in danger of being drowned, were not the water kept out by dykes as high as the waves. The river Amstel, so gentle that one can hardly perceive which way it runs, passes across the whole city and forms the great canal, over which there are two bridges. That at the mouth of the sea, called the New Bridge, is one of the finest of its kind, not only for its sluices, but for the magnificent spectacle thence of the harbour, where ships are continually going out or coming in from all parts of the world. Besides the great canal, there are others worthy of mention: the Emperor's Canal, the Lords' Canal and the Prince's Canal. All these canals are broad and deep and quays run alongside. The banks are faced with stone and brick and adorned with lime-trees and elms. Very fine houses are built on most of these quays, especially on the quay of the Lords' Canal.

...After I had been to the Town Hall, I went to see the square where the merchants assemble about the affairs of their trade from noon till half past one o'clock. This square, which is longer than it is broad, is surrounded by a large open gallery or corridor, supported by stone pillars, which serves as shelter in case of rain. This place is called the Exchange, and here are to be seen merchants of all nations, the diversity of whose clothes and language is no less pleasing than the beauty of the place. Above all, nothing is more interesting than to witness the hurrying of those who are called brokers, who are the men employed by the great merchants to traffic for the bills of exchange, or to transact their other affairs. To see them scurrying from one part to another all over this square, anyone would think that they were mad.

...After having admired everything that witnesses to the wealth of its inhabitants, I have arrived in Amsterdam, this modern Tyre, the mistress of commerce, the warehouse of the world, and one of the finest, greatest and most wealthy cities in Europe. It contains both sacred and profane edifices which are magnificent, but at the same time (for I speak freely), they retain something bourgeois about them which one does not feel in the buildings of Venice and Genoa, where the architecture is of sublimer taste because there the nobility govern. The things that are truly great and noble in Amsterdam are its ramparts, faced with brick, and the broad and deep ditches with which it is encompassed. Amsterdam is the only city in the world which may be compared in any measure with Venice, for although it is not built as Venice is, in the midst of the sea, it stands as that does upon piles. Like Venice, it consists of a vast number of islands, and its principal streets are the canals, which have also the advantage of spacious quays along their banks, planted with trees, whereas at Venice the water is enclosed by the houses themselves. That I take to be all the resemblance there is between these two rivals in commerce, for as to the beauty of the buildings there is no comparison; one Canal Grande and one Cannaregio being worth more in this respect than the whole of Amsterdam. There are palaces, here are houses, which are neat, genteel and pleasant but lack any architectural style and are built in brick. Formerly the manner of building of the inhabitants of Amsterdam was very extraordinary. Most of the old houses that are still in existence stand upon stilts, which I will explain: the front of the first floor, on the level of the ground, is commonly all of windows separated by wooden pillars, which support all the masonry of the other floors, which fortunately for them are very light; for there is seldom a wall more than two bricks in thickness, and the ceilings are nothing but boards, so that the people on the first floor cannot speak without being heard on the second... I cannot imagine how houses so light can stand, and some of them are so slanting that they suggest dancers rather than houses. A number of these houses have recently been set upright. The principal adornment of these houses is their windows; no other country has such fine glazing, and many of the houses have polished plate-glass.

The Senate meets in the Stadthouse. This edifice, so much celebrated for its magnificence and because it contains the richest bank in the world, is indeed a stately building, and though it has defects it may be ranked among the finest structures in Europe. It fronts a square called the Dam, in the centre of the city. The building is almost a complete square, with pavilions at each angle. In the middle of the main façade there is a projecting building which occupies one third of the front and is decorated with seven porticoes so small that they disfigure the whole of this great mass of architecture. Notwithstanding this defect, it is certain that a foreigner, if he is not intent upon comparing this Town Hall with the Palace of Versailles or the Escorial or the Procuratie Nuove, and when he looks at it thinks that he beholds a municipal building and not the palace of a king or the seat of government of a powerful state, will gaze on it with admiration, especially if he considers that all the materials used in this building had to be brought from other countries.

...One of the finest walks in the city is the bridge which joins the ramparts from one side of the Amstel to the other. It is six hundred and seventy feet in length, and here one enjoys an admirable prospect which is perhaps the only one that can be compared with the view from the Pont Royal in Paris.

Lettres et mémoires, London, 1747.

CHARLES LOUIS POLLNITZ
December 1732

...Amsterdam appears to no great advantage to a stranger on his first coming into it, unless he makes his way through the Heerengracht or the Keizersgracht streets: that of Haarlem is very long, but the sluices in the canal hurt the effect of it; the two former have also canals in the middle of them, and are very noble streets, but, like most in Holland, are planted with trees. I observed that some of the canals are very broad, and made a fine appearance, but the houses in general are not erected in a grand stile; on the contrary, very many of them disgrace the areas before them; this, though an evil, is in all the cities of Europe, and especially in London. In squares this great city appears to be very deficient; they are few in number, and have nothing in them striking: that called the Dam is the principal, but it is very irregular. It would be graced by the Stadthouse, were it not for a vile old building that disfigures its noble front, and which it is a scandal to the government to leave in its present situation.

But although Amsterdam cannot boast of many fine squares, like several other capital cities, yet it contains some fine public buildings that strike the spectator with astonishment at the magnificence to which trade has here attained... The building which is incomparably beyond all others is the Stadthouse; the front, as given by several authors, for I did not measure it, is 282, the depth is 232 and the height is 116 feet, besides a small cupola; it was begun to be raised in 1648; the front of the building has nothing of taste or elegance in it; it is a heavy pile which strikes the spectator with that idea which is raised by the grandeur of its magnitude... The inside of the building is finished in a very noble stile, considering the purpose to which it is applied, such as a prison, a bank, the seat of the Courts of Justice, the sessions rooms, guard rooms etc. The floors, walls and pillars are in general of marble, and many of the apartments are adorned with very fine paintings by the best of the Flemish masters.

I went to the top of the cupola for a view of the city and neighbouring country, which it gives in great perfection, commanding the whole space built, with the canals and the immense number of ships in the harbour, altogether forming a very noble prospect.

Travels through Holland, Flanders, Germany... in the years 1768, 1769, 1770, London 1772-6.

JOSEPH MARSHALL
1768

...The building is a parallelogram, the internal courtyard with its arcades is convenient, but the architecture is bad: the Ionic columns above the arches of the porticoes are not properly based, the niches and the surfaces of brickwork and stone contrast horribly in colour, and everywhere there are the usual very Gothic windows. But I think there can be no stranger spectacle in all Europe than that presented by the Exchange of Amsterdam. David Teniers, Bamboccio, Leonardo da Vinci, Ostade, Hogarth, would never tire of drawing caricatures there. Every kind of face can be seen, and for the most part so distorted that such variety and such distortion of the features of the human race hardly seems possible. The Jews and the Portuguese are prototypes of ugliness as extreme in their line as the most famous examples of beauty in Greece. Noses large and small, menacing noses, hooked noses, mouths stretching from ear to ear, twisted, protuberant; eyes wide open, eyes half-closed, bloodshot, surly eyes, jutting chins with fat dewlaps, sharp chins, flat chins, double and triple chins; hunchbacks of all kinds, crooked, spindly, lean, swollen, fleshy, knock-kneed legs — in short, in all my long travels I have never seen before gathered together all the ill-composed forms that nature has let fall from her hand here. The strangeness of the apparel corresponds to that of the faces, and it is indeed a wonder to have such men, clad almost in rags, speak to you in terms of millions and of news from the whole globe of the world, and to handle a patrimony, the fortunes of many, in little pieces of paper...

...The architecture of the Stadthouse is noble but has something German about it in the roofs, whose angles are like the section of a solid triangle. The architects of the north will never be able to eliminate the deformity of the great slope which they are obliged to give their gables; they cannot crown them with balustrades nor spread airy terraces such as those on which flourished the hanging gardens of antiquity, and the cornice of the classical order is overwhelmed by the slope of the roof and loses all elegance of proportion. I noted another defect in the porch or vestibule, which has seven arches along the front and two at the sides, and does not provide a magnificent entrance; but I am appeased by the political reasons more than by the mysterious ones. This Pritanaeum is also a strong-point, with prisons and courts, and a roused populace could invade it without difficulty were it easy to enter... The outside is, as I said, full of dignity. The Composite Order provides a great variety of caulicoles to the capitals, which sometimes take the form of a two-headed eagle, or an apple encircled by a serpent, or sometimes a crab, which in ancient medals signified a maritime city. The tympanum of the principal façade contains a richly decorative bas-relief which is over-crowded with figures: tridents, shells, laurel wreaths, coral, gilded unicorns ruin it, and are indicative of rather poor taste in whoever wished for such barbarous sumptuousness. Amsterdam wearing an Imperial crown is drawn in triumph by marine deities trumpeting her renown. Neptune with his trident accompanies her to smooth the waves for the passage of her ships, on a shell drawn by two unicorns. In the tympanum of the front facing the canal is Commerce, wearing the petasus of Mercury, one foot resting on the globe; and in the distance is a ship with full sails, the ancient badge of the city. The Ij and the Amstel, river deities, stand at her feet, men of all nations hasten to bring their wares to offer her in tribute. This bas-relief is better than the other. The two gables are crowned majestically with bronze statues of Peace, Prudence, Justice, Vigilance, and Atlas carrying the globe. But why does there have to be a replica of this Atlas, this same Peace and the other virtues in the Great Hall? There are also festoons which are repeated so often both inside and out that it suggests a sterility of invention on the part of the architect: these could be replaced by panels of other patterns in bas-relief, to vary the decoration. Beauty in ornament consists of harmoniously combined variety. The truth of this philosophical definition is more apparent in architecture than in any other production of the hand or mind of man...

...The praises one reads accorded to the harbour and to the arsenal are exaggerated. The latter certainly is not to be compared with the Venetian arsenal, so well described by our Dante. The armoury is a very poor thing in comparison with those of other ports; the rope-walk, 1,800 feet long, is larger than any I have yet seen in France, in Italy or in England. The arsenal at Venice will always be the most magnificent of all because of the height of its roof and its forest of stout columns. I climbed upon the camels, as they call certain huge vessels which raise the warships and carry them beyond the sands of the 'Pampus'. This is said to be the invention of Cornelius de Witt, the unfortunate victim of popular fury in The Hague; some erroneously attribute it to Peter the Great.

I climbed to the Tackt of the Admiralty, but saw nothing of interest, save for the extreme cleanliness for which the Dutch are famous; and I visited the warehouses of the East India Company... The harbour of the Company is close to the other and the same wall serves both rope-walks. The construction of Dutch ships differs from that of others on account of the sands which obstruct the Zuiderzee, and they have an enormous belly and a certain air of gravity which is in keeping with the phlegmatic character of the nation which steers and controls them.

DELFT

...The town of Delft is not large, but it is beautiful and discreetly enlivened with colour, canals and trees. The Old Palace in which William I, Prince of Orange, was murdered by the infamous Balthasar Gherard, an agent of Philip II, has been converted into a cloth factory and into a school, and the room in one of whose walls were the holes of three bullets which pierced the temple of the unfortunate prince, is no longer shown to visitors. I went to venerate his memory in the church of St. Martin. The monument erected to this great father of his country is indeed magnificent. His effigy lies, in princely attire, beneath a vault upheld by twenty-two pillars of black marble, and at his feet lies the faithful dog which died of sorrow after the assassination of his master. The hero is also depicted in bronze, in full armour except for the helmet with a large crest which lies at his feet. This statue lies above the other one, of marble, which portrays his corpse, so that the illusion of reality which one receives at first glance is to a large extent lost. A statue of Fame, balanced upon one foot, an ambitious conception which approaches that of Giambologna's Mercury, holds a crown of laurel above the warrior's head, and with the other hand holds a trumpet to her lips. The folds of the garments of the goddess are blown by the winds, whose wings, like those of seraphs, form the base upon which the figure is borne, as her foot presses upon them. Other statues representing various virtues adorn the front of the mausoleum, and many ingenious devices and inscriptions in praise of the dead prince are carved upon it. A long epitaph in good Latin recalls the glorious deeds and the unfortunate death of the great William, whom Philip II, the terror of Europe, feared, and failed to conquer or alarm, but by the hand of a hired assassin, with wicked deceit, removed from the world. The mausoleum is worthy of so great a man: the marble and bronze figures could not be better worked — there are some *putti* bearing torches, who are truly weeping; and the principal figure of William has an air of constancy and tranquillity amid the awful tempest.

Ragionamento sulla filosofia del secolo XVIII e frammenti di viaggi, Como, 1830.

CARLO GASTONE DELLA TORRE DI REZZONICO

1788

172. JOB ADRIAENSZ BERCKHEYDE: *An old Canal in Haarlem*. The Hague, Mauritshuis.
Signed and dated 1666, this shows the Oude Gracht, the old canal of Haarlem. Job Berckheyde, with his younger brother Gerrit and Jan van der Heyden, was one of the first artists in Europe to paint views which are accurate, objective and analytical but which catch the subject in a given moment of its history.

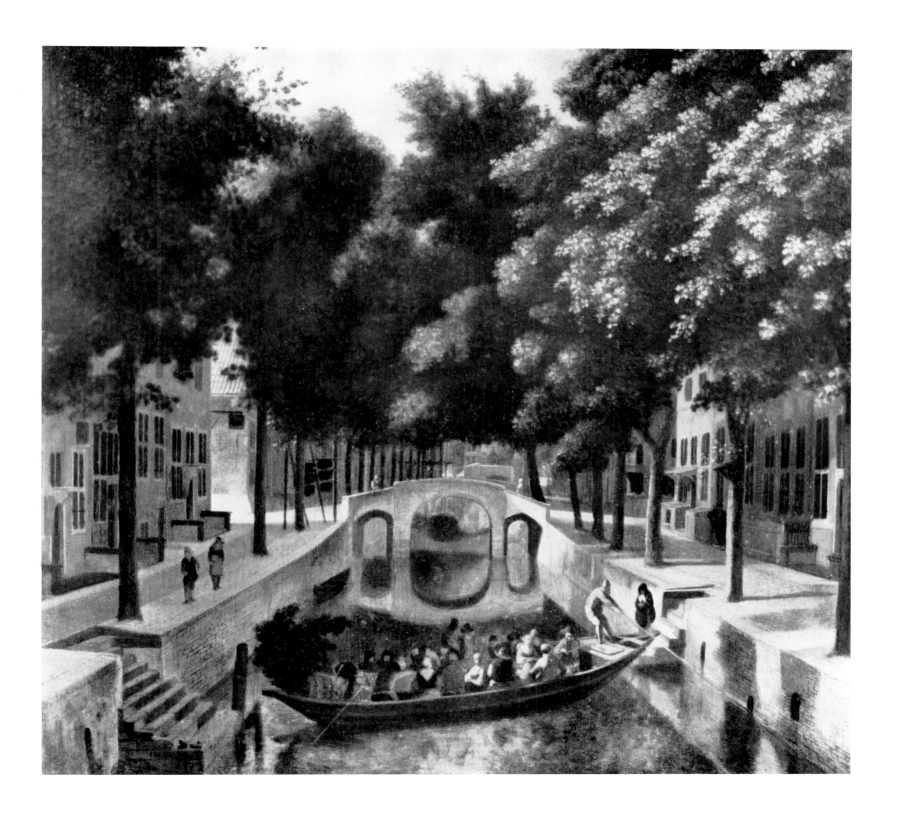

In this view of the old Exchange, as in the other works of the brothers Berckheyde, the city is depicted from an intimate experience of its daily life, sights familiar to those who live there and pass daily through its streets, an approach which clearly heralds that of the eighteenth-century view painters.

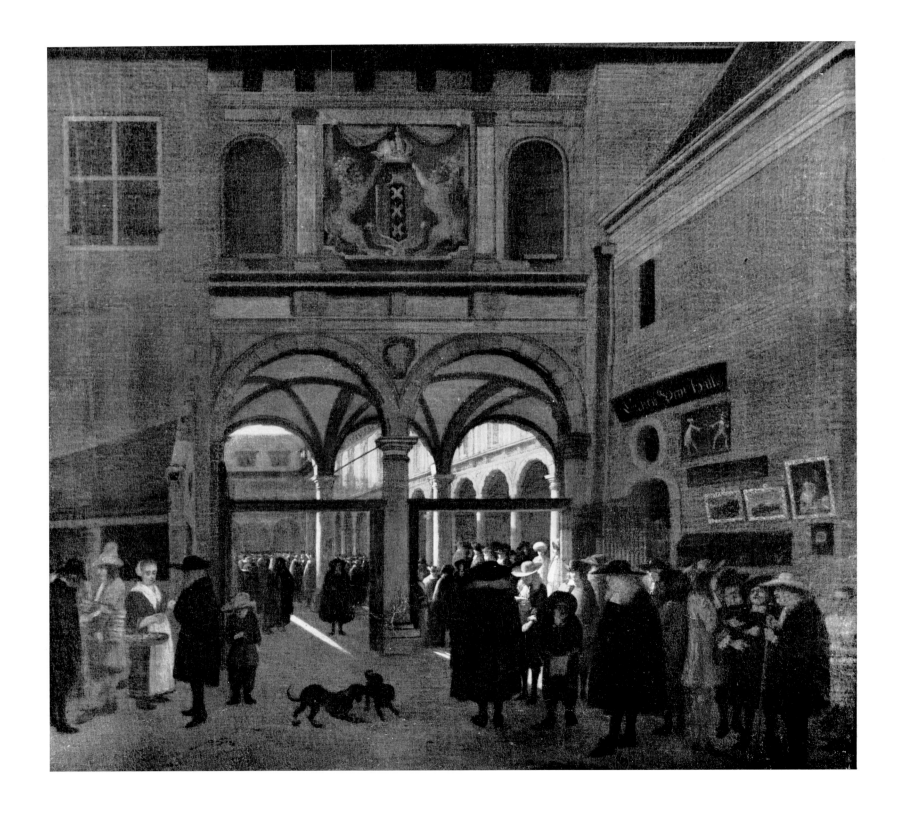

174. GERRIT BERCKHEYDE: *A Square in Haarlem*. Brussels, Musée Royal des Beaux-Arts.
This view of the square in front of the Church of St. Bavo (the Groote Kerk) in Haarlem is among Gerrit Berckheyde's best works.
Painted from a viewpoint in the street, it conveys an impression of the city as it might appear to a passer-by rather than a presentation
of a famous building.

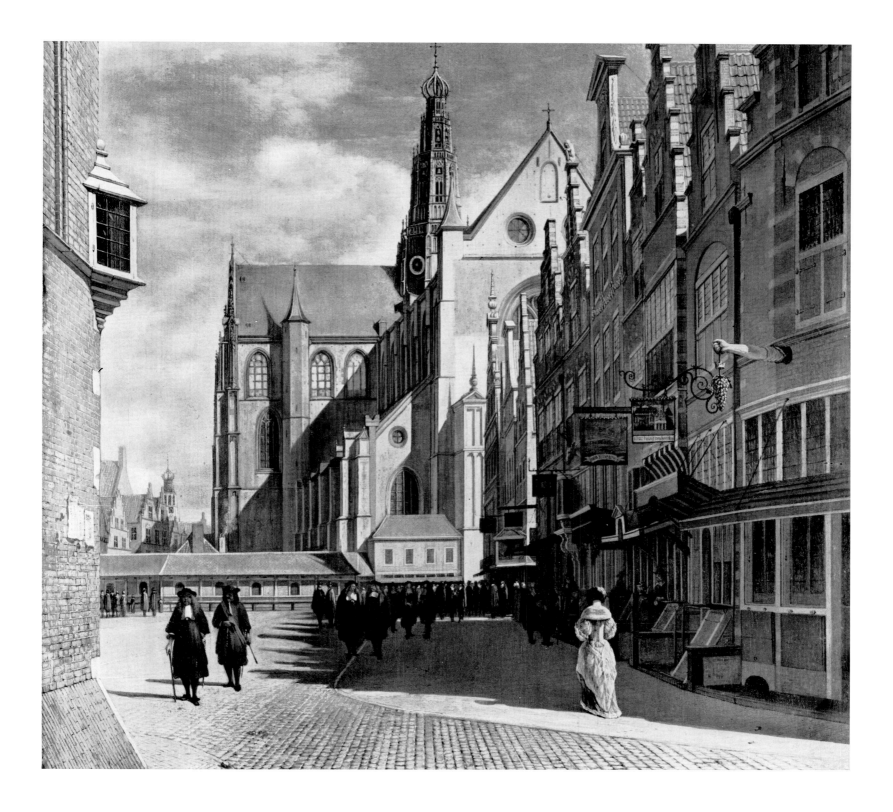

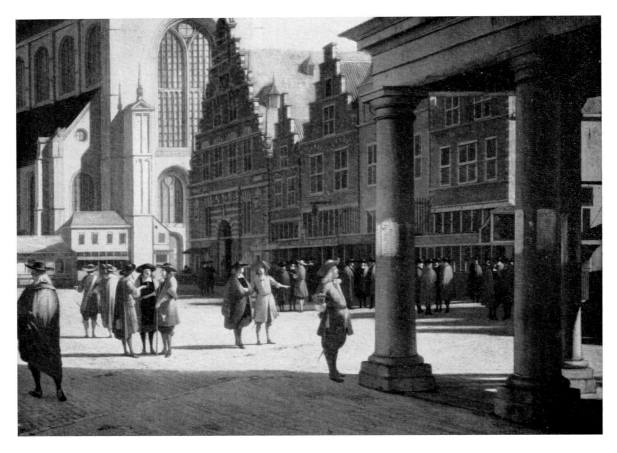

WARSAW

...From Zadrzin is only forty miles to Warsaw, the road running all the way within sight of the Vistula; in some places skirting marshes, but in others all through an arable country. This we travelled the 1st. of May, arriving at that city in the afternoon. It is the seat of government, the capital of the kingdom, and the residence of the King; yet there is nothing striking in it. The streets are many of them crooked and ill paved, the buildings have little of elegance in them, tho' some new ones, few in number, make a tolerable show; these are houses belonging to the Polish nobles, who make Warsaw their winter residence. The royal palace is a noble edifice, being beyond comparison the finest building in Poland. The apartments are very spacious, and some of them new fitted up and furnished in the English manner, being executed by London artists brought from thence at the king's expence: The room they call the Hall of Victory, from formerly having been a hall, is converted into a saloon hung with tapistry from Brussels; the ceiling, panels, door-cases, and window frames all neatly executed in white carving gilt: The rooms are very numerous, and all the offices for a court extremely convenient.

...The fortifications of Warsaw are sufficient to prevent the town being insulted by flying parties, or small armies, but could not stand a siege of any duration against an army well provided; it has two good walls, flanked by many bastions and tolerably lined with artillery; the ditch is broad and deep, and the waters of the Vistula may be let into it at pleasure. Warsaw is populous; being the capital of Poland always brought great numbers to settle in it, which the miserable state of most of the other towns in the kingdom has lately increased very much, so that the number of its inhabitants are computed to be above eighty thousand.

Travels through Holland, Flanders, Germany, ... in the years 1768, 1769, 1770, London, 1772-6.

JOSEPH MARSHALL
May 1770

...I never saw a road so barren of interesting scenes as that from Cracow to Warsaw; there is not a single object throughout the whole tract which can for a moment draw the attention of the most inquisitive traveller.

The country, for the most part of the way, was level, with little variation of surface; it was chiefly overspread with vast tracts of thick gloomy forest; and even where the country was more open, the distant horizon was always skirted with wood. The trees were mostly pines and firs, intermixed with beech, birch, and small oaks. The occasional breaks in the forest presented some pasture ground with here and there a few meagre crops of corn.

Without having actually traversed it, I could hardly have conceived so comfortless a region: a forlorn stillness and solitude prevailed almost through the whole extent, with few symptoms of an inhabited, and still less of a civilized country. Though in the high road, which unites Cracow and Warsaw, in the course of about 258 English miles, we met in our progress only two carriages and about a dozen carts. The country was equally thin of human habitations: a few straggling villages, all built of wood, succeeded one another at long intervals, whose miserable appearance corresponded to the wretchedness of the country around them. In these assemblages of huts, the only reception for travellers were hovels, belonging to Jews, totally destitute of furniture and every species of accomodation. We could seldom procure any other room but that in which the family lived; in the article of provision eggs and milk were our greatest luxuries, and could not always be obtained; our only bed was straw thrown upon the ground, and we thought ourselves happy when we could procure it clean. Even we, who were by no means delicate, and who had long been accustomed to put up with all inconveniences, found ourselves distressed in this land of desolation. Though in most countries we made a point of suspending our journey during night, in order that no scene might escape our observation; yet we here even preferred

continuing our route without intermission to the penance we endured in these receptacles of filth and penury; and we have reason to believe that the darkness of the night deprived us of nothing but the sight of gloomy forests, indifferent crops of corn, and objects of human misery.

The natives were poorer, humbler, and more miserable than any people we had yet observed in the course of our travels: wherever we stopped, they flocked around us in crowds; and, asking for charity, they used the most abject gestures.

The road bore as few marks of human industry as the country which it intersects. It was best where it was sandy; in other parts it was scarcely passable; and in the marshy grounds, where some labour was absolutely necessary to make it support the carriages, it was raised with sticks and boughs thrown promiscuously upon the surface, or formed by trunks of trees laid crossways.

After a tedious journey we at length approached Warsaw; but the roads being neither more passable, nor the country better cultivated, and the suburbs chiefly consisting of the same wooden hovels which compose the villages, we had no suspicion of being near the capital of Poland until we arrived at its gates.

The situation of Warsaw is not unpleasant: it is built partly in a plain, and partly upon a gentle ascent rising from the banks of the Vistula, which is about as broad as the Thames at Westminster-Bridge, but very shallow in summer. The city and its suburbs occupy a vast extent of ground, and are supposed to contain between sixty and seventy thousand inhabitants, among whom are a prodigious number of foreigners. The whole has a melancholy appearance, exhibiting that strong contrast of wealth and poverty, luxury and distress, which pervades every part of this unhappy country. The streets are spacious, but ill-paved; the churches and public buildings are large and magnificent; the palaces of the nobility are numerous and splendid; but the greatest part of the houses, particularly in the suburbs, are mean and ill-constructed wooden hovels.

...The levee being ended, we went over the palace, which was built by Sigismund III and which since his time has been the principal residence of the Polish monarchs. Warsaw is far more commodious for the capital than Cracow, because it is situated nearer to the centre of the kingdom, and because the diet is assembled in this city. The palace stands upon a rising ground at a small distance from the Vistula and commands a fine view of the river and of the adjacent country. Next to the audience chamber is an apartment fitted up with marble, which his majesty has dedicated to the memory of his predecessors the kings of Poland.

Travels into Poland, Russia, Sweden and Denmark, London, 1784. WILLIAM COXE
August 1778

...Warsaw is a rather large city of about 75,000 inhabitants, so ill-paved that it is impossible for horses to trot; the streets are dirty, with no lighting whatsoever, in some places flanked by buildings of considerable beauty but often by houses, or rather hovels, which are quite horrible. The palaces of the nobility are generally large and well-furnished.

Although the streets are in a shocking condition, and the roads leading to the city are covered with mud and dust, the Poles often ride on horseback: they have excellent horses and ride them perfectly.

The Vistula, a river of notable importance, separates Warsaw from the suburb of Praga, which can almost be considered a town in itself, since it has about 15,000 inhabitants; there are no bridges to facilitate communications, or at any rate there were none when we were there, and the river flowed tranquilly without any sign of ice.

The entertainment afforded by the city amounts to very little: a theatre which presented

Italian melodrama and an abominable national theatre. We attended a special concert, which was mediocre. Social life is said to be pleasant; the women have the reputation of being the best educated in Europe, all speak French, as indeed the men do also. This country has a marked aptitude for the study of languages: nothing is more common than a Pole of twenty years who can speak three or four languages perfectly, without a trace of foreign accent. Yet in spite of their famous upbringing, we find the Polish women have a rather brazen air, and besides, they act like young girls, which it appears to be the fashionable thing to do; it is apparently also the fashion to have the hair dressed in a horrible style.

The Royal castle is built on a hill close to the Vistula; it is a simple building, the roads leading to it are not at all convenient and its surroundings correspond perfectly to its extreme simplicity. In the square in front of the castle stands a tall column with a monument to Sigismund. The king's apartments have nothing of interest about them.

...At Lazienki, less than half a mile from Krakowskie Przedmiescie, the king has a villa which is particularly dear to him and which he visits almost daily (the road is truly appalling), and indeed it is believed that he intends to make it his permanent residence. Everything there is on a small scale but care has been paid to the least detail. The amenity of the surroundings of the villa, and the entertainment provided here by His Majesty for the people every Sunday during the summer make it a very pleasant and frequented place at that season. The palace stands on a little island; there are thirteen windows in the façade, with four Corinthian columns in the centre separated from the main structure by a wide terrace, and Corinthian pilasters decorate the whole length of the building; the shorter side has five windows, three of which are encased, with four Corinthian columns in front of it, and on each side there is a curved wing with three windows. The building is on one floor only.

The Primate, the King's brother, owns a palace of which the exterior is imposing and the interior very gracious, its apartments being furnished in fine taste. It houses several paintings among which is a 'Holy Family' attributed to Raphael; the attribution is rather improbable, although it is a painting of some value.

The palace of Princess Lubomirska is also impressive in appearance, and within it is furnished with elegant taste and adorned with many paintings. A palace which is not merely in need of repair, on the other hand, but even of rebuilding is the large Palace of Saxony. It has always been the property of the Elector, but now only a detachment of guards lives there, some old servants of the king, and the Elector's representative. The gardens, together with those of the Commission, provide the only places where one may stroll; they are extensive but bare and unadorned, there are only a few statues in wood or rough stone.

The Krasinski palace, now the High Court of Justice, contains the archives and also houses all the courts, the police, and so on. It is a building of noble design; opposite is the theatre and beside it the public garden of the Commission.

The buildings of the Artillery Barracks and the Horseguard Barracks are also noteworthy. The first has a façade containing twenty-three windows, with eight columns, four grouped and the other four standing separately, and two pillars, and the extremities of this front are adorned with four Ionic pilasters. The Horseguard Barracks, at the end of the gardens of the Saxon Palace, consist of a long street with nine pavilions on either side, grouped in threes, and linked one to another by stables, of which there are therefore twelve, each of which can house 44 horses. All the building is of brick save for the six centre pavilions, whose roofs are of boards and their stables entirely of wood.

...Warsaw is totally lacking in hospital facilities; everything that concerns health and personal well-being is in a state of complete abandon. Moreover the apothecaries have the reputation of carelessness in making up prescriptions, and it is well known that the mistakes of these gentlemen are rarely without grave consequences... There are few artists in

Warsaw, indeed there would be none if the king did not provide them with commissions; and it can be said that it is thanks to him that any have settled there. The sad events of 1795 must have inflicted a terrible blow on the Fine Arts, one whose consequences will make themselves felt for a long time to come.

...The road between Warsaw and Cracow runs uninterruptedly across plains and forests. We passed through several villages, but all were very poor, and some towns of which nothing remains but their name. It is hard to imagine the deplorable state of this road, especially during a time of thaw, the period in which we had to traverse it. The same thing occurs after heavy falls of rain. We will say only that the soil is very fertile, the roads are not constructed at all, and no work is ever done to them. The two last posting-houses are the most humble that can be imagined. Many ascents and descents are full of enormous holes and littered with the roots and trunks of trees which lie where nature has placed them, without it occuring to the public administration to remove them or to alter the direction of the road; this latter would be certainly a far easier solution to choose since there is no lack of land. But what can be expected of the public administration in a country without a govermnent, abandoned to itself, remaining in a state of nature especially in those respects in which it should not be? To the left, beyond Drzewicy and beside a bridge, there is a furnace for iron-smelting. From Radoszyc to Malagoszeza the five-mile stage is divided into two equal parts: the postmaster of the last posting-house is extremely insolent and a rascal to boot — that is, the one who was there at the beginning of 1792. From Warsaw to Cracow is 190 miles, all the route is as full of Jews as the Grand Duchy of Lithuania and the country before that.

Voyages de deux français... en 1790-1792, Paris, 1796.

...Warsaw, which is separated by the Vistula from the suburb of Praga, is a large city which, to anyone arriving there from Lithuania, has the appearance of a great capital; but the population does not correspond to the size of the city.

There were once about 60,000 inhabitants and at the time of the Diet of 1791 it attained a peak of 95,000 souls. The castle of the King, situated close to the Vistula, has an impressive appearance, but the architecture of the exterior is in poor taste. The interior, however, is furnished in excellent fashion, and adorned with *objets d'art* collected for the purpose and at his own expense by Stanislas Augustus Poniatowski.

Several of the city streets are quite wide and are paved. The many churches, most of which deserve to be visited, bear witness to the devotion of the Poles of times gone by. The Palace of the Governor, formerly the Krasinski Palace, is Italianate in style. The Saxon Palace stands at one end of a very wide square in a splendid garden which is open to the public. The school for military cadets, the Arsenal and the Barracks deserve mention as fine public buildings. As for the residences of the noble families, I will name only the palaces of the Prince, and of the Brühl, Radziwill, Czartoryski, Oginski, Potocki, Branicki, Raczynski, Bielinski, Tepper families, and there are more.

There are besides the country residence of the king at Lazienki, the castle at Wilanow, once the dwelling of John Sobieski; Ujazdow castle, now used as a barrack; La Garenne (Krolikarnia), Powonoski, Mariemont, the wood of Bielany and several other villas standing in parks, which adorn the surroundings of Warsaw on the right bank of the Vistula. On the opposite bank, however, the surroundings of Praga are sandy and uncultivated territory.

Observations sur la Pologne et les Polonais pour servir d'introduction aux mémoires de Michel Oginski, Paris 1827.

177. BERNARDO BELLOTTO: *General view of Warsaw and the Vistula from the suburb of Praga.* (detail). Warsaw, National Museum.

This work is dated 1770. On the right bank of the Vistula can be seen part of a royal procession along the road beside the river. On the left bank lies the city, with the front of the Royal Castle, built in 1742, above which rises its baroque tower. Beyond it to the right are the Cathedral of St. John and the tower of the Jesuit church. Along the Vistula are the buildings of the Old Town and the New Town (Stare et Nowe Miasto) with slender towers and the cupola of the Church of the Sisters of the Holy Sacrament.

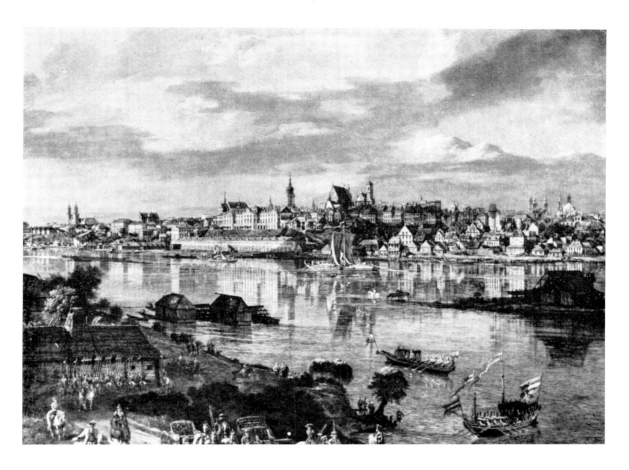

178. BERNARDO BELLOTTO: *View of Warsaw from the terrace of the Royal Castle* (detail). Warsaw, National Museum.

In the centre of the terrace Prince Joseph Poniatowski is being given a riding lesson; the apparent age of the prince suggests that the date of the painting is about 1773-4. On the right is a wing of the Royal Castle, and among the buildings of the city can be seen the church of the Carmelites in Krakowskie Przedmiescie and, behind it, the two towers of the Church of the Holy Cross.

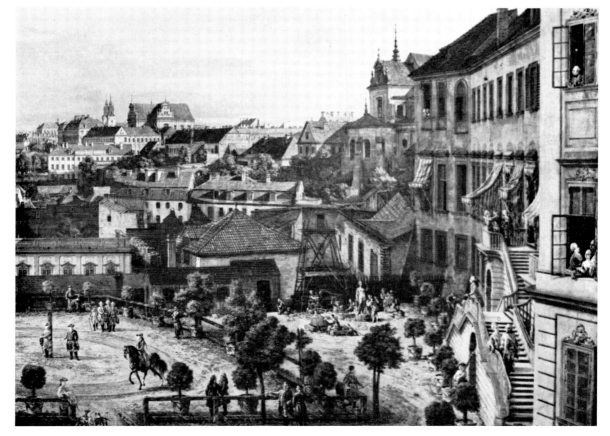

179. BERNARDO BELLOTTO: *View of Krakowskie Przedmiescie looking towards the statue of King Sigismund III and the Cracow Gate* (detail). Warsaw, National Museum.

In the right foreground is the statue of the Virgin erected in 1683 by the Italian architect Bellotti to commemorate the liberation of Vienna from the Turkish siege. On the right are the church of the Carmelites, of the second half of the seventeenth century, the Radziwill Palace and the church and convent of the Order of the Bernardines. In the distance can be seen the statue of Sigismund III and the front of the Cathedral of St. John.

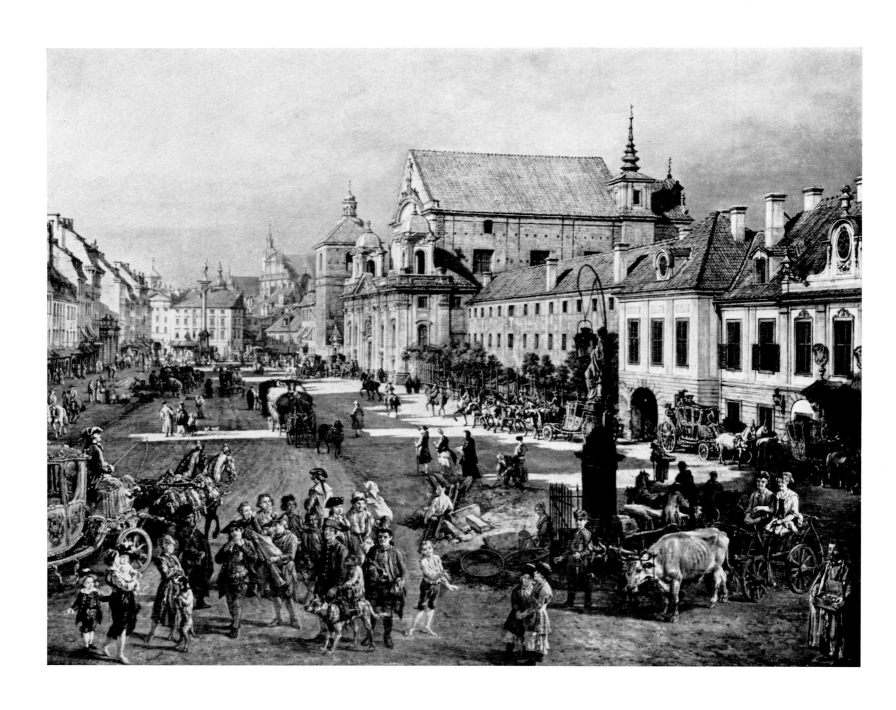

180. BERNARDO BELLOTTO: *View of Krakowskie Przedmiescie looking from the Cracow Gate* (detail). Warsaw, National Museum.
In the background to the left is the Carmelite church and the Church of the Holy Cross. On the right of the painting is the entrance to Senatorska Street in which can be seen part of the Palace of the Bishops of Cracow. The gateway which interrupts the line of houses on the right leads to the Malachowski Palace, beyond which lies the Palace of the Princes Czartoryski. This painting can be dated to 1767-8.

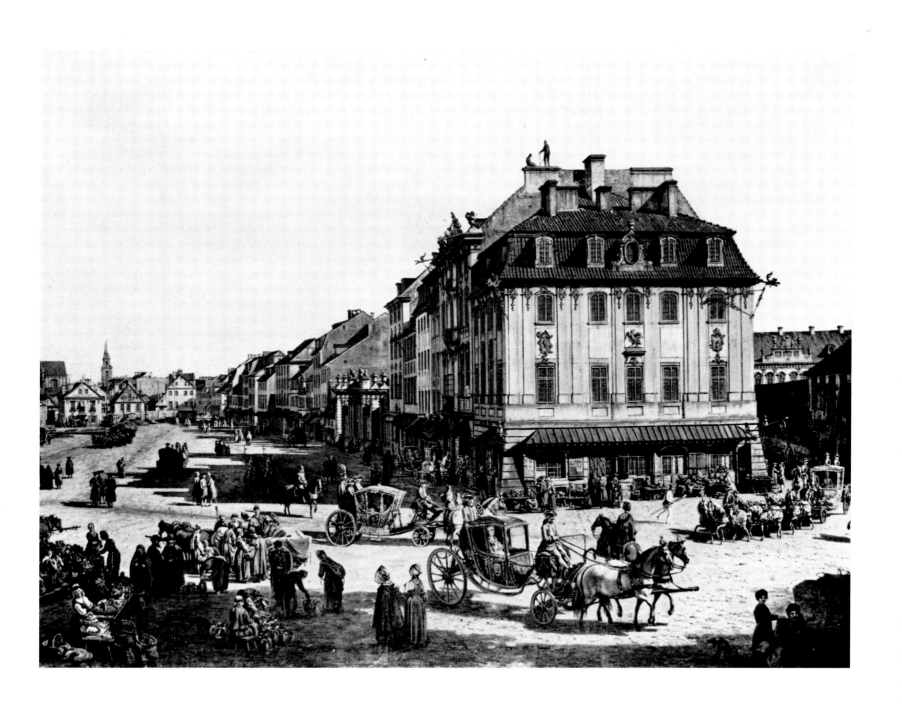

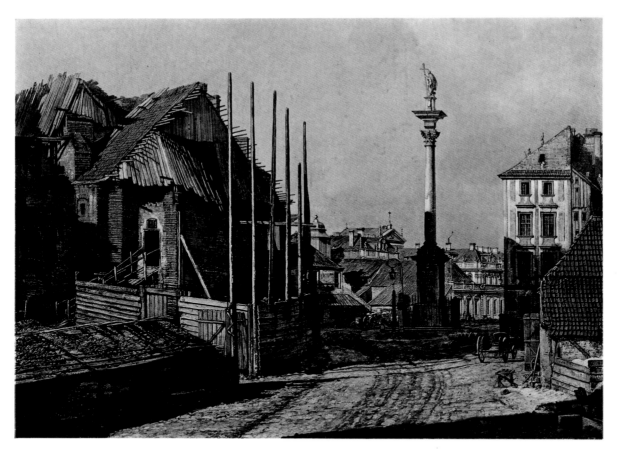

181-182. BERNARDO BELLOTTO: *The Statue of King Sigismund III and part of Warsaw near the Vistula* (details). Warsaw, National Museum.

This painting is a replica of one lost during the war and whose fate is unknown. It is one of Bellotto's first Polish paintings, contemporary with his decoration of Ujazdow Castle, near Warsaw. The view shows the column of Sigismund III and the top of the façade of the Capuchin church in Miodowa Street, and on the left, part of the ruins of the convent of the Bernardines. The probable date of this painting is 1767.

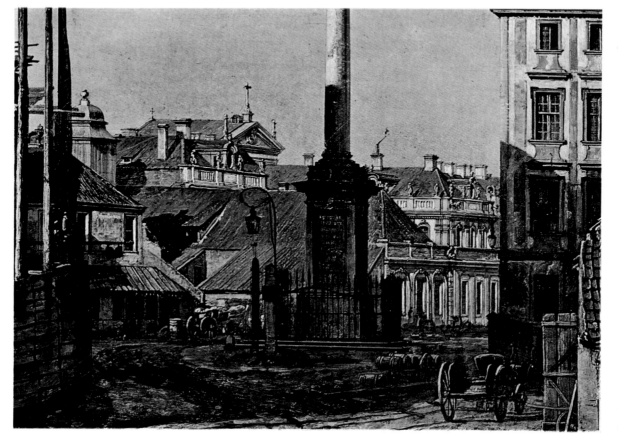

183. BERNARDO BELLOTTO: *View of Krakowskie Przedmiescie from Nowy Swiat.* Warsaw, National Museum.

The view is dominated by the façade of the Church of the Holy Cross, which was begun in 1682 by Giuseppe Bellotti and completed towards the middle of the following century by Giuseppe and Giacomo Fontana. Among the houses which line the street on the right, beyond the gateway which leads to the Casimir Barracks, is the Poniatowski Palace.

184. BERNARDO BELLOTTO: *The Carmelite Church in Krakowskie Przedmiescie* (detail). Warsaw, National Museum.

The front of the church of the Discalced Carmelites was built in 1773-80 by Ephraim Schroeger. To its right is the palace of Stanislaw Koniecpolski (1645) which was rebuilt in the middle of the eighteenth century.

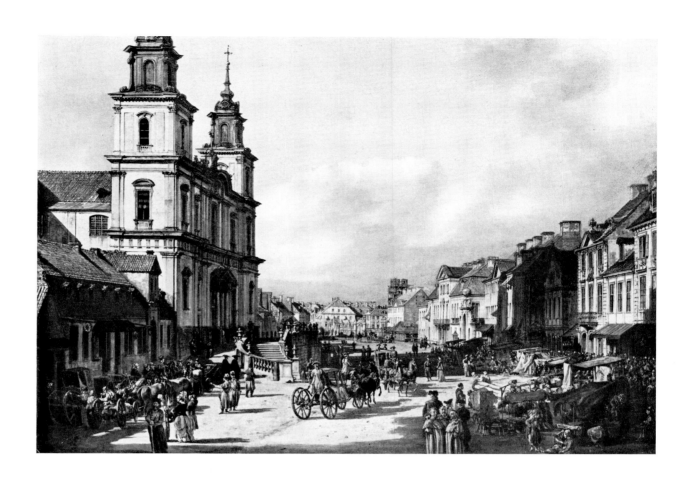

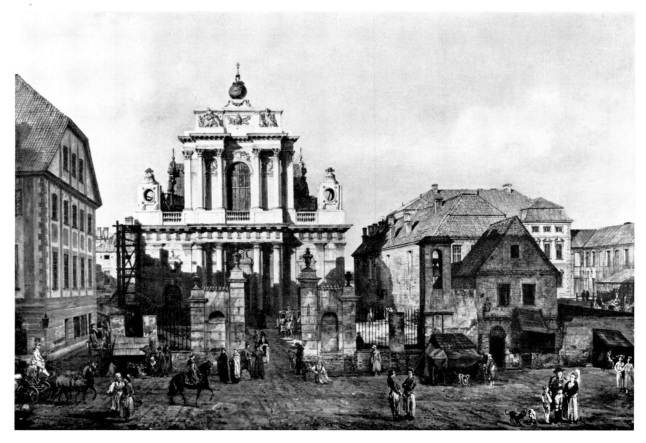

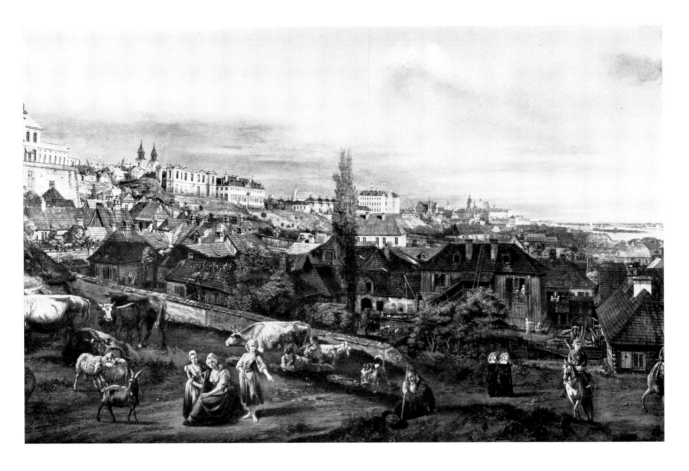

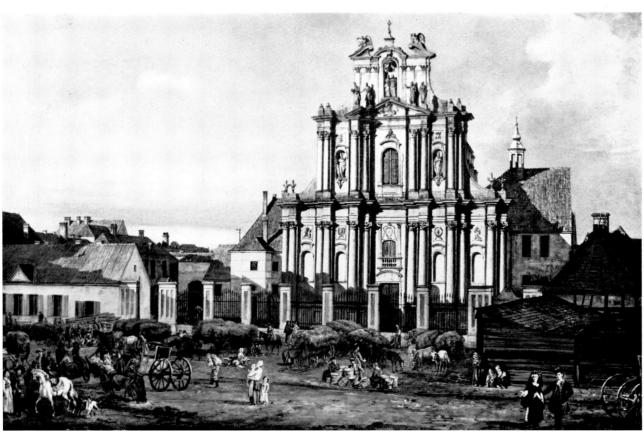

185. BERNARDO BELLOTTO: *View of Warsaw with the Prince's Palace* (detail). Warsaw, National Museum.

The view from beside the Vistula shows a country scene in the foreground, of the buildings and the atmosphere of the rural suburbs. Among the aristocratic palaces built on the slopes of the hill predominates the imposing edifice of the Prince's Palace, built at the end of the seventeenth century by Tylman de Gameren. Beyond are the towers of the Church of the Holy Cross, the Palace of the Prince of Nassau, the church of the Order of the Visitation and the Casimir Barracks.

186. BERNARDO BELLOTTO: *The Church of the Order of the Visitation in Krakowskie Przedmiescie*. Warsaw, National Museum.

The church was begun in the second half of the seventeenth century, but the façade, perhaps after a design by Giacomo Fontana, was built only in 1760. Beside the church are the convent buildings.

187. BERNARDO BELLOTTO: *The Reformed Church in Senatorska Street, Warsaw*. Warsaw, National Museum.

In Senatorska Street, a scene of peaceful animation, the church of the Reformed Franciscans stands surrounded with trees. At the end of the street is a group of houses. The baroque church was built in the last quarter of the seventeenth century.

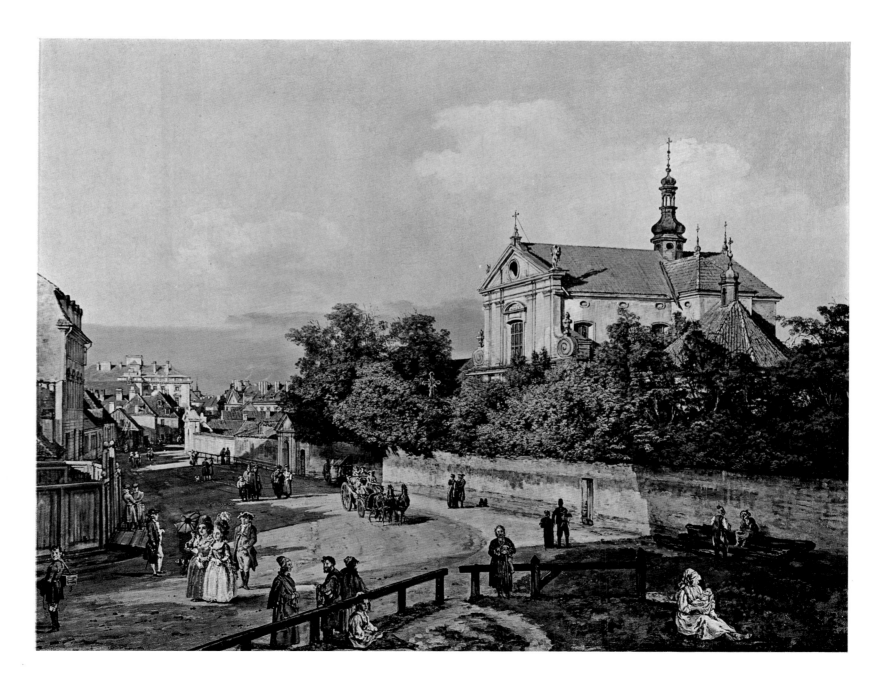

188. BERNARDO BELLOTTO: *The Square behind the Iron Gate* (detail). Warsaw, National Museum.

This corner of the city is painted from the Horse Guards Barracks. The left of the painting is occupied by the Wielopolski Palace, which later became the property of the Radziwill and the Lubomirski families. In the centre are the Saxon Palace and Gardens, in which a kind of 'Gloriette' was constructed in 1724. On the right of the painting are the towers of the Church of the Holy Cross and the dome of the Lutheran church, built in 1777-9 by Simeon Zug. This is therefore one of Bellotto's last works.

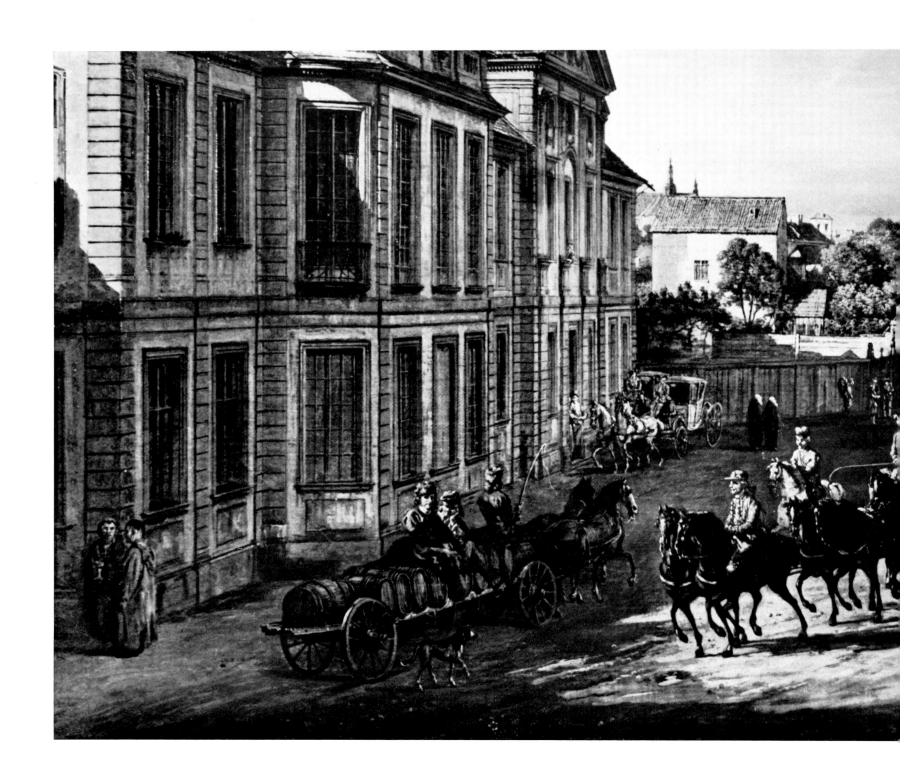

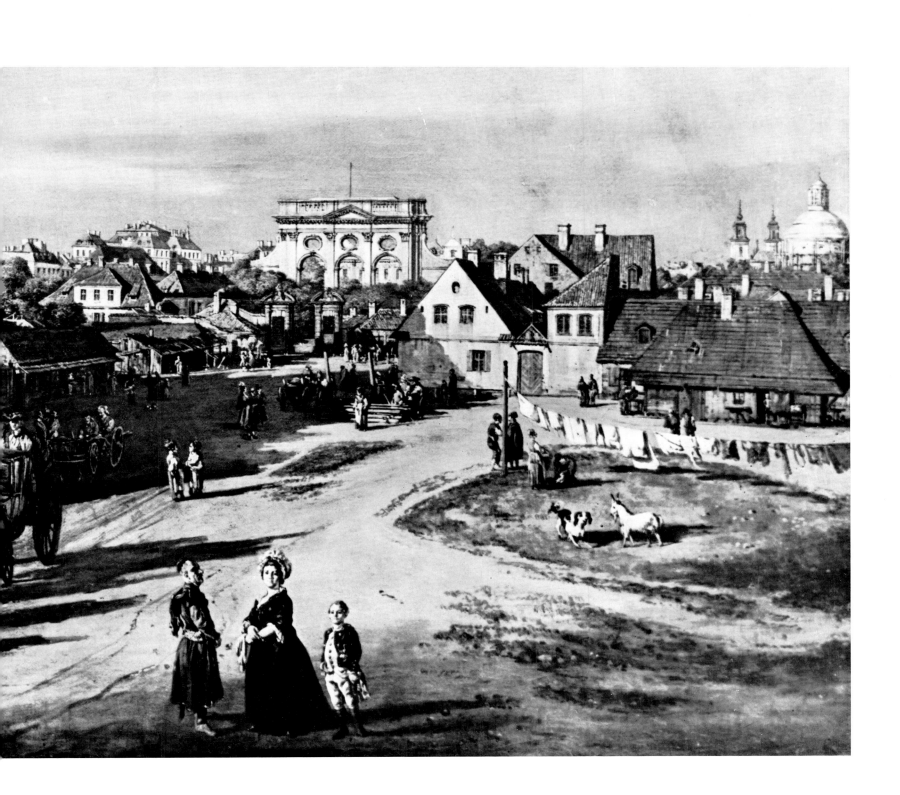

189-191. BERNARDO BELLOTTO: *The Church of the Sisters of the Holy Sacrament in the Market Square of the New town*. Warsaw, National Museum.

The wide square, filled with carts and people busy buying and selling in the market place, is dominated by the Church of the Holy Sacrament, built in 1688-90 by the Dutch architect Tylman de Gameren. Among the buildings of the New Town are prominent the Gothic Church of the Virgin (fifteenth century) and the roof and turret of the Church of St. Benno (seventeenth century). On the left are buildings of the Old Town.

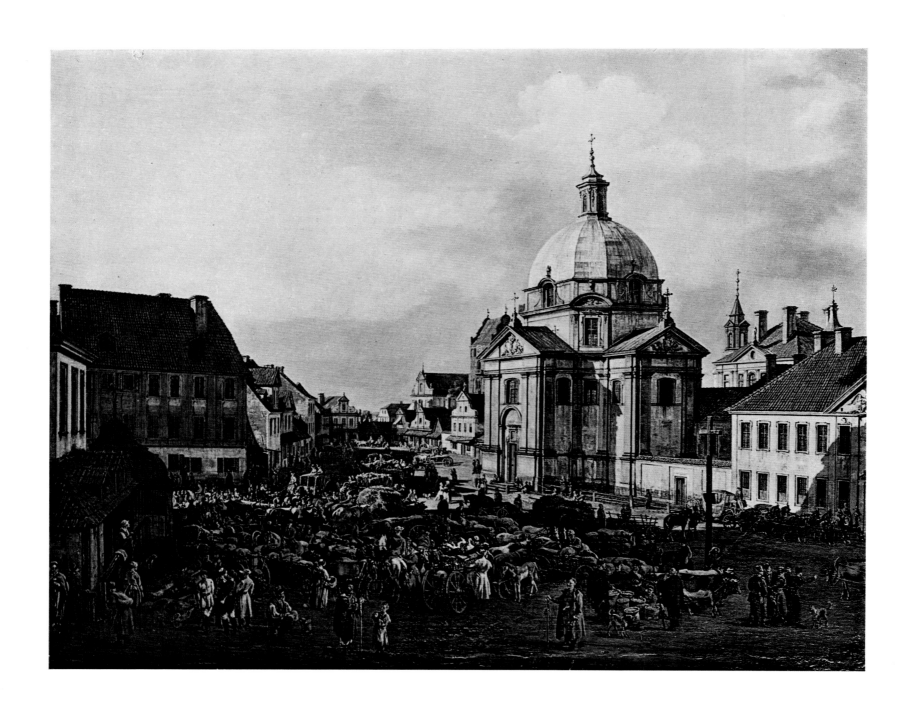

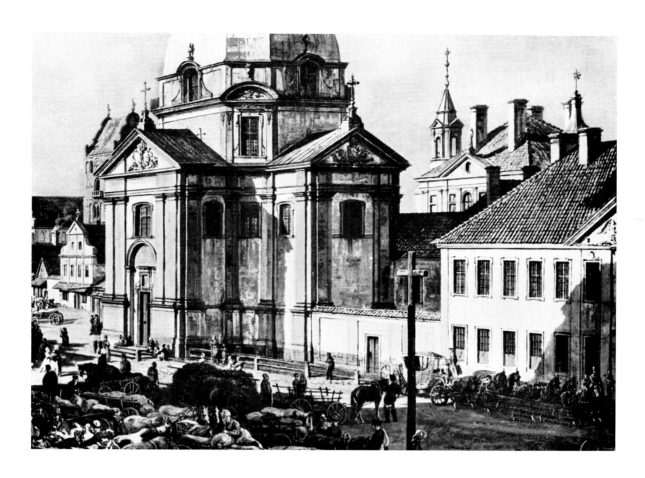

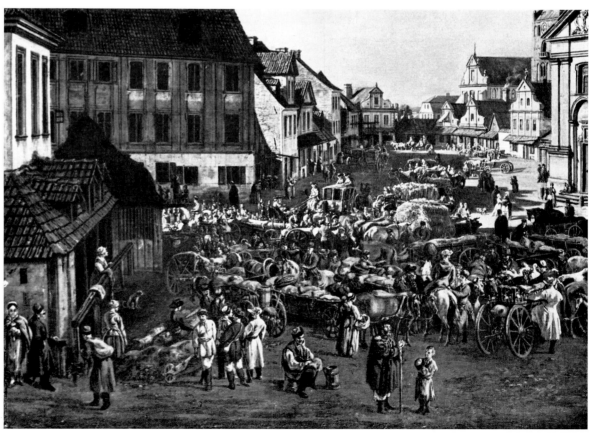

192. BERNARDO BELLOTTO: *The Church of the Brigittines and the Arsenal*. Warsaw, National Museum.

Soldiers in uniform are drawn up in ranks outside the Arsenal, which is surrounded by a little fence. Like the church of the Brigittines, the Arsenal was built towards the middle of the seventeenth century, but it was completely rebuilt a century later.

193-194. BERNARDO BELLOTTO: *View of the Wilanow Palace from the entrance* (details). Warsaw, National Museum.

One of the four views which Bellotto painted of this country palace. It was begun under King John III Sobieski in 1677 as a summer residence and work continued on it until his death in 1696. The chief architect and builder was the Italian Agostino Locci. The palace was bought by Isabel Sieniawska and then passed to the Czartoryski family and later to Isabel Lubomirska, who lived there often during the period in which Bellotto was active in Poland.

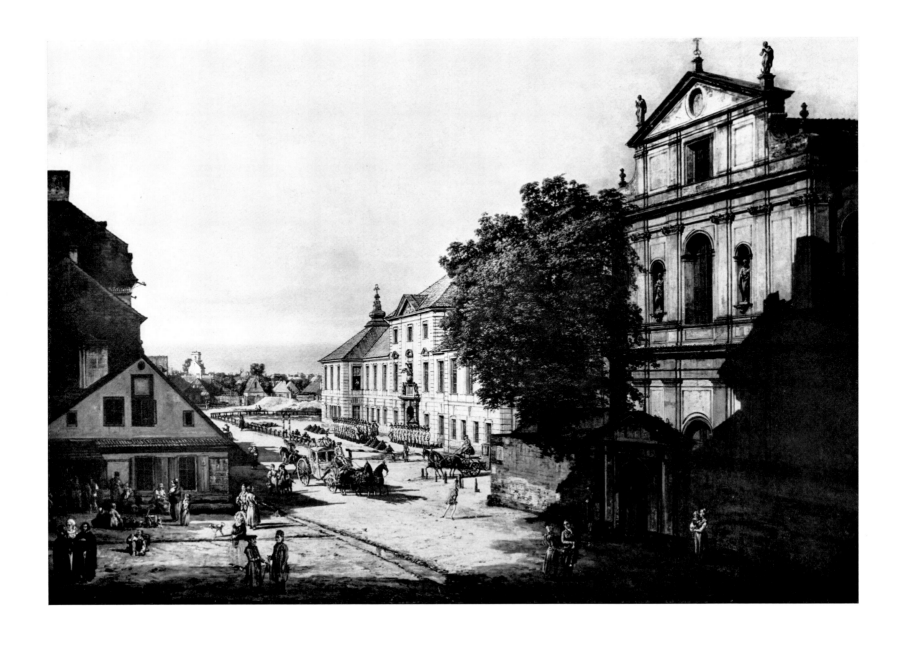

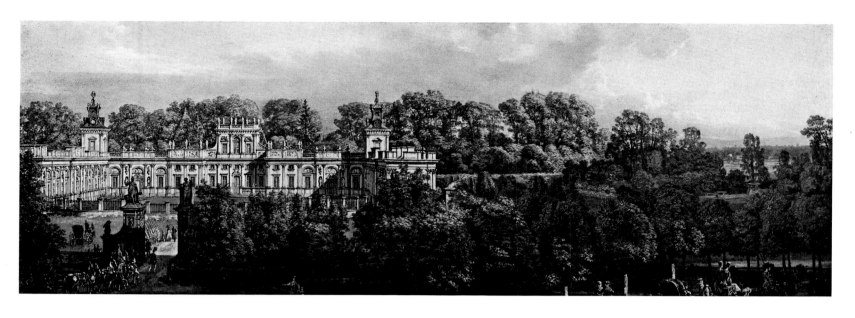

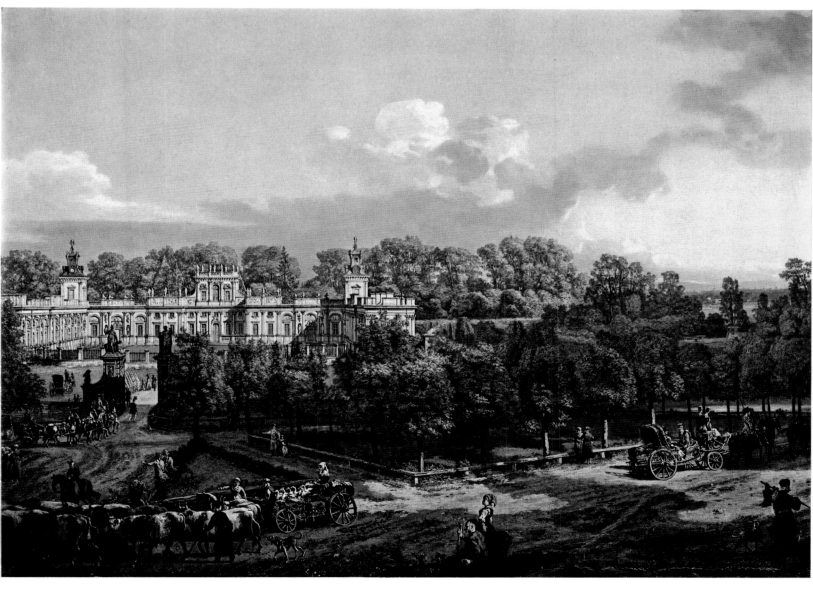

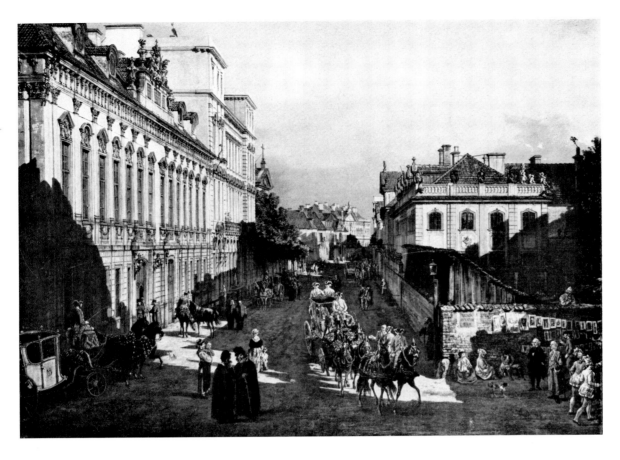

195-196. BERNARDO BELLOTTO: *View of Miodowa Street* (view and detail). Warsaw, National Museum. On the left in Miodowa Street are the Palace of the Archbishop and that of the banker Tepper. The first was built in the first half of the seventeenth century and rebuilt towards the middle of the eighteenth century, the second is a new building, of 1774-5, which gives an approximate date for the painting. Among the trees further along the street can be seen the top of the façade of the Capuchin Church (in which the artist is now buried), in the distance is the Krasinski Palace, and on the right the Branicki Palace, built in the middle of the eighteenth century, probably by Giacomo Fontana.

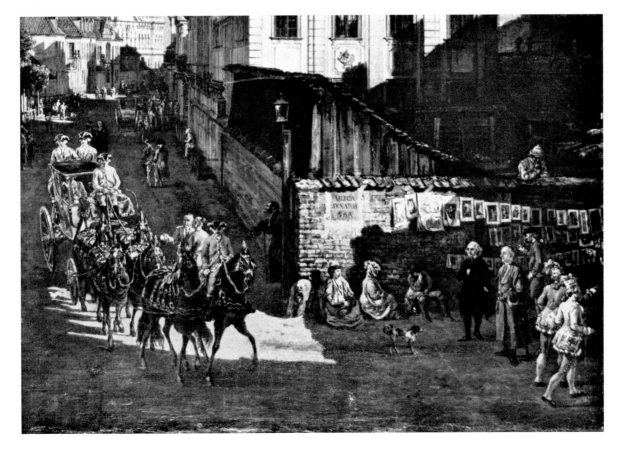

197. BERNARDO BELLOTTO:
Dluga Street (detail). Warsaw, National Museum.
The detail reproduced here shows the Krasinski Palace and the church of the Piarists, with the convent beside it.

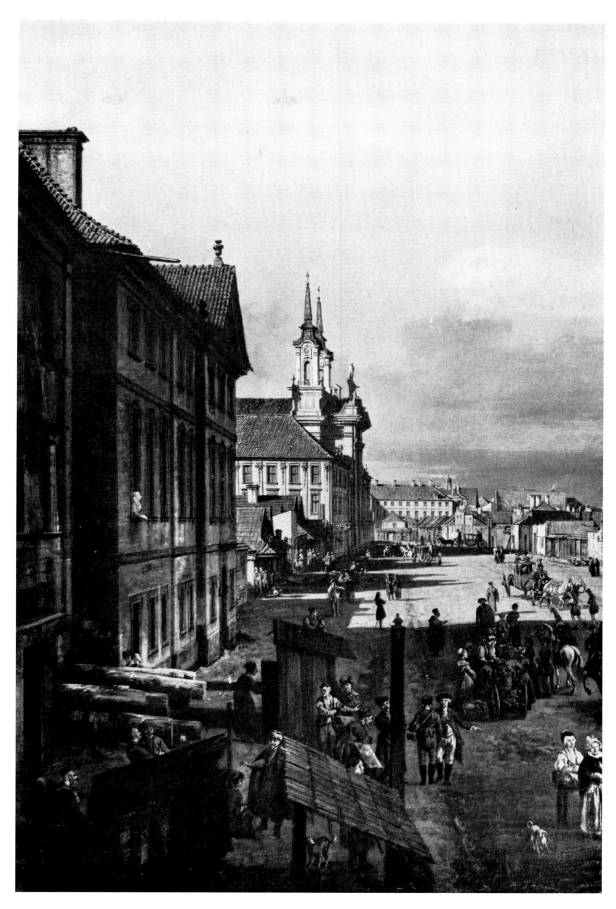

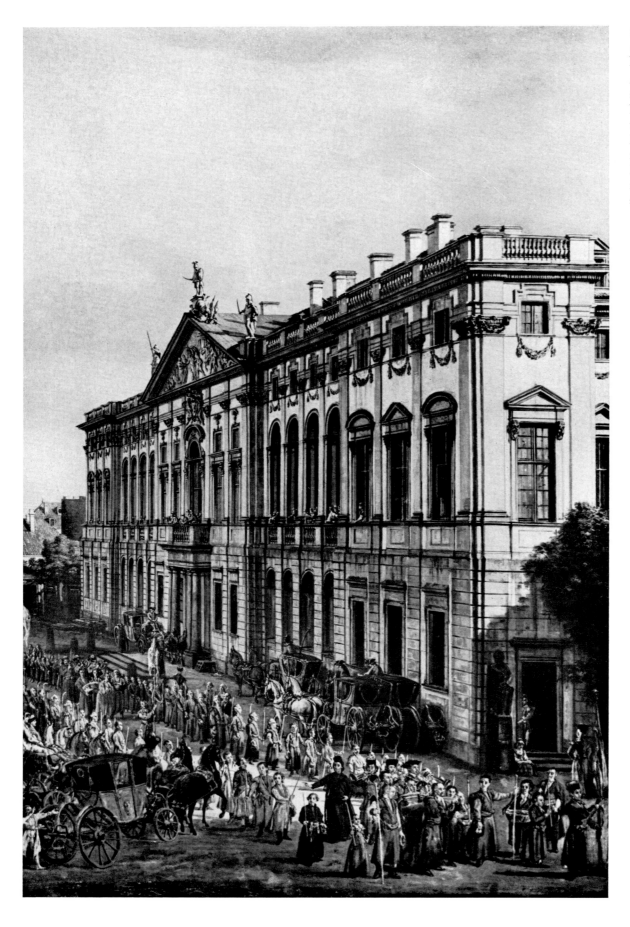

198. BERNARDO BELLOTTO: *Krasinski Square* (detail). Warsaw, National Museum.

A long procession files across the square in front of the Krasinski Palace, built in the last quarter of the seventeenth century by the Dutch architect Tylman de Gameren for J.D. Krasinski. The palace was handed over for government use in 1765 and was known as the Palace of the Republic.

RUSSIAN JOURNEY

...Had one trod the banks of the Neva a hundred years ago, when the foundations of Petersburg were not laid, and forced his way through the bull-rushes which then overspread them, and were he now to behold this new creation, he would imagine himself in a dream, reading the Arabian Nights Entertainment.

This morning, for the first time, I saw the sun rise from the woods surrounding Petersburg. Having made the tour of the streets, I sat down to write you a description of a city — but taking accidentally a volume of Fénélon's, I found it done to my hand.

'Salentum is yet in its infancy; the walls are not yet built; the Doric, the Corinthian, the Ionic pillars of its temples are just forming. The sound of the hammer, the songs of the workmen, re-echo from the neighbouring forests. The Household Gods of the Salentians are not yet placed in their niches.

Idomeneus, the great founder of this emporium, too soon entered into quarrels with the adjoining states. He laid the foundations of his city upon disputed ground...'

As I wandered in the streets, the first object that struck me was the equestrian statue of Peter the Great. I cannot describe the emotions I felt. This statue does equal honour to the munificence of Catherine II and to the artist, M. Falconet. I saw, at some distance, the imperial residence. I walked in front of it. Perhaps this is Catherine, at the window...

...Petersburg, with all its stately palaces and gilded domes, is situated in the midst of a wood, as wild and barren as any in the north. It presents a wonderful picture of what power and genius can accomplish. Independent of art, the Neva is its only ornament; a dead, sandy, flat country, covered with brushwood, surrounds it on every side; a few miserable huts scattered about complete the scene. The great Peter did not look to the most beautiful, but to the most useful spot, for the site of his capital: his object was commerce solely. Petersburg is the emporium for naval, Moscow for rural affairs. The city of Petersburg is not huddled together: it spreads out, like the wings of its Imperial Eagle. The principal quarter stands upon the continent and upon the south banks of the river Neva; the second division is what is called Old Petersburg, and is situated upon several islands towards the north banks; the third quarter, upon William's Island, in the middle channel of the Neva, between the other two. This notable river, after embracing the whole in its course, empties itself into the Gulf of Finland, immediately below the city.

The old city, originally built upon one island, bearing its name, now stretches over several lesser ones; it is very irregularly built, and consists chiefly of wooden houses. Here, however, are the first objects that draw attention — the Citadel, in which is the cathedral, a fine pile of building with its gilded spire and turrets, whose sparkling grandeur strikes the eye at a great distance, and marks the sacred spot where lie interred the remains of Peter I and his Empress, the Livonian Villager, Catherine I! This is the Russian Mecca, and none but infidels will neglect to make a pilgrimage to it.

From Old Petersburg we proceed, along a bridge of boats, to William's Island. Upon the north side, and fronting the old town are the Merchants' wharfs, the Exchange, Custom-House, and warehouses. In the river, between Old Petersburg and William's Island, lie all the vessels that take down to Cronstadt the produce of Russia, to larger foreign ships, that cannot come to Petersburg, the channel being narrow and shallow at the mouth of the river.

The south side of William's Island fronts the new city of Petersburg and here is built a superb line of houses, among which are the Imperial Academies, and the Museum. The Imperial Academy of Sciences is a grand structure, and is amply endued for its support. The Professors are eminent in the republic of letters, and are of different nations. Her Imperial Majesty, to adorn these establishments, selects merit from every climate and country.

The Museum is situated upon the highest and east point of William's Island, opposite the Imperial Palace, upon the continent, to the south; and the Citadel to the north. The west point of this island reaches to the mouth of the Neva. The Cadet Corps, or Academy of War, formerly the Palace of Prince Menzikoff, is situated betwixt the Academy of Sciences and the Museum...

Except this line of buildings upon the banks of the Neva, and another street, the whole of this quarter of the city consists of wooden houses: these are built very regularly in streets, cutting each other at right angles: canals run through the middle of the streets, but, owing to the level surface of the ground, the water in them, in the heat of summer stagnates, and is offensive. They serve no purpose and it would be proper to fill them up with earth. A bridge of boats crosses the Neva, opposite the Cadet Corps, making a communication from William's Island to the grand quarter of the city upon the continent. As you walk along this bridge, you have a front view of the equestrian statue of Peter I which is erected upon the opposite bank of the river; the horse, upon the summit of a rock, majestically rearing, and pawing the air — he seems conscious of his rider; 'he smells the battle afar off, his neck is cloathed with thunder'.

Upon the right hand of the statue and to the east, is the Admiralty and Dock-yards, and immediately beyond these the Imperial Palace. At this instant there are two first rate ships of war building under the Palace windows. From the Admiralty spire, all the streets run out as radii from the centre of a circle. The principal street is that line of buildings fronting the Neva, for an extent of between three and four English miles: the bank, for the same extent, is lined with granite stone, with ballustrade and foot-path of the same materials. Near the extremities of this superb street, called the Grand Million, and which taking the course of the Neva, forms a vast obtuse angle, a canal is cut across the main land, making the base of this angle, and surrounding the city upon the continent to the south; so that this quarter is entirely enclosed, with the Neva upon one side, and this canal upon the other, for an extent of about eight miles; the whole banks lined with granite stone, having granite ballustrades, or iron railing. Over these canals are erected draw-bridges, likewise built of granite stone. The quarter without this canal may be deemed the suburbs; the houses are mostly of wood, but the houses within the canal are mostly of brick, and plaistered, painted with every variety of colours! No wooden house is suffered to be re-built within the canal, but with brick, and the new is quickly driving the old city out of the gates! Amidst these wooden fabrics, the Russian churches everywhere shoot up their antique turrets! The Russians hold the form of their church walls as sacred as their forms of religion within them. The roofs are covered with block tin, and many of them gilded.

There are in Petersburg three Imperial Palaces. The palace near the Admiralty, in which Her Imperial Majesty resides, is a magnificent edifice of brick stuccoed, and adjoining is a long range of buildings, fronting the Neva, including the private Theatre of the Court. The Marble Palace is built of the stone which gives it this name. The third is the Summer Palace, built of timber, and yet the most regular and elegant. It is placed in the Summer gardens upon the banks of the river, and is truly a delightful residence...

The new church near the equestrian statue is a building of the finest Siberian marble, and will be one of the most costly and superb structures in the universe. The palace near the Admiralty is situated at the point of the angle which the river makes; and here the Neva rolls his tide, embracing the lodging of his Sovereign. From this spot one has the grandest prospect imaginable: before you, upon the other side of the river, is the old city, with its citadel and gilded spire; the houses surrounded or intermixed with woods. William's Island presents another prospect, of a different nature: a wood of masts, planted in front of the

streets: to the right and left is the Grand Million, every house in which is of elegant structure, and inhabited by the principal Russian Nobility and Gentlemen.

Travels into Norway, Denmark and Russia in the years 1788, 1789, 1790, and 1791, London, 1792.

ANDREW SWINTON
December 1788

...As I walked about this metropolis I was filled with astonishment upon reflecting, that so late as the beginning of this century, the ground on which Petersburgh now stands was only a vast morass occupied by a few fishermen's huts. The first building of the city is so recent as to be almost remembered by some persons who are now alive; and its gradual progress is accordingly traced without the least difficulty. The despotic authority of Peter, and his zeal for the improvement of the new capital, will appear from the orders issued by his command... The streets in general are broad and spacious; and three of the principal streets, which meet in a point at the Admiralty, and reach to the extremities of the suburbs, are at least two miles in length. Most of them are paved; but a few are still suffered to remain floored with planks. In several parts of the metropolis, particularly in the Vassili Ostrof, wooden houses and habitations, scarcely superior to common cottages, are blended with the public buildings; but this motley mixture is far less common than at Moscow, where alone can be formed a true idea of an ancient Russian city.

The brick houses are ornamented with a white stucco, which has led several travellers to say that they are built with stone; whereas, unless I am greatly mistaken, there are only two stone structures in all Petersburgh; the one is the church of St. Isaac, of hewn granite, and marble columns, but not yet finished; the other is the marble palace constructed at the expence of the empress, on the banks of the Neva, facing the citadel. The mansions of the nobility are many of them vast piles of building, but are not in general upon so large and magnificent a scale as several I observed at Moscow: they are furnished with great cost, and in the same elegant style as at Paris or London. They are situated chiefly on the south side of the Neva, either in the Admiralty Quarter, or in the suburbs of Livonia and Moscow, which are the finest parts of the city.

The views upon the banks of the Neva exhibit the most grand and lively scenes I ever beheld. That river is in many places as broad as the Thames at London: it is also deep, rapid, and as transparent as chrystal; and its banks are lined on each side with a continued range of handsome buildings. On the north side the fortress, the Academy of Sciences and the Academy of Arts are the most striking objects; on the opposite side are the Imperial palace, the Admiralty, the mansions of many Russian nobles, and the English line, so called because (a few houses excepted) the whole row is occupied by the English merchants. In the front of these buildings, on the south side, is the Quay, which stretches for three miles, except where it is interrupted by the Admiralty; and the Neva, during the whole of that space, has been lately embanked, at the expence of the empress, by a wall, parapet, and pavement of hewn granite; a most elegant and durable monument of imperial munificence.

...Petersburgh, from its low and marshy situation, is subject to inundations, which have occasionally risen so high as to threaten the town with a total submersion. These floods are chiefly occasioned by a west or south-west wind, which, blowing directly from the gulf, obstructs the current of the Neva, and causes a vast accumulation of its waters... The people did not (even during this extreme cold) add to their ordinary cloathing; which is at all times well calculated for the severities of their climate. They are careful in preserving their extremities against the cold, by covering their legs, hands, and head, with fur.

Their upper garment of sheep-skin, with the wool turned inwards, is tied round the waist with a sash; but their neck is quite bare, and their breast only covered with a coarse shirt; these parts, however, are well guarded by their beard, which is, for that reason, of great use in this country.

Travels into Poland, Russia,... London, 1784. WILLIAM COXE
1778

...But what shall I tell you first, what leave to second place, of this city, this great window newly opened in the north through which Russia has, so to speak, gazed on Europe?
We arrived in Petersburg a few days ago after passing two days at Kronstadt with Admiral Gordon. We had to leave the ship at Kronstadt as it draws about eleven feet; a little more water and we could have gone as far as Peterhof. We went up the Neva in a pretty decorated boat lent us by the admiral. For seven months of the year the Neva is a passage for boats, the other five for sledges...
After travelling for several hours, seeing nothing around us but water and the ugly, silent forest, suddenly there is a bend in the river and immediately, exactly as if we were at the Opera, the scene of an Imperial city lies before us. On either side of the river rise splendid palaces grouped together; towers with gilded spires, here and there pyramidal in shape; ships with their masts, their ensigns waving in the breeze, interrupt the lines of buildings and differentiate the planes of the picture. That, they tell us, is the Admiralty and the Arsenal — this, the Citadel, over there the Academy, here the Czarina's Winter Palace.
...Once we have entered Petersburg it no longer seems quite what it had seemed from a distance, perhaps because travellers are like hunters or lovers — or perhaps because its appearance was no longer enhanced by the proximity of the dreadful forest. However it may be, the situation of a city that is built on the banks of a great river and on several islands, which provide a variety of viewpoints and effects of perspective, cannot be other than beautiful. The buildings of Petersburg also make a fine impression, to those who retain in their mind's eye the houses of Reval and other cities of this northern region.
But the ground on which it is founded is low and marshy; the immense forest which surrounds it, seems lifeless; the materials of which it is built are undistinguished, and the designs of the buildings are not those of an Inigo Jones or a Palladio. The style of architecture that reigns here is a bastard mixture of Italian, French and Dutch in which the Dutch predominates. This is not surprising since it was in Holland that the Czar as it were commenced his studies, and from Sardam, like a new Prometheus, he carried that flame with which he brought life to his people. It seems, in effect, that purely as a remembrance of Holland he has chosen to build in the style of that country, to plant trees along the streets, to divide up the city with canals; which are certainly used as they are in Amsterdam or Utrecht.
...The boyars and gentlemen of the Empire were obliged by the Czar to leave Moscow, which was close to their country estates, to follow the court and to set up their homes here. Most of them have built palaces in accordance with the royal decree rather than from choice, so that here and there the walls are falling apart, or are so badly cracked that they hardly stand erect. Someone said that elsewhere ruins make themselves but here they are built. In this new metropolis they are constantly compelled to build new foundations for the buildings, both for this reason and also because of the lack of good material and the treacherous soil.

Opere scelte, Milan, 1823. FRANCESCO ALGAROTTI
1739

199. LOUIS-NICOLAS DE LESPINASSE: *View in Petersburg* (detail). Paris, Private collection.
The detail shows one of the many palaces of the nobility along the banks of the Neva. In the background are seen the walls of the fortress and part of the façade of the Peter and Paul cathedral with its slender spire.

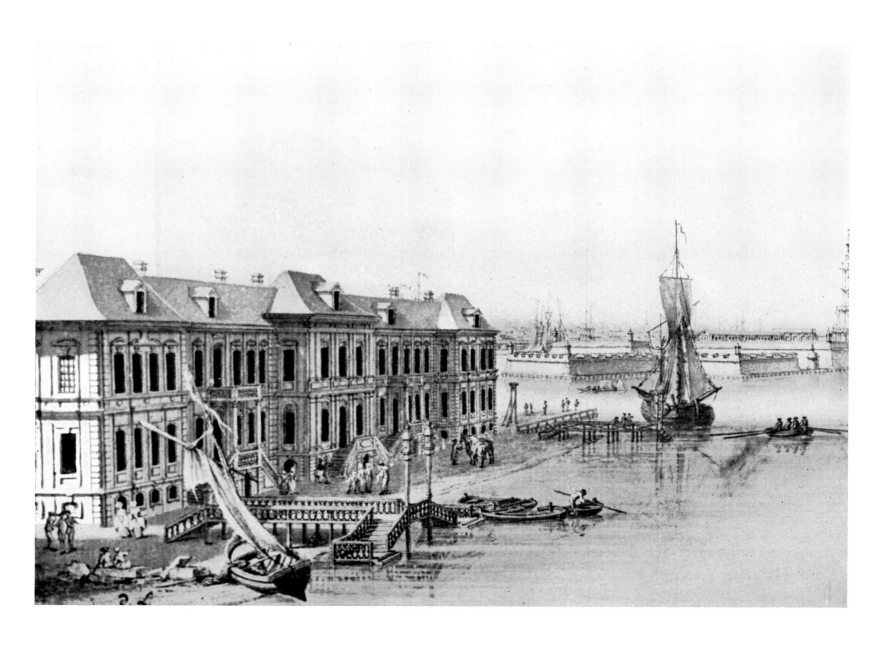

200. LOUIS-NICOLAS DE LESPINASSE: *View in Petersburg*. Paris, Private collection.
Lespinasse here shows the Admiralty, begun by Peter the Great in 1705, almost completely destroyed by fire in 1783 and then reconstructed by the architect Zakharov. Within the fortress walls, on the left, is the Peter and Paul cathedral, built by Domenico Trezzini, where Peter the Great and Catherine II are buried. Beyond are merchant ships on the Neva, and on the left bank of the river, to the right of the picture, are the buildings of the new Petersburg.

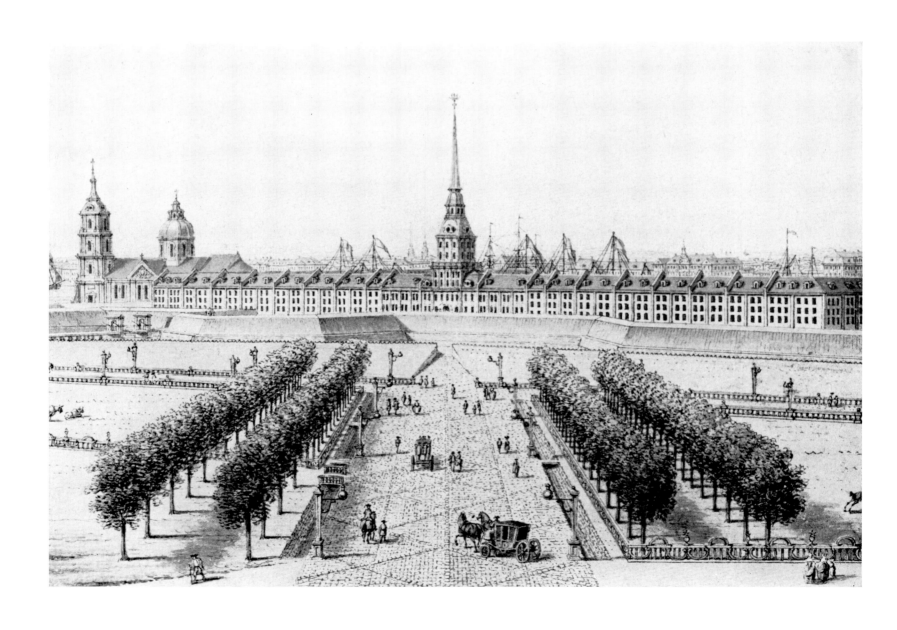

201. GIACOMO QUARENGHI: *Roseschina*. Bergamo, Biblioteca Civica.
This drawing shows a picturesque corner of the Russian countryside, the church tower dominating the little town.

202. GIACOMO QUARENGHI: *Poskoff*. Bergamo, Biblioteca Civica.
Another of the drawings from the albums at Bergamo, showing the ruins of the castle near the village of Poskoff.

LONDON

...London with its truly magnificent structures, both sacred and profane, might be ranked among the finest cities, but many of its streets are dirty and ill-paved, its houses are not very well built, of brick without any architectural adornment, and blackened by the smoke of coal fires, and this confers upon the city a gloomy air which considerably diminishes its attractions. The riches of London, if not of all England, are owing to the Thames. In all my travels I never saw a finer sight than this river, from its mouth to London Bridge. For besides its being continually covered with ships, barges, boats going up and down the river with the flow of the tide, its banks also are adorned with a variety of fine scenes: towns, villages, and country-houses. Among others to be seen is the great and magnificent Hospital of Greenwich, founded in the reign of Charles II for the invalids of the Navy. London stands on the left side of the river, where it forms a crescent.

Lettres et mémoires, London, 1747.
CHARLES LOUIS POLLNITZ
April 1733

...The throng and noise of people, coaches and carts was so great that we could hardly move forwards or hear each other speak. But what gave us heart in spite of these disasters was the succession of shops along either side of the whole long thoroughfare, so plentifully supplied with all manner of merchandise that they alone sufficed to give us an idea of the great opulence of the city and the realm. You will be expecting me to tell you much of London, and I can only tell you a little. No sooner had I arrived there than an old gentleman wished me to accompany him into the country, or rather to the suburbs of the city, since it was only fifteen miles away. No countryside can be more pretty and pleasing to see, and in this neighbourhood for thirty miles about is one continuous garden, with charming habitations. Apart from a few counties, there are no high mountains in this kingdom, nor any completely flat plains but of the smallest dimensions, so that the terrain is all of low hills interspersed here and there with small pleasant valleys with little streams running through them, and delightful vistas present themselves on all sides...

...A magnificent square edifice although in the Gothic style met my eyes, at the end of a very long and wide avenue of trees, whose age and size inspired awe and reverence in me. As I drew nearer my pleasure increased, for I saw an extensive grove of ancient oaks hedging it about, and wide green meadows peopled by an immense number of fallow-deer, and then a lake of clearest water which, by means of a most beautiful waterfall among artificial rocks which wonderfully imitate nature, passes on its water to a lower lake and thence into a river; this flows on past a temple, which spans it like a bridge, to a mill below, where these waters, gushing out again into the open, regain their liberty and flow where they will. These lakes and this river, abundantly rich in water-fowl and exquisite fish, serve as a moat to the venerable edifice, rich in gardens and woods, where nature and art compete, and perfect the delights of my sojourn.

Lettere familiari, London, 1758.
VINCENZO MARTINELLI
1748

...Although I had already seen many capital cities, nevertheless the capital of the British Empire impressed me in a particular fashion, by the number of its inhabitants and because at every step I received evidence that it justly enjoys the reputation of being the richest city in the Universe, and that in the building of it consideration was also given to its populace, since everywhere wide footpaths have been built, and by night it is well-lit by lanterns placed along the sides of the streets. What has surprised me even more is to see wide squares containing a garden in which the inhabitants of the surrounding houses, who possess

a key to it, may go to stroll. The Thames astonished me by the depth of its waters, so great as to allow large vessels to sail right up into the city.

Mémoires secrètes des Cours et des Gouvernements, Paris, 1793.

GIUSEPPE GORANI
1791

...I went to Greenwich, which is a place about two leagues distant from London. Here is a famous Hospital for the Sick. It is a splendid and an astonishing building. I do not believe that there is anything between Greenwich and Rome to equal it. For me, it is the greatest piece of architecture that I have ever seen. At its feet there flows the Thames, and it is a beautiful sight to watch the continual coming and going of many vessels. Here, furthermore, the Thames is only a quarter of its width at London, for it is the tide which broadens it. The ebb and flow of Ocean have this effect, that the Thames runs towards London during the flood tide, towards its mouth during the ebb; moreover the ebb and flow of the river itself is very noticeable, so that the waters visibly diminish and increase with the usual cycle of the sea's tides. The Thames, then, is sustained by the sea, and it is this which makes it as wide as our Po where it is broadest. This Hospital for the Sick is for the Invalids of the Navy.

...Also at Greenwich there is the royal park. It is full of deer which, since they are never hunted, are tame. In the park is the Observatory of the Royal Society. I went to see it; it is nothing special. There I examined the famous device which has become the prime longitude. On the right of the Observatory is a parapet from which you may see a panorama such as I have never enjoyed anywhere in the world. London can be seen, Greenwich below, the course of the Thames, the Hospital opposite; in fact I could not describe all that can be seen, but so truly enchanting is this prospect that I could stand there for whole days at a time.

...London is extremely large, and will continue to become larger. The houses rise from the ground like mushrooms. From one year to the next it is not uncommon to see the building of half a street. This happens because there is very little solidity in their construction. The walls are fragile, having as framework vertical and horizontal beams, the interstices being filled with bricks. The shock of a fairly serious earthquake would turn London into a heap of ruins — the English never build for posterity. Each man builds his house for himself, he builds in order to rent it out, not thinking beyond his own lifetime. So expert are the architects in this matter of the lifetime of the houses that they do not misjudge by a single year. At the predetermined time they fall, and someone else rebuilds on the ruins with the same degree of soundness.

...Nothwithstanding this, London is as beautiful as it is large. The streets are broad, for the most part straight, and flanked by two wide pavements. When the weather is dry it is like walking in a room. It is not that palaces are to be found in London, but the wideness, the length and straightness of the thoroughfares, the uniformity with which the houses are built, make up a whole which is more impressive than a number of fine works of architecture scattered here and there. There is also St. Paul's church, which is almost an exact copy of St. Peter's in Rome, except that it is about one-third smaller. Then there is the famous bridge at Westminster, remarkable for its length. From it one can see London along the banks of the Thames, which, as it bends to the right and spreads the city out right before one's eyes, is a most beautiful river.

London is almost always enveloped in the thick and heavy smoke of its many chimneys, in which mineral coal, the only kind of fire in use here, is burned. I find it preferable to a fire of wood: it gives more heat, it burns as well, and does not crackle. The fog which it

234

produces, for all its notoriety, is for me much less unpleasant than that of Paris. It is no more than a light smoke, which I should say is healthy, whereas the fog of Paris smells bad and inflames the eyes so that at times one has difficulty in keeping them open. Nor is it any more true that the sun rarely glances at London. A gust of wind disperses the smoke, and the sky is clear; this happens not infrequently.

The broad Thames is entirely covered for some miles downstream from London with ships and cargo vessels which form a forest of masts and another city on the water.

...I shall give you an idea of the fashion in which London is built... The streets are broad and hold the attention not by being flanked by great buildings but because the houses are built one after another with much love of order. There are some long stretches built in a straight line, the walls just as much so as the height and the windows. Taken separately, their distinction is slight, but as a unit they are wonderfully effective. This uniformity makes one part of London so like another that it is with difficulty that one learns to find one's way about alone... On either side there are fine wide pavements, raised a hand's breadth above the streets, but the street in the middle is very badly paved... Not all of London is beautiful. The new city of Westminster, which is a good third of the whole, corresponds to all that I have said; but the old city is filthy and generally ugly.

...I have had a good journey. It is not as short as is supposed, being a good 105 leagues, that is 105 of our miles. I suffered no ill effects from the short sea crossing from Calais to Dover. This is a voyage of seven leagues, which one can very often make in three hours. I was not impressed by the novelty of it. There is nothing more boring and monotonous than this immense basin of salt water.

...Here everything is on a large scale, in Paris everything is elegant. If Paris is large, London is enormous. As yet I have seen only a part of it, but I judge from this fact alone, namely that at night this city is lit up for six miles around. Arriving yesterday night, when I saw well-lit streets I said 'Here we are, in London!'

...The suburbs of the city begin six miles from its centre. Furthermore, it is illuminated as no other city is in Europe. There are lamps on either side of the street, lamps which are well made, as are all things which serve useful purposes in life here in London.

Carteggio di Pietro e di Alessandro Verri dal 1766 al 1797, Milan, 1923. ALESSANDRO VERRI
1768

...The first sight of London and its environs... Four leagues or more from London we turn aside slightly from the main road for a foretaste of the delightful countryside around it. What a beautiful surprise it is! The eye passes to and fro over countless squares of verdant meadowland surrounded with leafy trees, nor does it stop until it meets, at a great distance, the sky. Are these perhaps the much-vaunted English gardens, or do the English perhaps do nothing but lay out their land as gardens? The road is lined throughout with pleasant little country cottages, given prominence by their gardens and by the running streams which water them. While I revel in enchantment of this modern Tempe, the attentive interpreter who accompanies us shouts in my ear 'Here is London, here is London!' At this august name I bestirred myself; the endless mass of so many roofs and towers which confronted me at a single moment almost frightened me, and it held me rapt for a considerable time. It seemed that I saw a map engraved by the hand of a master and artfully thrown into relief by the mysterious optical device of M. de Charles. Our foaming steeds rush us along, and, traversing in less time than I can say it the large suburb of St. Thomas and the very pretty London Bridge over the majestic Thames, bring us to the spacious and airy quarter of St. Paul's, which at first I took to be an arcade of cupboards with mirrors, within

which were contained the most precious objects in the kingdom. The brightness of the shining glass, the harmony of the design of the shops, the abundance of goods of every kind displayed therein, the whole combination, in short, of what I have described and what I have left unsaid, served not a little to make my heart beat faster. How many times would Mademoiselle Merelle have uttered with emphasis her expressive 'charmant'!

Lettere scritte da più parti d'Europa a diversi amici e signori suoi nel 1783, Pavia, 1785. FRANCESCO LUINI
1783

...Having at last left the shores of France, no sooner had we disembarked at Dover than the coldness of the weather was reduced by half, and we found almost no snow at all between Dover and London. I liked England at once as much as I disliked Paris at first sight, and I liked London very much indeed. The streets, the taverns, the horses, the women, the universal well-being, the life and the activity of this island, the cleanliness and comfort of the houses, although they are very small, the absence of beggars, a perpetual circulation of money and industry, distributed as much through the provinces as in the capital: all these real and unique endowments which this fortunate and free land possesses won my heart from the very first, and in the two other journeys which I have made there before this I have never changed my opinion; for in all these ramifications of public felicity, which are the outcome of the best government, the difference between England and all the rest of Europe is too great. So that although I have not given any deep study to the constitution of the country, mother of such prosperity, I have well been able to observe and evaluate its divine effects.

Vita, Giornali, Lettere, Florence, 1861. VITTORIO ALFIERI
April 1768

Talking of London, he observed, 'Sir, if you wish to have a just notion of the magnitude of this city, you must not be satisfied with seeing its great streets and squares, but must survey the innumerable little lanes and courts. It is not in the showy evolutions of buildings, but in the multiplicity of human habitations which are crowded together, that the wonderful immensity of London consists'.

...On Saturday, July 30, Dr. Johnson and I took a sculler at the Temple-stairs, and set out for Greenwich. ...We landed at the Old Swan, and walked to Billingsgate, where we took oars and moved smoothly along the silver Thames. It was a very fine day. We were entertained with the immense number and variety of ships that were lying at anchor, and with the beautiful country on each side of the river. ...I was much pleased to find myself with Johnson at Greenwich... He remarked that the structure of Greenwich Hospital was too magnificent for a place of charity, and that its parts were too much detached, to make one great whole.

In London, a man may live in splendid society at one time, and in frugal retirement at another, without animadversion. There and there alone, a man's house is truly his *castle*, in which he can be in perfect safety from intrusion whenever he pleases. I never shall forget how well this was expressed to me one day... 'The chief advantage of London... is that a man is always *so near his burrow*.'

Boswell's *Life of Dr. Johnson*, 1791 JAMES BOSWELL
1763 and 1779

203. MARCO RICCI: *Capriccio with a fantastic view of London* (detail). Venice, Sonino Collection.
Marco Ricci was in London from 1708 to 1710. In the background of this painting, with its ancient ruins, appears the view of an ideal city which includes the dome of St. Paul's, completed by Wren in 1711.

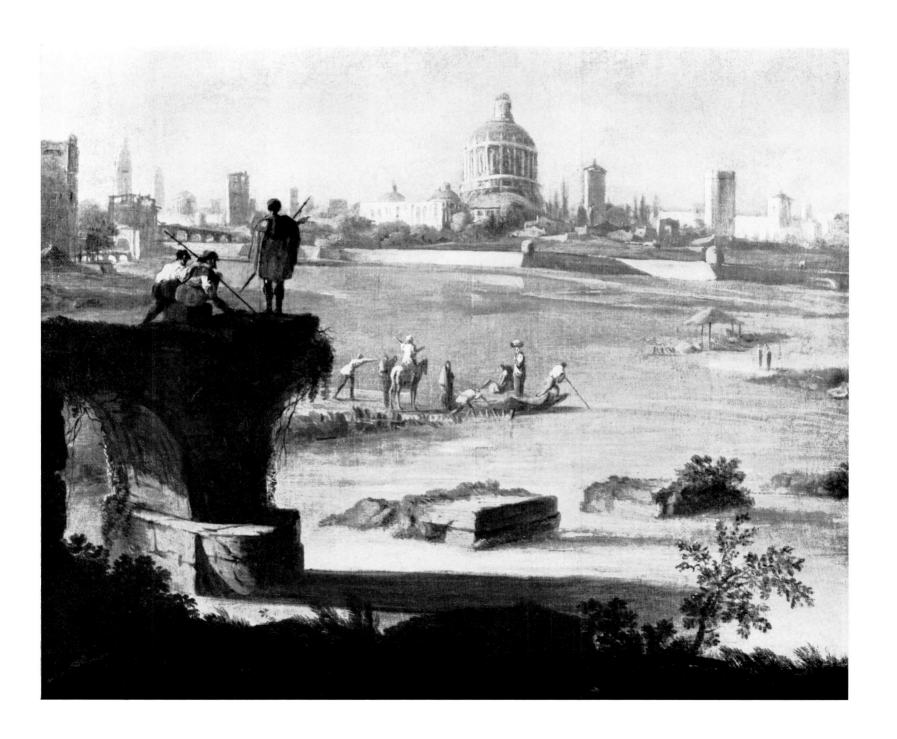

204. CANALETTO: *Whitehall and Richmond House*. Goodwood, Collection of the Duke of Richmond.
The view from a raised position, probably a window in Richmond House, whose stables are in the right foreground. The 'Privy Garden' is bounded on the right by the buildings of Montagu House, and a hedge and wall divide it from Whitehall on the left. At the end of the garden is the Banqueting Hall, behind which are to be seen the spire of St. Martin's-in-the-Fields and one of the towers of Northumberland House. On the left is the Holbein Gate, demolished in 1759, behind Charing Cross.

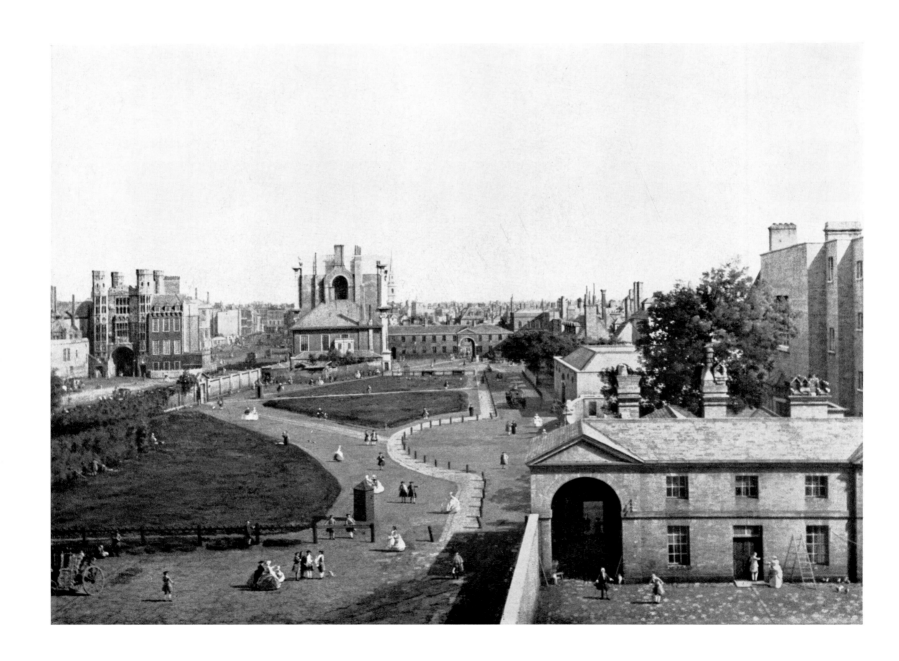

205-206. CANALETTO: *Festival on the Thames* (details). Prague, National Gallery.

View of London and the Thames during the festivities of Lord Mayor's Day. The left bank is dominated by St. Paul's Cathedral, rising above the warehouses and other buildings of the port. To the right of St. Paul's, among the spires of the City churches, is the Monument, and in the distance are the old London Bridge and the Tower of London. At the extreme right of the painting is the right bank of the river, with trees and boats under construction. In the middle of the Thames is the Lord Mayor's barge surrounded by other boats.

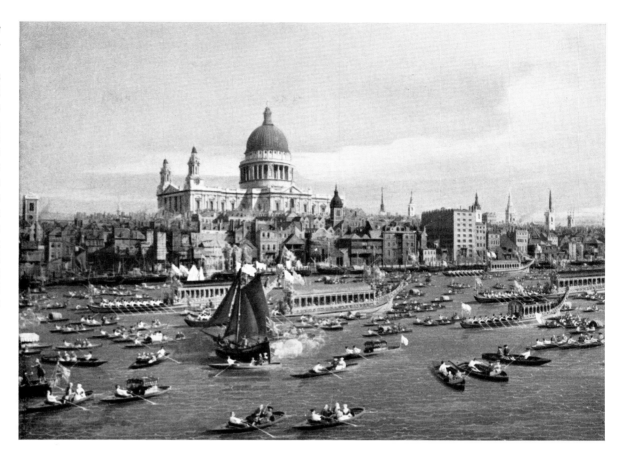

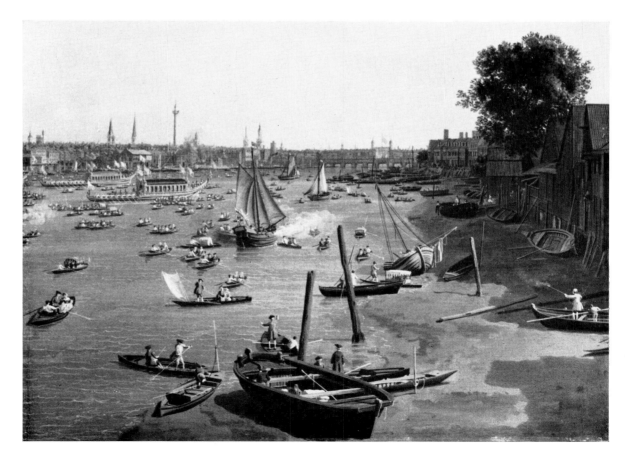

207. CANALETTO: *Northumberland House*. Minneapolis, Institute of Arts.

There is a painting of this identical subject in the collection of the Duke of Northumberland, Alnwick Castle. In the centre is Northumberland House with the façade constructed in 1752, surmounted by the figure of a lion cast in lead which is now at Syon House. Beyond the mansion is the beginning of the Strand; among the buildings on the left is the Golden Cross Inn with its sign, and other taverns. On the right is the equestrian statue of Charles I by Hubert Le Sueur.

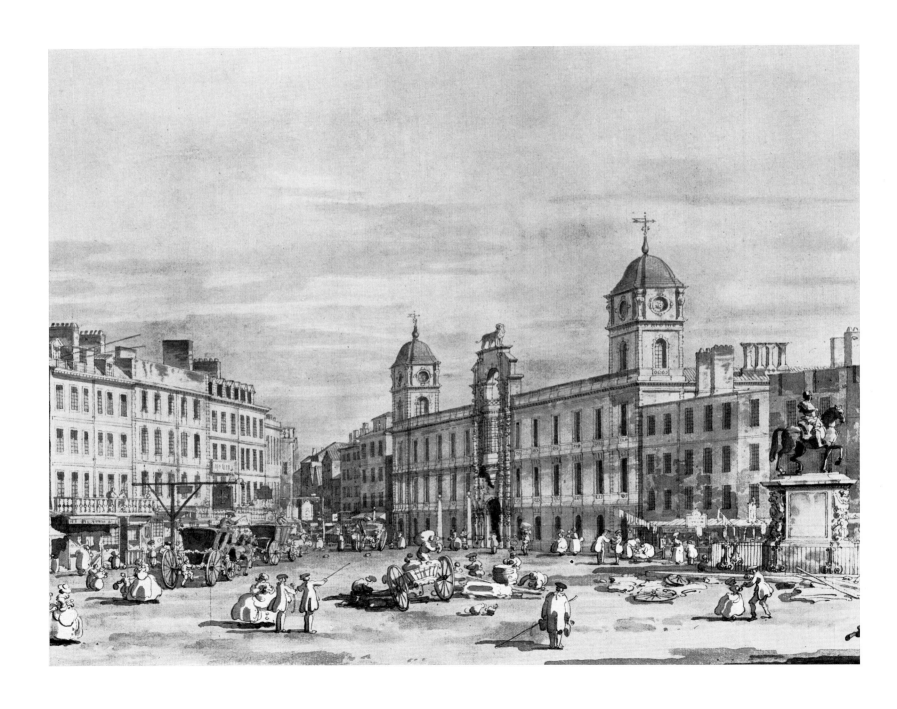

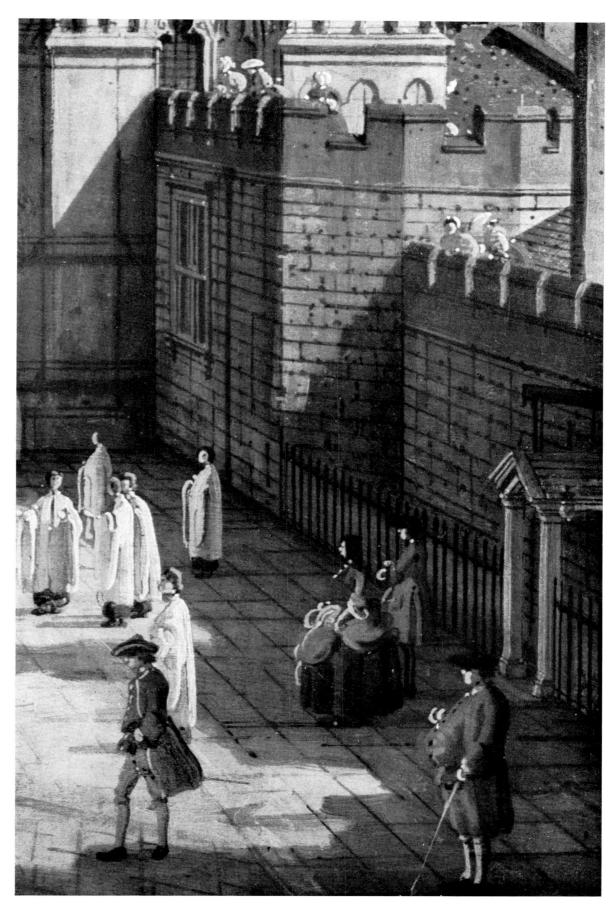

209. CANALETTO: *Westminster Abbey with the procession of Knights of the Order of the Bath* (detail). London, Dean and Chapter of Westminster.

The West front of the Abbey dominates the right hand part of the painting. To the left is the Church of St. Margaret with the Union Jack fluttering from its tower, behind it the sloping roof of Westminster Hall, and on the left are the houses of King Street, in approximately the position of the present Parliament Street.

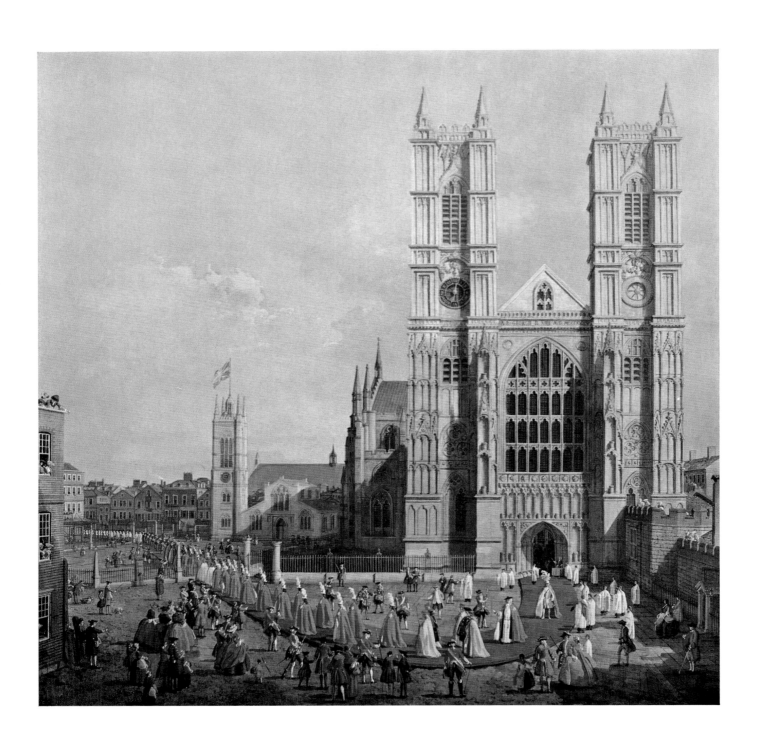

210. CANALETTO: *Westminster Abbey with the procession of the Knights of the Order of the Bath* (detail). London, Dean and Chapter of Westminster.

The procession of Knights in their red robes and plumed hats leaving the Abbey for the House of Lords. At the end of the procession is the Great Master followed by the Dean of Westminster in his capacity as Dean of the Order, and the path of the procession is lined by soldiers in scarlet uniform.

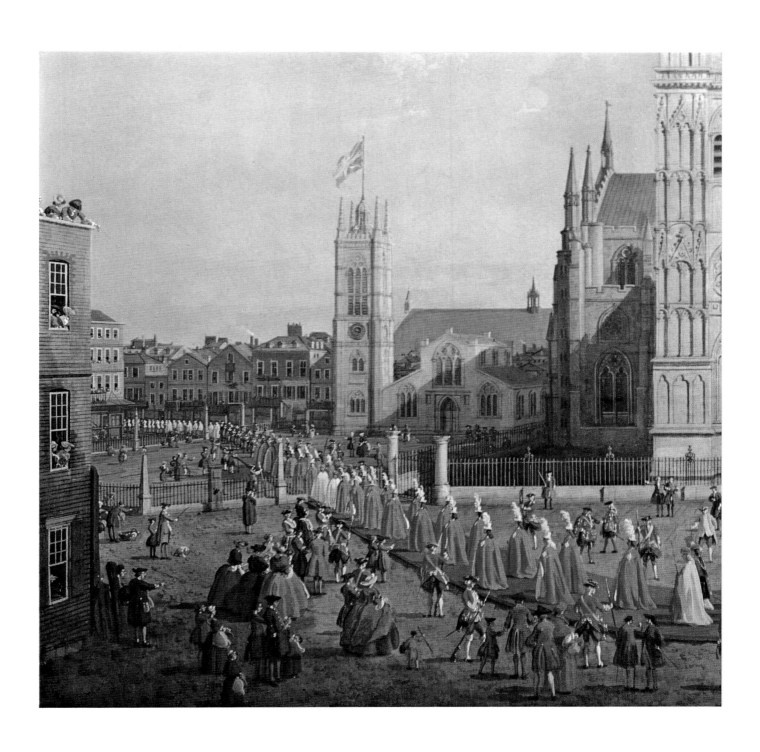

211. CANALETTO: *The Thames from the Terrace of Somerset House*. Windsor Castle, Royal Collection.
On the left is the terrace of Somerset House. In the curve of the river are St. Paul's and the City, with the spires of its numerous chur-
ches and the Monument. On the right, beyond the curve, old London Bridge.

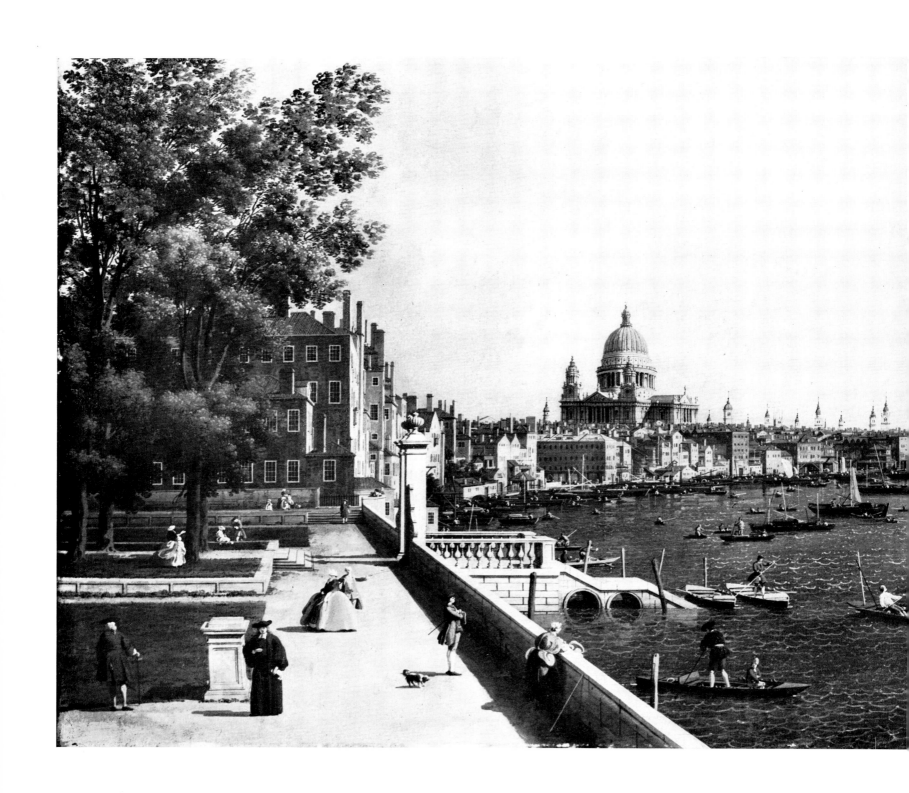

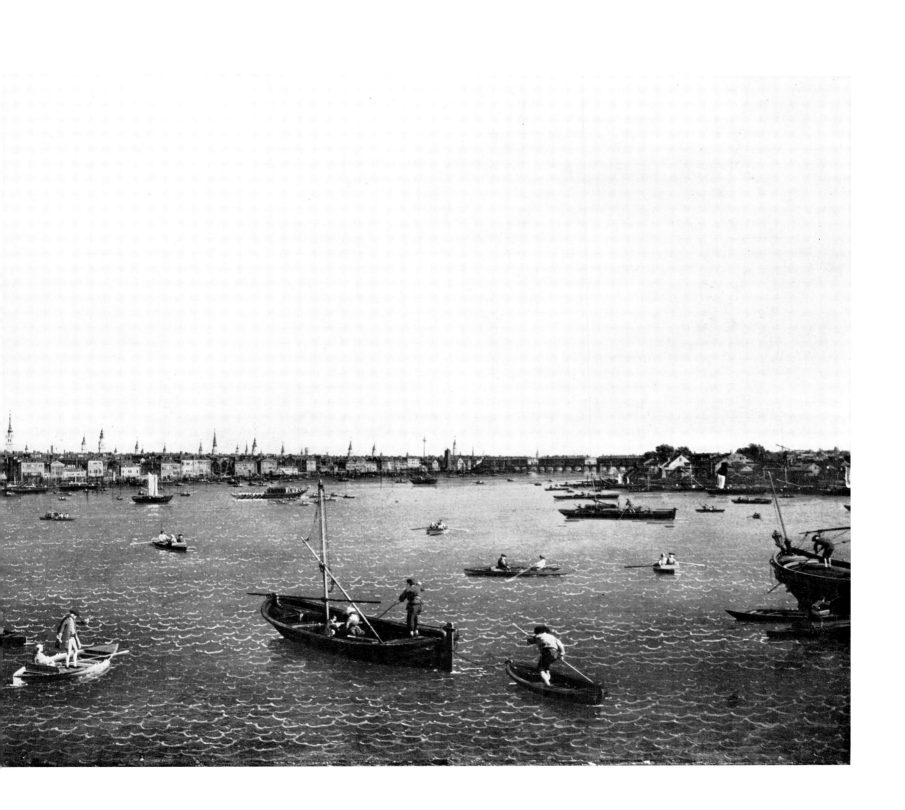

212-214. CANALETTO: *The Old Guardhouse from St James' Park* (details). Basingstoke, Collection of the Earl of Malmesbury.
This is probably one of the first works executed by Canaletto during his first visit to England. In the centre is the old Guardhouse which was demolished in 1749-50. (Canaletto later painted the new Horse Guards). On the left is the Admiralty and behind it the spire of St. Martin's-in-the-Fields.

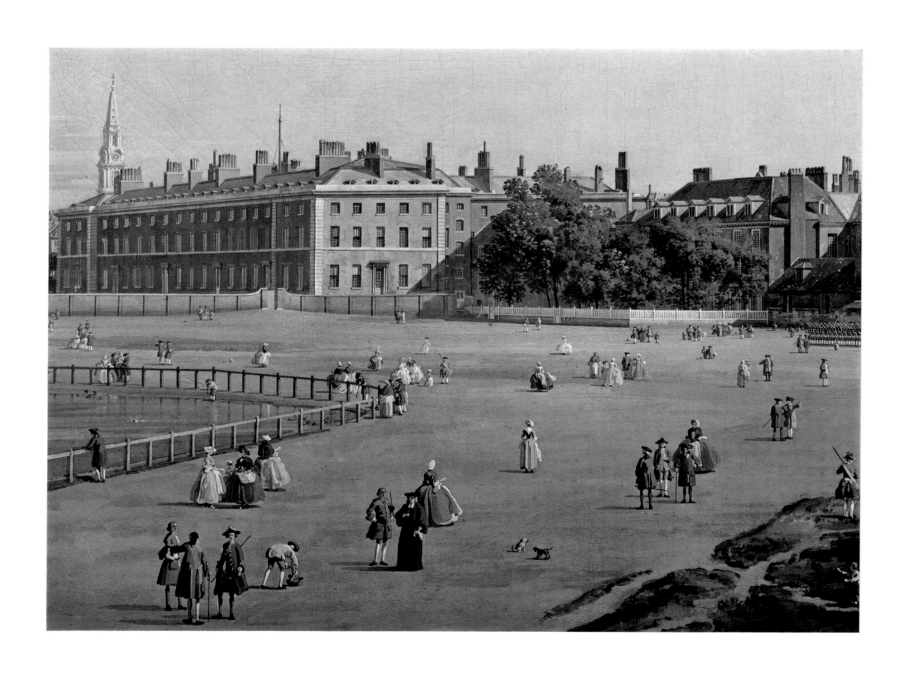

215. CANALETTO: *The Thames from the Terrace of Somerset House*. Windsor Castle, Royal Collection.
Companion to Pl. 211, this painting is from the same viewpoint but looking upstream. On the right in the foreground is the terrace of Somerset House, the wooden tower of the boatyard and, beyond the houses and warehouses of the left bank, the Banqueting Hall, the side of Westminster Abbey with the tower of St. Margaret's, the roof of Westminster Hall and Westminster Bridge, which appears to be completed so that the painting must be post-1746. Beyond the bridge can be seen the four towers of the Church of St. John the Evangelist, Smith Square.

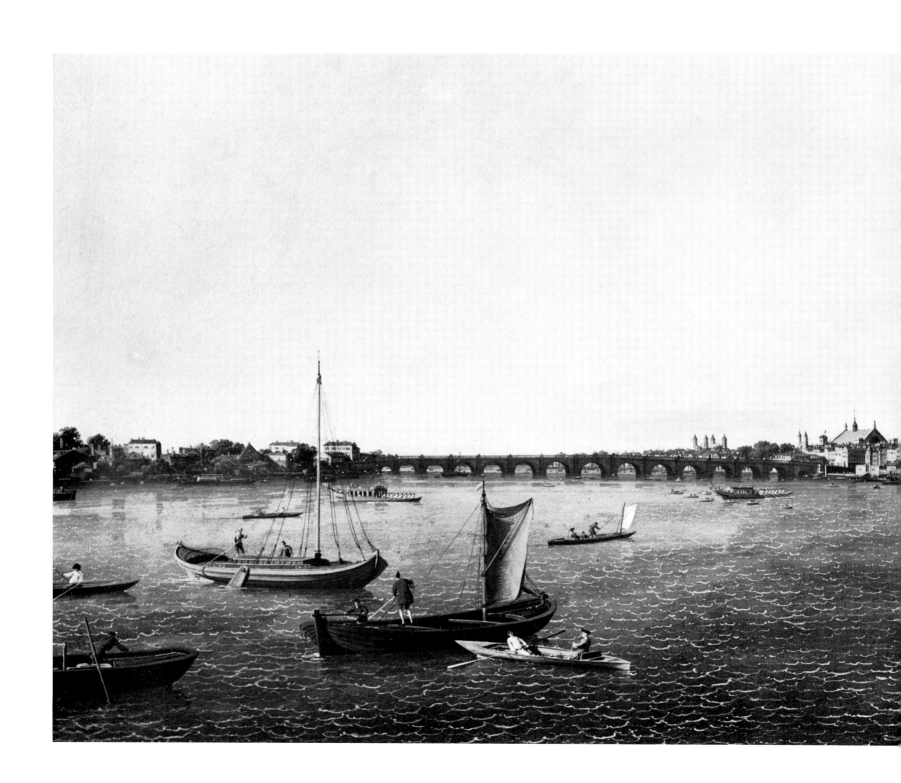

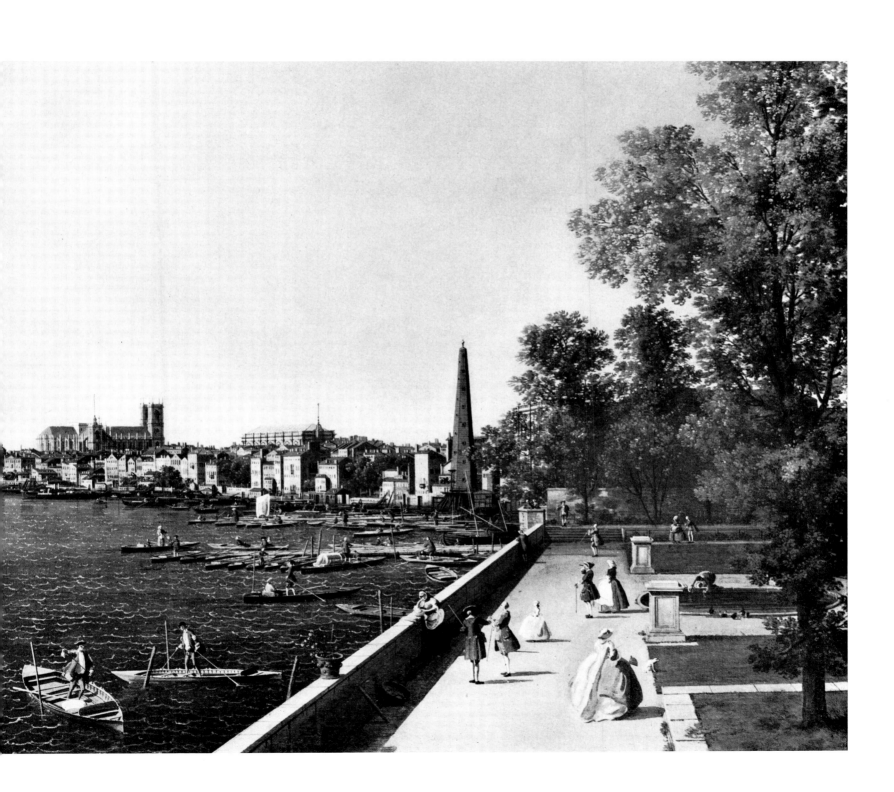

216. CANALETTO: *Greenwich Hospital*. Greenwich, National Maritime Museum.

Greenwich Hospital is seen from the left bank of the river. On the left of the painting is the Queen's House, on the right that of Charles II, and beyond the square with the statue of George II are the two domed additions of William and Mary.

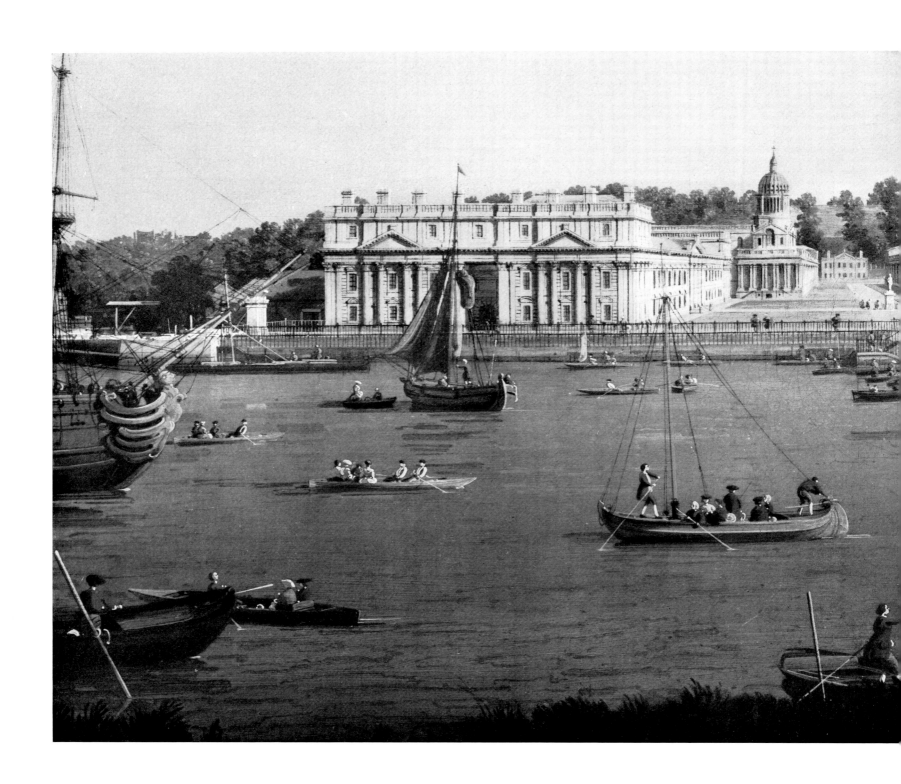

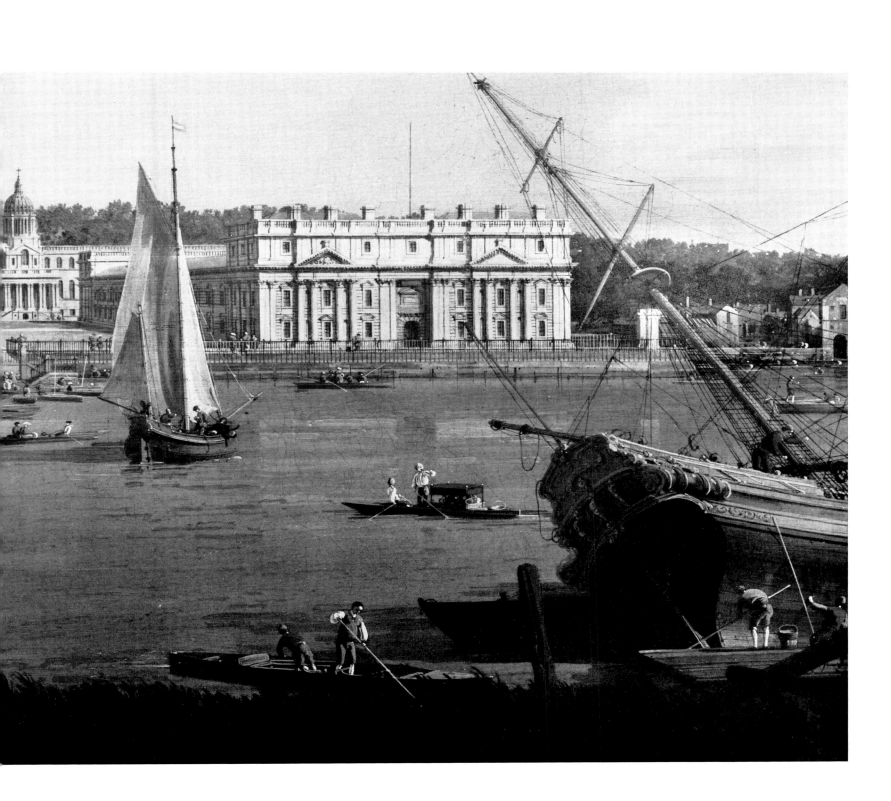

217. CANALETTO: *View of London and Westminster Bridge.* Prague, National Gallery.

The view is from a raised position on the right bank near Lambeth Palace, which can be seen in the foreground, and is a companion painting to that of the Thames on Lord Mayor's Day (Pls. 205-6). On the left bank are the four towers of St. John the Evangelist, Westminster Abbey, Westminster Hall and the spires of various churches, and on the right in the distance, the dome of St. Paul's.

218. CANALETTO: *Eton College.* London, National Gallery.

The chapel and school buildings are seen from the east, across the Thames. The small building in front of the chapel is probably the old kitchens. Some topographical details are incorrect, and the various buildings on the left and along the horizon are probably imaginary, but the position of the chapel relative to the school buildings is accurate. The painting is probably of 1747, the year in which Canaletto visited Windsor.

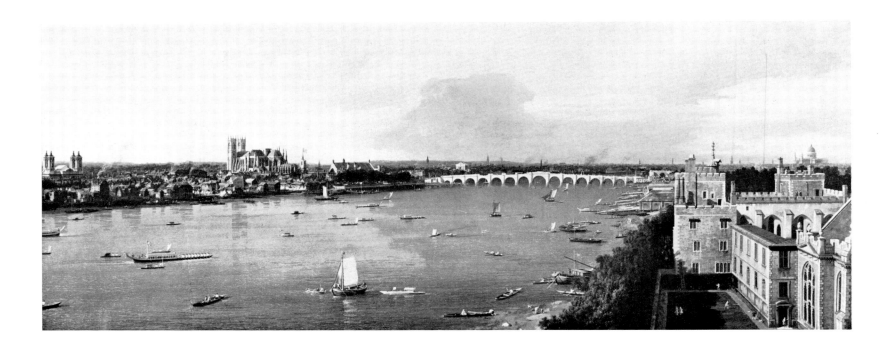

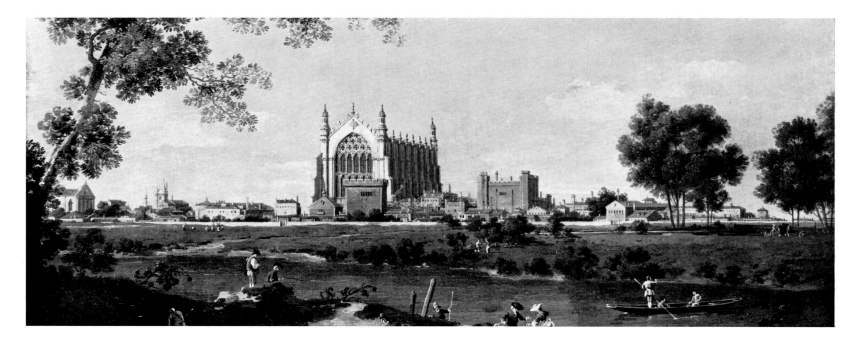

221-222. CANALETTO: *View of Warwick Castle* (details). Warwick, Collection of the Earl of Warwick.

One of many views of this subject by Canaletto, all from different viewpoints, this shows the castle from the south, across the river Avon. In the centre is the Ethelfleda's Mound and two small bridges. This painting has never left the possession of the Greville family; it was probably painted by Canaletto for Francis Greville who was created Earl of Brooke in 1746 and Earl of Warwick in 1579.

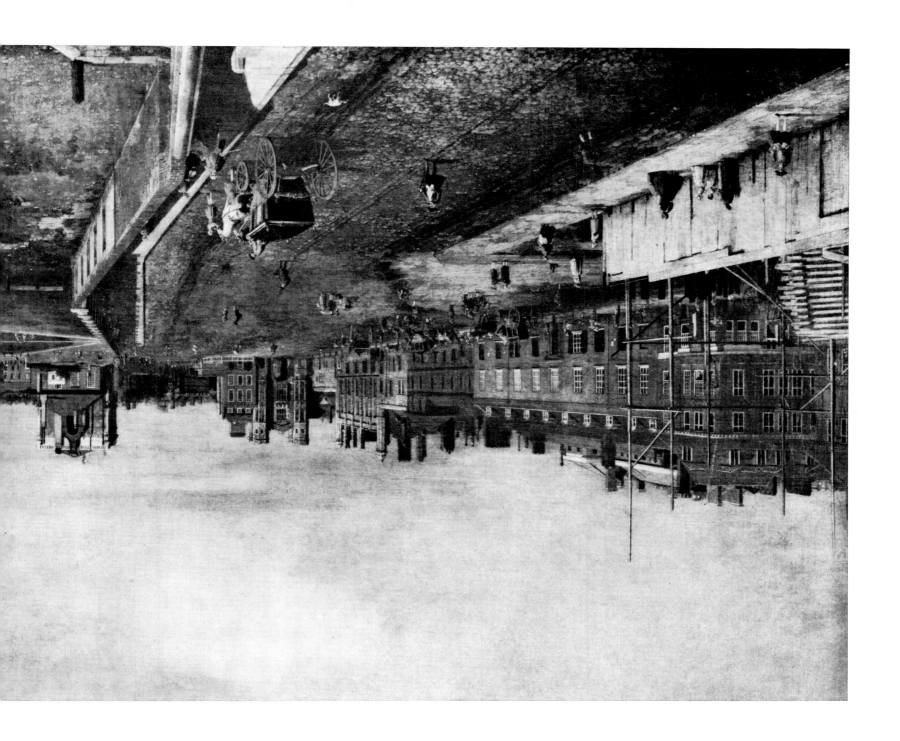

220. CANALETTO: *Whitehall and the Privy Garden.* Bowhill, Collection of the Duke of Buccleuch.

The view is similar to that in the collection of the Duke of Richmond, but the viewpoint is slightly to the left of the other, above the wall which separated Whitehall from the Privy Garden. On the right is a corner of Richmond House and its stables, behind which is seen the rear of Montagu House. Between the two houses are the Thames and, in the distance, St. Paul's. In the centre is the side of the Banqueting Hall and on the left the Holbein Gate. Further left and in the foreground is the scaffolding for a house which is being built on the site of what is now Parliament Street. This large canvas was painted probably in 1751. Canaletto always refused to sell it, and took it back with him to Venice, where it was later acquired by Dr. Hinchliffe.

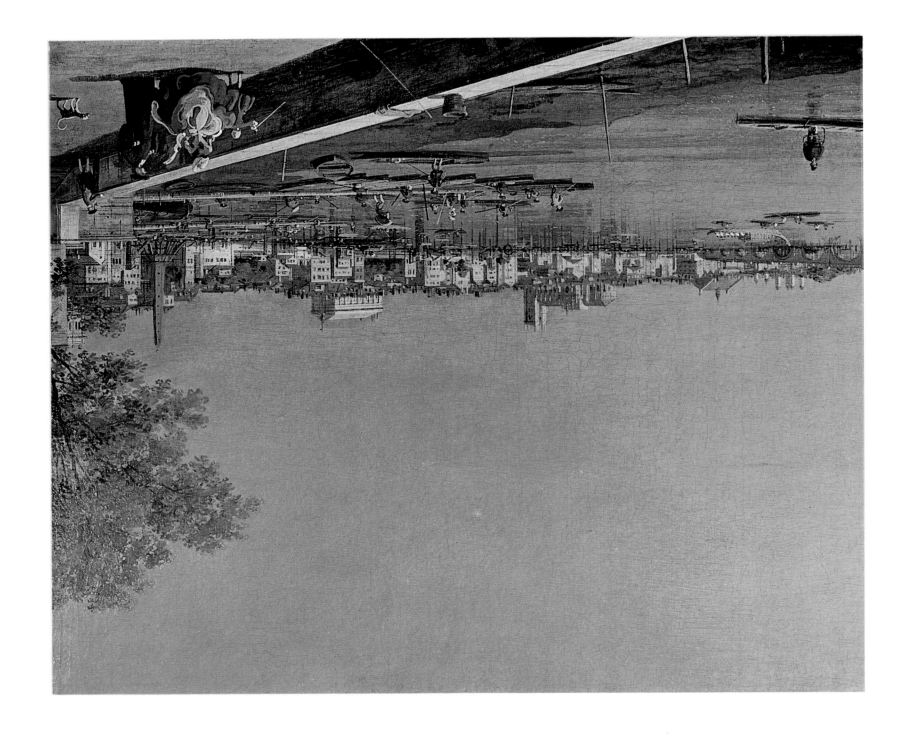

219. CANALETTO: *The Thames from the Terrace of Somerset House* (detail). Haddington, Collection of the Duke of Hamilton and Brandon. The painting is a smaller version of the Windsor view (Pl. 215) and differs from it in a few details, and it is also from a slightly different viewpoint. A drawing at Windsor seems to refer to this painting rather than to the other.

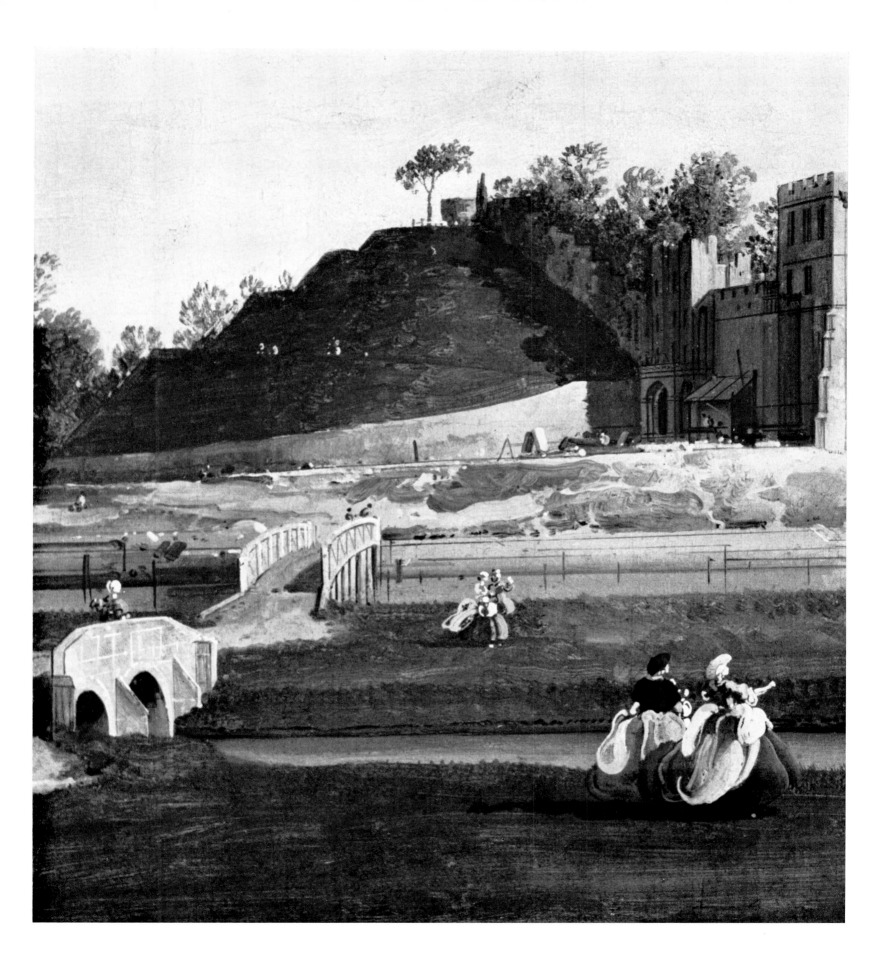

223. CANALETTO: *View of Warwick Castle* (detail). Warwick, Collection of the Earl of Warwick.
This detail shows Caesar's Tower, the mill and dam below, the main bridge over the river, and the Church of St. Nicholas beyond it.

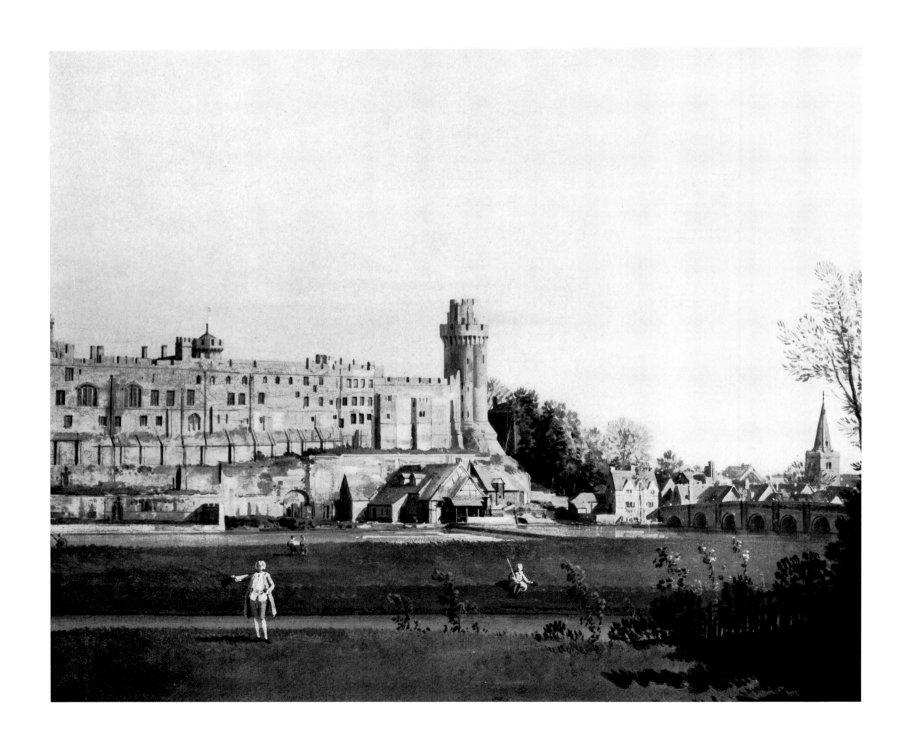

224. CANALETTO: *Somerset House* (detail). Minneapolis, Institute of Arts.
The view of Somerset House from the Thames, with the wide terrace animated by a variety of figures.

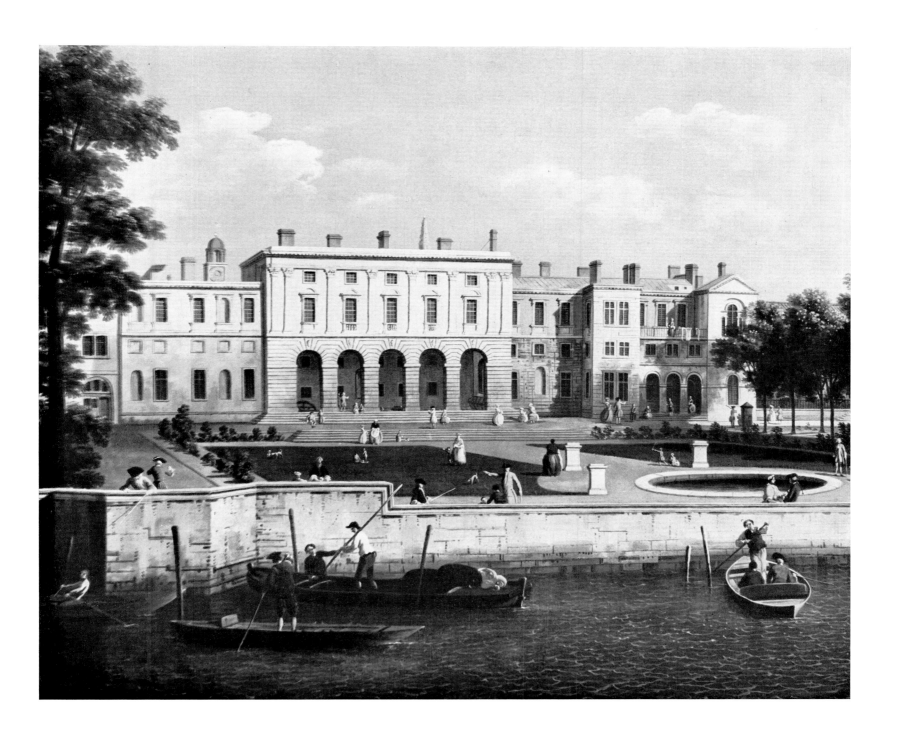

225. ANTONIO JOLI: *Whitehall from the north side, with the Banqueting Hall and the Holbein Gate* (detail). London, Private collection. Beyond the Banqueting Hall is the wall of the Privy Garden, and on the right can be seen part of the Holbein Gate.

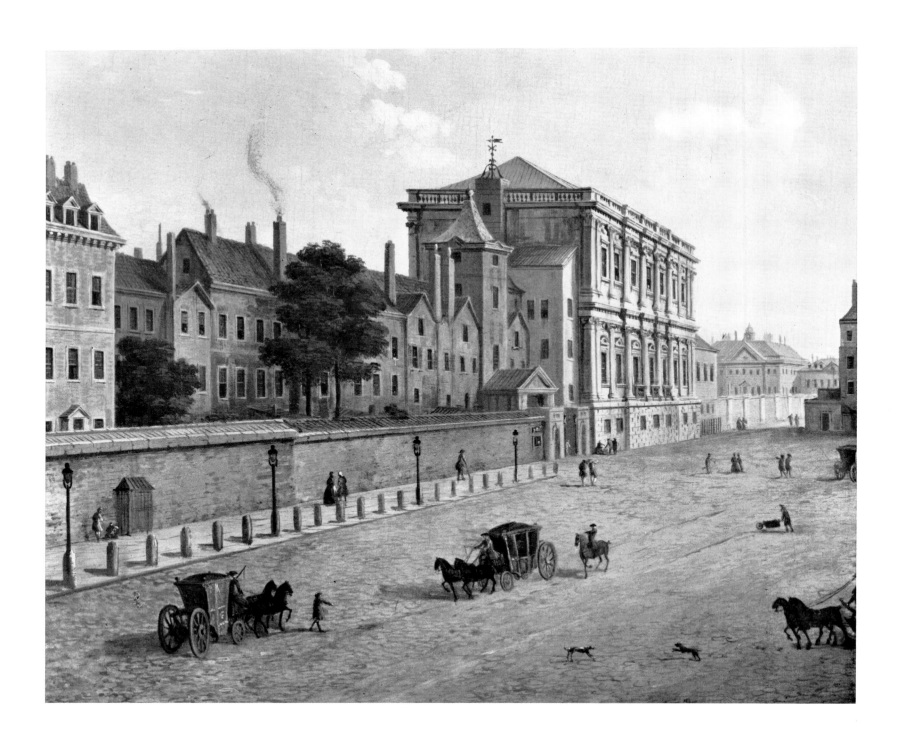

PARIS, VERSAILLES AND THE FRENCH PORTS

...It was some day in August, I cannot remember exactly which, but between the 15th and the 20th, a cloudy, cold, wet morning. I had left the fair sky of Provence and Italy; and I had never experienced such dirty fog, especially in August. Entering Paris through the wretched suburb of Saint Marcel and travelling on in this kind of stinking muddy sepulchre through the suburb of Saint Germain on my way to the inn, I felt my heart contract in anguish so much that in all my life I do not remember having felt such sadness for such a trifling cause. All that haste, all that longing, such mad dreams of my ardent fantasy — and then to find myself plunged into a fetid sewer. When I alighted at the inn I was already completely disillusioned, and had it not been for my extreme fatigue and the no little shame I should have incurred, I would have left again at once. Wandering all around Paris, as I did later, increasingly confirmed my disappointment: the meanness and clumsiness of the buildings, the ridiculous petty pomp of the few houses with any pretensions to be considered mansions, the dirtiness and Gothicism of the churches, the barbaric construction of the theatres at that time, and the many, many disagreeable things which met my eyes, not to mention the bitterest sight of all, the appallingly badly featured and be-plastered faces of the hideous women: all these things were not sufficiently compensated for by the beauty of the many gardens, the elegant and well-frequented public walks, the good taste and infinite number of fine carriages, the sublime façade of the Louvre, the innumerable entertainments, almost all of them good, and by other such things.

Vita, Giornali, Lettere, Florence, 1861.

VITTORIO ALFIERI
August 1767

...I went to Versailles. Like all other royal country residences, this is in a very bad situation. They like to overcome nature. What was Versailles in the time of Louis XIV? A hunting lodge built by Louis XIII in the middle of a bog. Now it is a city of 80,000 souls. The royal palace is vast, beautiful and astonishing. The garden is supreme of its kind. O, sojourn of the Muses and the Graces, how will you look in the springtime? Although the trees and plants are almost bare and withered, yet it pleases me beyond words. One thing among many others that has particularly enchanted me is a kind of grove shaped into a maze, in which from time to time there are small open places where fine lead statues represent the fables of Aesop or act as fountains. This in summer must be heavenly.

Carteggio di Pietro e di Alessandro Verri, dal 1766 al 1797, Milan, 1923.

PIETRO VERRI
1767

...The palace of Versailles, one of the objects of which report had given me the greatest expectation, is not in the least striking: I view it without emotion: the impression it makes is nothing. What can compensate the want of unity? From whatever point viewed, it appears an assemblage of buildings; a splendid quarter of a town, but not a fine edifice; an objection from which the garden front is not free, though by far the most beautiful. The great gallery is the finest room I have seen; the other apartments are nothing; but the pictures and statues are well known to be a capital collection. The whole palace, except the chapel, seems to be open to all the world; we pushed through an amazing crowd of all sorts of people to see the procession, many of them not very well dressed, whence it appears that no questions are asked. But the officers at the door of the apartment in which the king dined made a distinction, and would not permit all to enter promiscuously.

Travels in France and Italy, London, 1794.

ARTHUR YOUNG
May 1787

...The gardens of Versailles themselves are delightful. I have not yet mentioned them, and this is the time to do so. Vast in extent and varied in the different parts, on all sides there is a profusion of precious works in marble, original statues by famous contemporary artists and exact copies of the most prized figures by the ancients. Everywhere well-kept and ornamented avenues lead from shady, rustic corners; there are richly decorated pools, pleasingly designed parterres, magnificent fountains and jets of water reaching to amazing heights. The Orangery is a masterpiece: the number and size of the trees is wonderful, considering the climate which is naturally hostile to orange-trees; but the principal glory of these enchanting gardens are the groves.

These form a series of rooms or halls, which are not open to everyone; they can be seen by following the court on fête days or on the arrival of some illustrious foreigner, otherwise they are closed. Some persons, by grace and favour, are given a key to them. I had the good fortune to possess one, so I could examine them at my ease and give my friends the opportunity of enjoying them.

The groves number twelve in all: the *Salle de Bal*, the *Girandole*, the *Colonnade*, the *Dômes*, the *Encelade*, the *Obélisque*, the *Étoile*, the *Théâtre d'eau*, the *Bains d'Apollon*, the *Trois Fontaines*, the *Arc de Triomphe* and the *Labyrinthe*. In these groves are to be seen masterpieces of sculpture and architecture. The two most notable are the Bassin d'Apollon and the Colonnade. In the first there is a group of three figures in white marble, unique for their size and perfection; in the other there is a circular peristyle of thirty-two columns of various choice marbles.

Mémoires, Paris, 1787. CARLO GOLDONI
 May 1771

BREST

...The entrance to the roadstead is very narrow and winding, which has given it the name of Goulet (narrows). Seen from the opening of the bay, Brest stretches out in a pleasing fashion; its planning and its rising curve make it seem of far more notable size than it is in reality, and the works of fortification alternating with gardens and pretty little villas contribute to a fascinating prospect; and this in fact suggested to the celebrated Vernet one of his finest paintings. At the entrance to the port there is a flying bridge, which is a cabin holding five or six persons, suspended by pulleys from a cable which moves it from the coast to the fort or from the fort to the coast by means of a rope and drum mechanism. Besides commerce, which thrives by the advantages of the harbour facilities of Brest, there is a flourishing trade in fishing for sardines and mackerel.

Guide des Voyageurs en Europe, Weimar, 1784. HEINRICH AUGUST OTTOKAR REICHARD
 1740

LA ROCHELLE

...The city of La Rochelle is the capital of the province of Aunis. Although it is not of great antiquity, it acquired fame in the wars of religion during the last century. The first houses were built there to prevent the sporadic incursions of the Normans. The Protestants acquired the mastery of the city during the last century, and when the English and Dutch incited them to rebellion, because the sea facilitated the arrival of reinforcements they were sending, they drew down upon themselves the indignation of the Sovereign Prince and of Cardinal Richelieu for building a jetty of 747 paces long reaching out to sea.

La Rochelle surrendered on 29 October 1628. The King ordered that its fortifications should be razed to the ground, except for those which were judged to be necessary for the defense of the port, which was closed by a chain which goes from one tower to another.

Voyage historique de l'Europe, Paris, 1693.

BAYONNE

...Bayonne is by much the prettiest town I have seen in France; the houses are not only well built of stone, but the streets are wide and there are many openings which, though not regular squares, have a good effect. The river is broad, and many of the houses being fronted to it, the view of them from the bridge is fine. The promenade is charming; it has many rows of trees, whose heads join and form a shade delicious in this hot climate. In the evening, it was thronged with well-dressed people of both sexes: and the women, through all the country, are the handsomest I have seen in France. In coming hither from Pau, I saw what is very rare in that kingdom, clean and pretty country girls; in most of of the provinces, hard labour destroys both person and complexion. The bloom of health on the cheeks of a well-dressed country girl is not the worst feature in any landscape. I hired a chaloup for viewing the embankment at the mouth of the river. By the water spreading itself too much the harbour was injured; and the government, to contract it, has built a wall on the north bank a mile long, and another on the south shore of half the length. It is from ten to twenty feet wide, and about twelve high, from the top of the base of rough stone, which extends twelve or fifteen feet more. Towards the mouth of the harbour it is twenty feet wide and the stones on both sides crampt together with irons. They are now driving piles of pine sixteen feet deep for the foundation. It is a work of great expense, magnificence, and utility.

Travels in France and Italy, London, 1794. ARTHUR YOUNG
 August 1787

ANTIBES

...Antibes is situated on a neck of land, which runs out into the sea and becomes a kind of peninsula. The open sea breaks against its southern side; on the western is a large bay, in which any fleet may ride safe against the land winds; the eastern side, which looks towards Nice, is formed into a very good harbour by the help of a long mole built with large stones; and a chain of hills surrounds the town on the north.
Those hills are very fruitful, and yield vast quantities of the best wine and oil; but they have so absolute a command over the town, as would render its spacious fortifications of little use, was Antibes vigorously besieged by land. A battery of only twenty guns would, I think, demolish in a very few days the three great bastions on that side, in spite of the high cavaliers over them, and the castle with four small bastions that has been erected opposite to the harbour.

A Journey from London to Genoa, London, 1770. JOSEPH BARETTI
 November 1760

SCHAFFHAUSEN

...We passed hastily through Zuric, in our way to Schaffhausen, for although I had been assured that the cataract of the Rhine was 'but a fall of water', it had excited so tormenting

a curiosity, that I found I shoud be incapable of seeing any thing else with pleasure or advantage, till I had once gazed upon that object.

When we reached the summit of the hill which leads to the fall of the Rhine, we alighted from the carriage, and walked down the steep bank, whence I saw the river rolling turbulently over its bed of rocks, and heard the noise of the torrent, towards which we were descending, increasing as we drew near. My heart swelled with expectation — our path, as if formed to give the scene its full effect, concealed for some time the river from our view; till we reached a wooden balcony, projecting on the edge of the water, and whence, just sheltered from the torrent, it bursts in all its overwhelming wonders on the astonished sight. That stupendous cataract, rushing with wild impetuosity over those broken, unequal rocks, lifting up their sharp points amidst its sea of foam, disturb its headlong course, multiply its falls, and make the afflicted waters roar — that cadence of tumultuous sound, which had never till now struck upon my ear — those long feathery surges, giving the element a new aspect — that spray rising into clouds of vapour, and reflecting the prismatic colours, while it disperses itself over the hills — never, never can I forget the sensations of that moment! when with a sort of annihilation of self, with every past impression erased from my memory, I felt as if my heart were bursting with emotions too strong to be sustained. — Oh, majestic torrent! which hast conveyed a new image of nature to my soul, the moments I have passed in contemplating thy sublimity will form an epocha in my short span! — thy course is coeval with time, and thou wilt rush down thy rocky walls when this bosom, which throbs with admiration of thy greatness, shall beat no longer!

What an effort does it require to leave, after a transient glimpse, a scene, on which, while we meditate, we can take no account of time! Its narrow limits seem too confined for the expanded spirit; such objects appear to belong to immortality; they call the musing mind from all its little cares and vanities, to higher destinies, and regions more congenial than this world to the feelings they excite. I had been often summoned by my fellow travellers to depart, had often repeated 'but one moment more', and many 'moments more' had elapsed, before I could resolve to tear myself from the balcony.

We crossed the river, below the fall, in a boat, and had leisure to observe the surrounding scenery. The cataract, however, had for me a sort of fascinating power, which, if I withdrew my eyes for a moment, again fastened them on its impetuous waters. In the back ground of the torrent a bare mountain lifts its head encircled with its blue vapours; on the right rises a steep cliff of an enormous height, covered with wood, and upon its summit stands the castle of Lauffen, with its frowning towers, and encircled with its crannied wall; on the left human industry has seized upon a slender thread of this mighty torrent in its fall, and made it subservient to the purposes of commerce. Founderies, mills, and wheels are erected on the edge of the river, and a portion of the vast bason into which the cataract falls is confined by a dyke, which preserves the warehouses and the neighbouring huts from its inundations. Sheltered within this little nook, and accustomed to the neighbourhood of the torrent, the boatman unloads his merchandize, and the artisan pursues his toil, regardless of the falling river, and inattentive to those thundering sounds which seem calculated to suspend all human activity in solemn and awful astonishment; while the imagination of the spectator is struck with the comparative littleness of fleeting man, busy with his trivial occupations, contrasted with the view of nature in all her vast, eternal, uncontrolable grandeur.

We walked over the celebrated wooden bridge at Schaffhausen, of which the bold and simple construction is considered as an extraordinary effort of genius in the architect.

A Tour in Switzerland, London, 1798.

HELEN MARIA WILLIAMS
1798

226. HUBERT ROBERT: *The Vigiers Baths at Pont-Royal*. Paris, Banque de France.

The ruined arch of an imaginary bridge frames this view of the Pont-Royal and the corner pavilion of the Louvre. Between the bridges is the floating establishment of Vigiers' Baths, one of several such institutions which appeared in Paris in the second half of the century.

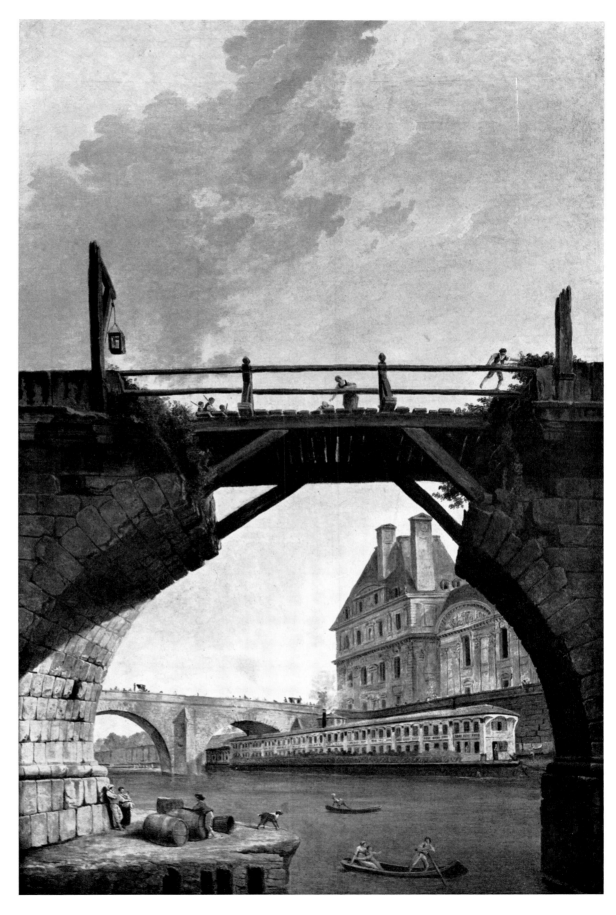

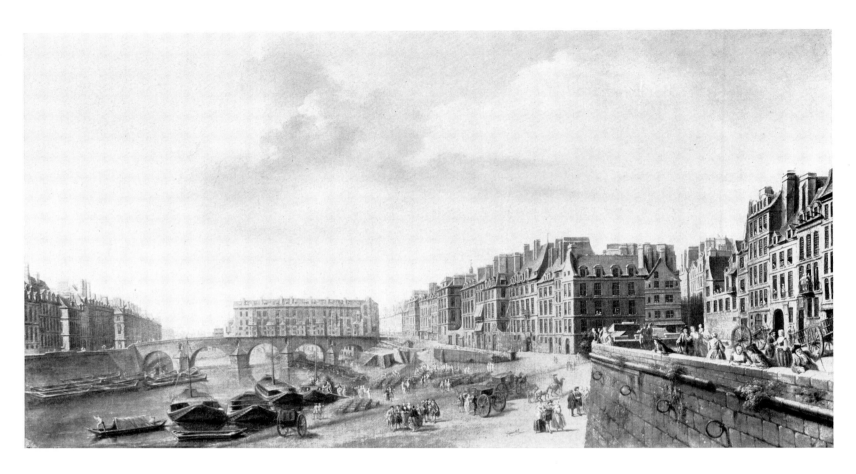

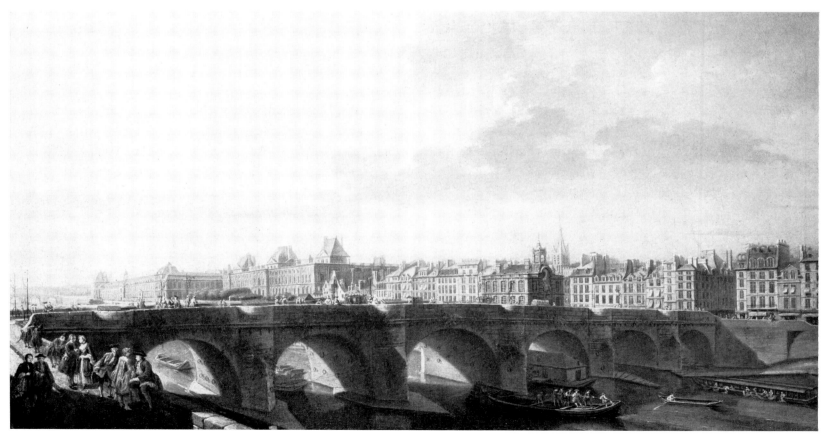

227. JEAN-BAPTISTE RAGUENET: *Pont-Marie*. Paris, Musée Camondo.
This view of the Pont-Marie, which was built in the seventeenth century and here still bears the old buildings which were later demolished, is from the right bank of the Seine looking north-west. On the left is the Quai d'Anjou, on the Ile St. Louis.

228. JEAN-BAPTISTE RAGUENET: *Pont-Neuf*. Paris, Musée Camondo.
The view from the Quai de l'Horloge, on the Ile de la Cité, shows only part of the long bridge, together with the right bank of the Seine, the Palais du Louvre and the tower of St. Germain l'Auxerrois.

229. JEAN-BAPTISTE RAGUENET: *Boatmen's Festival by the Pont de Notre-Dame* (detail). Paris, Musée Carnavalet.
A view of the bridge of Notre-Dame, one of the oldest in Paris, with the buildings which were demolished in 1786.

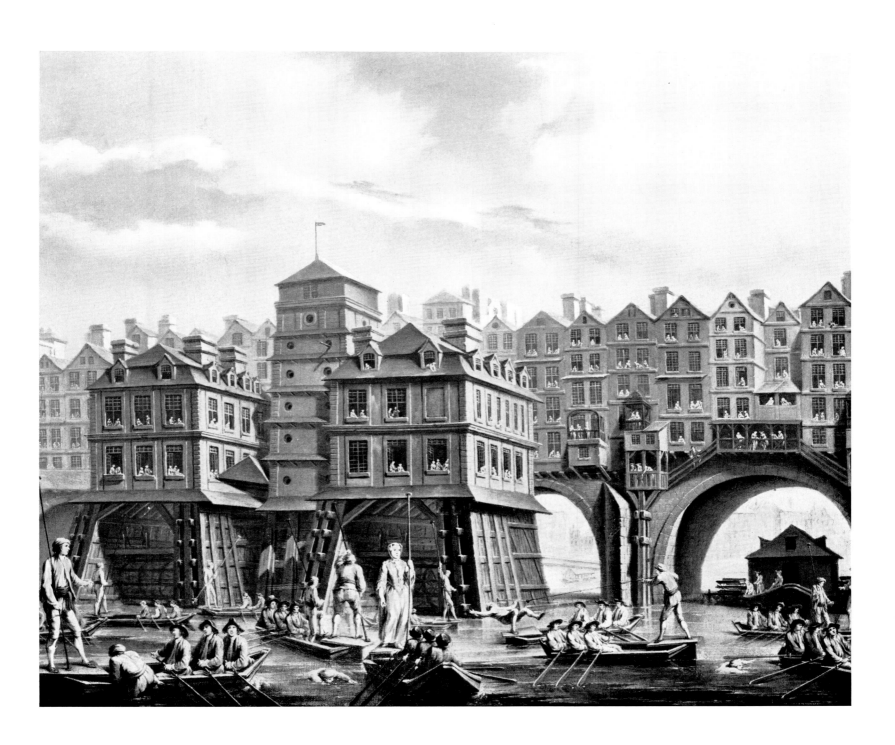

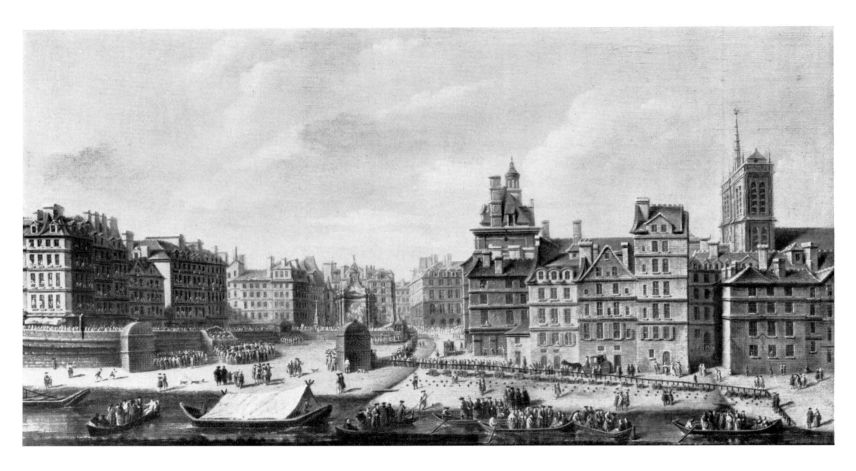

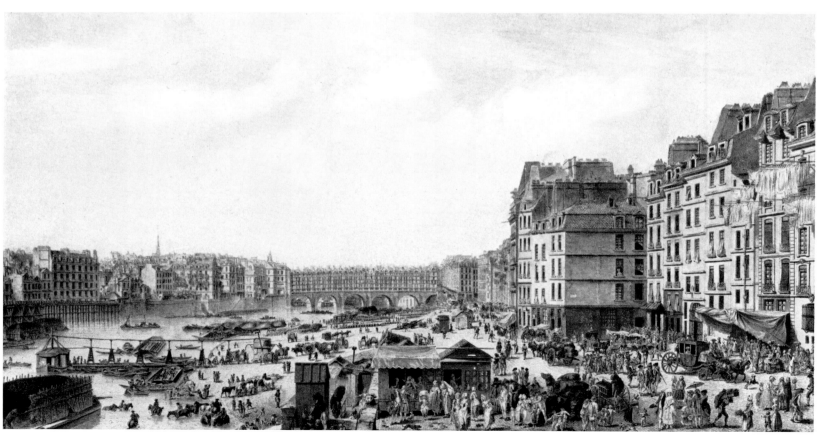

230. JEAN-BAPTISTE RAGUENET: *Celebrations in the Place de Grève for the birth of a Princess* (detail). Paris, Musée Carnavalet.
Place de Grève, now Place de l'Hôtel de Ville, from the Seine. The square was later the scene of executions.

231. LOUIS-NICOLAS DE LESPINASSE: *View of the Port-au-Blé* (detail). Paris, Musée Carnavalet.
The old 'Port-au-Blé' was in the seventeenth century one of the most active of the Paris river ports. On the left is the Ile de la Cité and the bridge of Notre-Dame with its houses which were demolished in 1786.

232. JEAN-BAPTISTE RAGUENET: *House at the sign of Notre-Dame* (detail). Paris, Musée Carnavalet.
Raguenet and his son Nicolas constituted, between 1750 and 1755, a kind of factory of views of Paris for foreigners. This painting, of 1751, shows a house which faced Place de Grève.

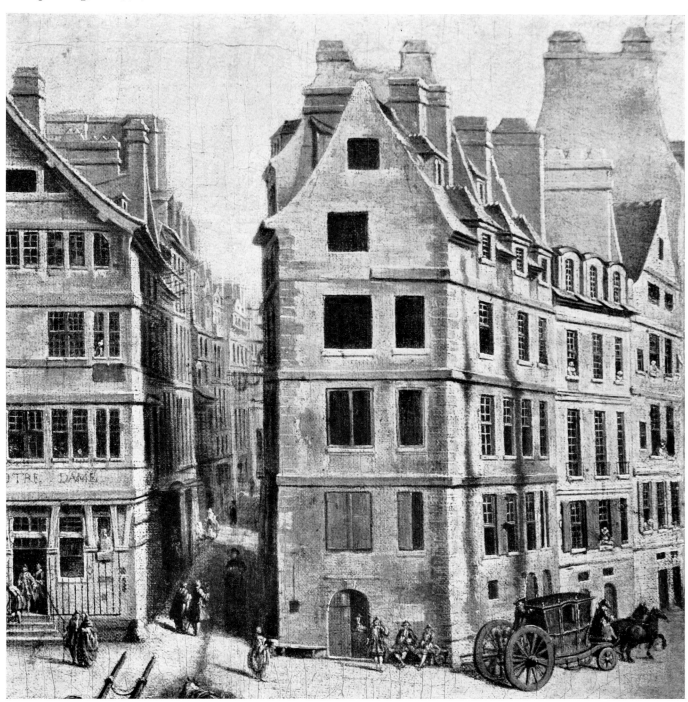

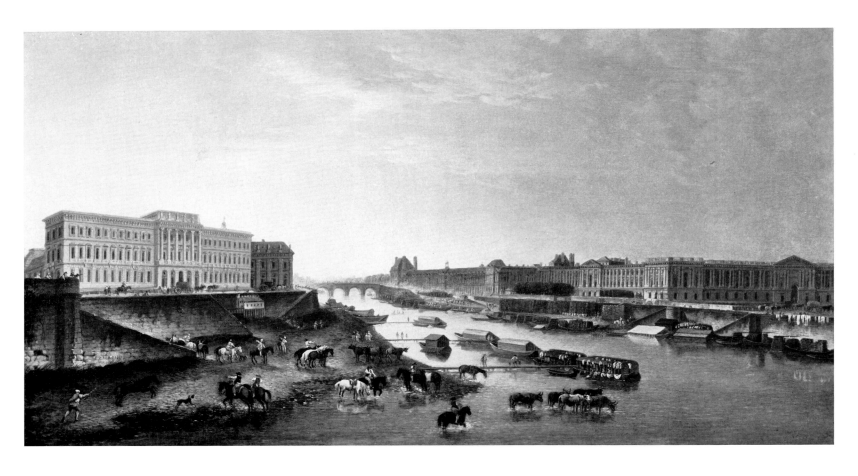

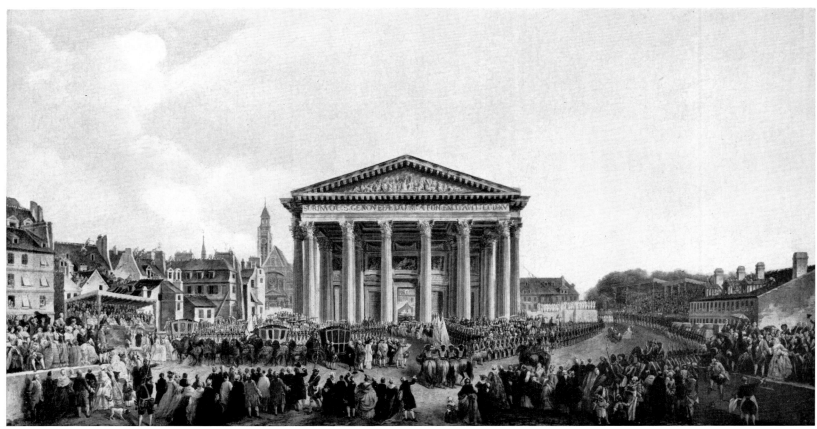

233. PIERRE-ANTOINE DEMA-
CHY: *View of the Seine*. Paris, Pri-
vate collection.

The view from the Vert-Galant,
below the Pont-Neuf, showing the
Louvre and the Pont-Royal on the
right bank and the old Hôtel de
Nevers and a corner of the Pa-
lais de l'Institut on the left.

234. PIERRE-ANTOINE DEMA-
CHY: *The Church of Ste. Geneviève
on the occasion of its opening*. Paris,
Musée Carnavalet.

The church, which later underwent
transformation, is the present Pan-
théon. On the left is the tower and
old façade of St. Etienne-du-Mont.

235. HUBERT ROBERT: *Demo-
lition of the Church of the Feuillants*
(detail). Paris, Musée Carnavalet.

The church of the Reformed Ci-
stercians which lay between Rue
St. Honoré and the north terrace
of the Tuileries, built by François
Mansart in 1624, was demolished
in 1804.

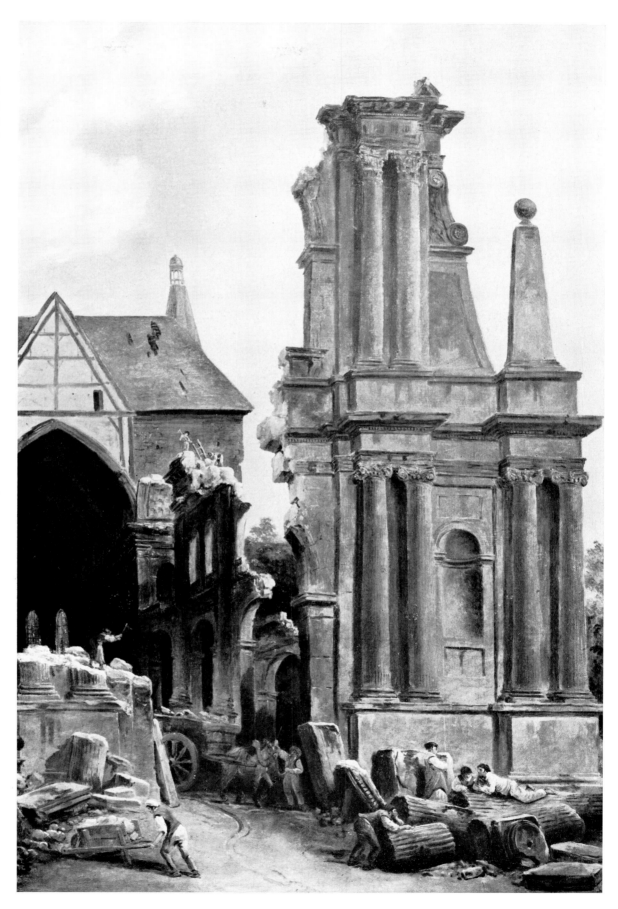

236. HUBERT ROBERT: *The Bassin d'Apollon at Versailles* (detail). Paris, Musée Carnavalet.
Robert was commissioned by Louis XV to rearrange the part of the garden of Versailles known as the 'Grove of Apollo' and he painted this view during the time when he was directing the work there. The central group of statues, showing Apollo in the home of Thetis tended by nymphs, is by François Girardon.

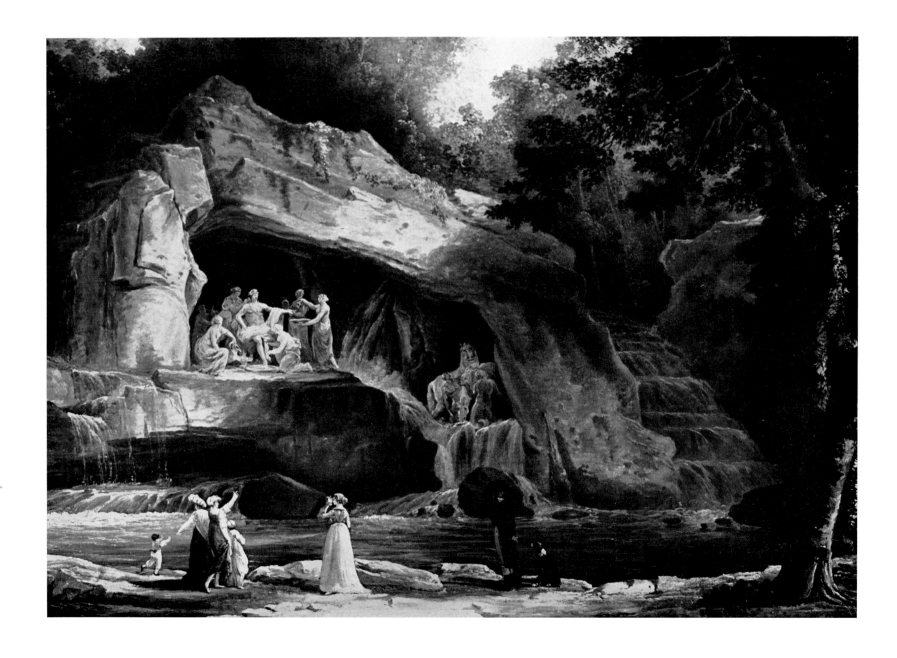

237. HUBERT ROBERT: *A Fire at the Opéra* (detail). Paris, Musée Carnavalet.

The painting shows the fire at the Opera House seen from the Palais-Royal. Fire broke out on 8 June 1781 in the Opéra which had been built within the perimeter of the Palais-Royal by the architect Moreau and completed in 1770. In this view the Opéra is hidden by the buildings of the Cour d'Honneur of the Palais-Royal, built for Richelieu but altered for Louis-Philippe d'Orléans between 1752 and 1760. On the left, behind the curtain of smoke, are the houses of Rue des Bons-Enfants.

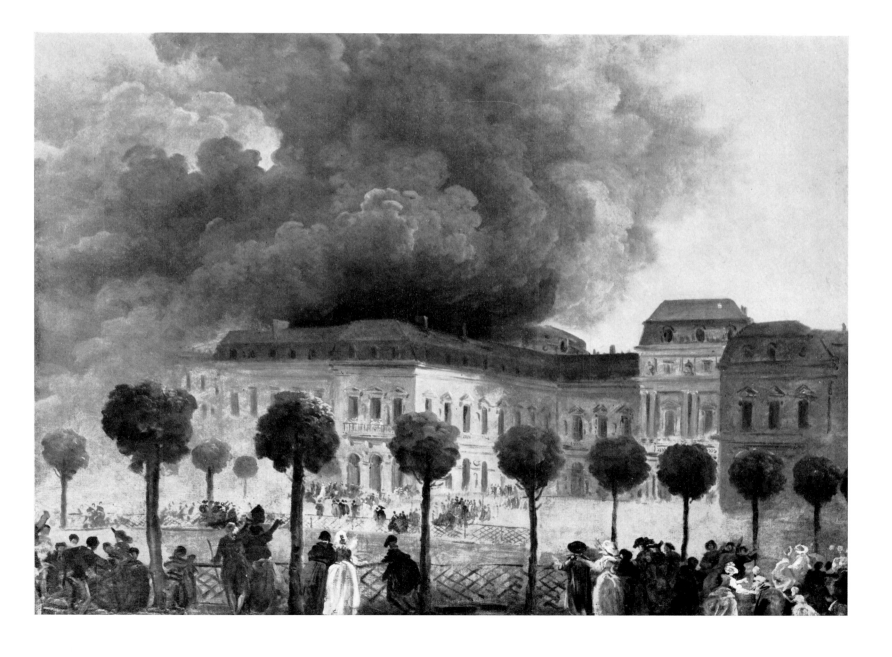

238. PIERRE-ANTOINE DEMACHY: *Clearing away masonry between St. Germain l'Auxerrois and the Louvre Colonnade* (detail). Paris, Private collection.

The painting shows some of the demolition work carried out at the time of the Revolution. The view is dominated by the façade of the Louvre which appears among the ruins and on the left, across the Seine, is the Institut de France.

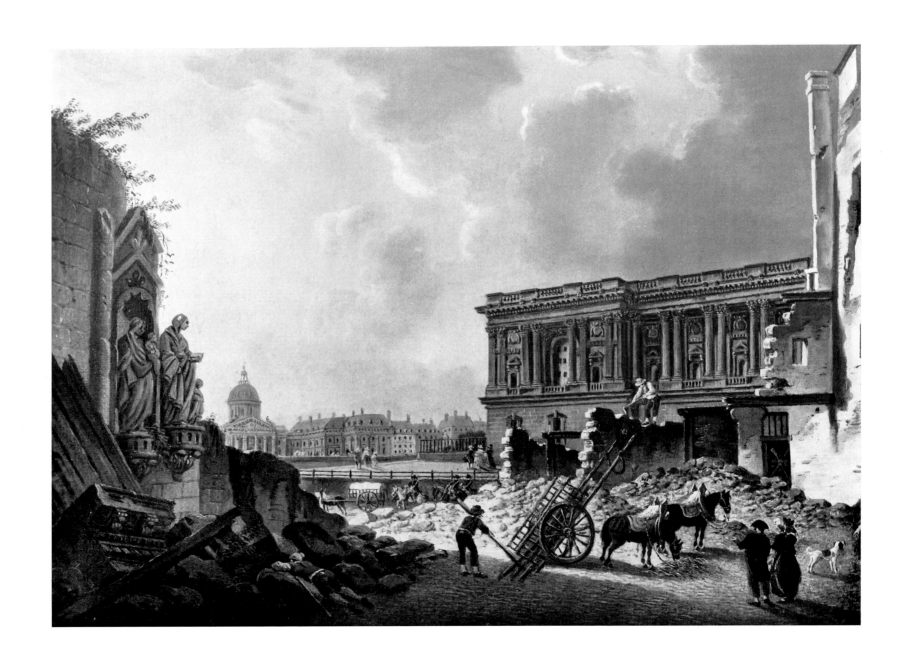

239. HUBERT ROBERT: *View of the Bassin d'Apollo* (detail). Versailles, Musée National de Versailles et des Trianons.
The painting shows the work of reconstruction of the gardens at Versailles in 1775 and in particular the rearrangement of the present Bassin d'Apollo. The trees of the former wood are being cut down, and one of the groups of the Horses of the Sun is already in its place. In the background is the front of the palace.

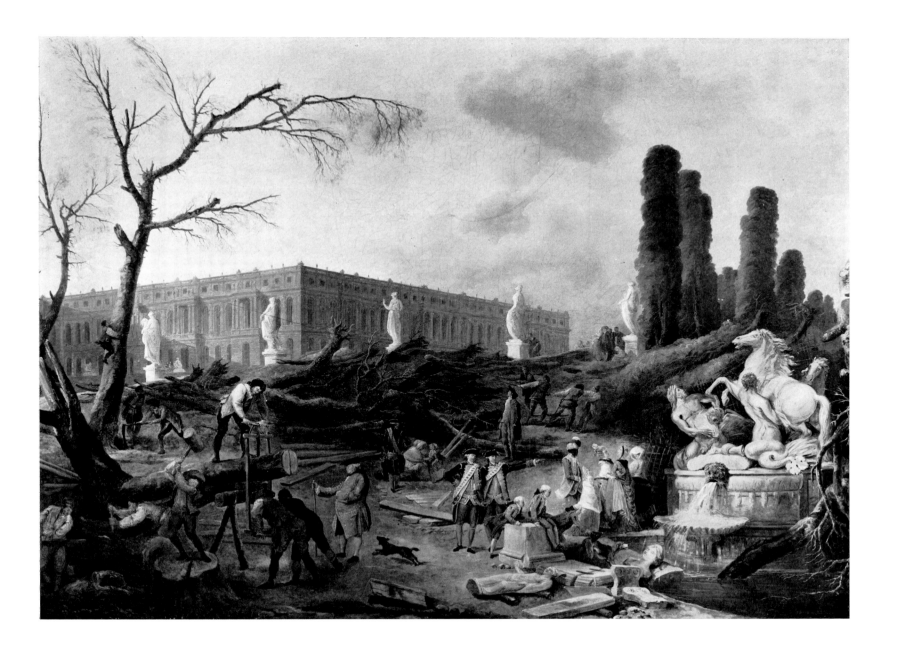

240. LOUIS-GABRIEL MOREAU THE ELDER: *Place Louis XV from the Seine* (detail). Paris, Private collection.

Place Louis XV, now Place de la Concorde, seen from the Seine, with the equestrian statue of the King by Edmé Bouchardon in the centre which was installed in 1663 and demolished by decree of the Legislative Assembly in 1792. At the corners of the square are four edifices which were intended as bases for statues, and in the centre of the view are the two buildings of the Garde-Meuble by Jacques-Ange Gabriel.

241. JOSEPH VERNET: *Marseilles* (detail). Paris, Musée de la Marine.

In October 1753 the Surintendance aux Bâtiments du Roi, on the suggestion of M. de Marigny, commissioned from Vernet a series of views of the ports of France which were to comprise a total of 24 paintings. At the request of Vernet, who found the travelling inconvenient and the remuneration insufficient, the number was reduced to 15, which he executed between 1754 and 1765.

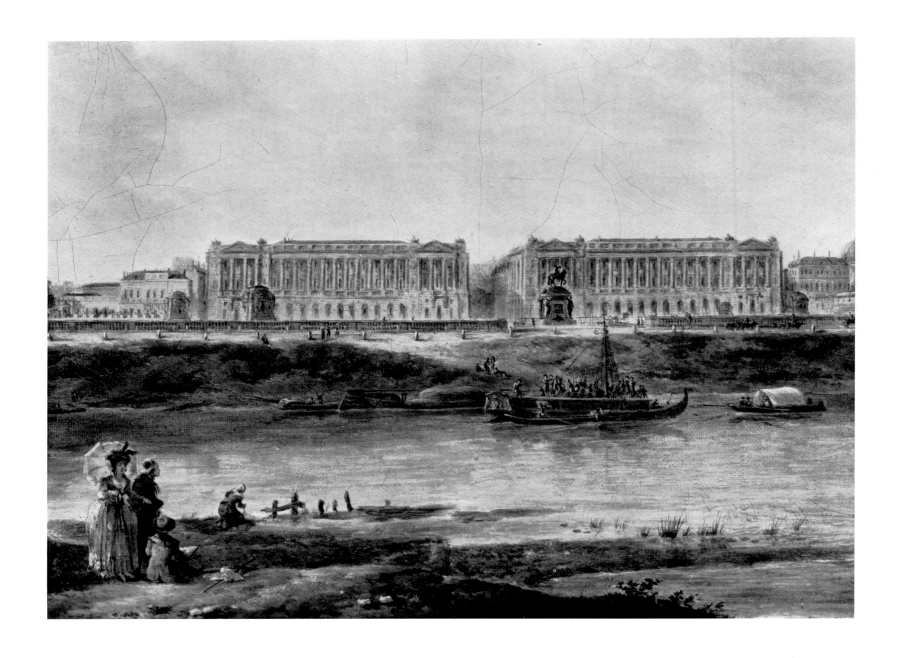

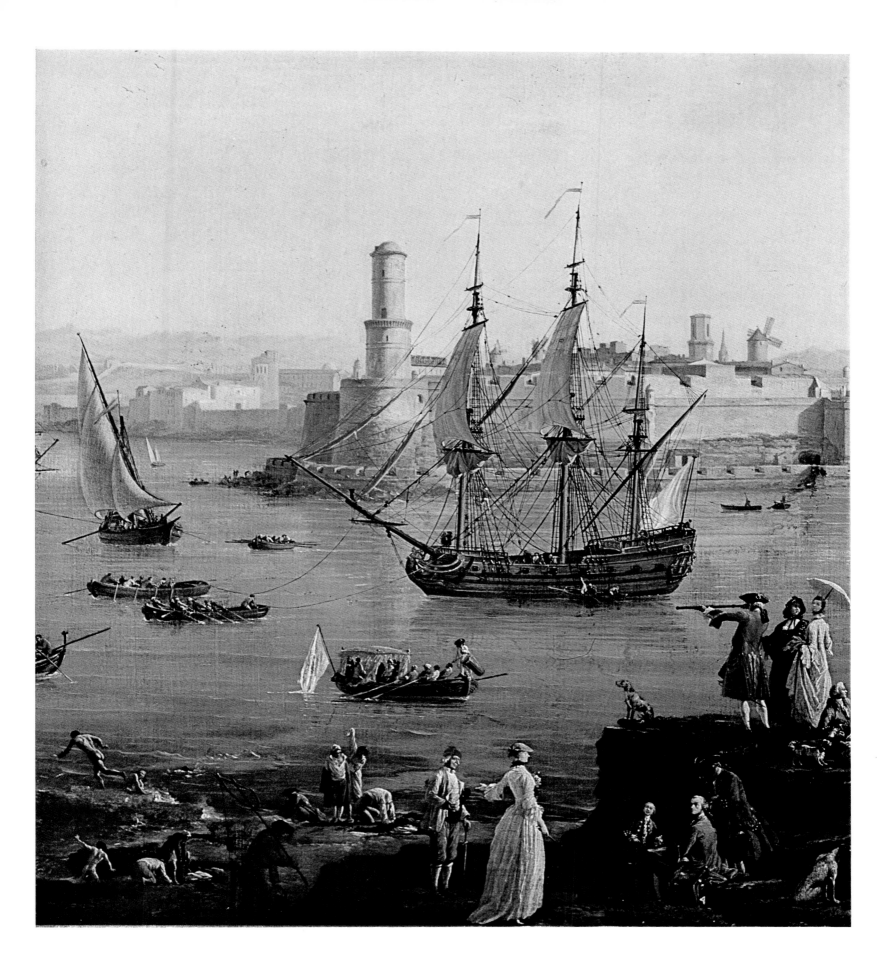

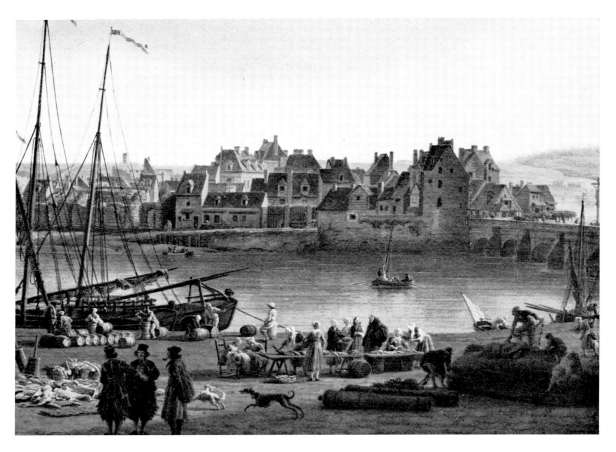

242-243. JOSEPH VERNET: *The Port of Dieppe* (details). Paris, Musée de la Marine.

The view of Dieppe was the last of the series of French ports painted by Vernet and is dated 1765.

244. JEAN-FRANÇOIS HUE: *The Port of St. Malo*. Paris, Musée de la Marine.

Since the series of views of French ports remained incomplete on the death of Vernet, Hue was designated to complete the undertaking and painted seven of them. The roads of the port of St. Malo are seen from the Anse des Sablons, St. Servan.

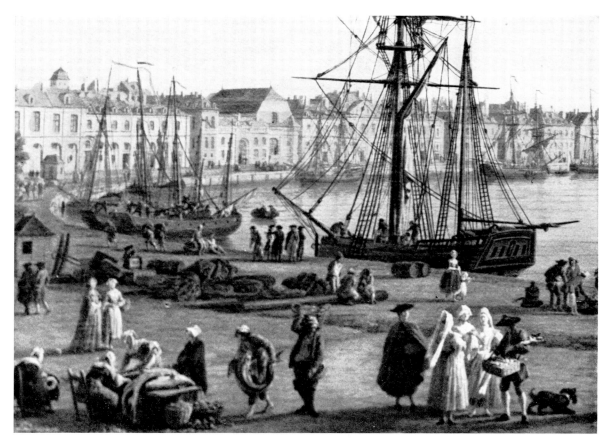

245. JEAN-FRANÇOIS HUE: *The Port of Brest*. Paris, Musée de la Marine.

Painted in 1794, the scene in the foreground shows the engineer M. Sauet demonstrating to the Representatives of the People the design of a ship under construction.

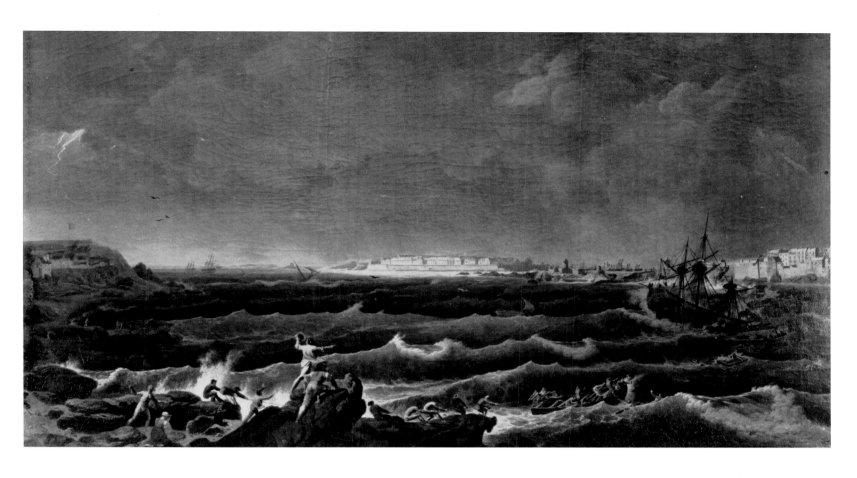

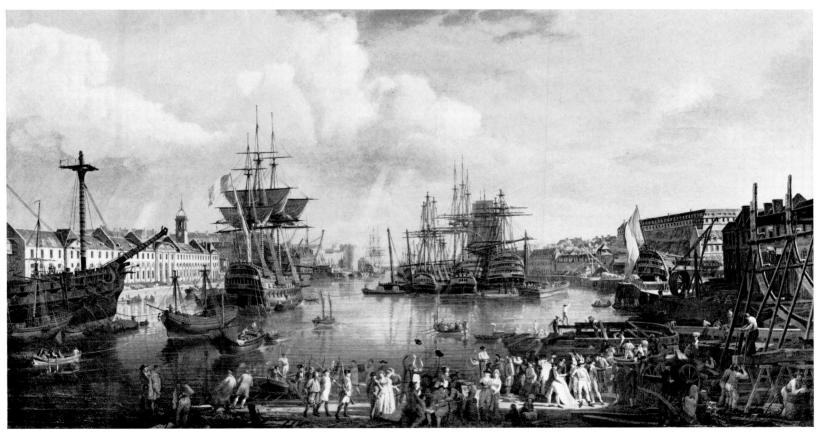

246. JOSEPH VERNET: *View of Avignon*. London, Private collection.
One of Vernet's finest views shows the city of Avignon dominated by the massive Papal Palace, from the right bank of the Rhône near Villeneuve. Commissioned by M. Peilhon in 1751 it was painted during the artist's visit to Avignon from July to October 1756.

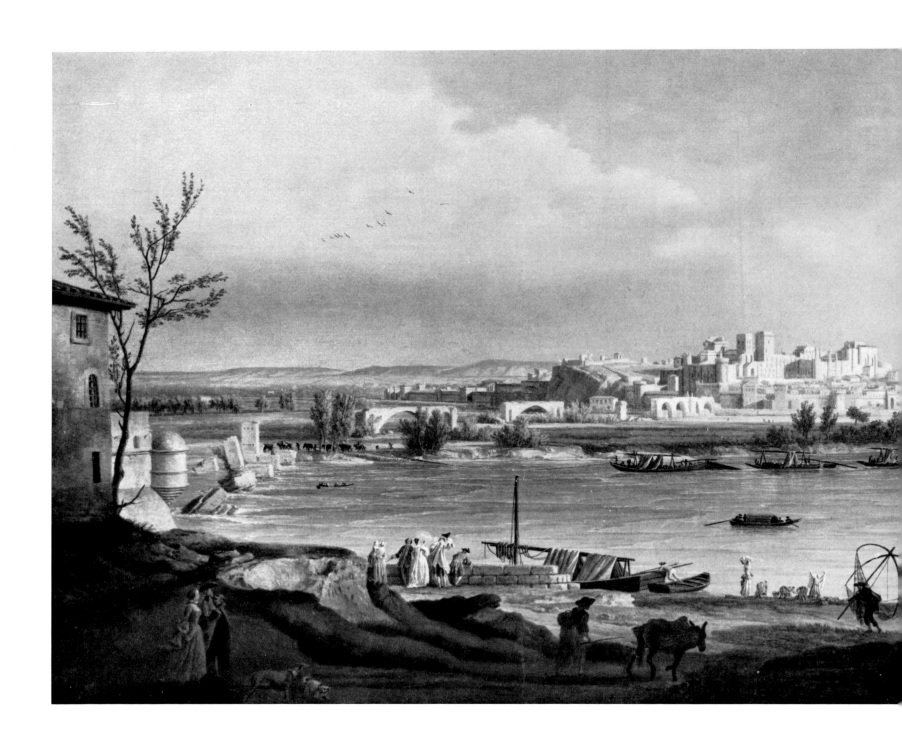

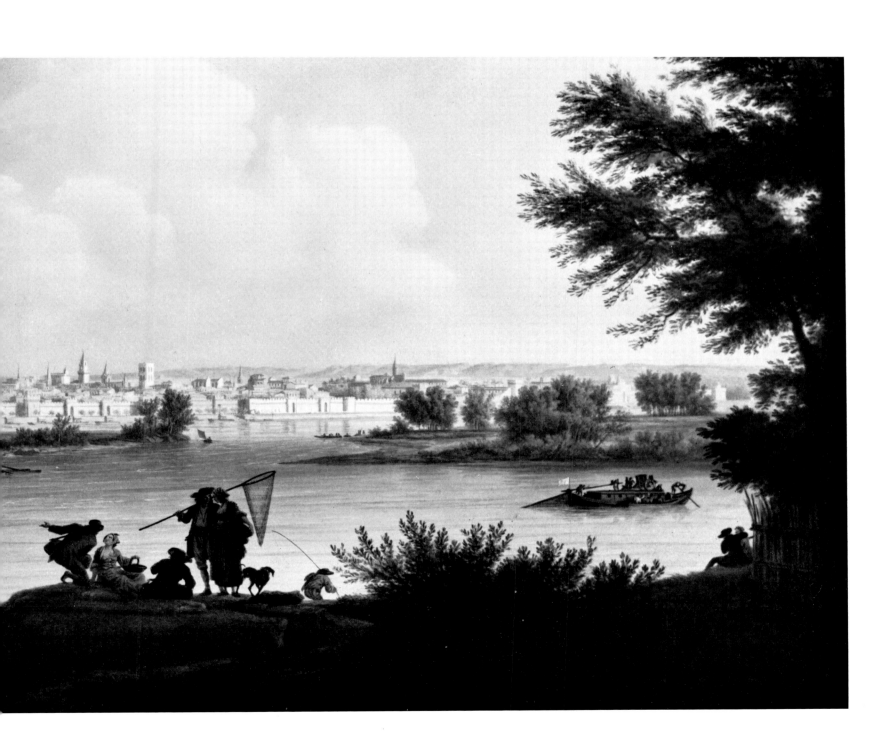

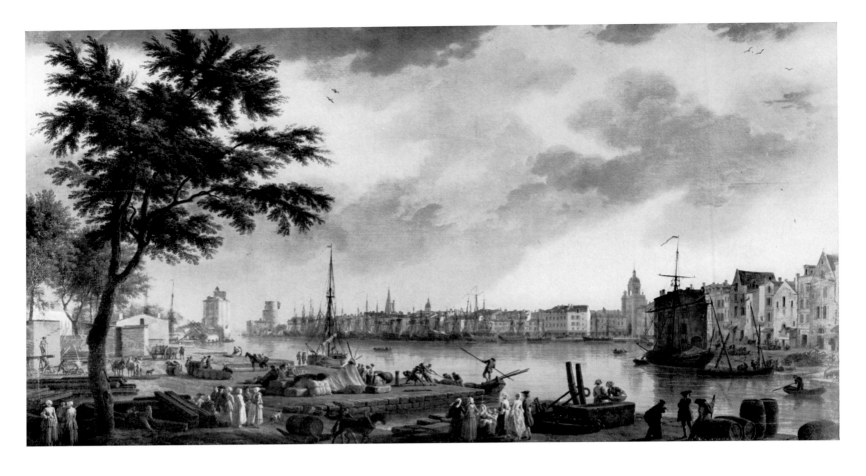

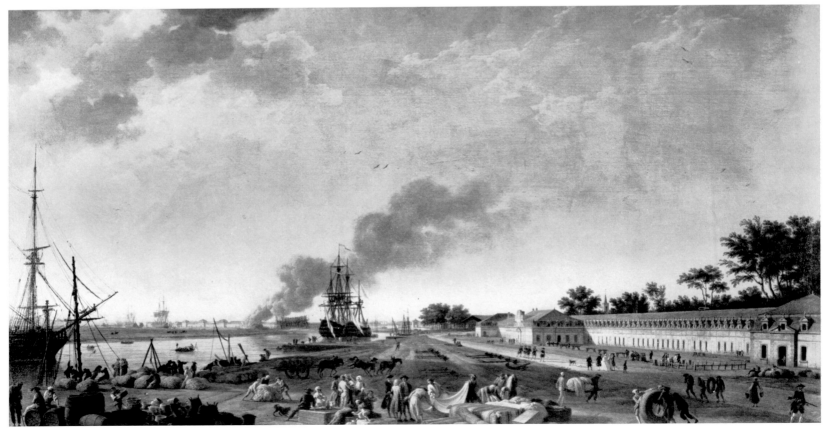

247. JOSEPH VERNET: *The Port of La Rochelle* (detail). Paris, Musée de la Marine.

The two towers on the left of the view are the famous towers at the entrance to the harbour. On the right is the Porte de la Grosse Horloge, on the left in the background is a ship on its side for the keel to be caulked.

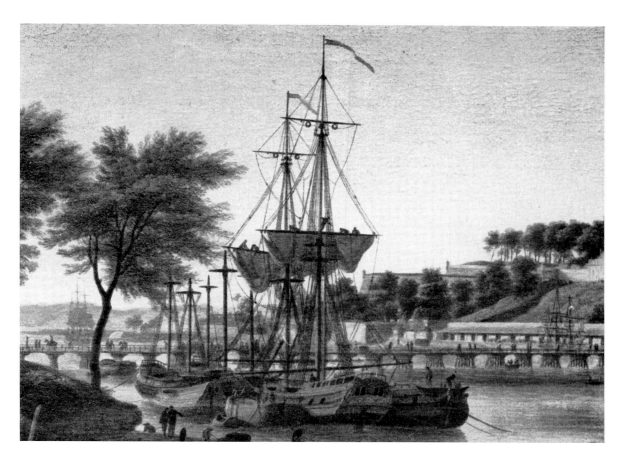

249. JOSEPH VERNET: *The Port of Bayonne* (detail). Paris, Musée de la Marine.

This second view of Bayonne is the twelfth in the series of French ports and was painted in 1761. It shows the port from the Allées Boufflers near the 'porte de Mousserolles'.

248. JOSEPH VERNET: *The Port of Rochefort*. Paris, Musée de la Marine.

The view of Rochefort is the last but one of Vernet's series of French ports and was painted in 1762.

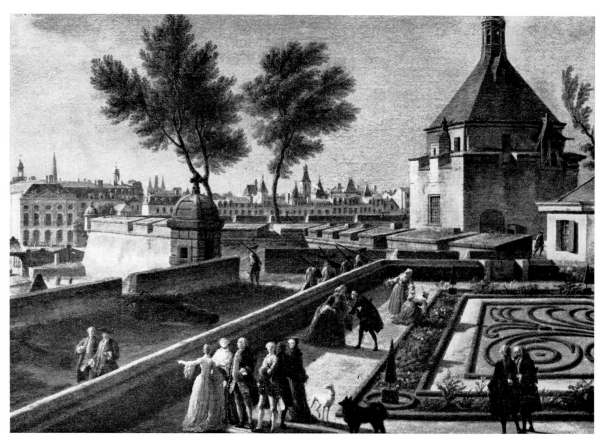

250. JOSEPH VERNET: *The Port of Bordeaux* (detail). Paris, Musée de la Marine.

A detail from one of the two views of Bordeaux, the tenth in the series of ports, this shows the city from the Château de la Trompette and was painted in 1759.

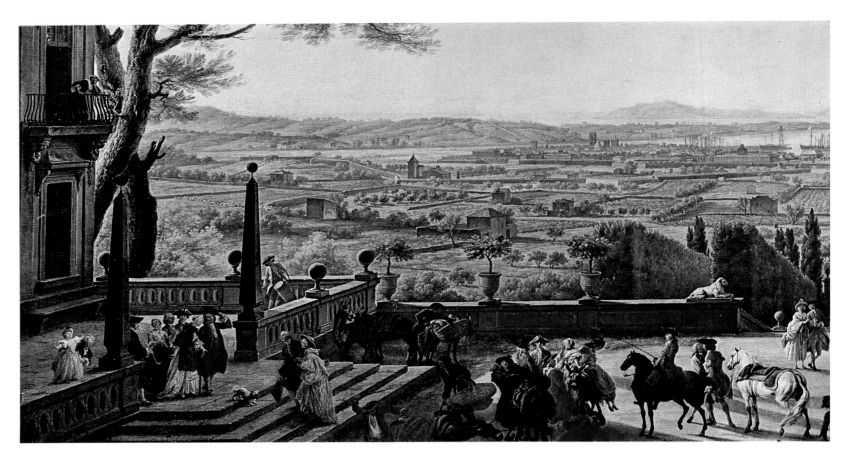

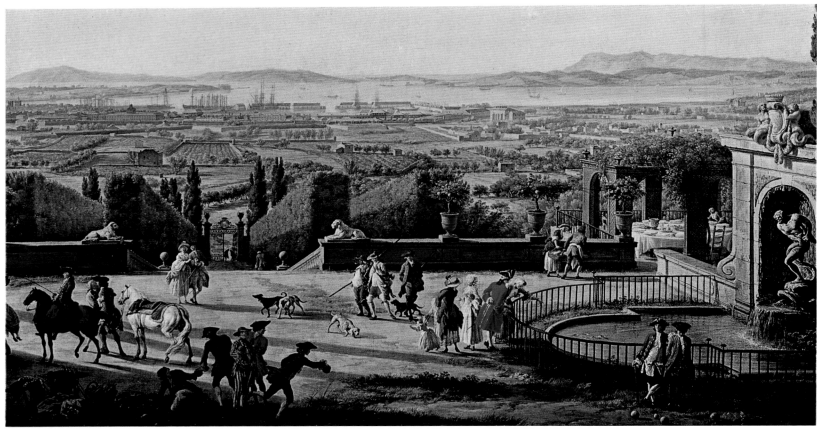

251-252. JOSEPH VERNET: *View of the City and Port of Toulon* (detail). Paris, Musée de la Marine.

This view, the fifth in the series of the ports of France, is from a viewpoint halfway up the mountain which rises behind the city. In the foreground is a 'belvedere' much frequented by the townspeople, in the distance are the city and the spacious roadstead. The painting is signed and dated 1756 and is the second of three views of Toulon.

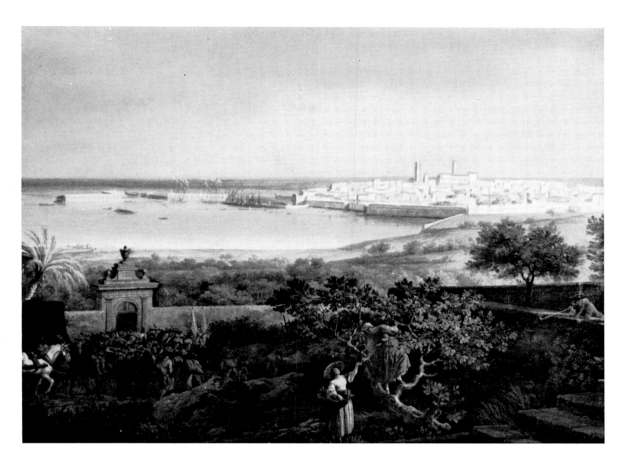

253. JOSEPH VERNET: *The Port of Antibes* (detail). Paris, Musée de la Marine.

The painting is signed and dated 1756. It is the seventh of the series of ports, and shows Antibes from its hinterland.

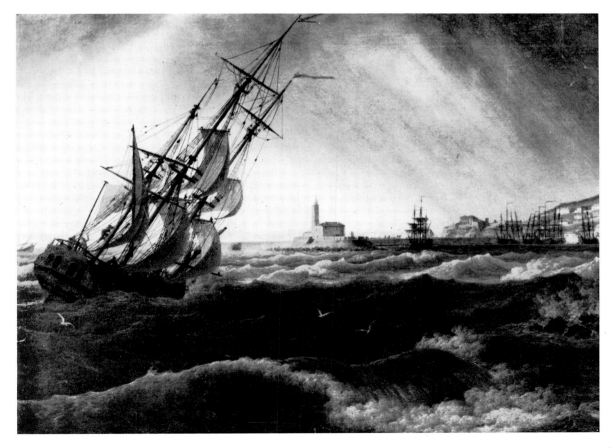

254. JOSEPH VERNET: *The Port of Sète* (detail). Paris, Musée de la Marine.

Signed and dated 1757, this is the eighth of the series of ports painted by Vernet. The port is shown from the sea, from behind the jetty.

255. JOSEPH VERNET: *Schaffhausen* (detail). Private collection.
The view shows the Rhine Falls at Laufen Castle, near Schaffhausen. The painting is signed and dated 1779 and, with another view of the Falls from the opposite bank of the Rhine, was painted for Girardot de Marigny.

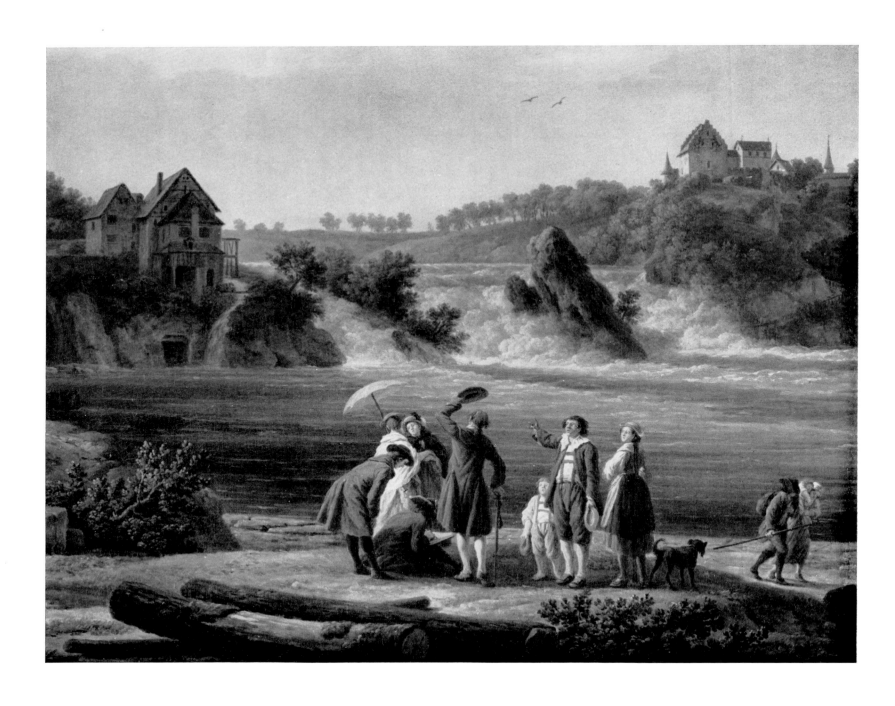

The following table lists for reference purposes the chief events in the lives of those artists whose work may be included under the general heading of view-painting, from the last quarter of the seventeenth century until the end of the eighteenth. The dates of some paintings of especial interest are also given, when these are known.

1675 Gaspar Van Wittel already in Rome.

1676 Marco Ricci born at Belluno.

1679 Luca Carlevarijs (born 1663) moves to Venice.

1681 The first views initialled and dated by Gaspar Van Wittel (Colonna Collection and Galleria Nazionale, Rome).

1684 Hendrik Frans van Lint born in Antwerp.

1685-90 Luca Carlevarijs probably in Rome.

1688 Antonio Visentini born in Venice.

1690 Gaspar Van Wittel: a dated view of the Borromean Islands, and a journey in Lombardy.

1691 Gian Paolo Panini born at Piacenza.

1694 Gaspar Van Wittel visits Bologna, Verona, Venice.

1695 Adrien Manglard born at Lyons.

1697 Gaspar Van Wittel: a dated view of Venice (Prado, Madrid).
Canaletto born in Venice (18 October).

1700 (*circa*) Antonio Joli born at Modena.

1702 Francesco Zuccarelli born.

1703 Luca Carlevarijs: *The Buildings and Views of Venice.*

1704 Luca Carlevarijs initials and dates *Walled City and Harbour.*

1707 Luca Carlevarijs is classified 'domiciled painter', that is, resident in Venice.

1708-11 Panini studies at Piacenza, probably with F. Bibiena, G. Natale and A. Galluzzi.

1708 (or earlier). Probable meeting of Marco Ricci and Filippo Juvarra; perhaps in Florence, with Cardinal Ottoboni.
Marco Ricci and Giovanni Antonio Pellegrini leave for England via Holland (probably with Charles Montague).

1709 Marco Ricci and Giovanni Antonio Pellegrini responsible for the scenery of Scarlatti's *Pirro e Demetrio* (Theatre Royal, Haymarket).

1710 Michele Marieschi born (1 December).
Marco Ricci probably returns to Venice.
Hendrik Frans van Lint in Rome.

1711 Gian Paolo Panini goes to Rome.
Gaspar Van Wittel admitted to the Accademia di San Luca, Rome.
Antonio Visentini becomes a member of the Guild of Painters in Venice.
Giuseppe Zocchi born in Florence.
Owen MacSwinny goes to Italy.

1712 Marco Ricci (probably with Sebastiano Ricci) returns to London.
Francesco Guardi born in Venice (5 October).

1713 Richard Wilson born at Penegoes.

1714 Joseph Vernet born at Avignon.

1715 Charles-Nicolas Cochin born in Paris.
Adrien Manglard in Rome, a pupil of Fergione.

1716 Marco Ricci in the home of Sebastiano Ricci in Venice.
Canaletto collaborates with Bernardo and Cristoforo in the scenery for *Arsilda regina di*

Pontoa and *L'Incoronazione di Dario* by Vivaldi, and *Penelope la Casta* by Chelleri (Teatro Sant'Angelo).
Lallemand born at Dijon.

1718-19 Gian Paolo Panini admitted to the Accademia di San Luca.
Gian Paolo Panini: decoration of the Villa Patrizi.

1719 Gian Paolo Panini active outside Rome (May to November).
(*circa*) Canaletto leaves for Rome.

1720 Bernardo Bellotto born in Venice (30 January).
Canaletto for the first time listed among members of the Guild of Painters (the Fraglia) in Venice.
(*circa*) Marco Ricci probably makes a journey to Rome.
Giovan Battista Piranesi born at Maiano di Mestre.
Antonio Joli in Rome.

1721 Charles-Louis Clérisseau born in Paris.

1723-25 Gian Paolo Panini: Two views of the Rivoli Palace (Turin).
Pierre Antoine Demachy born in Paris.
(4 June - 10 December) Letters from Marco Ricci to Francesco Gaburri on his activities as an engraver.
Paolo Anesi: Paintings of landscape around Rome (English collection).

1725 Marco and Sebastiano Ricci sign *The Tomb of the Duke of Devonshire* (Birmingham).
Canaletto states (25 November) that he has painted two views for Stefano Conti of Lucca.
(*circa*) Antonio Joli returns to Modena from Rome.

1726 Luca Carlevarijs in the Guild of Painters of Venice.
Date of the drawing of the *House of Marco Ricci* (Wallraf Collection).
Owen MacSwinny refers in a letter to an allegorical tomb for Lord Chancellor Somers which he hoped to sell to the Duke of Richmond, attributing it to the collaboration of Canaletto, Cimaroli and Piazzetta.

1727 (28 November). Letter from Owen MacSwinny to the Duke of Richmond discussing the character of Canaletto.
20 drawings by Gian Paolo Panini engraved by Zucchi: *The Caesars* (Palazzo Farnese).

1729 Gian Paolo Panini: *Piazza Navona* (Louvre).
Volaire born in Toulon.
(Venetian style, i.e. 1730, 21 January) Marco Ricci dies.
(Venetian style, i.e. 1730, 12 February) Luca Carlevarijs dies in Venice.
Canaletto: *The Reception of the Imperial Ambassador the Count of Bolagno* (Milan, Crespi Coll.).

1730 Carlo Orsolini publishes 20 etchings by Marco Ricci with a frontispiece engraved by Antonio Visentini.
Series of 14 views of Venice by Canaletto (Windsor) engraved by Visentini.

1731 Gian Paolo Panini: *Festivities in Piazza Navona* (Dublin).

1731-32 Joseph Vernet at Aix.

1732 Gian Paolo Panini at the French Academy in Rome.
Jean-Honoré Fragonard born at Grasse.
(July) Canaletto dates the drawing of *The Piazzetta* (Darmstadt).
Francesco Zuccarelli already in Venice.
Charles-Nicolas Cochin engraves *Parisian Life*.

1733 Hubert Robert born in Paris.
Antonio Stom listed in the Guild of Painters in Venice.

1734 Adrien Manglard a member of the Accademia di San Luca.
Joseph Smith writes to Lord Essex that he has asked Canaletto to complete four paintings for Lady Essex.
Joseph Vernet in Rome (1734-53).
Joseph Wright of Derby born at Derby.
Louis-Nicolas de Lespinasse born at Pouilly (Nièvre).

1735 Houel born in Rouen.

Adrien Manglard a member of the Académie Royale.
14 engravings made by Antonio Visentini from paintings by Canaletto, printed by Joseph Smith.
Michele Marieschi at Fano to prepare the church for the funeral of the Queen of Poland.

1736 Michele Marieschi: a drawing of a temple invaded by skeletons, engraved and dated by Giuseppe Camerata.
Michele Marieschi enrolled in the Guild of Painters in Venice. He is at Fano.
(13 September) Gaspar Van Wittel dies in Rome.
Michele Marieschi receives 50 zecchini for a painting from Marshal Schulenburg.

1737 Michele Marieschi receives 55 zecchini from Schulenburg for a view of the Rialto.
Joseph Vernet: first visit to Naples.
Jacob Philipp Hackert is born at Prenzlau.

1738 (11 September) Michele Marieschi receives 12 zecchini from Schulenburg for six small architectural perspective drawings.
Bernardo Bellotto listed in the Guild of Painters in Venice.

1739 (24 November) Charles de Brosses writes from Rome that Italian painting is in decline, but he praises the views of Canaletto.
Joseph Baudouin makes copies and publishes in London engravings of two of Canaletto's views: *The Campanile in Piazza San Marco* and *The Church of La Salute and the Grand Canal*.

1740 (*circa*) Canaletto probably returns to Rome.
Michele Marieschi receives 6 zecchini from Schulenburg for two views given to Marc'Antonio Diedo.
Bernardo Bellotto signs a drawing of *The Campo of SS. Giovanni e Paolo* (Darmstadt).
Antonio Joli in Venice.
William Marlow born in Southwark.
Gian Battista Piranesi in Rome at the Venetian Embassy.
Louis Gabriel Moreau born in Paris.

1741 Michele Marieschi publishes prints of 21 views of Venice, calling himself 'painter and architect'.

1742 Gian Paolo Panini: *Piazza Santa Maria Maggiore* (Quirinale).
Complete edition of the prints made by Visentini from paintings by Canaletto published by Joseph Smith.
(*circa*) Bernardo Bellotto probably visits Rome.
Series of five views of Rome by Canaletto (Windsor).

1734 Jean-Louis Desprez born at Auxerre.
24 aquatints reproducing works by Marco Ricci printed by Davide Antonio Fossati in Venice, dedicated to Conte Francesco Algarotti.
Canaletto signs and dates the painting *View of the Colosseum* (Hampton Court), *The Piazzetta from the Molo* and *The Doge's Palace with the Prisons* (Windsor).
(Venetian style, i.e. 1744, 18 January) Michele Marieschi dies.
Joseph Vernet member of the Accademia di San Luca, Rome.
Gian Paolo Panini: *Piazza del Quirinale* (Quirinale, Coffee House).

1744 (6 June) Smith already English Consul (significant date for the etchings by Canaletto in his own hand for Joseph Smith).
Canaletto signs and dates six views (5 at Windsor, 1 in a private collection).
Bernardo Bellotto: tour of Lombardy.
Lallemand goes to Paris.
Antonio Joli in London.
Hendrik Frans van Lint admitted to the Accademia dei Virtuosi del Pantheon.
Giuseppe Zocchi publishes a series of views of Florence and its environs.

1745 Gian Paolo Panini: *Charles III visits the Basilica of St. Peter's* (Naples).
Pierre Adrien Paris born at Besançon.
Bernardo Bellotto visits Florence, Turin, Verona.
Lady Oxford makes notes on various views of Venice by Canaletto which were in Castle Howard, of which ten were later destroyed.
Giovan Battista Piranesi returns to Rome. He engraves *Carceri*.

1746 Joseph Vernet a member of the Académie Royale. His second visit to Naples.

(May) Canaletto arrives in London with a letter from Joseph Smith asking MacSwinny to introduce Canaletto to the Duke of Richmond.
Antonio Visentini and Francesco Zuccarelli: two paintings for Joseph Smith: *The Triumphal Arch of George II* and *Burlington House*.
Gian Paolo Panini: *Charles III at the Coffee House of the Palazzo Quirinale*.

1747 Bernardo Bellotto, with his wife and children, leaves for Dresden.
Canaletto: *View of Eton* (National Gallery, London).
Canaletto: A view beneath the centre of Westminster Bridge engraved and published by Remigius Parr.

1748 Bernardo Bellotto appointed Court Painter at Dresden.
G.B. Piranesi: Roman antiquities of the time of the Republic (Triumphal arches).

1749 (26 July) The London Daily Advertiser publishes an announcement by Canaletto inviting the public to express an opinion of the drawing of a view of St. James' Park which was being displayed, since rumours were circulating that the artist was not Canaletto.
Canaletto: View of St. James' Park.
Charles-Louis Clérisseau: Prix de Rome.
Gian Paolo Panini: View of Rome from Monte Mario (Berlin). The first painting *Galleria*.
Charles-Nicolas Cochin goes to Rome with M. de Vandières (Marquis de Marigny).
In June, Vertue again mentions Canaletto, insinuating that 'he does not deal in truth'.

1750-55 Gian Paolo Panini: *View of Pisa* (Hartford, Conn.).
Richard Wilson goes to Italy.
Canaletto returns to Venice for a few months. He is probably in London in 1751.
Joseph Vernet: *Jousting on the Tiber in Rome*.
Ducros makes a tour of Naples, Sicily and Malta.
Lallemand in Rome, member of the Accademia di San Luca.
Pierre Henri Valenciennes born in Toulouse.
Antonio Joli mentioned in Madrid.
Lacroix: paintings signed between 1750 and 1761 in Rome.

1751 Charles-Nicolas Cochin at the French Academy in Rome.
Another edition of Visentini's prints *Urbis Venetiarum Prospectus Celebriores* (engravings from Canaletto).
Joseph Vernet at Marseilles.
(at the end of the year or early in 1752) Richard Wilson meets Joseph Vernet.

1751-53 Joseph Wright of Derby studies with Thomas Hudson.
Canaletto inserts another invitation in an English newspaper to view the painting *View of Chelsea College, Ranelagh and the Thames*.

1752 Francesco Zuccarelli leaves for London.
Jean-Honoré Fragonard wins the Prix de Rome.
Charles-Nicolas Cochin is appointed Keeper of the drawings in the Cabinet du Roi, Paris.
Hendrik Frans van Lint is elected Regent of the Accademia dei Virtuosi del Pantheon.
Joseph Vernet: visit to Marseilles.

1753-54 Adrien Manglard: 32 engravings on copper (views of the Roman Campagna).
Joseph Vernet leaves Italy for Marseilles. Journey to Paris. Member of the Académie Royale.
(28 July) Pietro Gradenigo notes that Canaletto has returned to Venice.
Abbé de Saint-Non: 'View of the neighbourhood of Nantes which I have drawn from nature'.

1754 Nicolle born in Paris.
Perrin born in Paris.
Antonio Joli returns to Venice.
Canaletto initials and dates the *Capriccio* (Lovelace).
Joseph Vernet begins *Les Ports de France* at Toulon.
Hubert Robert comes to Rome in the suite of the Comte de Stainville (Duc de Choiseul).
Gian Paolo Panini elected 58th 'principe' of the Accademia di San Luca.
R. Wilson signs and dates the *Temple of Minerva Medica* (Agnew), *Ponte Nomentano* (Agnew) and the *Lake of Albano with Castel Gandolfo* (London, Campbell, Golding).

1755 Joseph Vernet in Paris. First view of Toulon. He returns to Toulon. Paints two or three views of Toulon and one of Antibes.

1755-57 Robert Adam arrives in Rome and lives in the same house as Charles-Louis Clérisseau. (Before March 1760) John Plimmer in Rome until his death. Antonio Joli becomes a founder-member of the Accademia delle Belle Arti.

1756 Jean-Honoré Fragonard at the French Academy, Rome. He remains in Rome for five years with the Abbé de Saint-Non. Canaletto probably in Venice. (July-October) Vernet visits Avignon: *View of Avignon*; (November-May) Sète: *Port of Sète*. Giovan Battista Piranesi: *The Antiquities of Rome* (4 vols.).

1757 Charles-Louis Clérisseau at Split, on the Dalmatian coast. Charles-Nicolas Cochin ennobled in Paris. (Not earlier) Bernardo Bellotto moves to Vienna on the invitation of Maria Theresa.

1757-59 Vernet visits Bordeaux with Volaire (one or two views of Bordeaux). Vernet and Volaire collaborate until 1763. John Plimmer visits Naples. (*circa*) Antonio Joli in Naples.

1758 *Voyage d'Italie* published in three volumes. (Further editions in 1759 and 1761). Pierre-Antoine Demachy nominated to the Académie Royale as painter of architecture. John Plimmer lives with Thomas Jenkins in a house on the Corso. Signs and dates *Rome from Ponte Milvio*. Jonathan Skelton arrives in Rome.

1759 Hubert Robert apointed 'pensionnaire du Roi'. Prolonged stay in Rome. (July) Vernet and Volaire go to Bayonne (two views). Charles Natoire signs and dates *View of the Palace of the Caesars* (Cabinet des Dessins, Louvre). Jonathan Skelton dies (13 January). Antonio Joli in Naples: *Departure of Charles III for Spain* (Naples, Museo di San Martino). Abbé de Saint-Non goes to Rome.

1760 Hubert Robert and Abbé de Saint-Non go to Naples. Hubert Robert, Jean-Honoré Frgonard and the Abbé de Saint-Non at Villa d'Este, Tivoli. Adrien Manglard dies in Rome.

1761 Jean-Honoré Fragonard and the Abbé de Saint-Non return to Paris after visiting Naples, Bologna, Genoa and Venice. (July 1762) Joseph Vernet goes to La Rochelle (*Ports of La Rochelle and Rochefort*). Antonio Visentini teaches architecture at the Accademia di Belle Arti, Venice. Bernardo Bellotto at Munich and returns thence to Dresden. (1761-3) Francesco Guardi in the Guild of Painters in Venice. Giovan Battista Piranesi: *Of the magnificence and architecture of the Romans*. Paolo Anesi: Decoration of Villa Albani.

1762 (July) Joseph Vernet in Paris. Jacob Hackert in Stralsunda. Antonio Joli in Naples until 1777 as scene-painter at the Teatro San Carlo and works with Luigi Van Wittel on the portico of the Palazzo Reale. Giovan Battista Piranesi: *The Campus Martius of ancient Rome*. Joseph Vernet returns to Paris.

1763 Joseph Smith reaches an agreement for the sale of his entire collection of books, drawings, prints and paintings to George III. Charles Natoire: signs and dates *The Roman Forum* (London, F. Madan Coll.). Francesco Zuccarelli nominated member of the Accademia di Belle Arti at Venice. Bernardo Bellotto resigns his appointment and teaches perspective at the Fine Arts Academy, Dresden. Canaletto is at first not admitted to the Accademia di Belle Arti (January) but is admitted later (11 September). (*circa*) Bernardo Bellotto and his son leave for Petersburg but stay at the Court of the King of Poland (Stanislaus Augustus Poniatowski) in Warsaw. (1763-4) Bernardo Bellotto begins the decoration of Ujazdow Castle (destroyed in 1784). (1763-4) Hubert Robert travels to Florence (perhaps with Piranesi). He then travels to Rome and Naples, acting as guide to Watelet and Marguerite Le Comte. Vernet and Volaire part company. Hendrik Frans van Lint dies in Rome.

1764 (25 April) Pietro Gradenigo notes that Francesco Guardi is a pupil of Canaletto.
Ruins of the Palace of the Emperor Diocletian at Spalato in Dalmatia by Charles-Louis Clérisseau published in London.
Charles Percier born in Paris.
Volaire in Rome until 1769.
Hackert in Stockholm.
Moreau member of the Académie de St. Luc, Paris.

1765 Canaletto gives the Accademia a signed and dated painting.
Francesco Zuccarelli returns to England.
Joseph Vernet: *The Port of Dieppe.*
(21 October) Gian Paolo Panini dies in Rome.
Jean-Honoré Fragonard in Paris, member of the Académie Royale.
Hubert Robert returns to Paris.
Jacob Philipp Hackert in Paris.
(1765-8) William Marlow in France and Italy.

1766 Licence given by the Riformatori of Padua to print engravings by Brustolon from Canaletto's drawings of the Doge series.
Canaletto signs and dates drawing which is now in the Kunsthalle, Hamburg.
(or shortly after) Francesco Guardi paints the series in honour of Doge Alvise IV Mocenigo.
Hubert Robert member of the Académie Royale (« peintre en ruines »).
Jacob Philipp Hackert in Normandy with his brother Johann Gottfried.
William Marlow in Rome.

1767 Riedesel, a friend of Winckelmann, draws plans of Sicilian temples (Segesta and Selinunte).
Giuseppe Zocchi dies.

1768 Pierre-Jean Mariette writes from Paris to Temanza to say that he has received two prints from the Doge series, engraved from drawings by Canaletto.
Canaletto dies.
Charles-Louis Clérisseau returns to Paris.
Francesco Zuccarelli among the founders of the English Royal Academy.
Jacob Philipp Hackert and his brother in Rome (views for the Earl of Exeter).
Peter Fabris exhibits his work at the Free Society, London.

1769 Charles-Louis Clérisseau called 'painter of ruins'.
Houel travels to Rome by way of Susa, Turin, Casale, Piacenza, Parma, Bologna, Florence, Siena. He then goes to Naples with the Chevalier d'Agincourt.
Pierre-Henri Valenciennes in Italy with the Counsellor of the Paris Parlement, Matthias du Bourg.
Volaire takes up residence in Naples (he is the first to paint Vesuvius in eruption).
Pierre Adrien Pâris in Rome (without winning the Grand Prix).

1770 Houel journeys from Rome to Naples and Sicily.
Joseph Smith dies.
Ducros in Italy. He remains in Rome for nearly 30 years.
Hackert and his brother in Naples, where they work for William Hamilton.
Lallemand travels to England and thence to Dieppe.

1771 Nicolle: Gran Prix de Perspective.
Francesco Zuccarelli returns to Venice.
Charles-Louis Clérisseau travels to England and Russia.
Pierre-Henri Valenciennes returns to Paris.

1772 Houel returns to Paris.
Francesco Zuccarelli elected President of the Accademia of Venice.
(1772-3) Jean-Honoré Fragonard probably travelling in the Low Countries.
P. Fabris exhibits his work at the Society of Artists, London.

1773 Jean-Honoré Fragonard in Rome with M. Bergeret de Grancourt, and then visits Orléans, Aix, Toulouse, San Remo, Genoa, Pisa, Florence, Siena.
Lallemand in Dijon; contributes to the *Voyage pittoresque de la France* (landscapes of Burgundy).
Wright of Derby sets sail for Italy.

1774 (April) Jean-Honoré Fragonard and Bergeret de Grancourt visit Tivoli, Naples, Pompei.

In June they return to Rome and Frascati. In July they are at Florence, Bologna, Padua, Venice. In August they return to Paris via Vienna, Prague, Dresden, Frankfurt.
Houel member of the Academy, Paris.
Adrien Paris returns to Paris.
Wright of Derby reaches Rome.

1775 Perrin wins the second prize in the Grand Prix competition and goes to Rome.
William Pars in Rome until his death there, in 1782.
Joseph Wright and his wife return to England after visiting many Italian towns.

1776 Desprez wins the Grand Prix.
Houel returns to Naples and visits Sicily, Lipari and Malta.
Jean Benjamin Delaborde, *valet de chambre* of Louis XV, begins a work on Switzerland and Italy (topography, geography, history, civilization, literature, politics). He plans more than 1,200 engravings from Robert, Fragonard, Le Barbier, Pérignon, Chatel, Houel etc., in six volumes.
Lacroix in Paris.
Sir William Hamilton: *Campi Phlegraei.*

1777 Jean-Louis Desprez returns to Rome via Genoa. In December he is in Naples.
Pierre-Henri Valenciennes returns to Italy (from Marseilles to Civitavecchia and thence to Rome).
(29 April) Antonio Joli dies in Naples.
Wright of Derby settles in Derby.

1778 Jean-Louis Desprez in Naples (sent by the Abbé de Saint-Non); he visits Pompei. In the spring he visits the Adriatic coast (Manfredonia, Brindisi, Lecce, Otranto, Gallipoli etc.), Sicily, Malta and returns to Naples.
Francesco Zuccarelli dies in Florence.
Joseph Vernet tours Switzerland with his son Charles, Girardot and Marigny.
Charles-Louis Clérisseau publishes *Antiquités de la France.*
Giovan Battista Piranesi: *Views of the ruins of three great buildings in the town of Paestum, Plan of Rome and the Campus Martius.*
He dies in Rome.
Adrien Paris is appointed Dessinateur du Cabinet du Roi and Dessinateur des fêtes de Versailles, Trianon, Marly.

1779 Pierre-Henri Valenciennes in Naples and Sicily.
Jean-Louis Desprez returns to Rome.

1780 (17 October) Bernardo Bellotto dies in Warsaw.
Francis Towne travels to Rome.
Adrien Paris member of the Académie Royale.

1781 400 drawings and gouaches by Houel are sold to Catherine II.
(and 1782, 1783) The first three volumes by the Abbé de Saint-Non.
Pierre-Henri Valenciennes returns to France by way of Umbria, the Marches, Tuscany, Emilia, Lombardy, the Italian Lakes, Piedmont, Savoy and Switzerland.
He meets Joseph Vernet in Paris.

1782 (25 April) Francesco Guardi is commissioned by Edwards to execute four paintings of the visit of Pius VI to Venice.
Antonio Visentini dies.
Pierre-Henri Valenciennes returns to Rome. In 1782-7 he probably travels through Egypt, in Syria, Palestine, Lydia, Troy, Turkey and Greece.
Lacroix dies in Paris or Berlin.

1783 Adrien Paris returns to Italy and works for Saint-Non in Naples (*Voyage pittoresque*). He visits Pompei, Herculaneum. He meets Jean-Louis Desprez. Becomes friendly with Seroux d'Agincourt.
Hubert Robert travels from Paris to the Languedoc.
(1783-5). Abbé de Saint-Non: his book is published in London by Swinburne.
Jean-Louis Desprez accepts the invitation of Gustav III of Sweden to become his principal architect.

1784 Adrien Paris in Paris.
Perrin leaves Rome for Paris.

Francesco Guardi is elected to the Accademia di Belle Arti, Venice (perspective painter).
Hubert is appointed Keeper of paintings in the Musée Royal.

1785 Fourth volume of the work of Abbé de Saint-Non.

1786 Pierre-Antoine Demachy teacher of perspective at the Académie Royale.
Charles Percier wins the Grand Prix for architecture and goes to Rome. A friend of Pierre François Fontaine, he visits Naples, Florence, Bologna, Venice, Milan, Genoa.
(15 September - 15 October) Joseph Vernet's last visit to Avignon.

1787 Nicolle in Italy: he visits Florence, Venice, Bologna, Naples and especially Rome.
Perrin admitted to the Académie Royale, Paris.
Pierre-Henri Valenciennes member of the Académie Royale, Paris.
Lespinasse member of the Académie Royale, Paris.

1788 Licence granted by Doge Alvise Mocenigo to Gabriele Marchiò to print Francesco Guardi's views of Venice.

1789 Francesco Guardi paints *The Burning of S. Marcuola*.
Francesco Guardi present at a session of the Accademia to examine certain paintings attributed to Canaletto which are ultimately attributed to the school of Michele Marieschi.
(3 December) Joseph Vernet dies.

1790 Charles-Nicolas Cochin dies in Paris.

1791 Charles Percier in Paris.

1792 (1 January 1793, Venetian style) Francesco Guardi dies.

1794 Charles Percier and Pierre-François Fontaine take the place of Adrien Paris as directors of scenography at the Paris Opéra.
Hubert Robert is arrested as a 'suspected person'.

1797 Wright of Derby dies.

1798 Nicolle returns to Paris (He makes a second journey in 1806-11).

1800 Pierre-Henri Valenciennes publishes *Eléments de perspective pratique*.

BIOGRAPHIES

These brief summaries of the lives of artists give some indication of their training, their travels and encounters, but are offered as relevant information rather than exhaustive treatment, particularly in those cases where little work has been done on the subject.

ANESI, PAOLO

Plate 21.

A painter of views, landscapes and seascapes, he was probably born in Rome, and the earliest documentary evidence for his work dates from that city in 1725. In this year he entered the service of Cardinal Imperiali, with whom he remained until 1766. According to Lanzi, Anesi painted landscapes for Florentine patrons, was a close friend of Locatelli, and teacher of Zuccarelli. His work was mainly decorative, and in 1761 he painted a series of landscapes in fresco in the Villa Albani, which are among his finest achievements. His first important paintings are two landscapes of 1723, which are at present in a private collection in England. His views of Italian cities and his Italian landscapes show the influence of Van Wittel, his seascapes that of Manglard and Joseph Vernet.

BELLOTTO, BERNARDO

Plates 86-91, 97-99, 102-103, 105, 120-134, 137-142, 147-171, 177-198.

A nephew of Canaletto, he was born in Venice in 1720. He received his artistic training from his uncle and developed a style so similar to that of Canaletto that his youthful works are often indistinguishable from those of the older master. Bellotto soon became famous and at the age of eighteen was already a member of the Guild of Painters in Venice. He went to Rome, probably with his uncle, in about 1742. In 1744 he visited Lombardy and in the following year Florence, Turin and Verona. In 1747 he left Venice, never to return, and went to Dresden where in the following year he was appointed Court Painter. He gained fame in the work he did there, for the king and for many other patrons, particularly for his panoramic views of the city and the countryside around, and of Pirna and Königstein. In these works a sharp difference from those of Canaletto is evident: the colour is colder, his treatment of reality more objective and less animated.

At the beginning of the Seven Years' War in 1757, the Court moved to Warsaw; Bellotto, however, went to Vienna, where he remained until 1761, and thence to Munich before returning to Dresden. In 1763 he resigned his post as Court Painter in order to teach perspective in the Academy of Fine Arts, and in the same year he started out with his son Lorenzo for Petersburg. When he reached Warsaw, however, he settled in the Court of King Stanislaus of Poland and never reached Russia. (He died in Warsaw in 1780.) His first commission in Poland was the decoration of the Castle of Ujazdow for the king, which he completed in 1764. The building has since been destroyed. He also painted many views of the city's everyday life with such topographical exactness that they were used in the reconstruction of Warsaw after the Second World War.

BERCKHEYDE, ADRIANSZ JOB

Plates 172, 173.

Born in Haarlem on 27 January 1630, he was the elder brother of Gerrit Berckheyde, and trained first as a book-binder. In 1644 he began to study under Jacob Willemsz de Wet. In 1654 he travelled in Germany, together with his brother, and stayed for a long time in Cologne, Bonn, Mannheim and at the Court of Heidelberg. Although there is a record of thanks to him by the Prince Elector, nothing is known of any work executed by him for the court there. On his return to Haarlem, he lived with his brother and his sister Aechje and died there on 23 November 1693. His paintings, which are of a slightly earlier date than those of his brother, show a greater variety. Besides architectural paintings, views of the Amsterdam Exchange, of the cities of Rotterdam, Frankfurt, of the Church of St. Bavo

in Haarlem, there are some outstanding genre paintings which show him to be one of the foremost artists of his time in this field. Examples are *The Painter's Studio* of 1659 (The Hermitage), *Breakfast* (Schwerin) and *Soldiers on Guard* (Amalienstift, Dessau). The influence of his master de Wet is evident in his biblical paintings, *Christ the Friend of Children* (Schwerin) of 1662 and *Joseph and his Brethren in Egypt* (Haarlem) of 1669. Some of his landscapes are to be seen in the Berlin Museum and in the Liechtenstein Collections in Vienna and Moltke. There are also many sketches in the Albertina, Vienna, and in Amsterdam.

BERCKHEYDE, GERRIT Plates 174-176.

Born in Haarlem on 6 June 1638, his masters were Frans Hals and his brother Job, whom he accompanied on a long visit to Germany. On his return to Haarlem in 1660 he lived with his brother until his death, due to alcoholism, in 1698. More limited than his brother in his choice of subjects, he painted picturesque corners of Amsterdam and other cities, repeating them several times with slight alteration and adjustment. There are several of his works in The Hague, Amsterdam and Antwerp. One of the best known of his paintings is *The Flower Market at Amsterdam*, in the Rijksmuseum. A view of the Groote Kerk of Haarlem is in the Galleria Pitti, Florence. His paintings were greatly admired by his contemporaries and were also celebrated by many poets of his time.

CANALETTO Plates 13, 17, 18, 41-75, 204-224.

Giovanni Antonio Canale, known as Canaletto, was born in Venice in 1697. His father Bernardo and his elder brother Cristoforo were both scenographers and he began his career with them, profiting from the experience of theatrical construction and perspective. In about 1719 he went to Rome, where he worked as a theatre painter and also made drawings of the ancient monuments and of views of the city. In Rome he became acquainted with the work of Gaspar Van Wittel and possibly also with the artist himself, by whom he was strongly influenced. On his return to Venice in 1720 he joined the Guild of Painters. Two years later he was commissioned by Owen MacSwinny, together with Pittoni, Piazzetta and Cimaroli, to paint two 'tombs'. His first important views of Venice are two copies of paintings executed in 1725 and 1726 for Stefano Conti of Lucca, a merchant and lover of art. He was already a very active painter, the most sought-after since Luca Carlevarijs, when he met his most important patron, Joseph Smith, the English Consul-General at Venice, in 1730. During the years of their association Smith found many English purchasers for Canaletto and continually bought his work, as is shown by the 142 drawings, the 50 (originally 54) views of Venice, Padua and the Brenta, the Roman pictures and the *Capricci* which formed the collection sold by Consul Smith to George III.

There is insufficient evidence to confirm a second visit to Rome in 1740. In 1746 Canaletto went to England, where the fame which he had acquired through his English patrons in Italy ensured him a series of commissions to paint country houses and views of London. Quite soon, however, his popularity began to decline. From 1750 to 1751 he was again in Venice, returning to London in 1755. The date of his final return to Venice is unknown. In 1763 he was elected a member of the Accademia di Belle Arti and Prior of the Collegio dei Pittori. During this period he painted the series of twelve ceremonies connected with the Doge. In 1764 he was elected a member of the commission of Twelve of the Collegio dei Pittori. He died in Venice in 1768.

CARLEVARIJS, LUCA Plates 36-40.

Born at Udine in 1663, he was as a boy educated in the mathematical sciences, perspective and architecture, in order to follow his father's profession. In 1679 he settled in Venice.

It is possible, although there is no evidence for this, that as a young man he visited Rome in about 1685, but apart from this it seems that he left Venice only twice in his life, when he was invited to give his opinion as an expert on architecture at Conegliano (1712) and Udine (1714). He is, however, far better known as a painter, and especially as a painter of topographical subjects. His first subjects were seascapes and architectural *capricci* in which the influence of Salvator Rosa and Claude Lorrain is evident. His more mature landscapes suggest an element of Van Wittel but nevertheless are truly original in character. Throughout his life Venice was his subject, both of ideal views and of realistic views, in which he often depicts festivities to celebrate the arrival or departure of important visitors to Venice. He also executed etchings of the city, which he published in *Le Fabriche e vedute di Venezia* of 1703, which contains 104 reproductions of Venetian buildings. At the time of his death in 1730 (1729 Venetian style) his fame had not spread beyond Italy, although it is known that he had sent paintings to England. He was not a very prolific artist, but his work both as painter and as engraver was of great importance for later generations of view painters such as Marieschi, Zucchi, Bellotto and especially for Canaletto, whom tradition considers his disciple.

Carlevarijs was one of the first artists to portray Venice and its buildings, considering them excellent subjects for pictorial representation and commending them by his example to the artists who followed him.

DE LESPINASSE, LOUIS-NICOLAS

Plates 199, 200, 231.

He was born at Pouilly (Nièvre) in 1734. In 1787 he was elected a member of the Académie Royale, and he also received the title of Chevalier of the Royal and Military Order of St. Louis. Lespinasse painted historical scenes and architectural subjects, with a preference for views of Paris, which are of interest for the detailed information they provide of the city in the eighteenth century. His work was shown at the Salon from 1787 to 1801. He died in 1808.

DEMACHY, PIERRE-ANTOINE

Plates 233, 234, 238.

He was born in Paris in 1723 and died there in 1807, apparently without ever having travelled at all. He studied painting under Servandoni, an architect, scene-painter and painter, who had been one of Panini's first pupils in Rome. Demachy's views often show Italian scenes as well as Parisian ones; his Italian ruins and architectural compositions are strongly influenced by Panini. His work was greatly admired by art-lovers and critics and his career was a highly successful one. In 1758 he was admitted to the Académie Royale as painter of architectural subjects and in 1786 was appointed to a post at the Académie as teacher of perspective.

DE MARCHIS, ALESIO

Plates 19, 20.

Little is known of him. According to Lanzi he was a Neapolitan who painted decorations for the Ruspoli and Albani palaces in Rome and who also worked at Perugia and Urbino, painting landscapes, seascapes and architectural compositions for the villas of those cities and their environs. Fires often feature in his paintings; Lanzi says of him 'In order to paint fires with more veracity he set fire to a hay-loft. He was condemned to several years in prison and was released during the pontificate of Clement XI.'

DESPREZ, JEAN-LOUIS

The son of a wig-maker, Desprez was born at Auxerre in 1743. He began his artistic career in the field of architecture, first with Blondel and then with Desmaison. He is first recorded

as a student at the Académie Royale in 1765, the year in which he began to exhibit his work, entering a succession of competitions in the hope of winning the Grand Prix for architecture and thus being able to visit Rome. He was unsuccessful until 1776, but in that year he refused to go. However, he was in Rome in 1777, but his stay there was brief as he then accompanied the Abbé de Saint-Non to Naples in December in order to make some drawings for the *Voyage pittoresque*. Thence he continued his travels to include Pompei, Herculaneum and other historic towns to the east of Naples, the coast around Reggio, and Trapani and Palermo in Sicily, returning to Rome only in January 1779. This journey was of great importance for the artist, because thanks to the drawings he made for Saint-Non his field of activity widened to include landscapes and views as well as the architectural studies which had been his main subject. His output of drawings during this year of travel was enormous, every place he visited being recorded with great care and minute topographical exactness. Innumerable drawings from this period are preserved in the National Museum, Stockholm. When he returned to Rome, Desprez neglected his architectural studies completely and arranged the sketches he had made during his travels for inclusion in the Abbé's book. For his own pleasure, he elaborated the sketches and drawings into romantically imaginative historical and dramatic scenes. It is in these reworked drawings rather than in the sketches made during his travels that he reveals an affinity with Salvator Rosa, Marco Ricci and Joseph Vernet. Besides these drawings, Desprez also began to make sketches of landscape around Rome. During this period he also appears to have become seriously interested in scene-painting, combining his interest in architecture with his taste for dramatic and historical scenes. His designs are praised by Piranesi in a letter of 1784.

When Gustav III of Sweden visited Rome in 1783 he offered Desprez the post of architect and director of scenography at the Opera House in Stockholm. Desprez accepted and left Italy to settle in Stockholm, where he died in 1804.

FABRIS, PETER PIO Plate 32.

English by birth, Fabris seems to have spent most of his active life in Naples. Although some of his paintings are views of Rome and genre paintings, most of his landscapes were painted in and around Naples. He appears to have had English patrons, among whom was Sir William Hamilton, for whom he executed the drawings to illustrate Hamilton's *Campi Phlaegraei* which were engraved by Paul Sandby in 1776. His paintings were exhibited in London, at the Free Society in 1768 and at the Society of Artists in 1772. His activity continued at least until 1804, when he made some engravings illustrating Neapolitan costumes.

FRAGONARD, JEAN-HONORÉ

He was born in Grasse in 1732 and at the age of fifteen was apprenticed to Chardin and later to Boucher. In 1752, although he was not a student of the Académie Royale he was awarded the Prix de Rome, and four days later set off for Italy. His studies at the French Academy in Rome were not very profitable; acting on the advice of the Director, Natoire, he lived in the neighbourhood of Rome with his friend Hubert Robert and began to make faithful studies of the landscape. It was thanks to Robert that Fragonard made the acquaintance of the Abbé de Saint-Non, who soon became an intimate friend and protector. Saint-Non apparently accompanied Fragonard to Venice in the spring of 1760, and in the summer of that year invited Fragonard and Robert to stay with him for a time at the Villa d'Este at Tivoli. In the pleasant surroundings of fine avenues, gardens and innumerable fountains, Fragonard worked assiduously and profitably, and many of his finest drawings are of this time. In 1761 Fragonard and Saint-Non left Rome and returned to Paris by way of Bologna, Florence, Venice, Verona and Genoa. During the journey, instead of portraying landscape

subjects faithfully, as he had done before, he made rapid annotated paintings, which greatly pleased his friend.

In Paris, Fragonard painted several works based on his Italian travels, such as the gardens of the Villa d'Este. The commissions he received were entirely for decorative works in rococo style. After a journey to the Low Countries in 1772-3, Fragonard again visited Italy, this time in the company of his brother-in-law, Bergeret de Grancourt. They travelled to Rome passing through Antibes, San Remo, Genoa and Florence, and after a stay of about four months in Rome they went on to Naples, making excursions to Pompeii, Herculaneum and Vesuvius. Although Bergeret was not a great connoisseur and lover of art like the Abbé de Saint-Non, he encouraged Fragonard to persevere in his drawings, especially in Naples. They returned to Paris eventually by way of Vienna, Prague and Germany. Few of Frago-gonard's paintings show any traces of his journeyings in Europe, except for a few representing Italian landscapes, of 1775. His great success was due above all to his boudoir and erotic paintings, and portraits. But the impression made upon him by the places he visited during his travels with Saint-Non and with Bergeret is vivid in his drawings of them. He died in Paris in 1806.

GHEZZI, PIER LEONE Plate 16.

Born in 1674 in Rome, where he died in 1755, he was son and pupil of Giuseppe Ghezzi, and became a student of the Accademia di San Luca, which awarded him a prize in 1695 and in 1705 recorded him as a member and secretary to his father. He began his career as an engraver of his father's paintings and later as etcher of book-illustrations. In 1712 and in 1722 he was commissioned by Pope Clement XI to engrave allegorical and biblical subjects for the *Homiliae in Evangelia* and *Orationes Concistoriales*, and in 1727 he produced engravings for the *Camere sepolcrali dei liberti di Livia Augusta*. Apart from his activity as engraver, he assisted his father in the decoration of many churches in Rome: in the nave of San Giovanni in Laterano he painted the prophet Micah, in San Clemente the fresco of the martyrdom of St. Ignatius in the Colosseum; he also did the altar painting of the fifth chapel on the left in San Marcello, and in the Albani chapel in San Sebastiano. In Villa Falconieri at Frascati he decorated the great *salone* on the ground-floor with paintings. Ghezzi is better known for his caricatures and genre paintings of Roman life of his time. He also designed various apparatus for fireworks and machinery for festivals, the most famous of which is perhaps the decoration of Piazza Navona in Rome executed for Cardinal Polignac in 1729 to celebrate the birth of the Dauphin, which is perpetuated in a painting by G.P. Panini (Louvre, Paris). Self-portraits of Ghezzi are in the Accademia di San Luca, and in the Uffizi Gallery, Florence.

GUARDI, FRANCESCO Plates 76-84.

One of the last and most poetic of the view painters, Guardi was born in Venice in 1712. Little is known of his youth; both his father and elder brother were painters and it is reasonable to suppose that they all worked together, producing paintings of all kinds including altar-pieces, historical scenes and scenes of everyday life. Francesco seems to have considered himself free to paint as he liked after the death of his brother in 1760. In about that year he began his career as painter of Venice, its palaces, its piazze, its lagoon. From 1761 to 1763 Guardi was a member of the Guild of Painters in Venice, but he does not appear to have been particularly well-known, little was written about him by his contemporaries and his patrons were few and of little importance. John Strange, an Englishman resident in Venice from 1773 to 1788, was perhaps his best customer, and on his death he left a great number of drawings and paintings by Guardi. However, he received commissions from time to time for commemorative paintings such as the set depicting festivities in honour of Doge Alvise IV Mocenigo, of 1766 or soon after, and the four paintings of

Pius VI's visit to Venice in 1782. He also painted works for churches, such as the altar-piece of Saints Peter and Paul adoring the Trinity in the Parish Church of Rocegno. But chiefly he devoted himself to his favourite subject, Venice. According to some authorities he was a pupil of Canaletto and learnt to paint *vedute* from him. His earliest works have a structure similar to the views of Canaletto, but the Venice depicted by Guardi is very different from the Venice of Canaletto: the free handling and the more ephemeral quality of the views make them seem almost *capricci*. His landscapes painted from life show the influence of Ricci and Marieschi. Guardi became a member of the Accademia di Belle Arti only in 1784. In 1788, authorization was granted to Marchiò to publish some engravings and views by Guardi. He died in Venice in 1792 (Venetian style) apparently without being greatly appreciated by contemporary artists and critics.

HEYDEN, JAN VAN DER

Born at Gorinchen (Gorkum) in 1637, he was a painter of still-life, landscape and architectural subjects, and an engraver. Little is known of his early activity and artistic contacts, but he was perhaps influenced by Johannes Beerstraten, although there is a considerable difference both stylistically and technically between the two artists. There is evidence of a journey southwards made in 1660, certainly as far as Brussels and Cologne, and possibly also to the Mediterranean coast. The places and towns visited by him recur frequently in his paintings, but without precise topographical location. His best landscapes belong to this period, but later he turned rather to architectural subjects and to still-life paintings: books, globes, carpets, cupboards. From 1668 he occupied himself increasingly with essentially technical problems of practical application, such as improvements in street-lighting. The style of van der Heyden was of great influence in the eighteenth and nineteenth centuries: J. Compe, J. Janson, J.H. Prins, J.F. Valois are among his best known followers. He died in Amsterdam on 28 March 1712.

HOUASSE, MICHEL-ANGE
Plates 110, 111.

Son of the famous painter René-Antoine Houasse, he was born in Paris in about 1680. For four consecutive years, from 1694 to 1698, he won a prize at the Académie and was admitted to membership in 1707 with the painting *Hercules flinging Lykas into the sea*. In about 1727 he was invited to Spain as Court Painter by Philip V, but after only three years he returned to France seriously ill, and died a few months later at Arpajon. Works of his period in Spain include the altar-paintings in the former Jesuit College, now the University of Madrid, and six paintings in the Prado. Other works attributed to him are a portrait of Louis I, scenes from the life of Francisco Regis in the Church of San Salvador, Madrid, *bambocciate* and rural scenes in the castle of San Ildefonso. There are also some portraits and an interior view of the Académie de France in the Louvre.

HUE, JEAN-FRANÇOIS
Plates 244, 245.

He was born at St. Arnault-en-Yvelines (Seine-et-Oise) on 1 December 1571. A pupil of G.F. Doyen and Joseph Vernet, he was appointed 'peintre du roi' in 1780 and admitted to the Académie Royale in the following year. He was in Rome in 1785-6 where he painted many views of the city and its surroundings. He was best known for his seascapes and battle scenes, such as the naval engagement between the English and French fleets off the island of Grenada (Lesser Antilles) which with its companion *The Capture of Grenada* was purchased by the King (Musée de Versailles). After the death of Vernet he was entrusted with the task of completing the series of views of French ports, which he finished between 1792 and 1798. In 1800 he was commissioned by the Ministère de la Marine to organize the *Grande galerie du Garde-meuble*, and in 1809 Napoleon commissioned from him the painting of *The Taking*

of Genoa by the French (Musée de Versailles). This was his last official task, as he rapidly lost his reputation and came to be considered merely an imitator of Vernet. He died in Paris in 1823.

JOLI, ANTONIO Plates 27-30, 112, 113, 117-119, 135-136, 225.

He was born in about 1700 at Modena, where he was instructed in the rudiments of art by Raffaello Menia Rinaldi, but the decisive factor in his artistic formation was a period spent in Rome in 1720 as a collaborator of Panini, whose work had a great influence on Joli. His style followed closely that of Panini, but without attaining his gracefulness and vitality. He returned to Modena in 1725 for a time, and moved to Venice in 1740, where he also learnt from Canaletto. Like Canaletto he worked as a designer and in this capacity he made several journeys to Germany, England (1744), where he painted perspective views for Italian operatic productions, and to Spain, where he was employed by the Teatro del Buen Retiro in 1750. In 1754 he was again in Venice and in the following year he became a founder-member of the Accademia of painting and sculpture. Three large canvases showing the departure of Charles III from Naples are evidence of his presence in that city in 1759, and he settled there in 1762, working as a scenographer and decorator of the portico of the Palazzo Reale, until his death in 1777.

LINT, HENDRIK FRANS VAN Plate 8.

Born in Antwerp in 1684, he entered the studio of Pieter van Bredael at the age of twelve, remaining there for a year. Still very young (Zwolle thinks in 1710) he moved to Rome, where he died in 1763. He was admitted to the Accademia dei Virtuosi del Pantheon in 1744, becoming its Regent in 1752. He collaborated with Jan Frans van Bloemen, painting the figures in his landscapes. His own views and landscapes are influenced by the work of Gaspard Dughet, but his most obvious and most direct source of inspiration was Gaspar Van Wittel.

MANGLARD, ADRIEN Plate 31.

He was born in Lyons in 1695. It has been suggested that he studied painting under Adrian van der Kabel, the marine painter, but this is unlikely as van der Kabel died when Manglard was ten. He went to Rome at the age of twenty and continued his activity as a painter of seascapes working with Fergione. In 1734 he was elected to the Accademia di San Luca and in the following year admitted to the Académie Royale, but his work was never fully recognized in France whereas in Rome he was very successful. He received commissions from the Rospigliosi and Colonna families and was the guest of the Marchese Gabrielli in his palace on Monte Giordano. The influence of Salvator Rosa and Claude Lorrain is evident in the paintings of Manglard, who in turn influenced Joseph Vernet, whose first visit to Rome was in 1734. Although his production consists mainly of seascapes, Manglard engraved a series of 32 views of the Roman campagna in 1753-4. He was also a collector and his large collection of paintings and drawings was sold on his death in 1760.

MARIESCHI, MICHELE

One of the most romantic of the Venetian view painters, he was born in 1710 and died in 1743 (Venetian style). Little is known either of his short life or of the chronology of his works, which he never signed or dated. Marieschi began his career as a scene-painter; possibly he was a pupil of Gaspare Diziani, or at least was influenced by him. It is known that he travelled in Germany, where he painted several pictures (Orlandi, 1753), but nothing is known of the date, the length, the season of the journey, nor of the works it produced.

He was a member of the Guild of Painters in Venice from 1736 to 1741, which indicates that he was in Venice during those years; in 1736 he went to Fano, where he was responsible for painting the scene of the funeral of Maria Clementina, Queen of Poland. It is thought that Marieschi began to paint his views of Venice at this time; there are few of them, given the brevity of his life, but their quality, their vitality and the element of fantasy anticipate the paintings of Guardi. In 1736 Marieschi received payment from Marshal Schulenberg for a view of the Rialto, and Schulenberg continued as his patron until the artist's death. There is little evidence on which to base an account of his commissions and his popularity as an artist, but it appears that he had imitators and followers; in 1789 a meeting of the Accademia was held to consider the attribution of several works to Canaletto; they were instead judged to belong to the school of Marieschi.

MARLOW, WILLIAM Plate 106.

He was born in Southwark in 1740 and began to study painting with the marine painter Samuel Scott. He was a member of the Incorporated Society of Artists, and exhibited his paintings, which were for the most part landscapes of Wales and England, from 1762 to 1764. From 1765 to 1768 he worked in France and Italy, returning to London with many sketches and drawings of landscapes which he used for many years as material for his paintings. He also painted the English countryside and exhibited his work ar the Royal Academy from 1788 to 1807. He died at Twickenham in 1813.

MOREAU, LOUIS-GABRIEL L'AINÉ Plate 240.

The son of a potter, he was born in Paris in 1740 and studied with Demachy, whose style is reflected in his youthful works. In 1740 he was admitted to the Académie de St. Luc in Paris, but when this was suppressed in 1776 he did not succeed in entering the Académie Royale. Fortunately his patron, the Comte d'Artois, obtained for him a post in the Louvre. It seems that Moreau never left Paris and its immediate surroundings: the subjects of his oil paintings, watercolours, drawings and etchings are the landscapes of the Ile de France, the picturesque corners and the gardens of Paris. His work was never very popular. Between 1791 and 1804 he often exhibited at the Salon, but he never won a prize nor was his work praised by the critics. His landscapes are however painted with sensitivity, with delicate tones and a light touch suggestive of Corot.

PANINI, GIOVANNI PAOLO Plates 10-12.

One of the most important architects and painters in Italy in the eighteenth century, he was born at Piacenza in 1691. It is thought that he studied the work of Ferdinando Bibiena, Andrea Galuzzi and Giuseppe Natali, perhaps also working with them. He left Piacenza for Rome in 1711 and there he worked with Benedetto Luti, becoming very skilled in figure-drawing. He received his most important commission, the decoration of Villa Patrizi, in 1718, but he did not complete the work until 1725 as he combined painting in the Villa with other work, in Palazzo de Carolis (1720), in the Seminario for Cardinal Spinola and in the apartments of the Palazzo Quirinale for Innocent XIII. In 1725 he began work on the decoration of Palazzo Alberoni. At the same time Panini was painting works of smaller dimensions, religious and historical scenes, and both real and imaginary architectural pieces. Some influence of Salvator Rosa is evident in the religious and historical works, of Van Wittel and Locatelli in the views. In 1727 twenty drawings by Panini of Palazzo Farnese were engraved by Zucchi for a book, *I Cesari*, dedicated to Francesco I Farnese. France recognized the importance of Panini and treated him as a Frenchman to the extent of ad-

mitting him to the Académie Française in 1732. Among his chief patrons were the Marquis de Stainville and Cardinal Polignac, who commissioned from him views of Rome and paintings commemorating historical events and festivities. In 1749 Panini executed the first of his 'galleries' of paintings, for Silvio Valenti Gonzaga (Wadsworth), and on the model of this he painted the series of views of ancient and modern Rome, which were extremely successful. In 1754 he was elected Principe of the Accademia di San Luca. His talent ensured him a large number of followers and imitators: Clérisseau, Lallemand, Robert, Demachy and Joli are among those who appreciated his work and adopted his style of painting.

PARIS, PIERRE ADRIEN

Architect, scene-painter and collector, Paris was born at Besançon in 1745 but spent his early years in Switzerland, where his father was superintendent of Buildings to the Prince-Bishop of Basle. He went to Paris when he was fifteen to study in the Académie Royale d'Architecture. He failed to win the Grand Prix but nevertheless went to Rome in 1768, where he was highly thought of. When Fragonard and Bergeret de Grancourt went to Rome in 1773 Paris acted as their guide and became an intimate friend of Fragonard, who introduced him to the Abbé de Saint-Non and Robert. On his return to Paris in 1774 he was appointed Dessinateur du Cabinet du Roi, Architecte des Economats, and was given the task of designing scenery for festivities at Marly, the Trianons and Versailles, where Robert was in charge of the gardens. In 1780 he was elected to the Académie. He visited Italy again in 1783, making drawings at Rome and Naples for the *Voyage Pittoresque* of Saint-Non, and becoming a friend of Seroux d'Agincourt, the successor of Winckelmann. He visited Pompeii and Herculaneum, where he sketched the ruins and drew archaeological plans. In the following year he returned to Paris, where he designed for the Hôtel des Menus Plaisirs and several theatres and was also put in charge of the reconstruction of the château at Versailles. This plan was never executed owing to lack of funds. During the Revolution he left Paris for the Franche-Comté and Normandy. His last visit to Italy was in 1806 when, according to Sylars, he was made Director of the French Academy in Rome. In 1811 he was in charge of the excavations of the Colosseum and also of the transfer of the Borghese Collection to France. He returned to Besançon in 1817 and died there in 1819. He had always taken a great interest in the work of his contemporaries, of artists whom he met during his travels, and on his death he left to the town of Besançon a collection which testifies to his artistic sensitivity and his interest in the lesser-known artists of his time.

QUARENGHI, GIACOMO Plates 143, 144.

He was born at Capiatone a Rota Fuori, near Bergamo, on 20 September 1744, and began his studies in Bergamo in the studios of the painters Raggi and Bonomini, leaving for Rome to study with Raphael Mengs at the age of nineteen. From 1763 to 1770 he studied and drew the ancient monuments and buildings of Rome and its surroundings. He stayed in the Veneto, especially at Verona, in 1771, visiting also Venice, where he met Tomaso Temanza, Francesco Algarotti and Antonio Selva. After a brief stay in Bergamo he returned to Rome to build the new Church of Santa Scolastica for the Benedictines of Subiaco. In about 1779, when he had already committed himself to carry out various projects for private patrons in England, Baron Grimm, the Russian Minister, summoned him to Russia in the name of the Empress Catherine II. Quarenghi left for Petersburg in the same year, taking with him sketches of his Italian views in the little albums which are now preserved in the Biblioteca Civica at Bergamo. The first work with which he was entrusted by the Empress in the new city, which already contained imposing buildings by the Frenchman Vallin, the Venetian Rastrelli and the Scot Cameron, was the State Bank, which Antonio Diedo, of the Accademia of Venice, praised in a speech of commemoration in 1852 as 'an outstanding exam-

ple of the art of varying, breaking up and juxtaposing mass in a dramatic fashion so that an astonishing feeling of movement is imparted to the whole building'.

From 1780 until her death in 1796 the Empress followed with interest the architectural work done for her by Quarenghi, concerning herself in the progress of each building but leaving full liberty to the artist. Catherine II was succeeded in the government of the Empire by her son Paul I for five years, and after him by her grandson Alexander I, from 1801 to 1825. Quarenghi continued to work for them, although to a lesser degree, and produced more admirable buildings. In 1785, only five years after his arrival in Russia, Quarenghi listed all the works which he had completed or were in the course of construction or on the drawing-board in a letter to his friend Luigi Marchesi of Bergamo, and they totalled over fifty, some of them large edifices, others smaller, including palaces in Petersburg, Moscow, and in the Ukraine, Banks, the Exchange, blocks of shops, the Theatre of the Hermitage, galleries for works of art, two colleges, a hospital, two churches, a prison, various public buildings, garden pavilions, bridges in the Tsarkoie-Selo estate, bell-towers, funerary chapels, country villas, garden plans, and a large theatre for Petersburg; an amazing achievement especially when it is remembered that many of the projects were only realized after the submission of several alternative preliminary sketches, alterations, and many geometrical and perspective drawings. Quarenghi also undertook some work for his native city when in 1810 he was asked to build an arch in Bergamo, outside Porta Osio, to commemorate Napoleon's victories. He went to Bergamo in 1810 and returned to Russia in April 1811. The first stone was laid in 1812, but the work was not completed since in the same year the retreat from Moscow took place and the fortunes of the French Army began to decline. The arch, very similar in architectural detail but in wood, was erected instead in Petersburg for Tsar Alexander I, after the victorious return of the Russian army. Quarenghi died in Petersburg in 1817.

RICCI, MARCO Plate 203.

He was born at Belluno on 5 June 1676. His first master was probably his uncle Sebastiano, although there was a great difference in their artistic sensibilities. Little is known either of his life or of his activity as an artist, so that critics have been able to say little of his development. According to Temanza (1738), Marco had a quarrelsome and violent nature which led him to become involved in a fight in which he killed a man. He was obliged to flee from Venice and go to Split, where he made the acquaintance of 'an excellent painter of landscape'. It has recently been suggested that his master was Francesco Peruzzini, who collaborated with Magnasco in Lombardy and whose manner is suggestive of the pre-romantic stream of landscape painting the best known exponent of which was Salvator Rosa. It is certain that Marco Ricci knew Magnasco and studied his work with interest. In 1708 he went to England with Pellegrini at the invitation of the Earl of Manchester; he was already known there because Lord Irwin had taken home twenty of his paintings in 1706-7, including seascapes, landscapes and battle scenes. In London he worked as a scene-painter at Queens Theatre, Haymarket, and at Castle Howard, in company with Pellegrini, where in addition to the *sopraporte* (overdoors), which he painted with the kind of scene associated with his youth, he painted the interesting *View of the Mall* (Howard Collection). He returned to Venice after some differences with Pellegrini, but returned to England from 1712 to 1716 with his uncle. He then settled in Venice with his uncle in Calle del Salvadego, behind Piazza San Marco, leaving Venice only for a short trip to Rome, probably in 1720. Very few of his works are dated. *The Tomb of the Duke of Devonshire* (now in Birmingham) painted for Owen MacSwinny, who sold it to the Duke of Richmond, is known to be of 1725. The tempera painting of *The Monument to Newton* (Collection of H.M. the Queen) from Consul Smith's collection is of 1727 or 1728. Between 1723 and his death in 1730 he executed the 33 etchings that are known to be by him, in which he shows an increasing interest in landscape. He died on 21 January 1730 and was buried in the Church of San Moisè.

Born in Paris in 1733, he began to study art with the sculptor Michelangelo Slodtz, but his real artistic training only began when he went to Italy in 1754. His father was in the service of the Marquis de Stainville and Robert went to Italy in the suite of the Marquis' son, the Comte de Stainville (the future Duc de Choiseul) who was then the French Ambassador to the Papal Court. Stainville succeeded in obtaining for Robert a post at the French Academy and five years later Robert became 'pensionnaire du roi', which enabled him to stay in Rome for a further three years. His time in Italy was of great importance for Robert, who came to know the work of Joseph Vernet, Piranesi and in particular of Panini, who was highly thought of by Stainville and whose influence on Robert was strong. In 1756 he met Fragonard and discovered the world of ancient Rome, which became the favourite subject of his works.

In 1759 there arrived in Rome the Abbé de Saint-Non, who was compiling a volume of engravings of the ancient monuments of Naples and Sicily, for which he had engaged a large number of artists. He was of great importance in the careers of both Fragonard and Robert. In 1760 he took Robert with him to Naples, where they remained for a month and a half, returning to Rome with many drawings of landscape and of ancient sites, many of which were engraved for the Abbé's book. In the summer of the same year, Robert and Fragonard were guests of the Abbé at the Villa d'Este, Tivoli. To this period belong some of the finest and most successful drawings of the two artists, who rejoiced in the beautiful gardens and fountains of the Villa. In 1761 the Abbé and Fragonard returned to Paris, but Robert remained in Rome until the end of his time as 'pensionnaire' in the following year, when he visited Florence and Naples. After eleven years absence from France he decided to leave Italy, and he returned to Paris to find himself already famous, being admitted to the Académie Royale in the following year.

His years in Paris were very successful. He painted many Parisian scenes; the demolition of bridges and houses, buildings destroyed by fire and imaginary scenes of ruins. He also created elegant, imaginary architectural compositions and pastoral scenes animated by graceful figures and animals, based on memories of his travels in Italy, and the countryside and the antiquities he had seen there. In 1784 he was appointed Keeper of the paintings in the Musée Royal, which had recently been inaugurated. Robert fell into disgrace during the Revolution and was arrested as politically suspect and for a time he was imprisoned. Later he returned to his post and in 1802 he was awarded a life pension. In the same year he made another visit to Italy together with the painter Rey. He died in Paris in 1808.

VALENCIENNES, PIERRE-HENRI

He was born in Toulouse in 1750 and studied painting at the Académie Royale there as pupil of the history-painter Jean-Baptiste Despax and of the portraitist and miniaturist Guillaume Gabriel Bouton. But he was to be a painter of landscape on a grand scale and soon showed his taste for travelling, visiting Gascony, the Pyrenees, Catalonia, Provence and the Languedoc. His first visit to Italy was made when he was nineteen, with his patron Mathias du Bourg, Counsellor of the Parlement at Paris and Toulouse. Valenciennes was well received in Rome, where he remained until 1771. During the following years he worked in the studio of Gabriel Doyen in Paris, drawing in the environs of Paris, at Fontainebleau, Marly and so on. To this period perhaps belong also his visits to Madrid, London, Windsor and Berlin. He visited Italy a second time in 1777 and remained there until 1781, studying perspective and making many journeys within Italy. He returned to Paris via Switzerland. He was in Rome again in the following year, but from then until 1787 there is no evidence of his activities. It is perhaps during these years that he travelled to Egypt, Syria, Turkey and Greece. He returned to Paris in 1787 where he was admitted to membership of the Académie Royale and two years later he was also admitted to the Académie Royale of Toulouse.

Two signed and dated drawings of Italian landscape (Le Havre) might suggest a further visit to Italy in 1791, but it is more likely that he made them in Paris, where there is an uninterrupted record of activity in his studio in the Louvre. In 1800 Valenciennes published *Eléments de perspective pratique et de réflexion sur la peinture et le paysage*, an important contribution to the art criticism of the eighteenth century. In 1812 he was entrusted with the teaching of perspective at the Académie Royale and in 1815 he was awarded the insignia of the Légion d'Honneur. In 1816 he instituted a new prize at the Académie Royale, that of historical landscape, which continued to be awarded until 1865. His last visit to Rome in 1817 inspired more sketches and drawings. He died in Paris in 1819. His favourite theme in his paintings was the repetition of the same landscape at different seasons of the year and at different times of the day. These paintings, although they are simple, reveal a notable quality which heralds the nineteenth century and the Italian landscapes of Ingres and Corot.

VERNET, CLAUDE-JOSEPH Plates 22, 241-243, 246-255.

Son of the decorative painter Antoine Vernet, Joseph was born in 1714. His first teacher was his father, and in 1731 he went to Aix as a pupil to both Jacques Vialy and the marine painter J.B. de la Rose. The first documentary evidence of Joseph Vernet's work is of this year, when he painted a series of 12 *sopraporte* for the mansion of the Marquise de Simaine at Aix, which are now lost. With the assistance of the Marquis de Caumont and the Comte de Quinson, Vernet made a first visit to Rome in 1734, where the teachers at the French Academy declared that they could do little to help him: he was in fact by now interested only in seascape, and life painting and classical monuments held nothing for him. His enthusiasm was for the paintings of Salvator Rosa, Locatelli, Claude, Panini and Manglard. He travelled about in the neighbourhood of Rome making sketches and in 1737 visited Naples for the first time. Vernet's work soon won admiration and he received commissions both from Italians and from the many foreigners who came to Italy as tourists, especially from the English. In 1743 Vernet became a member of the Accademia di San Luca in Rome, and in 1746 of the Académie Royale of Paris. In that year he also made another trip to Naples. His output was considerable but the dominant subject of his paintings was not very popular in France and in 1750 the Marquis de Marigny, although he had a high opinion of Vernet, refused his request for an official position.

During 1751-2 Vernet and his family made several journeys to Marseilles and in 1753 they returned there once more, leaving Italy for ever. In the summer Vernet went to Paris and Marigny gave him the commission for a series of views of *The Ports of France*, which were to be his most famous and most popular paintings. There were to be 24 views, and his instructions from Marigny gave very precise directives concerning the composition of the scenes and the particular details which were to be included. Between 1753 and 1762 Vernet completed the 13 views of Marseilles, Antibes, Toulon, Sète, Bordeaux, Bayonne, Rochefort and La Rochelle and in 1765, with the consent of Marigny, he broke off the series with a painting of the port of Dieppe.

In Paris, where he lived until his death, he received many commissions from England, Russia and Spain as well as from France. He began to repeat his early compositions, however, and especially in the last years of his life there was a loss of verve and of freshness in his work. In 1778, at the age of 64, he visited Switzerland with his son Charles, with Girardot and Marigny, for whom he painted a number of works which have been lost. In December 1789 Joseph Vernet died in Paris. He had many followers and imitators, the artists who show his influence most strongly being Lallemand, Hue, La Croix (of Marseilles), Wilson and Hackert.

VAN WITTEL, GASPAR Plates 1-6, 9, 14, 15, 26, 33-35, 94-96, 100, 101.

He was born at Amersfoort, near Utrecht, in 1652 or 1653. A pupil of Mathias Withoos, a painter of landscape and still-life in Holland, he departed for Rome in 1674, where he

entered the service of Cornelis Meyer, an inventor and hydraulic engineer from Amsterdam, as draughtsman. He joined the *Schildersbent*, the association of Dutch artists resident in Rome, and about three years after his arrival he began with Meyer a journey of investigation of the Tiber which he recorded in fifty drawings. It is possible that Van Wittel began his career as a view painter before 1680, but the first dated paintings — two views of *Villa Medici and Trinità dei Monti* and one of *Ponte Rotto* — are of 1681. This was the beginning of a series of views of Rome — drawings and paintings in oil and tempera — which bear witness to an exceptionally prolific activity. In 1690 he signed a view of the *Isole Borromee* which is evidence of the artist's presence in Lombardy at that time, where he had probably gone in 1688. After a brief return to Rome he went back to North Italy in 1694, visiting Bologna, Verona and Venice before returning to Rome again in 1696, the year of one of his most famous paintings, the *Piazza di Montecavallo* with Innocent XII in a sedan-chair, which was certainly painted in Rome. Another work which was certainly painted in Rome is his first Venetian view, *The Molo and the Palazzo Ducale* (1697), based on a drawing he had made in Venice.

In 1700 he went to Naples on the invitation of the Viceroy, Don Luis de la Cerda, Duke of Medinacoeli, but he probably remained there only for one year. In Naples his son Luigi was born, the Viceroy acting as his godfather; this son was to be the architect of the Royal Palace of Caserta. Gaspar's first view of Naples (1701) was perhaps painted on the spot, but might well have been painted when he returned to Rome. He visited the south several times in the following years, going as far as Messina of which he painted an accurate view. In 1711 he joined the Accademia di San Luca and was its 'curatore di forestieri'. There are two signed imaginary views of the following year, and in 1712 he is recorded for the first time with the nickname of Gaspar of the Spectacles ('degli Occhiali'). There are no facts of any significance known about his later life. His fertile and profitable activity continued for many years — many views of Rome, one of Vaprio d'Adda (1719), two of Frascati (1720) and numerous drawings. The last known dated painting is of 1730, *Villa Pamphili outside Porta San Pancrazio*. He died six years later in Rome, and is buried in Santa Maria in Vallicella.

WRIGHT, JOSEPH

Usually called Wright of Derby, he was born in that town in 1734. He moved to London and studied from 1751 to 1753 with the portraitist Thomas Hudson, with whom he later collaborated. Some time after 1773 Wright visited Italy, an event of great importance for his artistic development. Before this visit he had painted chiefly portraits and candlelight pictures of scientific experiments like those of Honthorst. In Italy he began to sketch landscapes and townscapes and to study ancient remains, and on a journey to Naples he witnessed an eruption of Vesuvius. He returned to England in 1775 and as a result of his Italian journey, once he had settled in Derby in 1777, he began to paint the English countryside in a romantic manner and also to paint Italian subjects such as Neapolitan landscapes reminiscent of Salvator Rosa, views of Rome, and mythological subjects. He died at Derby in 1797.

ZOCCHI, GIUSEPPE Plates 104, 107.

He was born in Florence in 1711 and according to Lanzi his early studies were followed by a series of journeys, to Rome, Bologna and Lombardy. According to Mariette, however, he was a pupil of Vernet in Rome. Zocchi painted chiefly views of Tuscan towns and landcape, and also portrayed festivities in honour of important visits such as that of Francesco I of Tuscany to Siena. He painted frescoes in Villa Seristori, Palazzo Rinuccini and Galleria Gerini. The Marchese Andrea Gerini was his most important patron, for whom he executed a series of views of Florence and its surroundings which were published in 1744. Zocchi died during an epidemic in 1767.

BIBLIOGRAPHY *Only works of a general nature are listed here, and more particularly those recently published, in which references will be found to previous studies. For general problems and individual artists, reference should be made to the annual publication Arte Veneta.*

G. Fiocco, *Francesco Guardi*, 1923.

M. Stubel, *Canaletto*, Berlin-Dresden, 1923.

F. Ingersoll-Smouse, *Joseph Vernet, peintre de marine, 1714-1789*, Paris, 1926.

G. Fiocco, 'La Pittura veneziana alla mostra del Settecento', in *Rivista della città di Venezia*, 1929.

P. Sentenac, *Hubert Robert*, Paris, 1929.

E. Bock, J. Rosenberg, *Die niederländischen Meister*, Berlin, 1930.

G. Ceci, s.v. *Marieschi, Michele*, in *Thieme-Becker*, Leipzig, 1930, XXV, p. 97 (with bibliography).

L. Dimier, *Les peintres français du XVIIIe siècle*, Paris and Brussels, 1928-30.

G. Fiocco, s.v. *Bellotto* in *Enciclopedia Italiana*, 1930.

E. Giglioli, *Disegni stranieri di paese nella Galleria degli Uffizi*, in *Dedalo*, February 1930.

M. Tinti, *Guardi*, Paris, 1930.

H. Egger, *Römische Veduten, Handzeichnungen aus dem XV. bis XVIII. Jahrhundert zur Topographie der Stadt*, Vienna, 1931.

F. Mauroner, *Luca Carlevarijs*, Venice, 1931.

P. de Nolhac, *Fragonard*, Paris, 1931.

H. Egger, *Römische Veduten*, Vienna, 1932.

G. Fogolari, *Michele Marieschi* in *Enciclopedia Italiana*, Rome, 1934.

M. Goering, *Marco Ricci*, in *Thieme-Becker*, Leipzig, 1934, XXVIII.

C. Lorenzetti, *Gaspare Vanvitelli*, Milan, 1934.

R. Buscaroli, *La pittura di paesaggio in Italia*, Bologna, 1935.

F.H. Alwill, *Bernardo Bellotto*, 1936.

S. Rocheblave, *La peinture française au XVIIIe siècle*, Paris, 1937.

D. von Hadeln, *Drawings of Antonio Canal*, London, 1939.

G. Lorenzetti, *La pittura italiana del Settecento*, Novara, 1942.

F. Mauroner, *Luca Carlevarijs*, Padua, 1945.

W. Arslan, *Il concetto di luminismo e la pittura veneta barocca*, Milan, 1946.

R. Longhi, *Viatico per cinque secoli di pittura veneziana*, Venice, 1946.

M. Florisoone, *Le Dixhuitième siècle*, Paris, 1948.

R. Longhi, 'Velazquez 1630: La « rissa all'Ambasciata di Spagna »' in *Paragone*, January 1950, pp. 30-34.

L. Van Puyvelde, *La peinture flamande à Rome*, Brussels, 1950.

S. Kozakiewicz, *Canaletto*, Warsaw, 1953.

F.J.B. Watson, *Canaletto*, London and New York, 2nd. ed. 1954.

R. Longhi, 'Viviano Codazzi e l'invenzione della veduta realistica' in *Paragone*, November 1955, pp. 40-46.

S. Lorentz, *Bellotto a Varsavia*, Catalogue of the Exhibition, Venice-Milan, 1955.

D. Sutton, Introduction to: *Artists in 17th Century Rome*. Catalogue of loan exhib., Wildenstein and Co. Ltd., London, June-July 1955.

E. Brunetti, 'Situazione di Viviano Codazzi', in *Paragone*, July 1956, pp. 548-54.

R. Causa, *Pitloo*, Naples, 1956.

M. di Carpegna, *Paesisti e vedutisti a Roma nel '600 e nel '700*, Rome, 1956.

D. Gioseffi, *Pittura veneta del Settecento*, Bergamo, 1956.

M. Levey, *National Gallery Catalogues: The Eighteenth Century Italian Schools*, London, 1956.

L. Réau, *Fragonard, sa vie et son oeuvre*, Paris, 1956.

311

Europäisches Rokoko, Catalogue of the Exhibition, Munich, 1958.

T. Pignatti, *Il quaderno del Canaletto alle Gallerie di Venezia*, Milan, 1958.

D. Gioseffi, *Canaletto, Il Quaderno delle Gallerie Veneziane e l'impiego della camera ottica*, Trieste, 1959.

M. Levey, *Painting in XVIIIth century Venice*, London, 1959.

C. Brandi, *Canaletto*, Milan, 1960.

R. Pallucchini, *La pittura veneziana del Settecento*, Venice and Rome 1960 (with full bibliography).

F. Arisi, *Gian Paolo Panini*, Milan, 1961.

G. Bazin, *L'Italia vista dai pittori francesi del XVIII e XIX secolo*, Catalogue of the Exhibition, February-March 1961.

W. Bernt, *Die niederländischen Maler des 17. Jahrhunderts*, vol. IV, Munich, 1962.

W.G. Constable, *Canaletto*, Oxford, 1962.

F. Haskell, *Patrons and Painters*, London, 1963.

G.M. Pilo, *Marco Ricci*, Catalogue of the Exhibition (with bibliography), Venice, 1963.

M. Levey, *Canaletto Paintings in the Royal Collection*, London, 1964.

E. Martini, *La pittura veneziana del Settecento*, Venice, 1964.

Bernardo Bellotto genannt Canaletto, Catalogue of the Exhibition (with bibliography), Vienna, 1965.

G. Briganti, 'La mostra del Bellotto a Vienna: diventò grande quando lasciò Venezia' in *L'Espresso* no. 31, 1965.

W.G. Constable, *Canaletto*, Catalogue of the Exhibition, 1964-5.

Francesco Guardi, Catalogue, Fundaçao Calouste Gulbenkian, Lisbon, 1965.

S. Kozakiewicz, *Bernardo Bellotto, Dizionario Bibliografico degli italiani*, Rome, 1965.

A. Martini, 'Notizie su Pietro Antoniani, milanese a Napoli,' in *Paragone*, March, 1965, pp. 80-3.

Nederlandse 17. Eeuwse Italianiserende Landschapschilders, Centraal Museum, Utrecht, March-May 1965.

P. Zampetti, *Catalogo della Mostra dei Guardi*, 1st. and 2nd. editions, 1965.

P. Zampetti, *Gian Antonio e Francesco Guardi*, Venice, 1965.

G. Briganti, *Gaspar Van Wittel e l'origine della veduta settecentesca*, Rome, 1966.

T. Pignatti, 'Gli inizi di Bernardo Bellotto', in *Arte Veneta*, 1966, pp. 218-29.

T. Pignatti, 'The Brothers Guardi: Mystery from the Venetian Carnival', in *Art News Annual*, 1966, pp. 23-35.

F. Valcanover, *I vedutisti veneziani*, Milan, 1966.

Atti del Convegno Guardesco in Venezia, 13-14 settembre 1965, Venice, 1966-7.

Disegni di Giacomo Quarenghi, Catalogue of the Exhibition (with an introduction by G. Fiocco), Vicenza, 1967.

D. Gioseffi, s.v. *Prospettiva* in *Enciclopedia Universale dell'Arte*, 1967.

R. Pallucchini, 'I vedutisti veneziani del Settecento', in *Atti dell'Istituto Veneto di scienze, lettere e arti*, Venice, 1967.

A. Rizzi, *Luca Carlevarijs*, Venice, 1967.

P. Zampetti, *I vedutisti veneziani del Settecento*, Catalogue of the Exhibition, Venice, 1967.

G. Briganti and G.J. Hoogewerff, s.v. *Van Wittel* in *Thieme-Becker Künstlerlexikon*, XXXV.

SOURCES OF PHOTOGRAPHS

A.C.L., Brussels: 174
Alinari, Florence: 10, 86-89.
Bruno Balestrini, Electa: 36-38, 42, 44-76, 78, 81-84, 90-93, 97, 102, 103, 105, 110, 111, 123, 130, 151, 154, 164, 167, 181, 182, 185, 187, 192, 194, 208-210, 212-214, 219, 221-223, 241.
Bazzecchi, Florence: 33, 34.
Boccardi, Rome: 16.
Bulloz, Paris: 226-232, 234, 236, 237, 239.
Dingjan, The Hague: 145, 146, 172.
Edelmann, Frankfurt: 173.
Archivio Electa: 1-6, 9, 11, 13, 14, 17, 18, 26, 35, 39, 96, 100, 101, 106, 109, 112, 113, 135, 136, 203, 204, 224, 225, 246.
Flavien, Paris: 199, 200.
Fleming, London: 7, 30.
Fotoexpress, Bergamo: 143, 144, 201, 202.
Deutsche Fotothek, Dresden: 99, 149.
Freeman, London: 211, 215.
Kapuscik, Warsaw: 189.
Archivio Mas, Barcelona: 117-119.
Meyer, Vienna: 130.
Newbery, London: 255.
Nimatallah, Milan: 114-116, 251, 252.
Galerie Pardo, Paris: 233, 238, 240.
Romanowski, Warsaw: 177-180, 183, 184, 186, 188, 190, 191, 193, 195-198.
Scala, Florence: 27, 28.
Steinkopf, Berlin: 77.
Vasari, Rome: 15, 24, 32, 94, 104, 107.

Cambridge, Fitzwilliam Museum: 176.
Dresden, Staatliche Kunstsammlungen: 98, 147, 148, 150, 152, 153, 155-163, 165, 166, 168-171.
Edinburgh, National Gallery of Scotland: 220.
Florence, Soprintendenza alle Gallerie: 95, 108.
Greenwich, National Maritime Museum: 216.
London, National Gallery: 22, 41, 43, 79, 175, 218.
Madrid, Museo del Prado: 29.
Minneapolis Institute of Arts: 207.
Munich, Residenz Museum: 137-142.
Naples, Soprintendenza: 25.
Oxford, Ashmolean Museum: 40.
Paris, Musée de la Marine: 242-245, 247-250, 253, 254.
Prague, National Gallery: 205, 206, 217.
Rome, Gabinetto Fotografico Nazionale: 8, 12, 19-21, 31.
Trieste, Fondazione Scaramangà: 85.
Vienna, Kunsthistorisches Museum: 120-122, 124-129, 131-134.
Warsaw, National Museum: 197.
Washington, National Gallery of Art: 80.

LIST OF COLLECTIONS

Bellotto: The Reformed Church in Warsaw, pl. 187.
Bellotto: The Square behind the Iron Gate, pl. 188.
Warwick, Earl of Warwick.
Canaletto: View of Warwick Castle, pls. 221-3.
Washington, National Gallery of Art.
Canaletto: The three-arched Bridge, pl. 80.

Windsor Castle, Royal Collection.
Canaletto: The Roman Forum, pl. 17.
Canaletto: The Thames from Somerset House, pls. 211, 215.
Woburn Abbey, Duke of Bedford.
Canaletto: Campo di S. Maria Formosa, pl. 59.
Canaletto: The Scuola di S. Rocco, pls. 66-7.
Canaletto: The Grand Canal, pls. 68-9.

INDEX OF ARTISTS AND PLACES